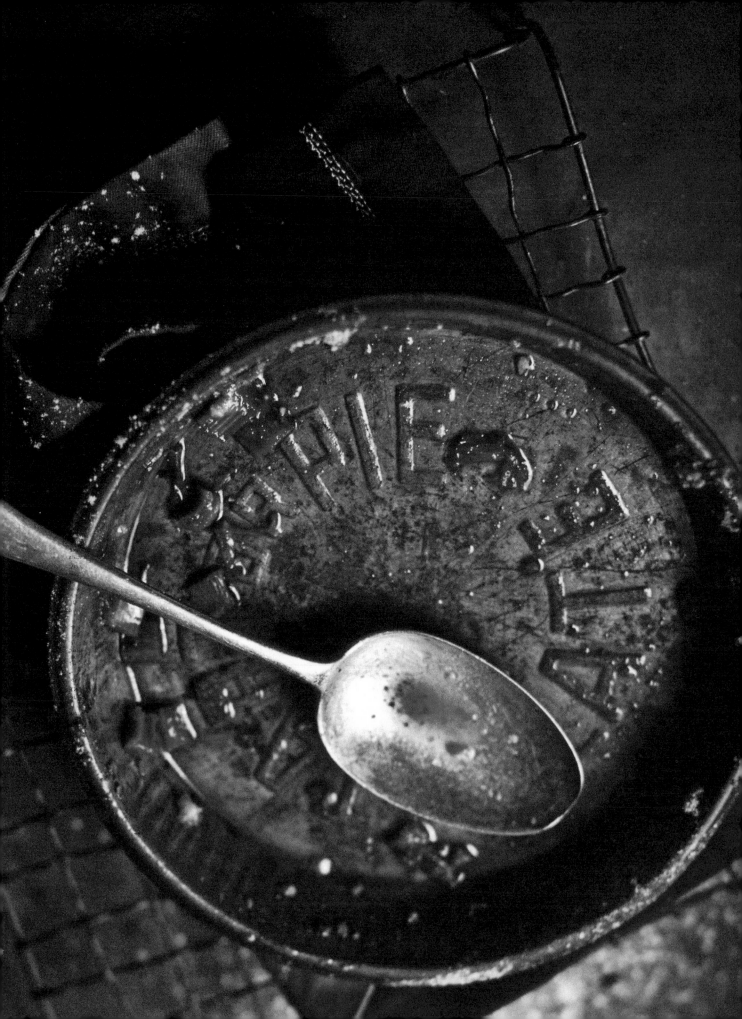

KATIE QUINN DAVIES
began her career as a *graphic designer*,
then, in 2009,
focused her creative energies on

FOOD PHOTOGRAPHY

and soon her blog,
'WHAT KATIE ATE', was born.
It became an *internet phenomenon*,
with a *huge* following
in *Australia*, Europe and the U.S.
When she's not shooting advertising
and *editorial* features for leading
food and lifestyle magazines
from her *Sydney* studio,
Katie *loves* to cook and
update the blog
with a variety of
new and *seasonal* recipes.

whatkatieate.com

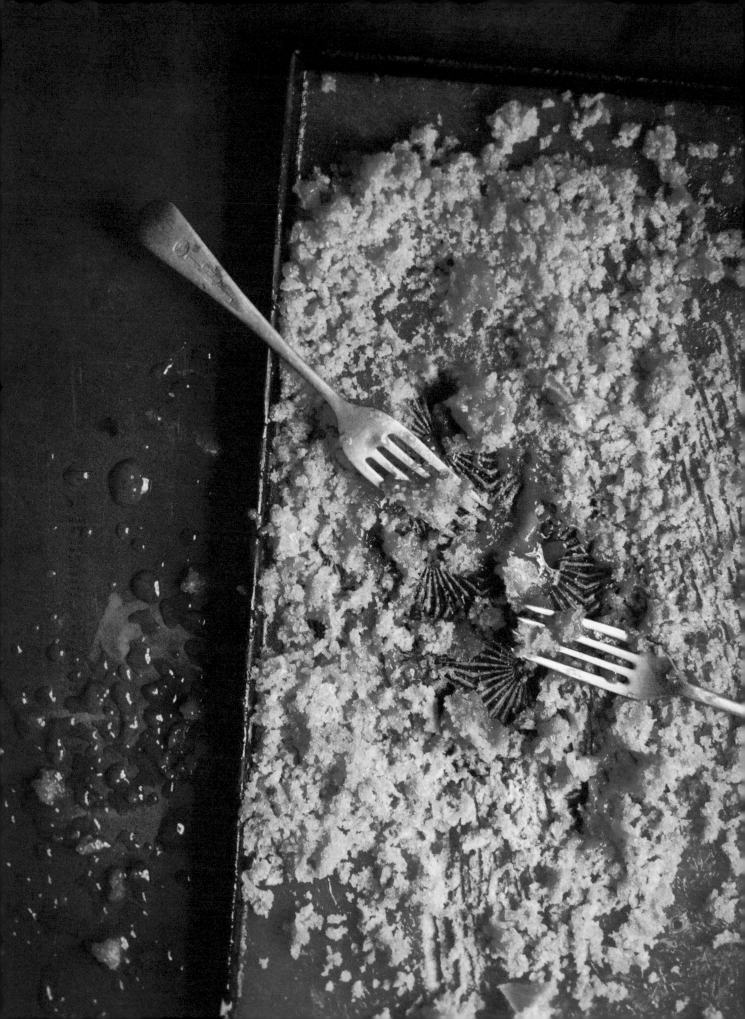

WHAT KATIE ATE

Recipes and other BiTS & Bobs

Photography by

KATiE QuiNN DAViES

Collins

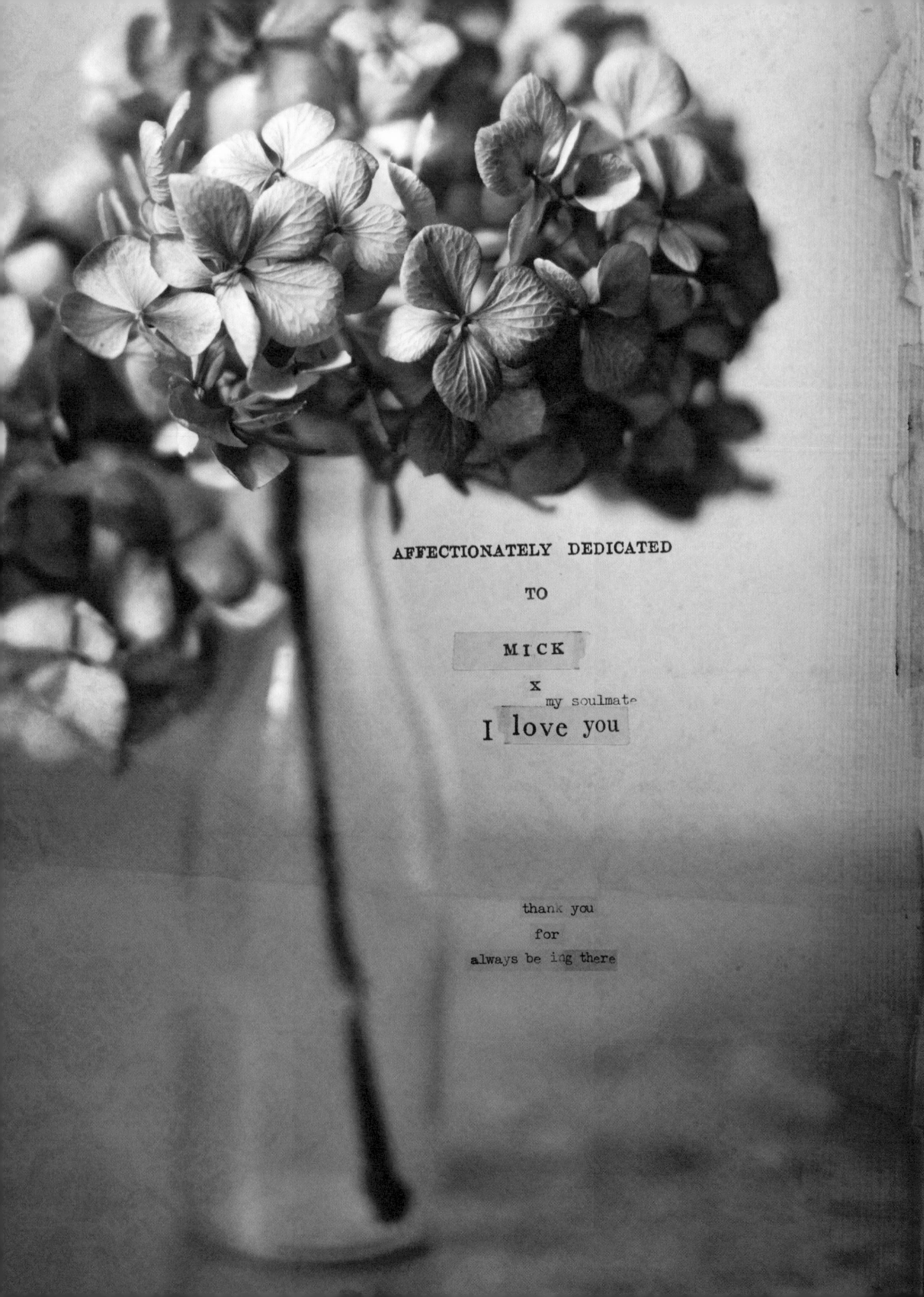

AFFECTIONATELY DEDICATED

TO

MICK

x

my soulmate

I love you

thank you

for

always be ing there

CONTENTS

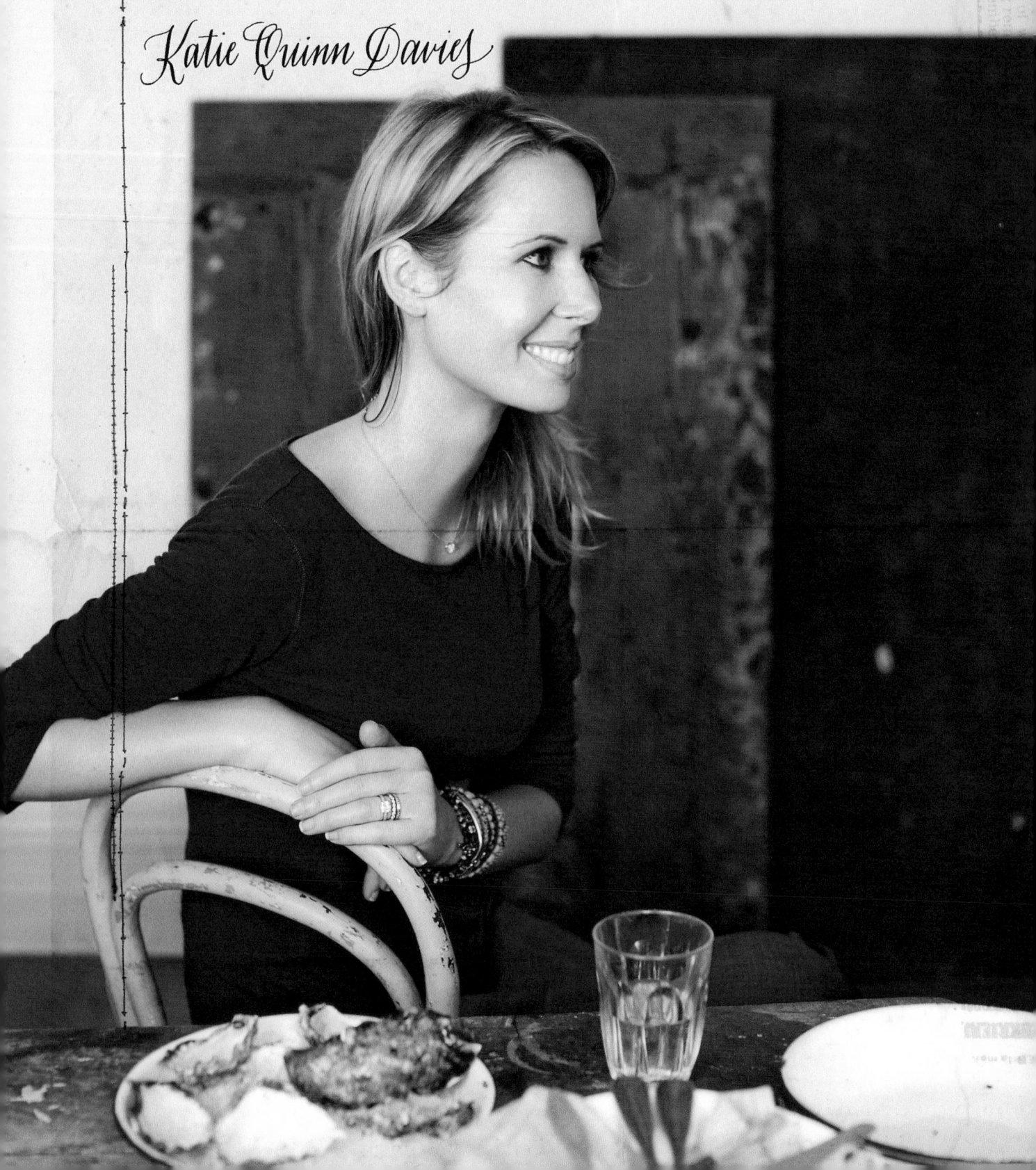

Katie Quinn Davies

Born and bred in Dublin, I have always loved good, honest home-cooked food, although I only really got into cooking for myself in my early thirties. (Apart, that is, from having my own Saturday morning cooking show aged six, when I would get up super-early while everyone was still asleep and, channelling Delia Smith, use up the ingredients in the store cupboard to concoct all manner of gloopy messes!). As a ten-year-old kid, my idea of the perfect meal consisted of as many sweets as I could fit into my mouth, washed down with a cola-flavoured Slush Puppy. I didn't come from a particularly 'foodie' family. Although my mum was an incredible baker and fantastic at catering for large gatherings, give her a sausage or a piece of steak and she would cook it to within a blackened inch of its life.

I spent most of my twenties working in Dublin as a graphic designer. Ireland was going through an economic boom, and it was an exciting time to be involved in the creative industry: I absolutely adored it. Along the way, I met my Aussie husband Mick, and in 2006 we moved to Melbourne, where I landed a job as Design Director for a leading studio. It was around this time that, after a successful ten-year design career, and despite my love for all things design, I started to wonder if this path was still the right one for me. I plodded reluctantly into work every day with a general sense that something better was around the corner for me, but frustratingly, I couldn't quite work out exactly what it was.

Then, in 2009, my mum died, exactly twenty years after my dad had died at the relatively young age of 55. She had suffered from Alzheimer's for many years, and my sister Julie had looked after her in Dublin in the later stages of Mum's life while I was in Australia. Following her death, I was finally spurred into action to sort out my career, and with the money she and Dad left me, I was lucky enough to be able to leave my design job and spend some time working out what I was going to do.

For some reason, everything I dabbled in over the ensuing months revolved around food; it was becoming a real passion. First off, I decided I was going to become Australia's Next Top Cupcake Baker and open my own cupcake shop. After a week or so baking cupcakes 24/7, I was totally over it, and sick as a dog from eating so much buttercream icing. Then, I was going to be Australia's Next Top Iced Cookie Maker, which involved parting with a small fortune to buy piping nozzles and all the other paraphernalia, and spending two weeks being covered head to toe in very brightly coloured royal icing (sure, how hard can it be to ice a cookie perfectly? Well, let me tell you, it's bloody impossible!). Next up, macarons. Eeek, dear God, why?! This phase involved Mick coming home from work each day to find me in tears in the corner of the kitchen, covered in ground almonds and meringue, after fourteen failed attempts to get them right. My tip: leave it to Ladurée. That's all I'm going to say about that hellish week of my life.

All this failed experimentation left me feeling pretty deflated. Then, one Sunday evening, as I was cooking a meal for Mick, the idea hit me like a steam train: I was going to combine my creative background with my love of food to become a food stylist and photographer. I adored photography, having studied it at art school, and had spent plenty of time on photoshoots in my career as a designer. I was also utterly fascinated with the art of food styling. In particular, I remembered working with a photographer friend of mine back in Dublin, John Jordan, who used to share a studio with a food

photographer — I would find myself getting completely distracted watching the stylist meticulously prepare food for the shots. Although I was aware that starting a new career as a professional food photographer at the age of 33 was going to be an uphill battle, I was up for it!

With this new-found determination, I set myself up with some good cameras, enrolled in a part-time digital photography course, and started cooking, styling and shooting food from home. I quickly learnt a few of the vagaries of the food photography game, the first being that you need to buy about ten times the amount of ingredients you think you'll need, just to get that one perfect hero shot (seventeen slightly cold burgers, anyone?). In fact, I had read that burgers, sandwiches and ice cream could be the trickiest to get looking good on camera, so I set about tackling these with a vengeance, and absolutely adored the craft of tweaking them again and again to get the right result. But it wasn't until I heard that Getty Images wanted to buy forty of my photos that I thought I might actually be able to make this work. For the next nine months, I continued to cook and shoot, cook and shoot, practising over and over. I failed miserably on many occasions, and this was when I learnt the most. Everything I know today I owe to making mistakes and figuring out how to fix them, even if it took me four or five tries.

While I was busy honing my style, I also knew I needed to raise my profile as a photographer and get my work out to a wider audience. My photography tutor, Mark Boyle, suggested I start my own blog, which could serve as a sort of online portfolio. Initially I baulked at the idea, as I thought blogs were just for proper writers, but when he suggested I call it 'What Katie Ate', I was smitten. I had read the *What Katy Did* books as a child, and the whole concept really struck a chord with me. So I gave the blog a bash, posting pictures of each day's cooking efforts accompanied by a short write-up. After a few weeks, feeling like a bit of an idiot and convinced that I was just talking to myself, I stopped updating the blog. Some ten months later, I got an email from a reader of the blog asking why I hadn't continued with it, as she had missed reading about my cooking adventures. I was touched — and surprised — and this inspired me to continue with the blog, updating it whenever I could find the time between shoots.

By now, Mick and I had moved to Sydney and I was getting regular work as a food photographer. The blog readership soon started to grow, and I was devising and cooking my own recipes for each post. It was also around this time that I was offered the opportunity to turn the blog into a book and, of course, I jumped at the chance. I was thrilled to be creating a permanent record of some of my favourite dishes from the blog, as well as showcasing new photography and recipes. My own cookbook — who would have thought it?

— — — — — —

I suppose my style of cooking could best be described as simple and seasonal. I'm not a trained chef by any means, just someone who loves the rituals of cooking and the pleasure it gives people. I like to experiment in the kitchen, throwing in a bit of this and a bit of that, concocting new ideas and pairing different ingredients (I guess it's not a million miles away from my cooking technique as a six-year-old!). I also love to try recipes given to me by family and friends, many of which have become part of my regular repertoire (with a 'Katie-tweak' here and there). Many of these appear in the book, especially recipes from my husband, Mick, who is an amazing cook, and from his parents, the wonderful Bob and Sheila (yes, they are Australian and yes, those are their real names!).

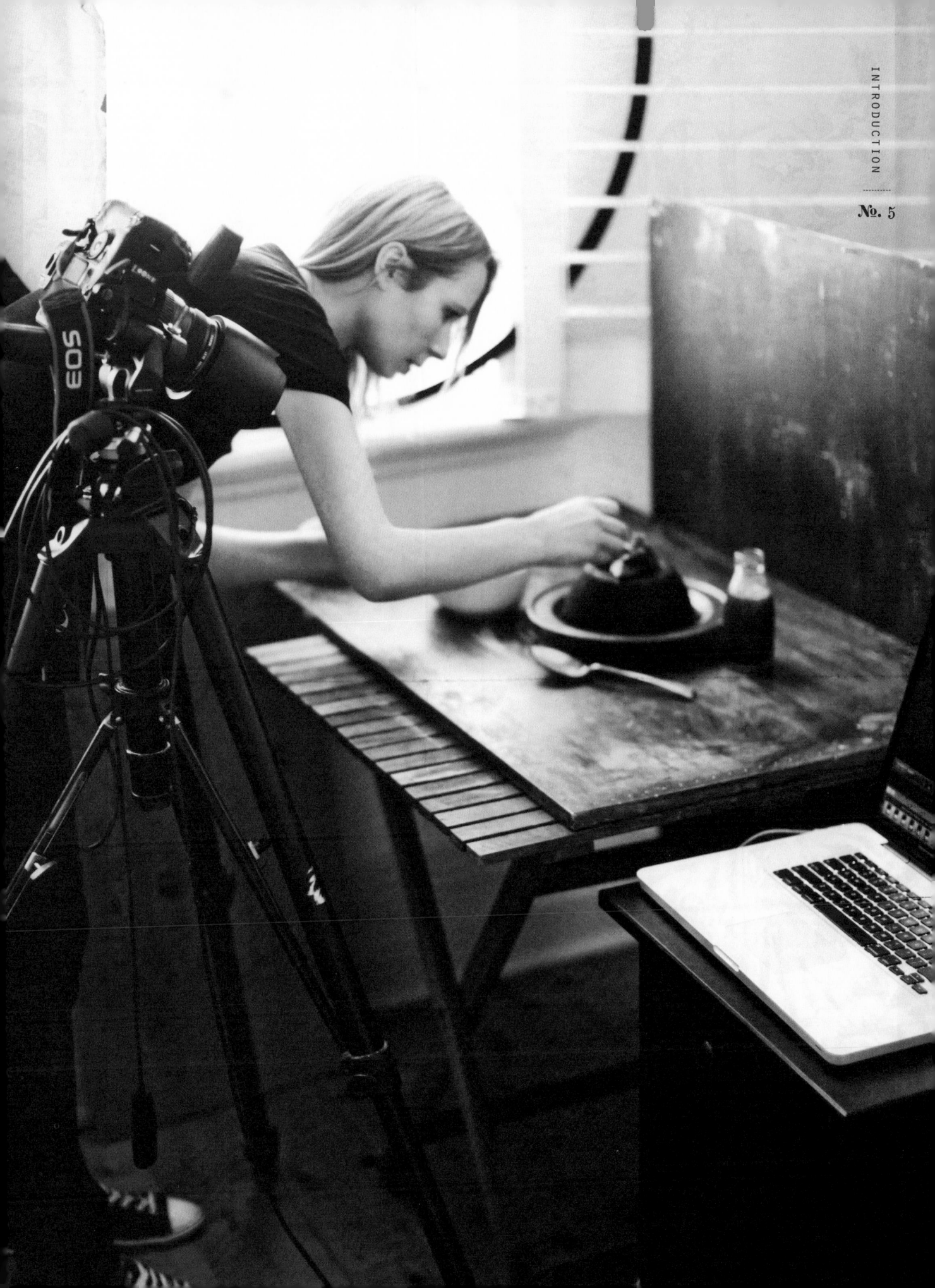

I love nothing more than having friends over for a meal on a Saturday night, sharing great food, wine and music, so many of my recipes are written with entertaining in mind. Some dishes are quick and easy, others take longer to prepare, but with most you can do this prepping a good few hours in advance (or even the night before), leaving you more time to spend with your friends. Actually, one of my favourite things about entertaining is taking the time to prepare the food — I find it hugely relaxing. I tend to really throw myself into it, and have been known to spend a whole day pottering in the kitchen getting everything ready for a dinner party. I am also a big fan of making canapés, though I realise I might be in the minority here (most people would rather pull out their own teeth than painstakingly prepare miniature food for fifty people, but I relish it!).

I love to eat out, and when I find a dish that really strikes a chord with me I'll try to re-create it at home, guessing what went into it and maybe combining flavours or ideas from two or three different dishes to create a new one. Overall, I don't like to take my cooking too seriously, which I think is reflected in the way I style food. If I pull a pie out of the oven and find it has sunk in the middle, I'll improvise by piling up some semi-roasted herbs on top to make it look nice and rustic — it will still taste delicious. If I want Michelin-star-quality food, I'll treat myself to a meal at a good restaurant and commend the incredible work of the trained chefs. At home, I like to keep things real and a bit more down to earth.

I'm a bit of a salad fiend, but that doesn't mean I love eating 'rabbit food' (let's face it, there's only so much lettuce, cucumber and tomato one can bear). I pride myself on coming up with ways to spruce up the ol' salad, so you won't feel like you're eating grass, but instead are enjoying something really tasty and relatively healthy. It's nothing revolutionary, but over the years I've found that adding a few roasted nuts or seeds to a salad livens it up enormously. Lightly roasted pumpkin seeds are a winner and add texture and interest, as do sunflower seeds and chia seeds (which are packed full of nutrients). Some shavings of cheese also add a tangy bite to salads, and take the boring edge off them. Salads are so versatile — I have one most nights of the week, usually accompanied by a nice piece of fillet steak, fish or free-range chicken breast. I also love to make one or two of my salads to take to friends' places for weekend barbecues — they always go down a treat.

This past year spent compiling the book has been an amazing journey for me. There have been lots of highs and, I'll admit, a few lows — the amount of work required to write, cook, style, shoot and design a cookbook almost single-handedly has been somewhat of a revelation to me (and to Mick, who has shared this journey with me closely). But whenever I felt things were getting on top of me, I would turn to the blog, and be encouraged by the comments from readers (such as 'counting the days until the book's launch!'). These were incredibly inspiring and always kept me going. I hope you'll all enjoy cooking — and eating — with me.

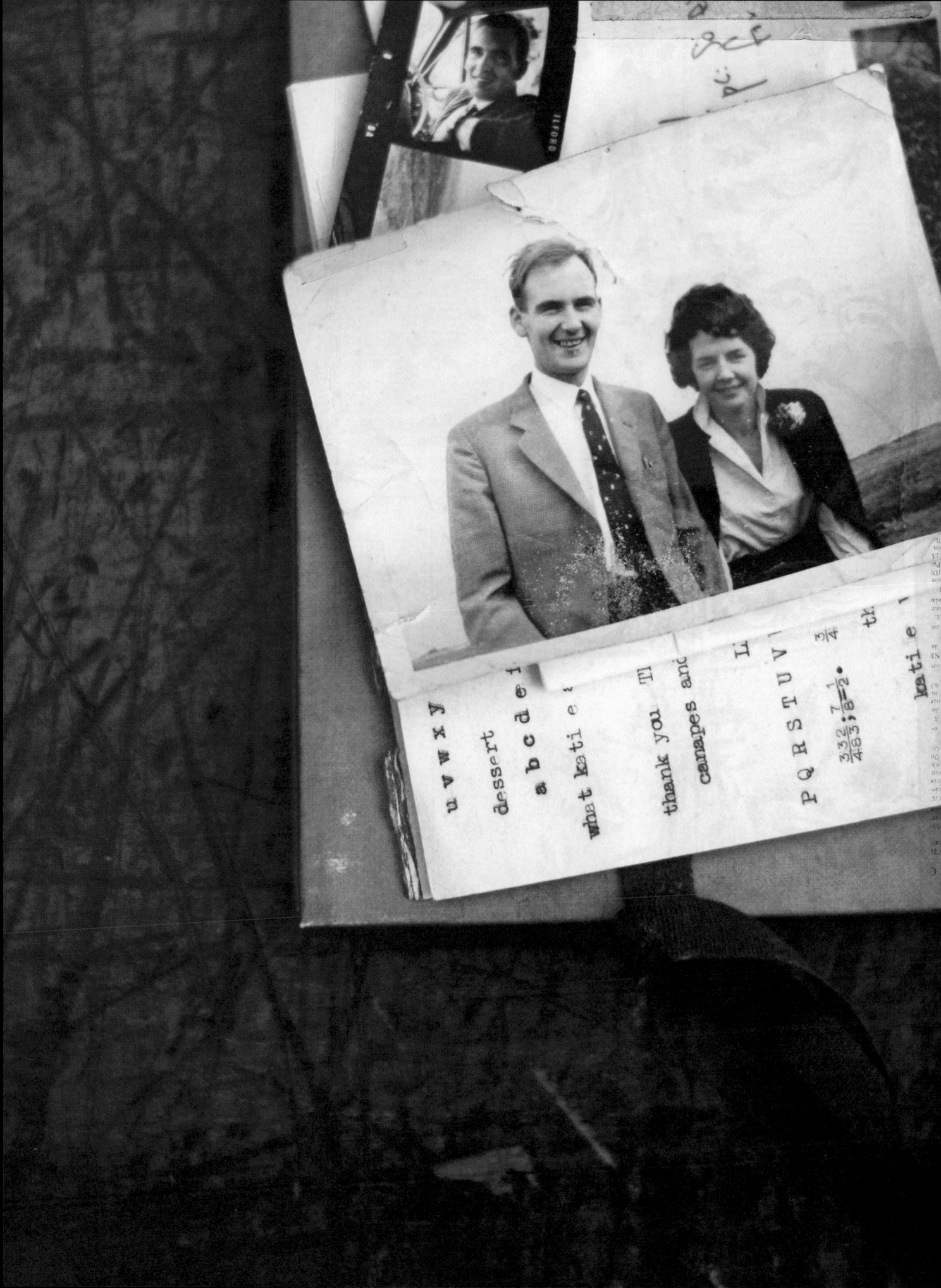

№. 10

As someone who only got into cooking in her thirties, I have learnt a lot
in a relatively short time, and made more than my fair share of mistakes!
Here is some kitchen wisdom I've picked up along the way — a few little tips
and tricks that should make life easier for you in the kitchen.

Blind-baking pastry for mini tarts or pies

I love making my own canapés, and one of my specialties is making teeny-tiny
pies in mini muffin tins. Following much fiddly trial and error trying to line
each tiny case with paper and baking beans for blind-baking, I hit upon an easy
solution — using one mini muffin tin slotted into another to create the perfect-
shaped weight. Line the holes of one tin with pastry rounds, using the rounded
end of a pestle (if you have one) or your fingers to push the pastry gently into
the holes. Take the second tin, turn it upside down and grease the undersides
of the holes, then press firmly into the first tin and, voila, they're ready for
chilling and blind baking. You'll need to stock up on mini muffin tins (to make
twenty-four pastry cases, you'll need four 12-hole mini muffin tins, unless you
want to cook them in batches), but they are inexpensive and also come in handy
when you want to cook a serious batch of muffins.

Chocolate

When cooking with chocolate, I use one that has at least 60-70% cocoa solids
(my favourite brand is Valrhona). This is important as it gives a lovely richness
without being cloyingly sweet. If you're melting chocolate over a pan of hot
water, be careful not to let the water boil. If the chocolate gets too hot, it
will separate and you'll have to start again, which is a real pain (and can get
expensive!). Take your time and be patient — the results will be worth it.

Chopping onions

About to peel and dice an onion? Don't do what my mother-in-law hilariously does
and don a pair of thick, perspex welder's glasses to stop her eyes watering
(LOL — true!). Instead, hold your wrists under running water for a second or two
before you start, keeping them wet as you chop the onion. Alternatively, chew a
piece of chewing gum — it really does work!

Cooking with alcohol

I love to use alcohol in my cooking, especially when making sweet things — it
really gives an edge to the flavour. Because I'm mad about hazelnuts, I use
a lot of Frangelico (a hazelnut liqueur), but feel free to use whatever
liqueur you fancy — Amaretto, Kahlua, Baileys Irish Cream, the list goes
on. And if you want your food alcohol-free, then just substitute with milk.

Juicing lemons and limes

I use a lot of citrus juice in my cooking, as it adds a lovely freshness and
tanginess. I've found that you get much more juice out of lemons and limes if you
microwave them for a minute or so, then roll them on a chopping board with the palm
of your hand before slicing and squeezing. If you're barbecuing meat, chicken or
fish, slice a lemon or lime in half and place the halves, cut-side down, on the
grill for a minute or two, then squeeze the juice over the grilled meat or fish
as it cooks. Grill some extra halves to serve — they look great, as well as being
super-juicy.

Mayonnaise

When making a mayonnaise, I never use extra virgin olive oil — I don't like the
strong flavour it gives the mayo. I use a very light olive oil or a combo of

rapeseed oil and light olive oil. On that note, don't use your extra virgin olive oil for cooking either, as it has a low smoking point and tends to get too hot too quickly. Use a light or normal olive oil, rapeseed or rice bran oil for cooking, and save your expensive extra virgin olive oil for salad dressings and dips.

Meringues

To ensure perfect meringues every time, wipe the inside of your mixing bowl with the cut-side of half a lemon before you start, to remove any traces of oil from the bowl. Egg whites behave much better when they're at room temperature, so try and remove them from the fridge and separate them well before you start cooking (even better, separate the eggs the day before and store them in a bowl, covered, on your worktop).

Saving a ganache

I love a good ganache — as well as tasting amazing, it has an incredible glossy sheen. I've made a few in my time, and have had my fair share of disasters (mostly when I've really splurged on the chocolate). If your ganache 'splits', or separates, whisk it with a hand-held blender and it will bounce back in no time. As a preventative action, I've found that if you pour the cream into the cold chocolate, then leave the mixture to stand for 5 minutes before stirring, the chances of it splitting are almost zero.

Sterilising jars and bottles for preserves

To sterilise jars and bottles, bring a large saucepan or stockpot of water to the boil. Check that your jars and bottles have no nicks or cracks in them, then unscrew the lids. Place the jars, bottles and lids in the boiling water, making sure they are completely submerged, and leave to bubble away for 10 minutes. Carefully remove the items from the water and place upside down to drain on a clean tea towel. Use a funnel or ladle to fill the jars and bottles, leaving a 1 cm gap at the top. Wipe the rims with a clean cloth, then secure the lids.

Using free-range

You may notice throughout the book that I have suggested using free-range eggs and free-range meat. I passionately believe that we should all make a conscientious effort to ensure the animals we eat endure as little suffering as possible. There really is no excuse these days to buy eggs or meat from caged animals. I urge you to support your local butcher when you can. They will often source their meat from smaller, independent farms — and these, in turn, tend to place more emphasis on the welfare of their livestock.

MY CANNOT-LIVE-WITHOUT KITCHEN ITEMS ARE:

A cherry stoner — cutting around the fruit to remove the stone has to be one of the most laborious chores ever! This little gadget does it in seconds, and it works with olives too.

A hand-held blender — I have a Bamix and it's utterly brilliant. I use it mainly for making mayonnaise; it takes literally 10 seconds.

A KitchenAid electric mixer — there's not much I can say that hasn't already been said about these kitchen workhorses. Invest in one and you'll never regret it.

All the recipes in this book have been developed and tested using a fan-assisted oven. If using a conventional oven, you'll generally need to increase the oven temperature by 20°C, but please note that cooking times may vary, depending on your individual oven.

FRUIT DRINKS

Just Juice

Banana, *Strawberry* and GINGER *smoothies*

I drink a homemade smoothie most mornings for brekkie. I love
to use fresh berries such as strawberries, raspberries and
blueberries when I can, as they are packed full of antioxidants
and great for you. However, fresh berries can get pretty pricey
when they're not in season, so I tend to use whatever fruit
I have to hand — smoothies are a great way to use up any overripe
fruit languishing in the fruit bowl. Feel free to add a peach or
a nectarine to this smoothie if you have one: they go very well
with the strawberries and ginger.

500 ML MILK
95 G NATURAL YOGHURT
3 BANANAS, ROUGHLY CHOPPED
HANDFUL STRAWBERRIES, HULLED
1 X 2 CM PIECE GINGER, PEELED AND GRATED
1 TABLESPOON RUNNY HONEY
HANDFUL ICE CUBES, PLUS EXTRA TO SERVE (OPTIONAL)

Place all the ingredients in a blender and whizz until smooth.
Serve in chilled glasses with extra ice, if you like.

Serves 3–4
(makes approximately 1 litre)

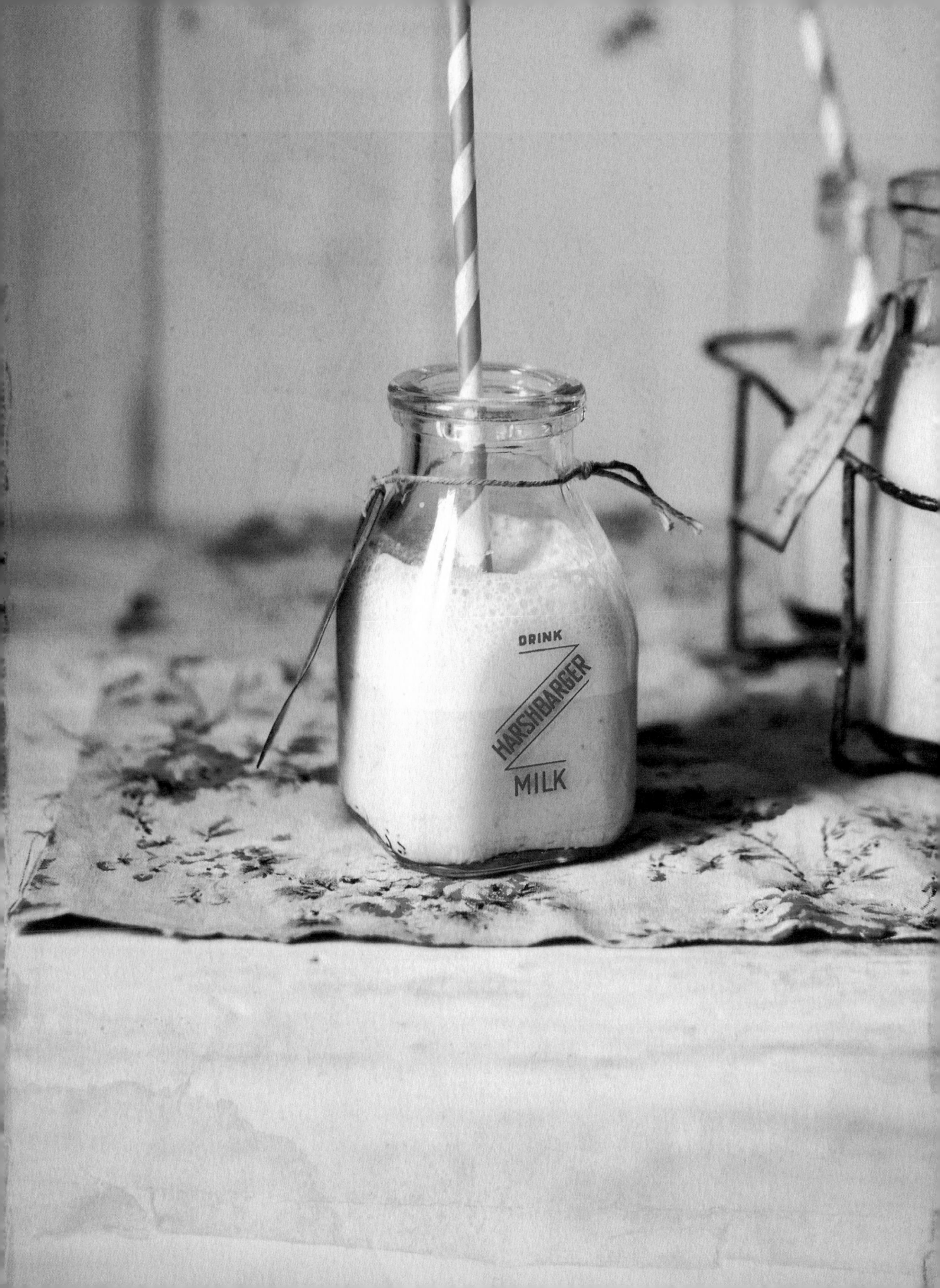

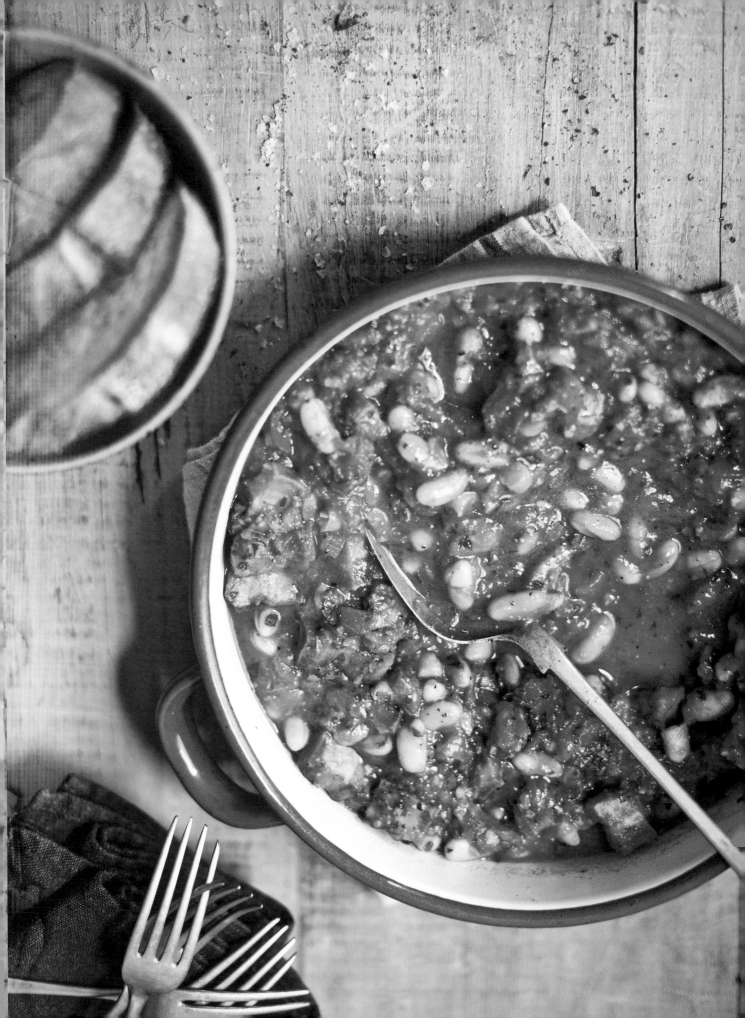

These homemade beans are super-easy to make, very flavoursome
and a great alternative to sugar and salt-laden tinned baked
beans. You can omit the pancetta, if you like, to make this
a vegetarian dish. These beans pair wonderfully with a soft
poached egg topped with lots of black pepper, and a big cup
of hot breakfast tea.

HOMEMADE Baked Beans on toast

2 TABLESPOONS OLIVE OIL
1 ONION, FINELY DICED
SEA SALT AND FRESHLY GROUND BLACK PEPPER
2 GARLIC CLOVES, CRUSHED
175 G PANCETTA, EXCESS FAT REMOVED, CUT INTO 1 CM CUBES
3 THYME SPRIGS, LEAVES PICKED
2 X 400 G TINS CHOPPED TOMATOES
1 LONG RED CHILLI, THINLY SLICED
1 TABLESPOON BROWN SAUCE, SUCH AS HP
1 TABLESPOON WORCESTERSHIRE SAUCE
1 TEASPOON DIJON MUSTARD
1 TEASPOON HOT ENGLISH MUSTARD
2 X 400 G TINS CANNELLINI BEANS, RINSED AND DRAINED
4-6 THICK SLICES CRUSTY BREAD
FINELY CHOPPED FLAT-LEAF PARSLEY, TO SERVE

Heat 1 tablespoon olive oil in a large heavy-
based saucepan or flameproof casserole dish.
Add the onion, season with a pinch of salt
and cook over a medium heat for 5 minutes.
Add the garlic and cook for another 5
minutes, stirring occasionally.

Meanwhile, heat the remaining olive oil
in a small frying pan over a medium
heat, add the pancetta and cook until
golden and crispy.

Add the pancetta to the onion
mixture, along with the thyme
leaves, tomato, chilli, sauces
and mustards. Simmer for 20 minutes,
then reduce the heat to low and
stir in the cannellini beans.
Cook for 10 minutes, then season
with salt and pepper and cook for
a further 10 minutes.

Toast the bread, place
one slice on each plate
and serve the beans on
top with a sprinkling
of parsley.

Serves 4-6

I adore crêpes. As a kid I used to make them after school,
trying in vain to flip them with a perfect reverse landing.
I much prefer these delicate crêpes to the thick hot cakes you
so often see on breakfast menus, as they are much less filling
and stodgy. If blood oranges and ruby grapefruit are not in
season, just use regular oranges and grapefruit.

№. 23

BUTTERMILK Crêpes
with Citrus Compote

150 G PLAIN FLOUR
150 G WHOLEMEAL PLAIN FLOUR
4 FREE-RANGE EGGS
625 ML MILK
375 ML BUTTERMILK
SEA SALT (OPTIONAL)
BUTTER OR RAPESEED OIL SPRAY, FOR COOKING
360 G RUNNY HONEY
2 ROSEMARY SPRIGS
CRÈME FRAÎCHE, TO SERVE

Citrus compote
6 LARGE BLOOD ORANGES
3 RUBY RED GRAPEFRUIT
2 TABLESPOONS CASTER SUGAR
SMALL HANDFUL MINT LEAVES

Serves 4-6

To make the citrus compote, first segment the fruit. Cut
the top and bottom from one orange, then place on a chopping
board. Working from top to bottom, use a small, sharp knife
to cut away all the skin and pith. Take the fruit in your
hand and, holding it over a bowl to catch the juices,
carefully cut each inner segment away from the membrane,
letting the segments fall into the bowl — they should be
free of any white pith or pips. Repeat with the remaining
oranges and the grapefruit.

Heat a large frying pan over a medium heat. Add the fruit
segments and juices and 1 tablespoon sugar and mix to
combine. Cook for 3-4 minutes to soften the fruit, then
transfer the contents of the pan to a sieve placed
over a bowl. Reserve the fruit and set aside, and return
the juices to the pan. Add the remaining sugar and simmer
over a medium heat for 12-15 minutes until reduced by two-
thirds and syrupy. Pour the syrup over the reserved fruit
segments, stir through the mint leaves and set aside.

Recipe continued over page...

BUTTERMILK Crêpes
with Citrus Compote continued...

Preheat the oven to its lowest temperature.

Sift the plain flour into a large bowl, then
add the wholemeal flour and make a well in the
centre. Crack the eggs into the well. Combine
the milk and buttermilk in a jug with a fork
then, using a large balloon whisk, start to
combine the flour and eggs, gradually adding the
milk. You want the batter to be the consistency
of thin, runny cream. At this stage, add a pinch
of salt, if you like.

Warm a crêpe pan (mine measures 18 cm) over a
high heat, add a small knob of butter and let it
melt. Alternatively, spray with rapeseed oil and
let it warm through. Add 1 small ladle (about
125 ml) of batter, swirling the pan to ensure
a thin, even coverage. Cook for about 1 minute
then, using a palette knife or spatula, flip the
crêpe over and cook the other side for 1 minute
or until browned and crispy at the edges (I find
the second side takes a teeny bit longer to cook
than the first). Turn out onto a plate and
repeat with the remaining batter, keeping the
cooked crêpes warm in the oven while you do
the rest — you should have enough to make
about sixteen crêpes.

Meanwhile, place the honey and rosemary sprigs
in a small saucepan. Bring to simmering point,
then cook over a low-medium heat for 6 minutes
to infuse the flavours — be careful not to let
the honey boil as it can burn and spoil very
quickly. Carefully transfer to a jar.

Place a warm crêpe on a plate, add a tablespoon
of citrus compote to one half and top with
a generous teaspoon of crème fraîche. Fold the
crêpe over the filling and then into quarters.
Repeat with two more crêpes (three per serving
is ideal) and finish with a good drizzle of
rosemary honey.

Often a photography shoot means early starts, and I have to
snap up brekkie on the go — usually I grab a pastry from my local
coffee shop. These homemade muffins are a great, healthy-ish
alternative, and the best part is you can make a large batch,
store them in an airtight container and they'll last the week.
Or, you can take the whole batch into work with you, and be in
the running for Employee of the Year! I love this combination
of apple and strawberries, and the almonds provide a nice crunchy
contrast to the soft fruit. A few blueberries or blackberries
would be a great addition too, so if they are in season, throw
in a handful.

Strawberry, APPLE and almond
breakfast muffins

185 G SELF-RAISING FLOUR
65 G GROUND ALMONDS
130 G CASTER SUGAR
2 TEASPOONS BAKING POWDER
1$\frac{1}{2}$ TEASPOONS GROUND CINNAMON
FINELY GRATED ZEST OF $\frac{1}{2}$ LEMON
LARGE PINCH FINE SALT
2 TEASPOONS VANILLA EXTRACT
120 G UNSALTED BUTTER, MELTED AND COOLED
2 FREE-RANGE EGGS, LIGHTLY BEATEN
1 APPLE, PEELED, CORED AND CUT INTO SMALL CUBES
6 LARGE STRAWBERRIES, HULLED AND QUARTERED
50 G FLAKED ALMONDS
1–2 TABLESPOONS BROWN SUGAR

Preheat the oven to 180°C (fan), 200°C, gas mark 6.

Line a 12-hole standard muffin tin with paper cases or small
rounds of baking paper.

Place the flour, ground almonds, caster sugar, baking powder,
cinnamon, lemon zest and salt in a bowl and mix well. In a
separate bowl, mix together the vanilla extract, melted butter,
beaten eggs and 180 ml warm water. Add the wet ingredients to the
dry ingredients and mix with a wooden spoon, then add the apple
and gently stir to combine. Spoon the batter into the prepared
tin, filling each case to about three-quarters full.

Place two strawberry quarters on top of each muffin, then
sprinkle with the flaked almonds and brown sugar. Bake for
25–30 minutes or until a skewer inserted in the centre of
a muffin comes out clean.

makes 12

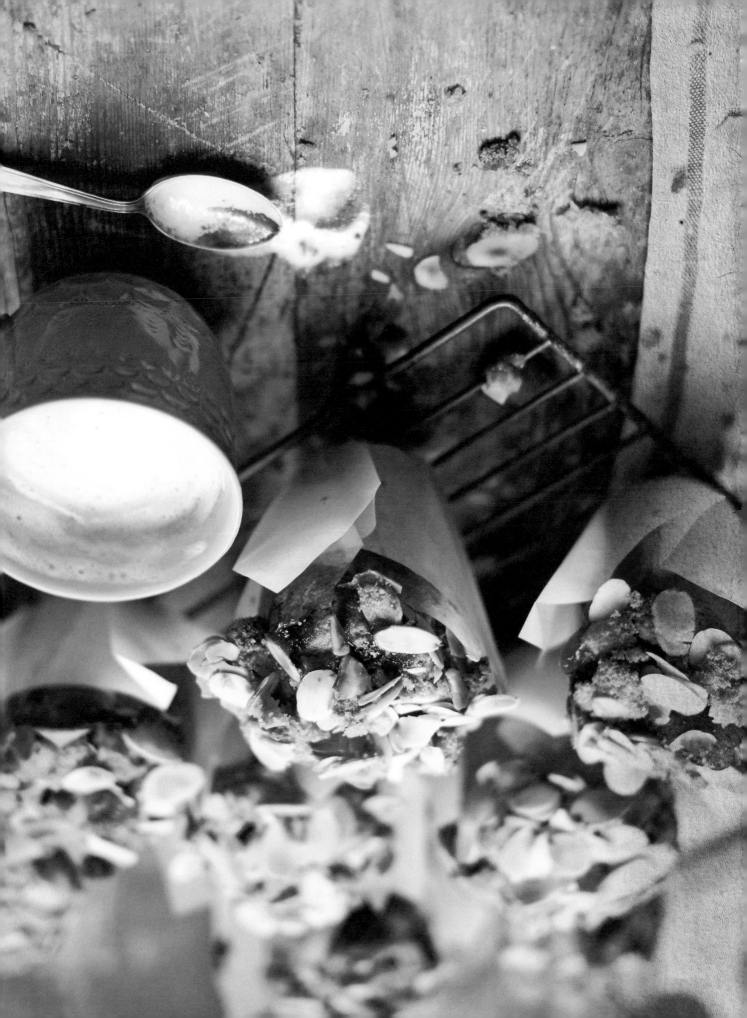

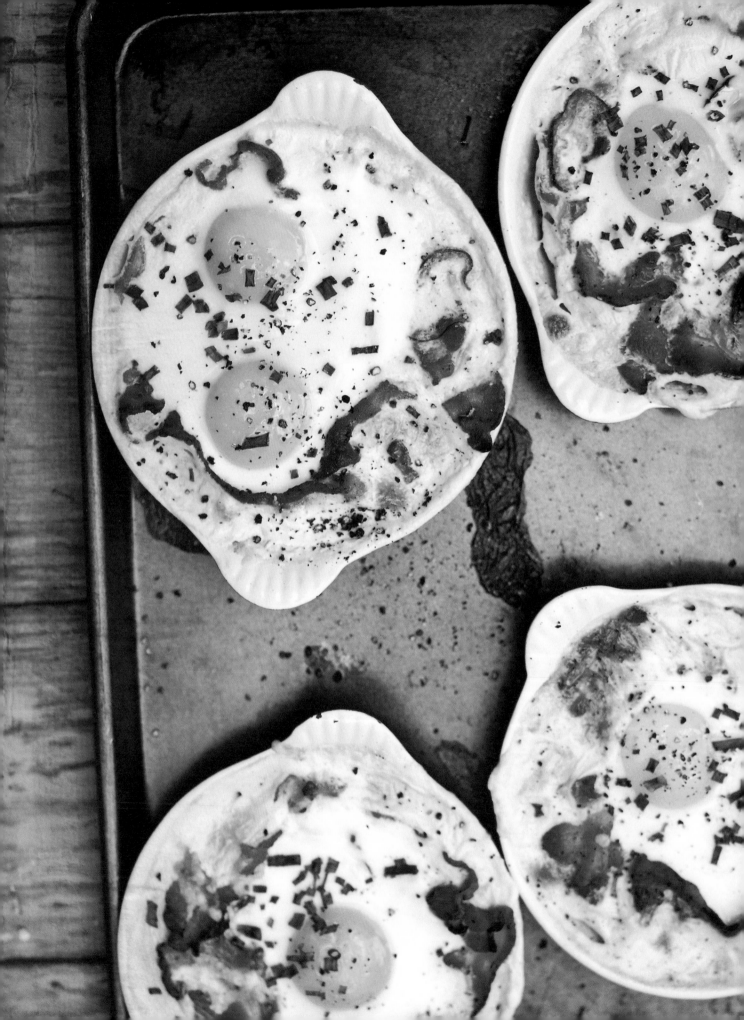

Baked eggs with POTATO, prosciutto and chilli

I've featured quite a few recipes for baked eggs on my blog over
the years, and they have always been very popular (they are a particular
favourite in our household — my husband Mick adores them for Sunday
brunch). I came up with this recipe during a trip to the US in 2011,
when I was inspired by the most amazing multicoloured potatoes I found
at a grocery store in Venice Beach. If you can't get your hands on
fresh jalapeño chillies, you should be able to get them in jars from
speciality food shops, or you could use a fresh long red chilli instead.

Serves 4

6 WAXY POTATOES, SKINS ON, WASHED
1 TEASPOON FINE SALT
1 TABLESPOON OLIVE OIL
12 SLICES GOOD-QUALITY PROSCIUTTO OR SERRANO HAM
500 ML CREAM
120 G MATURE CHEDDAR, GRATED
 PLUS A LITTLE EXTRA TO SCATTER
SEA SALT AND FRESHLY GROUND BLACK PEPPER
1 JALAPEÑO OR LONG RED CHILLI, DESEEDED,
 SLICED PAPER-THIN
4 LARGE FREE-RANGE EGGS
1 BUNCH CHIVES, SNIPPED

Preheat the oven to 180°C (fan), 200°C, gas mark 6.

Half-fill a large saucepan with cold water and add the potatoes and salt.
Bring to the boil, then reduce the heat to medium and simmer for 20 minutes or
until the potatoes are just cooked through. Drain and leave to cool slightly,
then cut into thin slices.

Heat the olive oil in a frying pan over a medium heat then, working in batches,
fry the sliced potato until softened in the middle and lightly golden and crispy
on the outside, adding more oil to the pan between batches if needed. Drain on
kitchen paper and pat off any excess oil.

Liberally grease four shallow gratin-style dishes, each approximately 12 cm
in diameter. Line each one with two layers of fried potato, then place three
slices of prosciutto or Serrano ham around the edges to form a border (this
helps to hold the liquid ingredients inside).

Place the cream, grated Cheddar and a pinch of salt and pepper in a jug, then
stir to combine. Pour the mixture evenly into the dishes (you might need to
spoon out the cheese if it settles at the bottom of the jug), then top with
chilli. Scatter a little extra cheese over the top, then carefully crack one
egg into each dish.

Choose a roasting tin large enough to hold the four smaller dishes, and carefully
place them inside. Pour enough water into the roasting tin to come halfway up the
sides of the dishes, then bake for 15–20 minutes or until the egg white has set.

Serve immediately, garnished with chives and a final grinding of black pepper.

Katie's extra-creamy scrambled eggs
with smoked salmon and SPINACH

My bog-standard weekday breakfast is Vegemite on toast (it only took me about, oh, ten years to grow to love this iconic Aussie foodstuff, after being repulsed by it on first tasting). On the weekends, when I have a bit more time, I love to cook eggs, and scrambled eggs is one of my faves. These are particularly rich and luscious, and they pair brilliantly with salmon and spinach.

400 G BABY SPINACH LEAVES
6 FREE-RANGE EGGS
SEA SALT AND FRESHLY GROUND BLACK PEPPER
2 SPRING ONIONS, TRIMMED AND VERY FINELY SLICED
3 TABLESPOONS CREAM
2 TABLESPOONS SOURED CREAM
KNOB OF BUTTER
1 TEASPOON FINELY CHOPPED DILL, PLUS EXTRA CHOPPED DILL
2 THICK SLICES CRUSTY BREAD
FINELY GRATED ZEST OF $1/2$ LEMON
100 G SMOKED SALMON, CUT INTO THIN STRIPS
LEMON WEDGES, TO SERVE

Place the spinach in a large saucepan with 3 tablespoons water. Cover and cook over a medium heat for 1–2 minutes until wilted. Briefly drain in a colander or sieve, then return to the pan and keep warm.

Meanwhile, whisk the eggs in a bowl and season with salt and pepper. Add the spring onion, cream, soured cream, butter and dill and whisk again gently.

Heat a large non-stick frying pan over a low-medium heat. Add the egg mixture and allow it to settle a little then, using a spatula, gently scrape the mixture from the bottom of the pan as it cooks. You want it to be cooked through, but still soft and fluffy.

Toast the bread, place one slice on each plate and top with the spinach. Sprinkle over a pinch of lemon zest, then add the scrambled eggs and smoked salmon strips. Scatter over a little extra dill and a good grinding of pepper and serve with lemon wedges.

serves 2

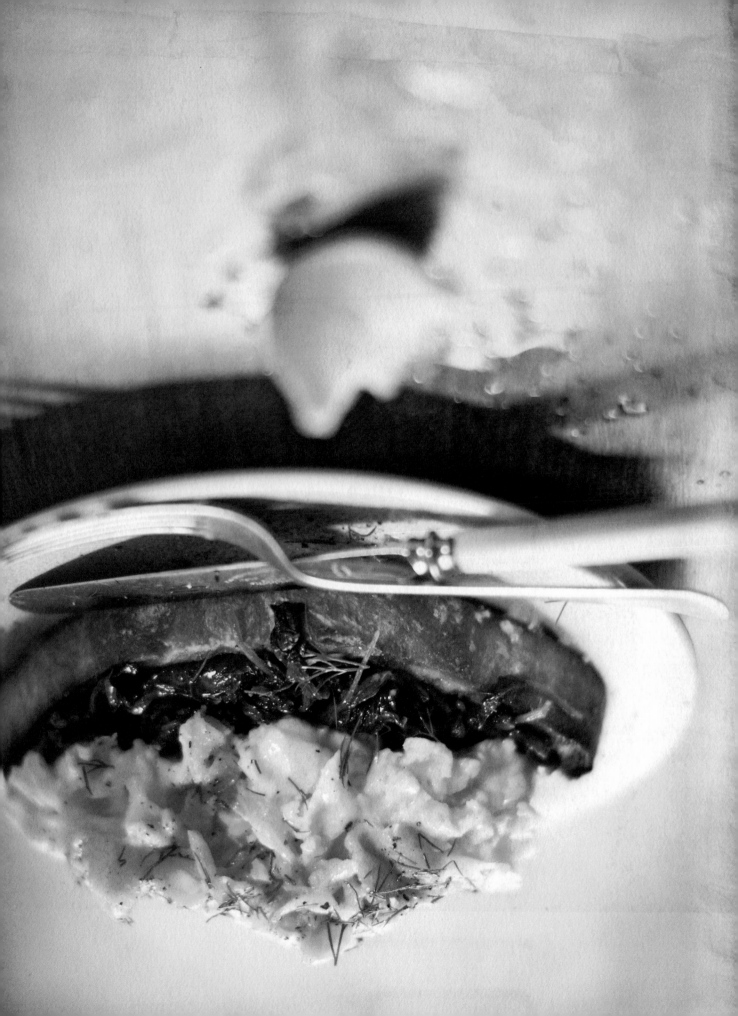

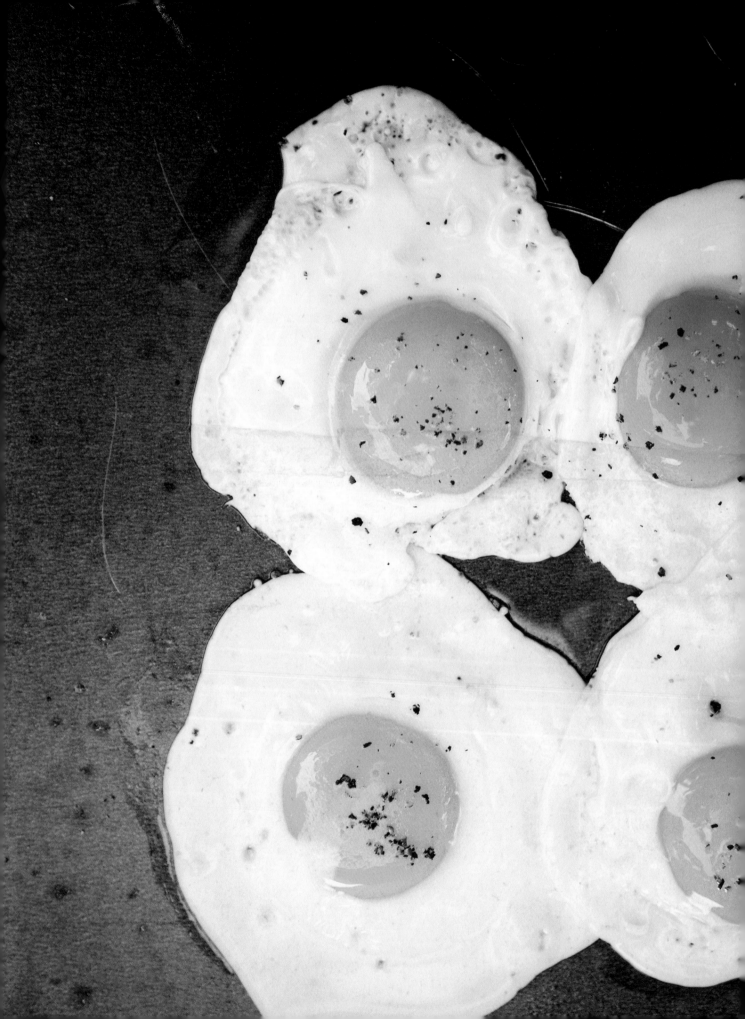

$1·20

I'm going to be completely honest here and confess that, when it comes to mushrooms, I'm not really their No.1 fan. I like a few scattered on a pizza or cooked in a pasta sauce, but any more than that and I'm a bit so-so. I think you either love them or hate them.

My husband adores mushrooms like there's no tomorrow. After a recent trip to our local farmers' market, where I spied the most incredible range of locally grown mushroom varieties, including chestnuts, shiitake and oyster mushrooms, I thought I'd whip him up some mushrooms on toast as a treat. Cooked simply with butter and parsley, and served warm on a thick piece of toasted bread, this brekkie will warm the heart of any mushroom fanatic.

Mushrooms ON TOAST
with *Walnuts* and
Goat's Cheese

1 TABLESPOON OLIVE OIL
2 LARGE HANDFULS MUSHROOMS, CLEANED AND SLICED
SEA SALT AND FRESHLY GROUND BLACK PEPPER
1 TABLESPOON BUTTER
SMALL HANDFUL WALNUTS, ROUGHLY CHOPPED
3 THYME SPRIGS, LEAVES PICKED
2 THICK SLICES CRUSTY BREAD
1 LARGE GARLIC CLOVE, PEELED AND HALVED LENGTHWAYS
75 G SOFT GOAT'S CHEESE
EXTRA VIRGIN OLIVE OIL, FOR DRIZZLING
SMALL HANDFUL FLAT-LEAF PARSLEY LEAVES
SHAVED PARMESAN, TO GARNISH

Pour the olive oil into a heavy-based frying pan and warm gently over a medium heat for 30 seconds. Add the mushrooms, season lightly with salt and fry for about 5 minutes, stirring occasionally. Add the butter, walnuts and thyme and toss to combine, then fry for a further 5 minutes until the mushrooms are golden brown and cooked through.

Toast the bread, then rub one side with half a garlic clove and spread thickly with goat's cheese.

Pile the mushrooms on top, drizzle with extra virgin olive oil, then season with a little more salt and lots of pepper. Finish with a scattering of parsley and shaved Parmesan.

Serves 2

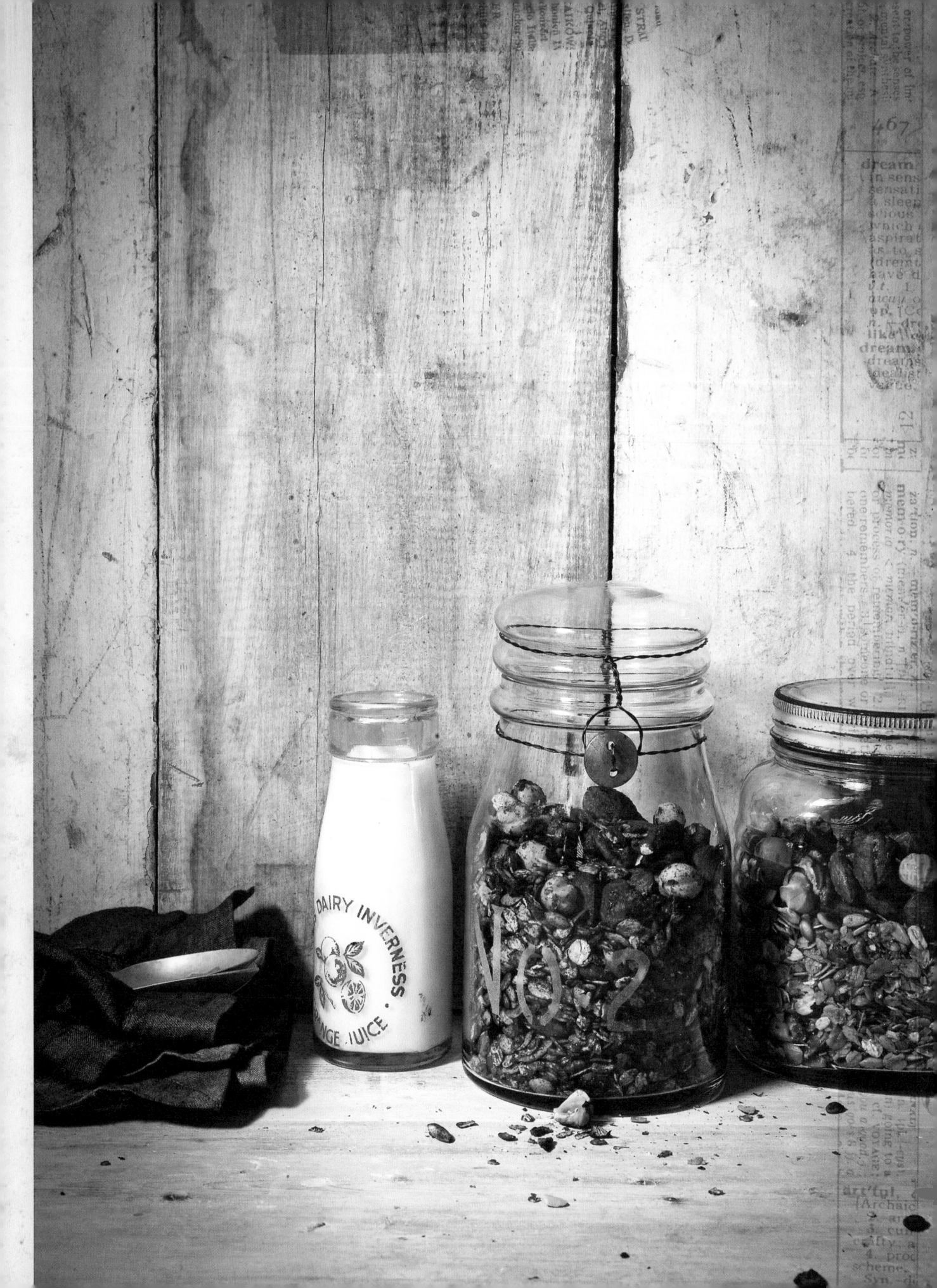

Bob Davies is my father-in-law, a fantastic and enthusiastic
cook and, just like his son, a top bloke! Bob makes this
muesli every two weeks or so and stores it in a big airtight
container. It's very yummy, packed full of healthy nuts and
seeds and has great texture and flavour. To make a more
decadent chocolate version, add 2 tablespoons of cocoa powder
to the dry ingredients just before you divide them in half.

Bob's toasted MUESLI

495 G ROLLED OATS
75 G WHEATGERM
60 G SHREDDED COCONUT
105 G SUNFLOWER SEEDS
200 G PUMPKIN SEEDS
160 G ALMONDS
140 G HAZELNUTS, SKINNED
3 TABLESPOONS RAPESEED, PEANUT OR SUNFLOWER OIL
3 TABLESPOONS RUNNY HONEY, PLUS EXTRA TO SERVE (OPTIONAL)
3 TABLESPOONS MAPLE SYRUP
280 G SULTANAS, CURRANTS OR RAISINS (OR A COMBINATION)
70 G CHOPPED DRIED DATES OR FIGS

makes 1.5 kg

Preheat the oven to 130°C (fan), 150°C, gas mark 2 and line
two baking trays with baking paper.

Combine the oats, wheatgerm, coconut, seeds and nuts in
a large bowl, then divide this mixture in half, leaving
half in the large bowl and setting aside the other half,
covered, in a smaller bowl.

Heat the oil, honey and maple syrup in a saucepan over a
low-medium heat for 5-6 minutes until the mixture is thin
and runny, then pour it over the oat mixture in the large
bowl. Mix really well with a spoon until well-coated but
not too clumped together; if the mixture looks a bit wet,
mix in some of the reserved dry oat mixture.

Divide the wet oat mixture between the prepared trays,
then bake for about 1 hour, shaking the trays occasionally
to make sure the mixture cooks evenly. It should be
a luscious golden colour when it's done — take care not
to let it darken too much.

Remove the trays from the oven and let the mixture cool
completely, then tip it into a large bowl and combine with
the reserved dry oat mixture and the dried fruit.

Serve in individual bowls with cold milk poured over and
extra honey drizzled on top (if using). Store the leftovers
in an airtight container for up to 2 weeks.

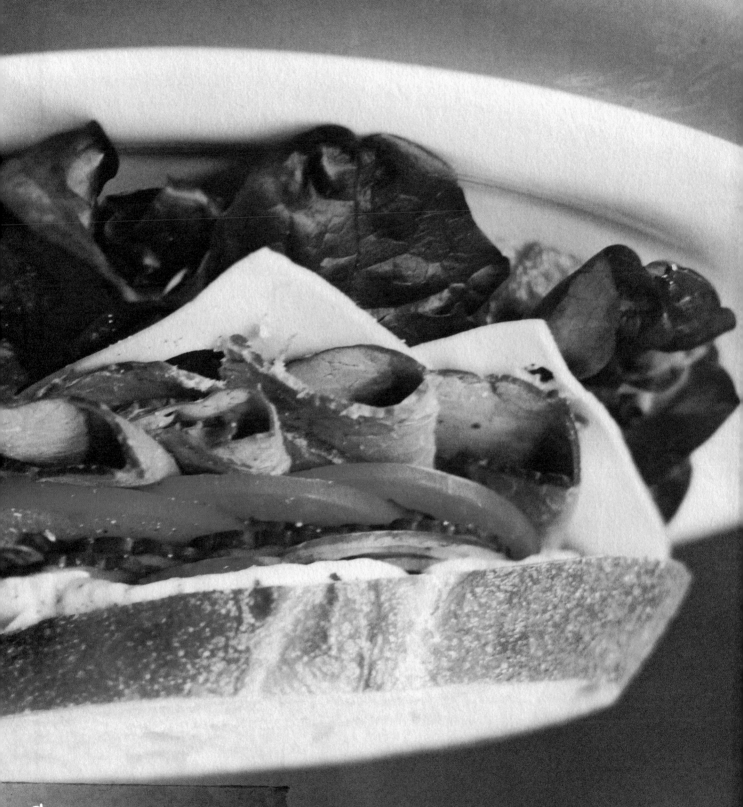

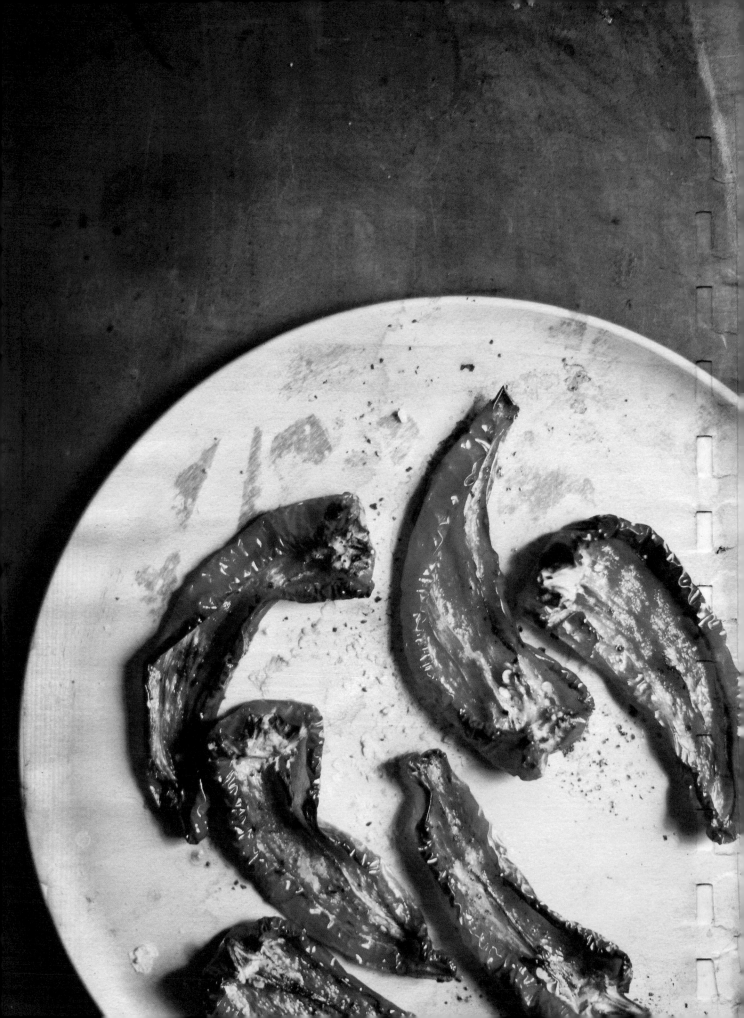

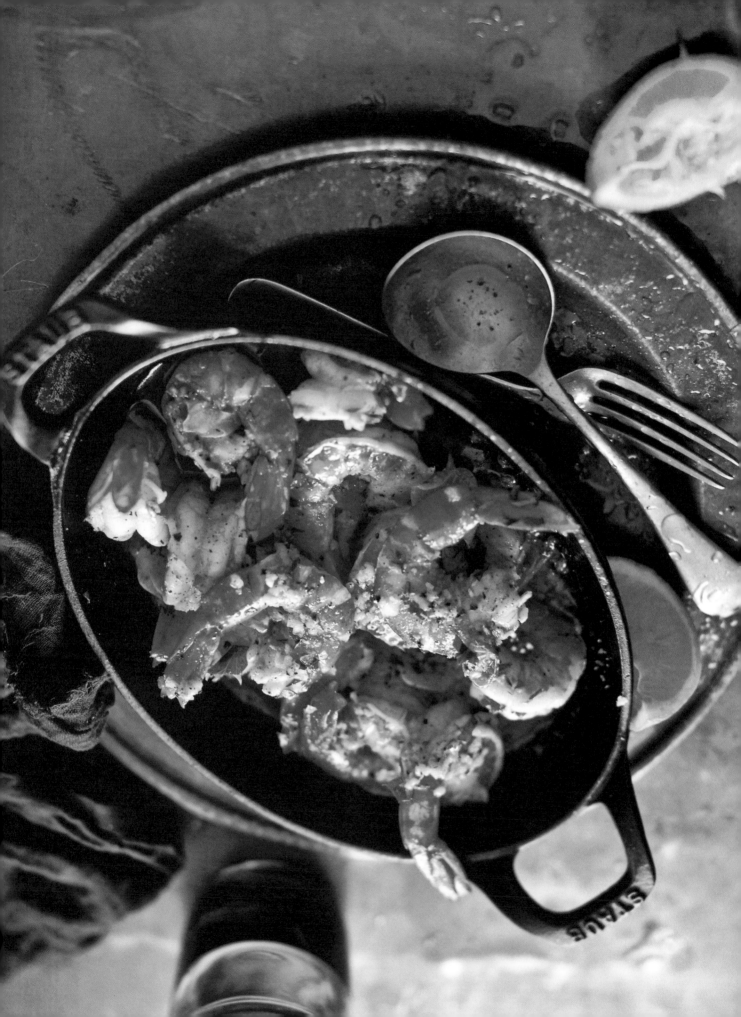

sizzling prawns

These prawns have a superb flavour and are very enjoyable to cook, as you sizzle them over a high heat in a cast-iron pan. I like to serve them piping hot, but they work equally well served warm or cold.

500 G UNCOOKED PRAWNS, PEELED AND DEVEINED
(RESERVING HEADS AND SHELLS), TAILS INTACT
500 ML CHICKEN OR FISH STOCK
FRESHLY GROUND BLACK PEPPER
6 GARLIC CLOVES, CRUSHED
FINELY GRATED ZEST AND JUICE OF 1 LIME
1/2 TEASPOON SMOKED PAPRIKA
1/2 TEASPOON DRIED CHILLI FLAKES
80 ML EXTRA VIRGIN OLIVE OIL
SEA SALT
HANDFUL FLAT-LEAF PARSLEY LEAVES,
FINELY CHOPPED
LIME WEDGES AND CRUSTY BREAD, TO SERVE

Serves 2–4

Place the prawn heads and shells in a medium-sized saucepan. Add the stock and season with pepper. Bring to the boil, then reduce the heat to medium and simmer for 15–20 minutes. Strain the stock into a bowl, discarding the heads and shells, then cover and set aside.

Meanwhile, place the garlic, lime zest and juice, smoked paprika, chilli flakes and olive oil in a bowl and mix to combine. Add the prawns and toss to coat thoroughly in the marinade. Season well with salt and pepper, then cover and chill in the fridge for 15–30 minutes.

Drain the prawns, reserving the marinade. Place a heavy shallow cast-iron pan over a high heat, add the marinade and bring to the boil. Add 125 ml of the stock and stir to combine, then add the prawns and simmer over a high heat for 5–10 minutes or until cooked through.

Just before serving, add a final spoonful of stock, then scatter with the parsley. Serve hot with lime wedges and lots of crusty bread.

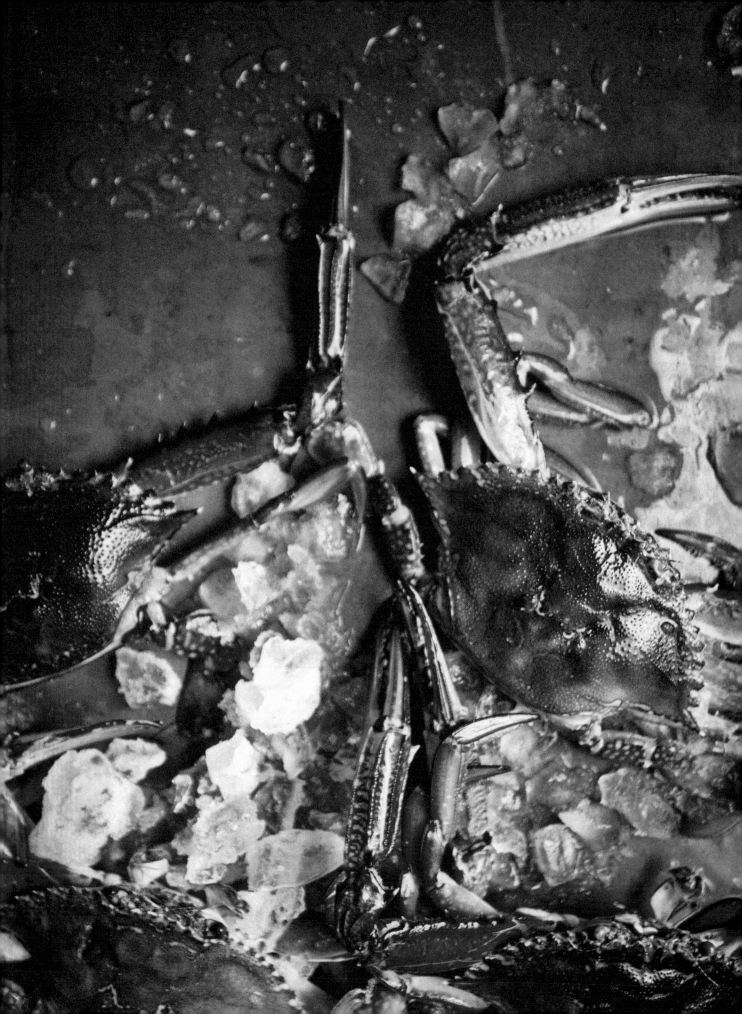

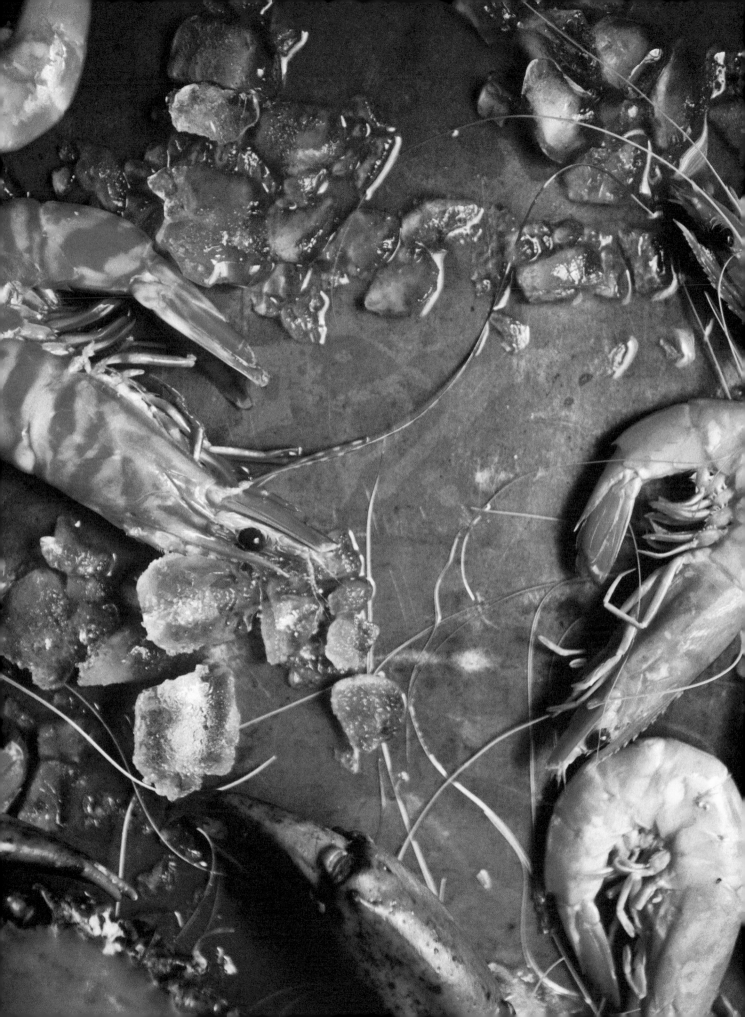

Calan's soup

Serves 6

Colm is a very dear Irish friend of mine. He's a wonderful guy who, like myself, loves throwing a good dinner party. I've enjoyed many an amazing night at his house in Dublin, staying up into the wee hours, with our bellies full of superb and lovingly cooked food and great French red wine. For years, I've told him he should sell his amazing tomato soup, and when I was gathering recipes for my cookbook, I just knew I had to include this one. A handy tip: use thin rubber gloves when peeling the skin off the charred peppers, or they'll turn your nails a horrible shade of black!

14 LARGE VINE-RIPENED TOMATOES, HALVED LENGTHWAYS

OLIVE OIL, FOR DRIZZLING

2 LARGE GARLIC CLOVES, VERY THINLY SLICED

SEA SALT AND FRESHLY GROUND BLACK PEPPER

4 RED PEPPERS

1 X 400G TIN CHOPPED TOMATOES

1 LONG RED CHILLI, FINELY CHOPPED

$1/2$ TEASPOON GOOD-QUALITY SMOKED PAPRIKA

1 LARGE HANDFUL BASIL, ROUGHLY CHOPPED,
PLUS A LITTLE EXTRA TO GARNISH

THYME LEAVES, TO GARNISH

Goat's Cheese Croûtons

1 CRUSTY FRENCH-STYLE BAGUETTE, THICKLY SLICED

450G GOOD-QUALITY SOFT GOAT'S CHEESE

Preheat the oven to 120°C (fan), 140°C, gas mark 1.

Place the tomato halves, cut-side up, on a baking tray. Drizzle each half with a little olive oil, top with a slice of garlic and season with salt and pepper. Roast for 2 hours or until the tomatoes are soft and caramelised.

Meanwhile, using tongs, hold the whole peppers over a naked gas flame on your hob, rotating them occasionally and taking care not to burn yourself, until the skins are charred all over. (If you don't have a gas hob, you can achieve a similar result by charring the peppers on a barbecue or chargrill pan or in a preheated 200°C (fan), 220°C, gasmark 7 oven.) Place the peppers in a large bowl, cover with cling film and set aside until cool enough to handle, then remove the charred skin. Cut away the core and white inner membrane and discard the seeds, then cut the flesh into large pieces and place in a large heavy-based saucepan, along with the roast tomatoes.

Add the tinned tomatoes, chilli, paprika and roughly chopped basil to the pan and season with salt and pepper. Using the empty tomato tin as a measure, add two full tins of cold water. Mix together well, then simmer over a low-medium heat for an hour or so or until the soup has thickened.

Remove the pan from the heat, leave the soup to cool for a few minutes, then transfer to a blender and pulse until smooth (or blend in the pan using a hand-held blender). Return the soup to the pan and reheat gently. Taste and season again if required.

To make the croûtons, toast the bread slices under a hot grill. Spread thickly with goat's cheese, then grill again until the cheese is warmed through and slightly softened.

Ladle the soup into bowls and place a goat's cheese croûton on top. Scatter a few thyme and extra basil leaves over, then add a final grinding of black pepper and serve piping hot.

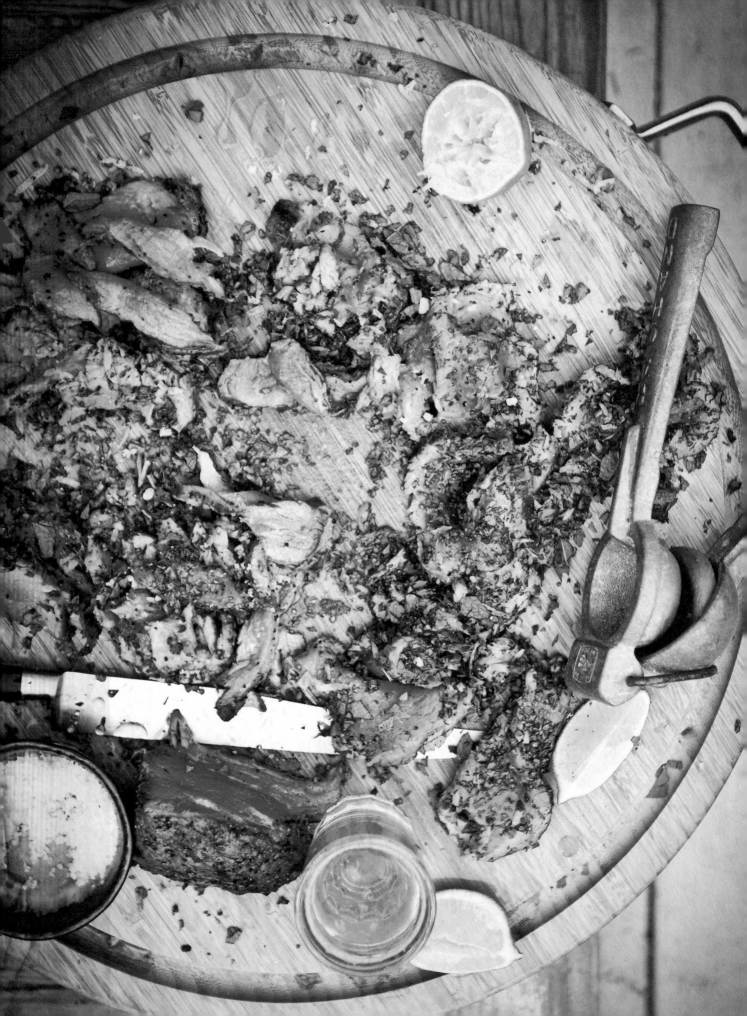

Barbecued *peppercorn beef fillet*
with chilli AND *herb gremolata*

We've made this dish at our place for years, and it's a really easy and quick idea for an afternoon barbecue. To spice it up a bit, I decided to add a gremolata featuring some of the flavours I enjoyed on a recent road trip along the old Route 66 in the US.

The habanero chilli gives it an extra kick, and works beautifully with the lime. If you can't get a habanero, use a bird's eye chilli or one or two fresh long red chillies instead. This meal goes particularly well with a few icy-cold beers.

2 TABLESPOONS PINK PEPPERCORNS
2 TABLESPOONS BLACK PEPPERCORNS
2 TABLESPOONS SEA SALT
OLIVE OIL, FOR COATING
1 X 1.5KG PIECE FREE-RANGE BEEF FILLET
2-3 LIMES, QUARTERED
CRUSTY BREAD, TO SERVE

Chilli and herb gremolata
LARGE HANDFUL MINT LEAVES, FINELY CHOPPED
LARGE HANDFUL FLAT-LEAF PARSLEY LEAVES, FINELY CHOPPED
1-2 LONG GREEN CHILLIES (OR TO TASTE), FINELY CHOPPED
1/4 HABANERO CHILLI, FINELY CHOPPED
FINELY GRATED ZEST OF 1 LEMON

Coarsely grind the pink and black peppercorns using a mortar and pestle. Add the salt and lightly crush, then tip out onto a large dinner plate and shake the plate to distribute evenly. Pour a teaspoon of olive oil into the palm of your hand and rub all over the beef fillet. Roll the beef in the peppercorn mixture until evenly coated.

Preheat a barbecue or chargrill pan and cook the beef fillet until medium-rare (this should take 40-45 minutes on a hot barbecue set to 200°C); alternatively, sear the meat on all sides in a hot frying pan, then transfer to a 180°C (fan), 200°C, gas mark 6 oven for 40-45 minutes. Allow the meat to rest for 5-10 minutes before cutting into super-thin slices using a very sharp knife.

To make the gremolata, combine all the ingredients in a bowl.

To serve, tip the gremolata onto a large serving platter or wooden chopping board, add the beef slices and toss to coat. Serve with lime quarters and crusty bread.

Serves 4-6

This classic soda bread is an Irish staple, and most families in Ireland will have their own version. It doesn't contain yeast and therefore doesn't need time to rise, so it takes literally 5 minutes to prepare. I have baked this bread many a time while living in Oz, and I am always asked for the recipe. Turn thin slices into cute little canapés by simply arranging the salmon over the bread, then cutting out small rounds with a 4 cm pastry cutter. Spread each piece with a teaspoon of wasabi cream, then scatter with little sprigs of dill, some black pepper and a squeeze of lemon juice before serving.

Irish BROWN BREAD with smoked salmon and *wasabi cream*

240 G CRÈME FRAÎCHE
1 1/2 TEASPOONS WASABI PASTE
UNSALTED BUTTER, FOR SPREADING
12 SLICES GOOD-QUALITY SMOKED SALMON
FRESHLY GROUND BLACK PEPPER
DILL SPRIGS AND LEMON WEDGES, TO SERVE

Soda bread
125 G PLAIN FLOUR
1 TEASPOON FINE SALT
1 TEASPOON BICARBONATE OF SODA
350 G WHOLEMEAL PLAIN FLOUR
15 G WHEATGERM
400 ML BUTTERMILK

Serves 6

Preheat the oven to 200°C (fan), 220°C, gas mark 7.

To make the bread, sift the plain flour, salt and bicarbonate of soda into a bowl, then add the wholemeal flour and wheatgerm and stir together thoroughly to combine. Make a well in the centre, then pour in the buttermilk, mixing until a dough forms — the texture should be soft but still a little sticky.

Turn out onto a well-floured work surface. Gather the dough together and very gently knead just a little in the flour to counteract the stickiness. Shape the dough into a round flat loaf (approximately 15–18 cm in diameter) and transfer to a floured baking tray. Dip a sharp knife in flour and score a cross about 1 cm deep right the way across the top of the loaf.

Bake for 40 minutes or until the crust is golden and the base sounds hollow when tapped in the centre. Remove and cool on a wire rack.

Place the crème fraîche and wasabi in a small bowl and mix together well.

Cut the bread into thick slices and spread lightly with butter, then add a thick layer of wasabi cream. Top with salmon and season with pepper. Cut the slices in half and serve with some sprigs of dill, lemon wedges and the remaining wasabi cream.

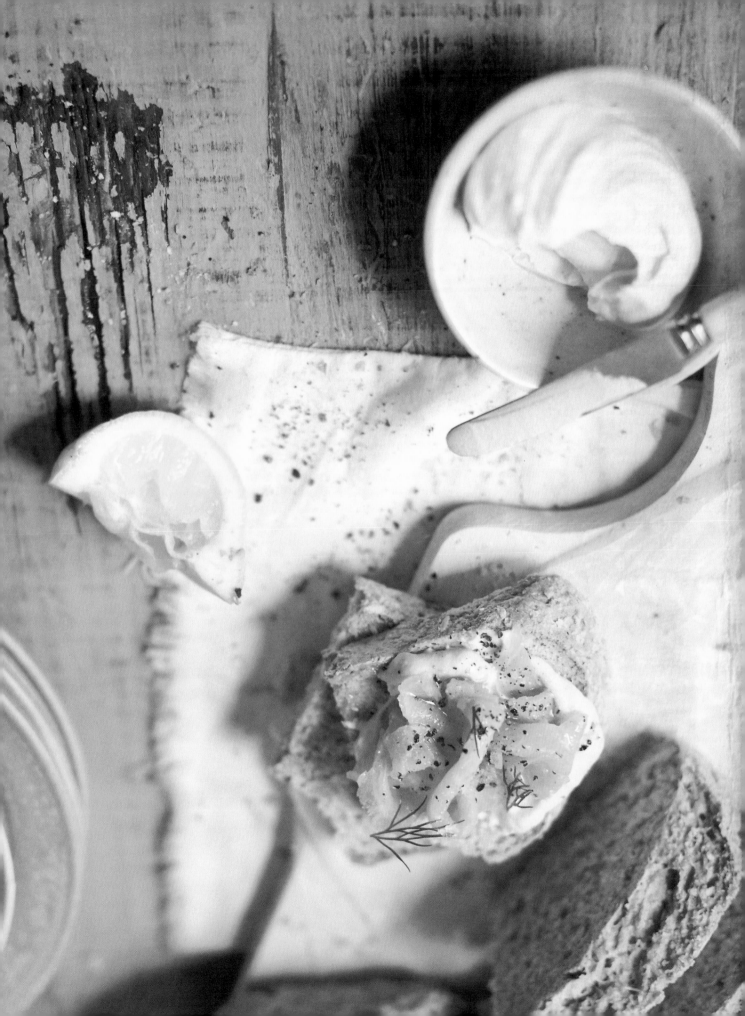

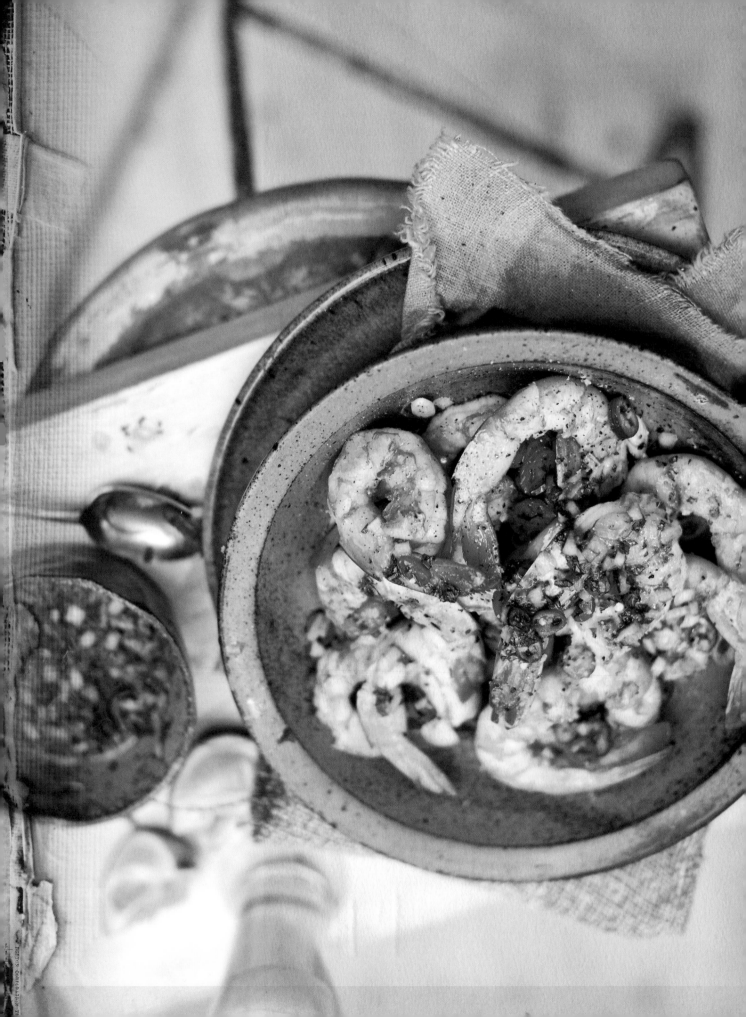

This is a simple dish full of summery flavours that is very easy to throw together. Feel free to buy prepared uncooked prawn meat if you're short of time. The sauce is my take on the classic Thai dipping sauce, nam jim. To make this more of a main meal, you could thread cubes of firm white fish onto skewers and barbecue them, then serve these alongside the prawns with some salads and crusty bread.

BARBECUED prawns with
Thai dipping sauce

1 KG UNCOOKED PRAWNS, PEELED AND DEVEINED, TAILS INTACT
JUICE OF 2 LIMES
SEA SALT AND FRESHLY GROUND BLACK PEPPER
2 LIMES, HALVED
EXTRA LIME QUARTERS AND CRUSTY BREAD, TO SERVE

Thai dipping sauce
2 GARLIC CLOVES, CRUSHED
2 TABLESPOONS FISH SAUCE
3 TABLESPOONS LIME JUICE
2 TABLESPOONS BROWN SUGAR
$1/2$ SMALL RED ONION, FINELY DICED
1 LONG RED CHILLI, FINELY CHOPPED
1 LONG GREEN CHILLI, FINELY CHOPPED
1 TABLESPOON CHOPPED CORIANDER
1 TABLESPOON CHOPPED MINT
1 X 1 CM PIECE GINGER, FINELY GRATED
PINCH SEA SALT AND FRESHLY GROUND BLACK PEPPER

Serves 4

Place the prawns in a large bowl, add the lime juice and season with a sprinkling of salt and pepper. Toss to coat the prawns evenly. Cover the bowl with cling film and chill for 15-30 minutes in the fridge.

To make the dipping sauce, combine all the ingredients in a small bowl.

Preheat a barbecue or chargrill pan to medium-hot. Add the lime halves, cut-side down, and chargrill for 2 minutes until caramelised, then remove and set aside. Add the prawns and cook for 3 minutes, then turn them over and cook for 1-2 minutes or until they turn pink and are just cooked through, squeezing the caramelised lime halves over them as they cook.

Serve the prawns warm with the dipping sauce. Squeeze over some extra lime juice and accompany with crusty bread.

Pasta is one of my favourite foods – I adore it both fresh and dried – and it is a staple in our house. This dish can be served for lunch or dinner, and I find in the summer months it's a great option for a lazy Sunday lunch with mates. The tomatoes are roasted for just 15 minutes, so you won't need to have the oven on for hours, and their subtle sweetness contrasts well with the salty speck or pancetta. I like to try and get a piece of speck or pancetta with just a thin layer of fat on it (or I trim off the excess fat). If you can't get hold of speck or pancetta, use good-quality free-range bacon instead.

ORECCHIETTE with *roast* tomatoes and *pecorino cream sauce*

250 G SMALL VINE-RIPENED TOMATOES
OLIVE OIL, FOR COOKING
SEA SALT AND FRESHLY GROUND BLACK PEPPER
HANDFUL BASIL LEAVES, HALF ROUGHLY TORN
HANDFUL OREGANO LEAVES, ROUGHLY CHOPPED
240 G FROZEN BABY PEAS
600 G ORECCHIETTE PASTA
350 G SPECK OR PANCETTA, CUT INTO SMALL CHUNKS
750 ML CREAM
200 G PECORINO, GRATED
100 G PINE NUTS, ROASTED (OPTIONAL)
EXTRA VIRGIN OLIVE OIL, FOR DRIZZLING
CRUSTY BREAD, TO SERVE

Serves 4

Preheat the oven to 180°C (fan), 200°C, gas mark 6.　　№. 57

Place the tomatoes on a baking tray, then drizzle with olive oil, season with salt and pepper and scatter over the torn basil and half the oregano. Roast for 15 minutes or until softened.

Blanch the peas in a saucepan of boiling water for 4–5 minutes or until almost cooked. Drain.

Cook the orecchiette in a large saucepan of salted boiling water for 10–12 minutes or until al dente. Drain, then return to the pan and drizzle with a little olive oil. Cover and keep warm.

Meanwhile, heat 1 tablespoon olive oil in a large frying pan over a medium heat. Add the speck or pancetta and cook until golden and crispy. Pour in the cream and stir to coat, then add the pecorino and season with a little salt and a decent amount of pepper. Cook for 10 minutes over a low heat to allow the flavours to infuse and the liquid to reduce by one-third, then add the peas and orecchiette and stir to coat.

Transfer to a large serving platter and scatter the roast tomatoes and pine nuts, if using, over the top. Garnish with the remaining basil and oregano, drizzle with extra virgin olive oil and serve immediately with crusty bread.

PULLED PORK sandwich
with *apple cider slaw*

Being a huge fan of pork (everything tastes better with bacon,
right?), I have tried a few pulled pork sandwiches ('pps') in my time.
In 2011, I had what turned out to be the most unforgettable,
mouthwatering and delectable pps I've ever eaten, in a bar on
Commercial Street in Provincetown, Massachusetts. The secret's in the
sauce, apparently, so when I returned home, I set myself the challenge
of creating my own version. I studied and tested other sauces on the
market before concocting, in true Willy Wonka fashion, 'Katie's Pulled
Pork Sandwich Finger-licking Sauce' to go with the pps — and if I ever
get a cooking-sauce deal, that's going on the label.
You heard it here first, folks...

2 KG FREE-RANGE PORK SHOULDER, BONE IN
SEA SALT AND FRESHLY GROUND BLACK PEPPER
MINI BRIOCHE (SEE PAGE 108), TO SERVE

Pulled pork sauce
2 TABLESPOONS OLIVE OIL
1 ONION, VERY FINELY DICED
SEA SALT AND FRESHLY GROUND BLACK PEPPER
2 GARLIC CLOVES, CRUSHED
1 CARROT, VERY FINELY DICED
2 CELERY STICKS, VERY FINELY DICED
1 LONG RED CHILLI, FINELY DICED
250 ML APPLE CIDER VINEGAR
2 TABLESPOONS BROWN SUGAR
1 TABLESPOON TOMATO PURÉE
4 TABLESPOONS TREACLE
2 TABLESPOONS MUSTARD POWDER
$1/4$ TEASPOON GROUND TURMERIC
125 ML WHITE VINEGAR
1 LITRE CHICKEN STOCK
$1/2$ TEASPOON DRIED CHILLI FLAKES
1 TABLESPOON CHIPOTLE SAUCE
$1^1/_2$ TEASPOONS CORNFLOUR MIXED WITH 2 TABLESPOONS COLD WATER

Apple cider slaw
$1/4$ WHITE CABBAGE, CORED, LEAVES VERY FINELY SLICED
$1/4$ RED CABBAGE, CORED, LEAVES VERY FINELY SLICED
1 CARROT, PEELED AND CUT INTO RIBBONS WITH A VEGETABLE PEELER
6–8 RADISHES, VERY FINELY SLICED
3 SPRING ONIONS, TRIMMED AND VERY FINELY SLICED

Apple cider dressing
3 TABLESPOONS APPLE CIDER VINEGAR
80 ML RED WINE VINEGAR
3 TABLESPOONS EXTRA VIRGIN OLIVE OIL
JUICE OF 1 LEMON
SEA SALT AND FRESHLY GROUND BLACK PEPPER

Serves 6

Recipe method over page . . .

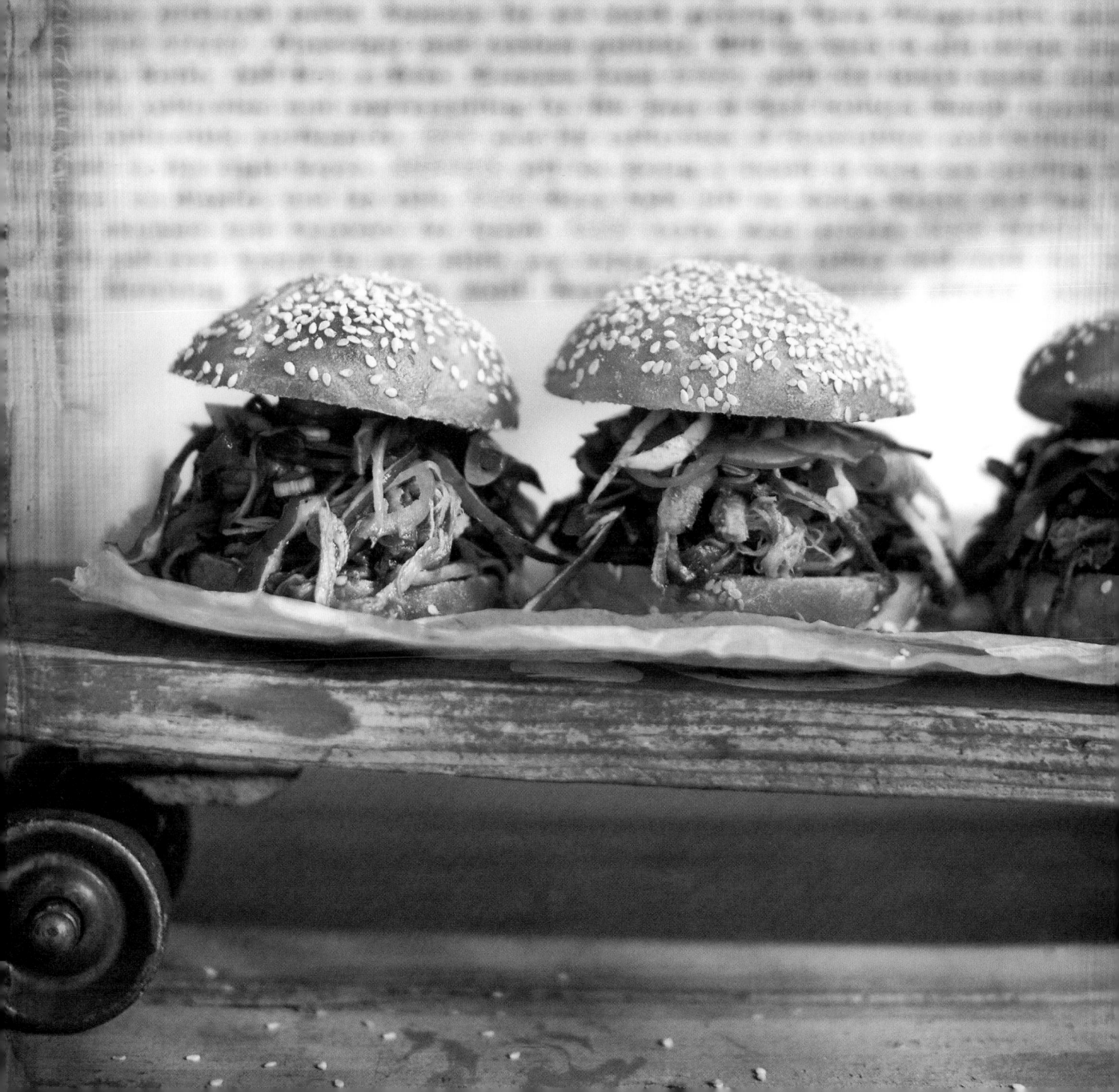

PULLED PORK sandwich
with *apple cider slaw*
continued...

Preheat the oven to 160°C (fan), 180°C, gas mark 4.

Place the pork shoulder in a roasting tin, skin-side down, and season
with salt and pepper. Flip it over so the skin is facing upwards, then
cover with foil and roast for 5-6 hours. Check after 3 hours — if the
pork is starting to dry out, add a good splash of water to the roasting
tin and return to the oven. Transfer the cooked pork to a wire rack to
cool, then turn it over and shred the meat using a fork (the meat should
come away in clumps and be really soft and succulent).

Meanwhile, to make the sauce, heat the olive oil in a large saucepan
over a medium heat. Add the onion and a pinch of salt and cook,
stirring, for 5 minutes. Add the garlic and cook for another 2-3
minutes, then add the carrot, celery and chilli and cook for 10 minutes
or until the vegetables start to soften. Add all the remaining
ingredients except the cornflour paste and simmer gently, uncovered,
for 1½-2 hours or until reduced and thickened. Remove the pan from the
heat and pass the contents through a sieve, pressing down on the solids
to get as much liquid through as you can. Return the strained sauce to
the pan, stir in the cornflour paste and warm through.

Add the pulled pork to the sauce and stir to coat thoroughly.

To make the slaw, place all the vegetables in a large bowl and mix
well. Combine the dressing ingredients, then add to the vegetables
and toss gently to coat.

Serve the pulled pork and slaw in mini brioche.

№. 62

Caramelised onion and goat's cheese tartlets with BALSAMIC SYRUP

These make for a superb lunch; they're also the perfect starter for a dinner party. You can make the caramelised onions in the morning, or even the night before, and keep them covered until required. Take care when cooking the tartlets — I have made the mistake many a time of serving a beautiful, well-risen tart only to discover upon eating it that the base isn't cooked properly! Check by using a palette knife or similar to gently lift the tartlets and make sure the bases are not soggy or soft. If they are, reduce the oven temperature to 160°C (fan), 180°C, gas mark 4 and return to the oven for further cooking.

1 LARGE SHEET GOOD-QUALITY PUFF PASTRY
1 FREE-RANGE EGG YOLK, MIXED WITH A SPLASH OF MILK
4 HEAPED TABLESPOONS CARAMELISED ONION JAM (SEE PAGE 223)
175 G GOOD-QUALITY GOAT'S CHEESE, CUT INTO 1.5 CM THICK ROUNDS
3-4 THYME SPRIGS, LEAVES PICKED, PLUS EXTRA SPRIGS TO GARNISH
SEA SALT AND FRESHLY GROUND BLACK PEPPER
250 ML BALSAMIC VINEGAR (USE THE BEST YOU CAN GET)
3 TABLESPOONS BROWN SUGAR

Serves 4

Preheat the oven to 200°C (fan), 220°C, gas mark 7.

Using a 12 cm round pastry cutter or a small bowl as a template, cut four rounds of pastry and place on a large non-stick or lined baking sheet. Score a 2 cm border around the edges of the rounds, being careful not to cut all the way through. Avoiding the border, prick the bases all over with a fork. Brush the borders with egg wash, taking care not to let the egg run down the sides or the pastry will rise unevenly.

Again, avoiding the border, divide the caramelised onion jam among the bases, spreading it out evenly. Place a round of goat's cheese on top, then scatter with the thyme leaves and season with pepper.

Bake for 20 minutes or until the puff pastry borders are golden and risen and the bases of the tartlets are cooked.

Meanwhile, place the balsamic vinegar in a small saucepan and bring to the boil, then reduce the heat and simmer until reduced by half. Add the brown sugar and simmer until the mixture becomes syrupy — it should coat the back of a spoon when it's ready. Set aside to cool and thicken.

Serve the tartlets drizzled with the balsamic syrup and scattered with thyme sprigs.

Poussin with spicy rub and CHARGRILLED lime

This spicy rub gives a smoky, sweet flavour to white meat: you could just as easily use chicken pieces such as wings or drumsticks. Once cooked, chop the meat into bite-sized pieces and serve on a big platter, drizzled with lime juice.

Chargrilling limes or lemons on the barbecue is a fantastic way to extract the maximum amount of juice from them.

4 POUSSINS (BABY CHICKENS)
6-8 LIMES, HALVED

Spicy rub
2 TEASPOONS BROWN SUGAR
1/2 TEASPOON SALT
2 TEASPOONS SMOKED PAPRIKA
1 TEASPOON GROUND ALLSPICE
1 TEASPOON CAYENNE PEPPER
1 TABLESPOON FRESHLY GROUND BLACK PEPPER
1 TEASPOON GARLIC POWDER

Serves 4

To make the spicy rub, place all the ingredients in a small bowl and mix together thoroughly.

To spatchcock the poussin, use a clean pair of kitchen scissors to cut down each side of the spine and remove it. Trim the neck, remove any innards and press down on the bird to flatten. Rinse well under cold running water and pat dry.

Preheat a barbecue or a chargrill pan to a medium-high heat.

Place the flattened birds on a large baking tray and liberally coat in the spicy rub — make sure you coat both sides.

Add the lime halves to the preheated barbecue or chargrill pan and cook for a couple of minutes until caramelised, then remove and set aside.

Grill the poussins for 20-25 minutes on each side or until cooked through, squeezing the juice from some of the chargrilled limes over the birds as they cook. Serve hot, chopped into pieces, with the remaining chargrilled lime halves alongside.

This recipe was inspired by a local takeaway
joint; it's light and packed full of fresh
flavours and crunchy textures. Let's face it,
how bad can a salad be if it's got pork belly
in it — with crackling! Woo hoo!

Vietnamese salad
with crispy
PORK BELLY

1 KG FREE-RANGE PORK BELLY
SEA SALT AND FRESHLY GROUND BLACK PEPPER
OLIVE OIL, FOR RUBBING
SESAME SEEDS, TO GARNISH

Vietnamese salad

2–3 SPRING ONIONS, TRIMMED AND FINELY SLICED
1 LONG RED CHILLI, DESEEDED, THINLY SLICED
$\frac{1}{2}$ LARGE CUCUMBER, CUT INTO 1 CM DICE
1 GREEN PAPAYA, PEELED AND THINLY SLICED
HANDFUL CORIANDER LEAVES, TORN
LARGE HANDFUL MINT LEAVES, TORN, PLUS EXTRA TO GARNISH
70 G ROASTED UNSALTED PEANUTS

Lime and vinegar dressing

2 TABLESPOONS RICE WINE VINEGAR
3 TEASPOONS FISH SAUCE
2 TEASPOONS SOY SAUCE
2 TABLESPOONS LIME JUICE
1 TABLESPOON FINELY GRATED PALM SUGAR
1 BIRD'S EYE CHILLI, DESEEDED, THINLY SLICED
SEA SALT AND FRESHLY GROUND BLACK PEPPER

Serves 4

Preheat the oven to 240°C (fan), 250°C, gas mark 10.

Place the pork belly on a clean work surface, skin-side up, and pat the skin
thoroughly dry with kichen paper. Using a very sharp small knife, carefully score
the skin at 1.5 cm intervals, taking care not to cut all the way through to the
meat. Rub 2½ teaspoons sea salt into the skin, pushing it right into the slits and
spreading it all over the surface. Turn the meat over and, using your hands, rub the
underside with a little olive oil and season with salt and a good grinding of
pepper.

Place the pork in a roasting tin, skin-side up. Roast for 30 minutes (this gets the
crackling off to a good start), then turn the heat down to 180°C (fan), 200°C, gas
mark 6 and cook for a further 2 hours. If the crackling hasn't hardened all over at
this stage, simply increase the temperature to 200°C (fan), 220°C, gas mark 7 and
cook for another 20 minutes or so (you want the crackling to be golden and hard when
tapped with the back of a spoon). Remove the pork from the oven and transfer to a
wire rack positioned over a plate, to catch the juices that will escape from the
meat as it rests. Leave to cool completely. When cooled, cut the pork into strips
using the crackling score lines as a guide, then cut each slice into small cubes.

To make the salad, place all the ingredients in a bowl and toss together. To make
the dressing, whisk all the ingredients in a small bowl.

Pour half the dressing over the salad and toss to coat. Add the pork cubes and toss
again. To serve, place a large handful of salad on each plate, garnish with the extra
mint leaves and some sesame seeds, and serve with the remaining dressing on the side
for people to help themselves.

Back in 2011, I featured a piece on the blog about a little restaurant just around the corner from my house. Love.fish is owned and run by two good friends, Michael and Michelle. Their food is wonderful: ethically sourced, sustainable fish cooked simply and paired with an extensive range of beautifully flavoursome, healthy salads and sides. One of my regular favourites is this recipe, as I adore vinegary foods and love the texture of the pickled radish. You can substitute the barramundi with any other firm, white fish you like.

Barramundi with pickled radish, GREEN BEAN and watercress salad

1 GREEN APPLE
1–2 TEASPOONS LEMON JUICE
HANDFUL GREEN BEANS, TOPPED AND TAILED
150 ML EXTRA VIRGIN OLIVE OIL
HANDFUL WATERCRESS, WASHED AND LEAVES PICKED
2 x 200 G BARRAMUNDI FILLETS, BONES REMOVED
OLIVE OIL, FOR COOKING
FRESHLY GROUND BLACK PEPPER

Pickled radish

250 ML WHITE VINEGAR
1 TEASPOON FINE SALT
110 G GRANULATED SUGAR
1 STAR ANISE
$1/2$ TEASPOON BROWN MUSTARD SEEDS
1 CARDAMOM POD, CRUSHED
6 RADISHES, QUARTERED

Serves 2

To make the pickled radish, place the vinegar, salt, sugar, star anise, mustard seeds, cardamom pod and 125 ml water in a medium-sized saucepan over a low–medium heat and cook until the sugar and salt have dissolved. Add the radishes and heat until just simmering — don't let the liquid boil. Remove from the heat and leave to cool for 30 minutes, then place in the fridge to cool completely. Transfer the pickled radish to a small bowl and reserve 50 ml of the pickling liquid.

Using a mandoline or a very sharp knife, finely slice the apple into ten paper-thin circles (you don't need to core the apple, just remove any small bits of seed from the slices). Transfer to a bowl, drizzle with the lemon juice to prevent the apple from going brown and set aside.

Blanch the green beans in a small saucepan of boiling water for 2–3 minutes, then drain and plunge into a bowl of iced water (this keeps them crisp and retains their vivid colour).

Whisk together the extra virgin olive oil and the reserved pickling liquid to make a dressing. Combine the beans, watercress and pickled radish in a bowl. Add the dressing and toss gently to coat.

Heat a frying pan over a high heat. Rub both sides of the fish fillets with a little olive oil, then place them, skin-side down, in the hot pan for 8–10 minutes, placing a weight, such as a small cast-iron pan, on the fillets to flatten them and help produce a crisper skin. Turn the fillets over and cook for a further 2 minutes or until just opaque in the centre. Remove the pan from the heat and leave the fish to rest for 2 minutes.

To serve, divide the apple slices between serving plates, then top with some salad and the fish fillets, and finish with a grinding of pepper.

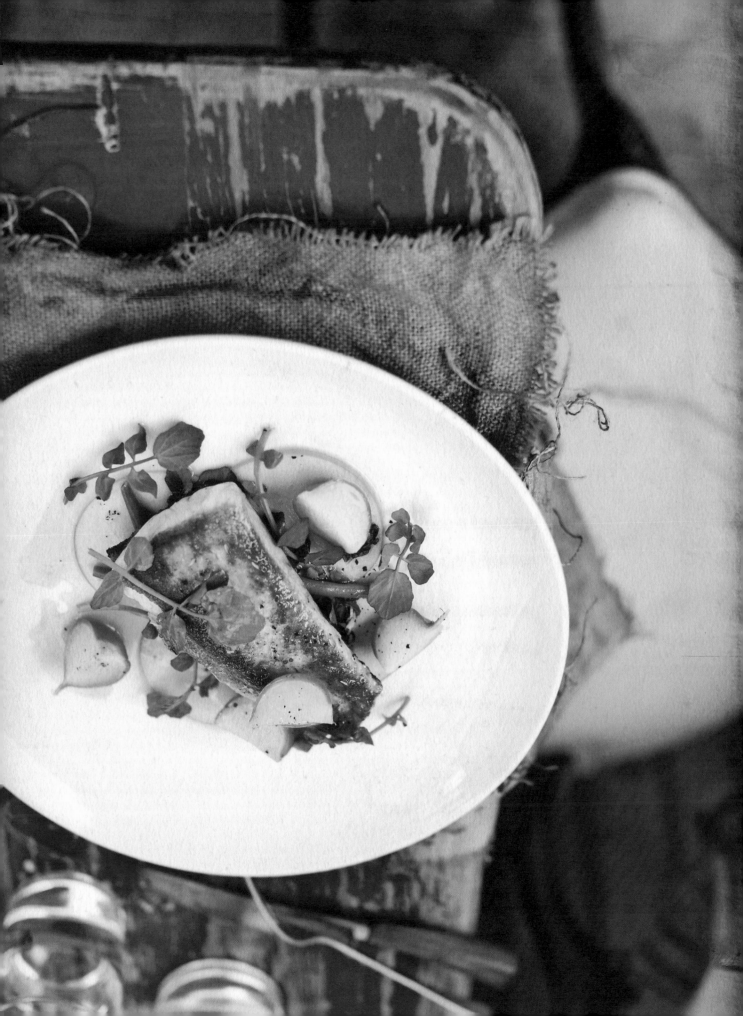

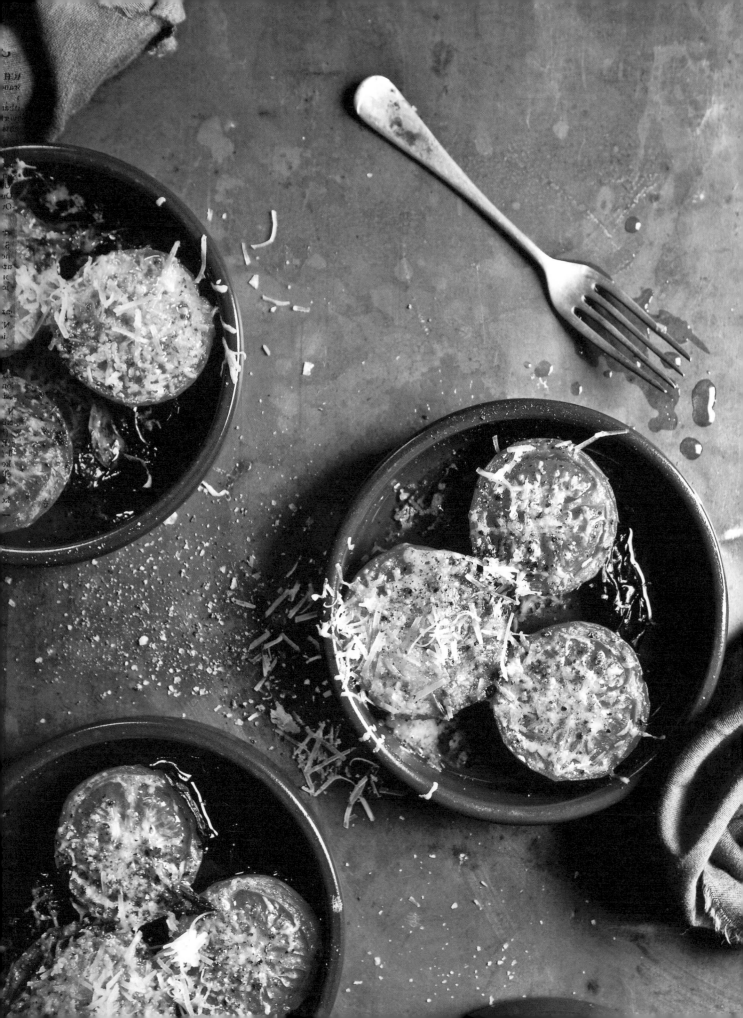

Slow-roasted TOMATOES with Manchego

I am an enormous fan of tomatoes — I eat them with almost every meal. One of my favourite ways to cook tomatoes is to slow-roast them with olive oil and basil. Here I've also added Manchego, a delicious hard cheese from the La Mancha region of Spain made from sheep's milk.

I like to cook and serve these in individual tapas bowls, but you could just as easily use one large baking dish. Slow-roasted tomatoes are so versatile and go beautifully with aged Parma ham or Patatas Bravas with Ham and Egg (see page 74) for a light lunch. They also make a superb base for soups and pizza sauces.

6 LARGE VINE-RIPENED TOMATOES, HALVED LENGTHWAYS
80 ML LIGHT OLIVE OIL
SEA SALT AND FRESHLY GROUND BLACK PEPPER
HANDFUL LARGE BASIL LEAVES
100G MANCHEGO, GRATED, PLUS EXTRA TO SERVE
GRILLED BREAD SLICES, TO SERVE

Serves 4

Preheat the oven to 120°C (fan), 140°C, gas mark 1.

Divide the tomato halves among four individual heatproof tapas bowls, placing them cut-side up.

Drizzle the olive oil over the tomato halves and season very well with salt and pepper. Arrange the basil leaves around the tomato halves, pushing them into the oil. Transfer to the oven and roast for 1½ hours or until the tomatoes are soft.

Sprinkle with the grated Manchego, then return to the oven for another 10 minutes to melt the cheese.

Serve piping hot with extra grated Manchego sprinkled on top. Accompany with slices of grilled bread.

Mix all ingredients & season well with Salt & Pepper

a handful chopped parsley

cooked Prawns

(caramelised)
in olive oil til

small onion (diced & sautéed

2 sticks celery Diced

Small can Sweet Corn (...

bag of peas

L'IDEALE A CONSERVES

2roz. 8oz. CARTONS

Patatas Bravas with Ham and Egg

Honestly, is there anything better than spicy potatoes, crispy ham and a fried egg, cooked together in one little bowl and topped with lots of black pepper? Yummo! This is comfort food at its best, and makes for a perfect lunch on a winter's day, served with lots of crusty sourdough bread.

6 LARGE WAXY POTATOES, QUARTERED LENGTHWAYS,
THEN CUT INTO 2-3 CM CHUNKS
1 TEASPOON FINE SALT
160 ML OLIVE OIL, PLUS EXTRA FOR PAN-FRYING
2 LONG RED CHILLIES, THINLY SLICED
2 TEASPOONS SMOKED PAPRIKA
3 THYME SPRIGS, LEAVES PICKED
SEA SALT AND FRESHLY GROUND BLACK PEPPER
8 SLICES GOOD-QUALITY PARMA HAM
4 LARGE FREE-RANGE EGGS
CRUSTY BREAD, TO SERVE

Serves 4

Half-fill a large saucepan with cold water and add the potatoes and salt. Bring to the boil, then reduce the heat to medium and simmer for 20 minutes or until just cooked, then drain and set aside.

Place the olive oil, chillies, paprika, thyme leaves, a pinch of salt and lots of pepper into a small bowl and mix together well.

Heat 1-2 tablespoons olive oil in a large frying pan over a medium heat. Add half the potatoes and fry until lightly golden and crispy. Remove and drain on kitchen paper. Repeat with the remaining potatoes, adding more oil if needed, then return all the potatoes to the pan. Add the chilli-oil mixture and toss so the potato is well coated. Fry for another minute or two, then remove the pan from the heat and set aside.

Line a baking tray with foil, then place the Parma ham on top in a single layer. Cook for 5 minutes under a hot grill until crispy.

Generously grease four individual heatproof tapas bowls with olive oil. Line the edges of each bowl with two slices of grilled ham. Divide the potato evenly among the bowls, leaving a space in the centre, then crack an egg into the space. Place the bowls on four individual gas burners or electric hotplates on a simmer mat over a medium-high heat and cook for 10-15 minutes or until the egg white is cooked through (or cook one at a time over one burner). Be really careful when you handle the dishes as they will be utterly volcanic – protect your hands and serve each dish on a heatproof board or plate. Season with a little salt and pepper and serve piping hot, with fresh bread to soak up the delicious juices.

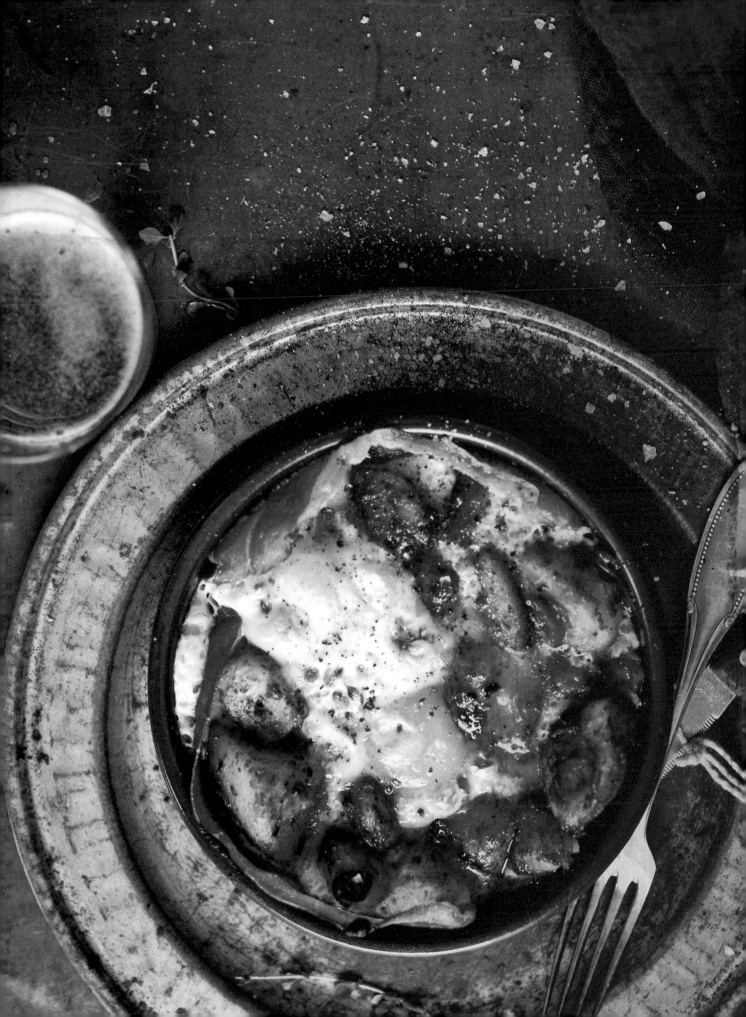

SALADS

CHAPTER № 3

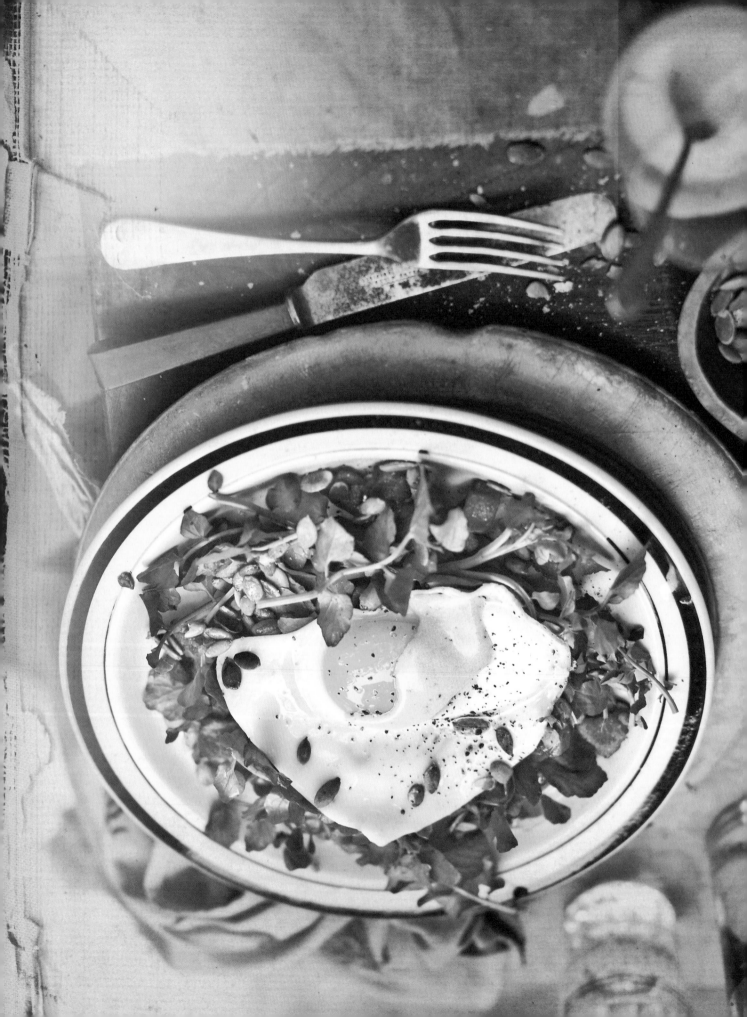

Roasted PUMPKIN SEED
and *watercress salad*
with *a fried* DUCK EGG

This recipe is a made-up combo of two lunches I enjoyed on a recent
trip to New York — it combines all my favourite flavours. The
dressing is wonderfully piquant, the roasted pumpkin seeds are
salty and crunchy, the watercress gives a subtle, spicy kick
and the duck-egg yolk offers a superb creamy, runny contrast.
Then there's the crispy bacon...what more is there to say?

Duck eggs are considerably larger and richer than hen eggs,
so it's worth seeking them out. If you can't get hold of any,
use free-range, organic hen eggs instead.

200 G PUMPKIN SEEDS
SEA SALT AND FRESHLY GROUND BLACK PEPPER
OLIVE OIL, FOR COOKING
10 RASHERS FREE-RANGE BACON, FAT AND RIND REMOVED,
 CUT INTO 2 CM PIECES
2 LARGE BUNCHES WATERCRESS, WASHED AND LEAVES PICKED
4 DUCK EGGS

Sweet mustard dressing
3 TABLESPOONS EXTRA VIRGIN OLIVE OIL
$1^1/_2$ TABLESPOONS SHERRY VINEGAR
3 TEASPOONS DIJON MUSTARD
SEA SALT AND FRESHLY GROUND BLACK PEPPER

Serves 4 as a light meal

Preheat the oven to 180°C (fan), 200°C, gas mark 6.

Scatter the pumpkin seeds on a baking tray and season with a little salt
and pepper. Drizzle over a small amount of olive oil and toss to coat. Roast for
10—15 minutes until light golden brown, then set aside to cool.

Heat 1 teaspoon olive oil in a frying pan over a medium heat, then when hot, add
the bacon and fry for 10 minutes or until crispy and cooked through. Set aside on
kitchen paper to drain.

To make the dressing, whisk all the ingredients together in a small bowl.

Divide the watercress, bacon and pumpkin seeds among serving plates and drizzle
some dressing over each.

Heat 1—2 tablespoons olive oil over a low-medium heat in a large frying pan,
then crack in two eggs at a time, frying them for 3—4 minutes until the whites
are set but the yolks are still runny, or until cooked to your liking.

Top each plate with a fried duck egg and serve with extra dressing on the side.

Chorizo and potato salad with ROCKET and MANCHEGO shavings

I first tried manchego (see page 71) during a school trip to Spain a (fair) few years ago. I love hard cheese such as Cheddar, and this is similar but with a superb nutty flavour. Buy the best-quality chorizo you can; it really does make all the difference.

500 G WAXY POTATOES
1 TEASPOON FINE SALT
OLIVE OIL, FOR COOKING
250 G CHORIZO, HALVED LENGTHWAYS, THEN CUT INTO THIN SLICES
75 G DRAINED SUN-DRIED TOMATOES
ZEST AND JUICE OF 1 LEMON, ZEST REMOVED IN THIN CURLS USING
 A CITRUS ZESTER
1 RED ONION, HALVED AND FINELY SLICED
1 LARGE GARLIC CLOVE, FINELY CHOPPED
2 TABLESPOONS EXTRA VIRGIN OLIVE OIL
SEA SALT AND FRESHLY GROUND BLACK PEPPER
LARGE HANDFUL ROCKET LEAVES, CUT INTO STRIPS
150 G MANCHEGO, SHAVED

Serves 4-6 as a side

Half-fill a large saucepan with cold water and add the potatoes and salt. Bring to the boil, then reduce the heat to medium and simmer for 20 minutes or until the potatoes are just cooked through. Drain and leave to cool completely before cutting into 2 cm slices, then transfer to a large bowl.

Heat 1 tablespoon olive oil in a frying pan over a medium heat, then add the chorizo and fry for 10 minutes or until crisp. Remove from the pan and add to the potatoes, along with the sun-dried tomatoes, lemon zest and onion.

Whisk together the finely chopped garlic, extra virgin olive oil and lemon juice in a small bowl, season with salt and pepper, then pour over the salad. Toss gently, then turn out onto a serving platter.

Scatter with the rocket and shaved Manchego and serve.

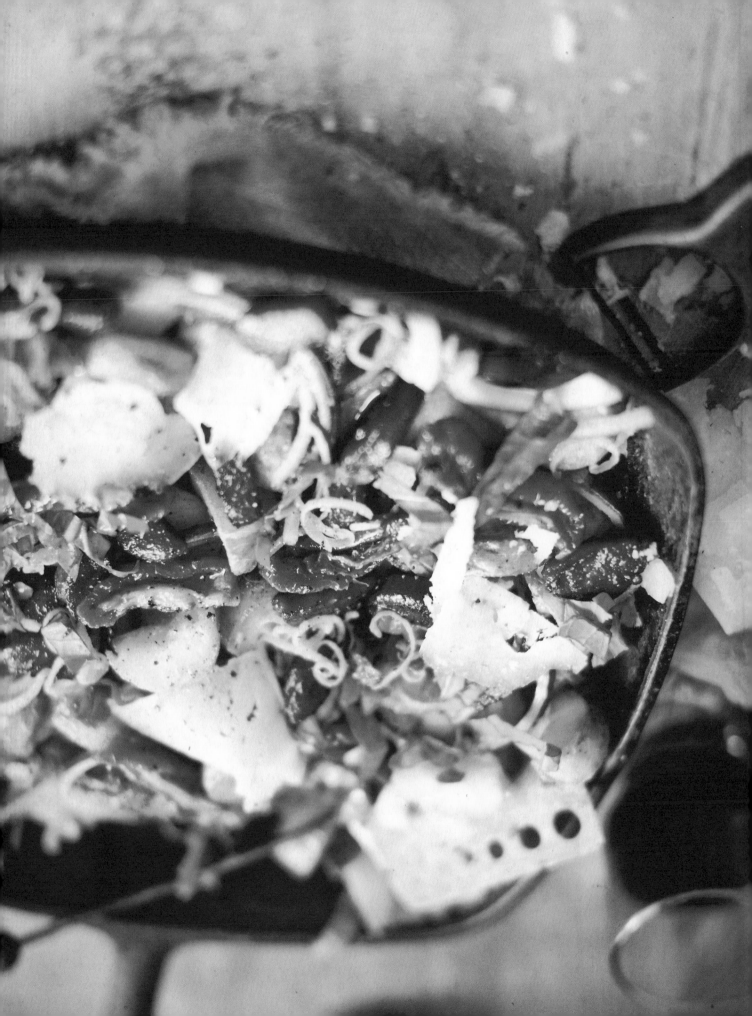

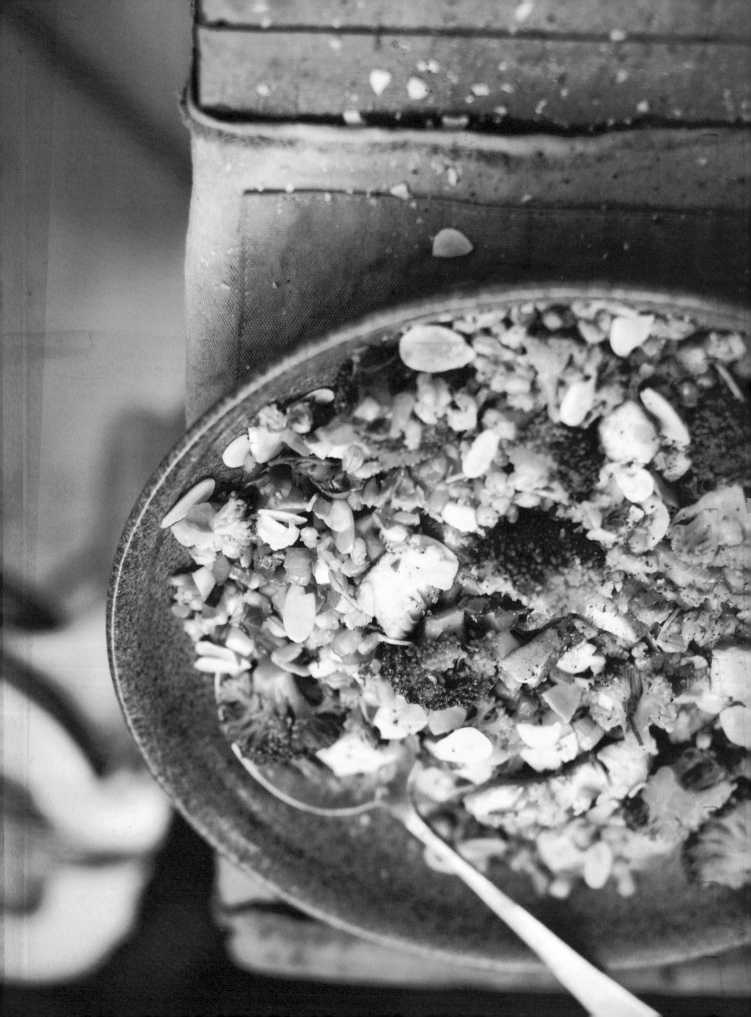

Pearl barley is such a versatile ingredient. It lends bulk
to soups and salads and has a wonderful nutty flavour. It's
a good alternative to rice and also goes really well with other
grains, such as lentils. To make this dish gluten-free, simply
replace the pearl barley with quinoa, cooked as per the
instructions on the packet. I like to include the green parts
of the spring onion as well as the white for extra colour.

1 x 200 G FREE-RANGE CHICKEN BREAST FILLET, CUT LENGTHWAYS INTO THIRDS
20 G FLAKED ALMONDS
200 G PEARL BARLEY
JUICE OF 1 LEMON
1 TABLESPOON OLIVE OIL, PLUS EXTRA FOR BRUSHING
SEA SALT AND FRESHLY GROUND BLACK PEPPER
1 HEAD BROCCOLI, BROKEN INTO FLORETS
1 COURGETTE, TRIMMED AND CUT LENGTHWAYS INTO $1/2$ CM STRIPS
3 SPRING ONIONS, TRIMMED AND FINELY SLICED
1 GREEN PEPPER, TRIMMED, DESEEDED AND FINELY DICED
LARGE HANDFUL ROCKET LEAVES, FINELY CHOPPED

Marinade
JUICE OF 1 LEMON
1 TEASPOON BOUGHT HARISSA PASTE
1 TABLESPOON OLIVE OIL
PINCH SEA SALT

Serves 2 as a main or 4 as a side

Pearl barley salad with HARISSA-SPICED chicken

To make the marinade, place all the ingredients
in a bowl and whisk together. Put the chicken
into a shallow container and pour the marinade
over, making sure the chicken is well coated.
Place in the fridge for 30 minutes—1 hour.

Meanwhile, preheat the oven to 180°C (fan),
200°C, gas mark 6. Spread the flaked almonds
out on a baking tray and roast for 5—6 minutes,
then set aside.

Place the pearl barley in a saucepan and
cover with 750 ml cold water. Bring
to the boil, then reduce the heat and simmer
over a low heat for 35 minutes. Drain and
rinse with cold water, then set aside in a bowl
to cool slightly. Place the lemon juice, 1
tablespoon olive oil and some black pepper in
a small bowl and whisk together, then pour
this mixture over the pearl barley, stir to
coat and set aside.

Cook the broccoli in a saucepan of simmering
water for 2—3 minutes, then drain and plunge
immediately into a bowl of iced water. Drain
again and set aside.

Brush each side of the courgette strips with
a little olive oil. Heat a frying pan or
chargrill pan and cook the courgette strips
on both sides until light golden brown. Leave
to cool slightly before dicing finely.

Heat a large frying pan over a medium heat
and cook the chicken with its excess marinade
for 10—12 minutes or until the chicken is
caramelised on the outside and cooked through
and the marinade is bubbling. Remove the
chicken and juices and set aside, covered,
to rest for 5 minutes before slicing each
chicken strip very thinly.

Place the chicken, almonds, pearl barley,
broccoli, courgette, spring onions, green
pepper and rocket into a large bowl and mix
thoroughly to combine. Season with salt and
pepper to taste and serve.

Candied pancetta, BALSAMIC and PERSIAN feta salad

This salad has always been a surefire crowd-pleaser: there's just something about the combination of balsamic and wholegrain mustard with the salty, sweet and crisp pancetta that keeps people coming back for more. If you can't get your hands on pancetta, use Parma ham, but don't add any extra salt, as I always find Parma ham is salty enough on its own. Grapefruit gives a really refreshing edge to the salad.

LARGE HANDFUL CASHEW NUTS
2 RUBY RED GRAPEFRUIT
6 HANDFULS MIXED LETTUCE LEAVES, WASHED AND DRIED
1 PUNNET (250 G) CHERRY TOMATOES, HALVED
1 BUNCH SPRING ONIONS, TRIMMED AND SLICED ON THE DIAGONAL
250 G PERSIAN FETA OR GOOD-QUALITY GREEK FETA, CRUMBLED
10 THIN SLICES PANCETTA
1 TABLESPOON RUNNY HONEY

Balsamic mustard dressing
2 TABLESPOONS GOOD-QUALITY BALSAMIC VINEGAR
100 ML EXTRA VIRGIN OLIVE OIL
1 TABLESPOON WHOLEGRAIN MUSTARD
SEA SALT AND FRESHLY GROUND BLACK PEPPER

Serves 4 as a side

Preheat the oven to 180°C (fan), 200°C, gas mark 6. Spread the cashews out on a baking tray and roast for 7–10 minutes until golden, then set aside.

Cut the top and bottom from each grapefruit. Place on a chopping board and, working from top to bottom, use a small, sharp knife to cut away all the skin and pith. Take the fruit in your hand and, holding it over a bowl to catch the juices, carefully cut each inner segment away from the membrane, letting the segments fall into the bowl — they should be free of any white pith or pips.

Place the lettuce, tomatoes, spring onions, feta, grapefruit segments and cashews in a large salad bowl and toss to combine.

Lay the pancetta on a baking tray and drizzle with the honey. Place under a hot grill for 5–6 minutes until crisp — keep a close eye on it as the honey can cause the pancetta to burn easily. Leave to cool slightly, then crumble the crispy pancetta all over the salad.

To make the dressing, whisk all the ingredients together in a small bowl. Drizzle over the salad, toss to combine and serve.

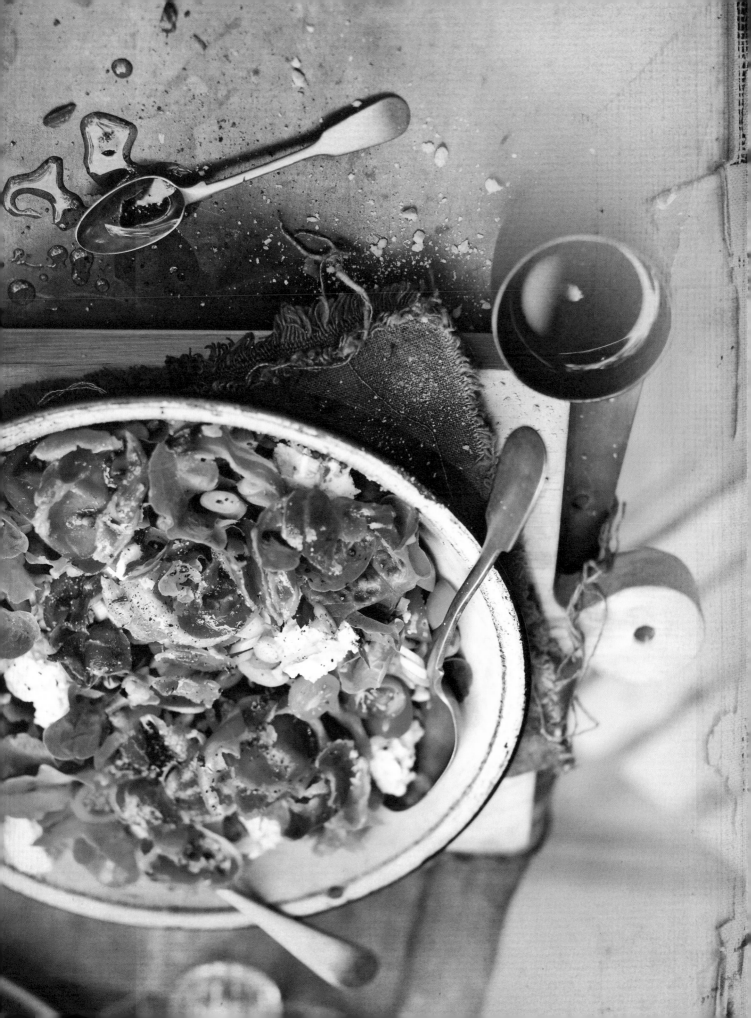

RED CABBAGE
and fennel salad
with tarragon and
lemon yoghurt

This salad not only looks fantastic, but it's also
jam-packed full of fresh flavours and textures, all brought
together with a smooth, zingy yoghurt dressing. It pairs
very well with grilled snapper or sardines for dinner,
or seared scallops for a light starter.

120 G PECANS
4 BLOOD ORANGES
1 LARGE BULB FENNEL
$1/4$ RED CABBAGE, CORED, LEAVES VERY FINELY SLICED
200 G SOFT GOAT'S CHEESE
SEA SALT AND FRESHLY GROUND BLACK PEPPER

Tarragon and lemon yoghurt
SMALL HANDFUL TARRAGON LEAVES, FINELY CHOPPED
JUICE OF 1 LEMON
2 TABLESPOONS EXTRA VIRGIN OLIVE OIL
HANDFUL FRESH MINT LEAVES, FINELY CHOPPED
95 G GREEK-STYLE YOGHURT
SEA SALT AND FRESHLY GROUND BLACK PEPPER

Serves 4 as a side

Preheat the oven to 180°C (fan), 200°C, gas mark 6. Spread
the pecans out on a baking tray and roast for 7-10 minutes, then
roughly chop and set aside.

To make the yoghurt dressing, whisk all the ingredients together
in a small bowl and chill in the fridge until needed.

Cut the top and bottom from each orange. Place on a chopping board and,
working from top to bottom, use a small, sharp knife to cut away all
the skin and pith. Take the fruit in your hand and, holding it over
a large serving bowl to catch the juices, carefully cut each inner
segment away from the membrane, letting the segments fall into the
bowl — they should be free of any white pith or pips.

Add the fennel, cabbage and pecans to the bowl and toss to combine.
Crumble over the goat's cheese, then drizzle over the yoghurt
dressing, season and serve.

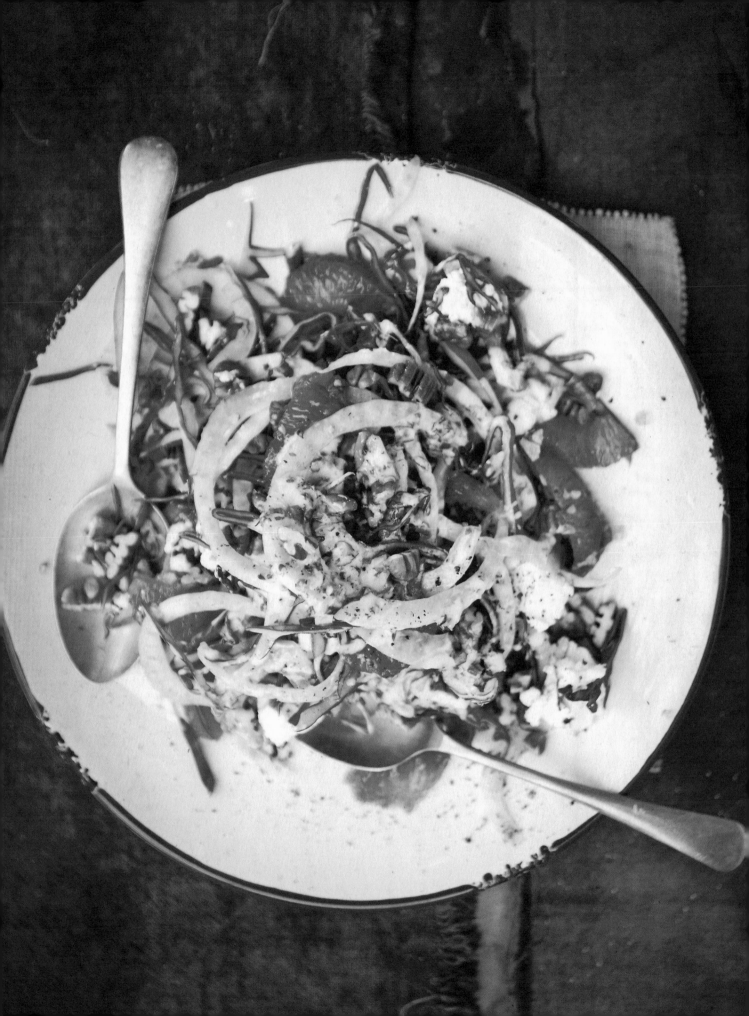

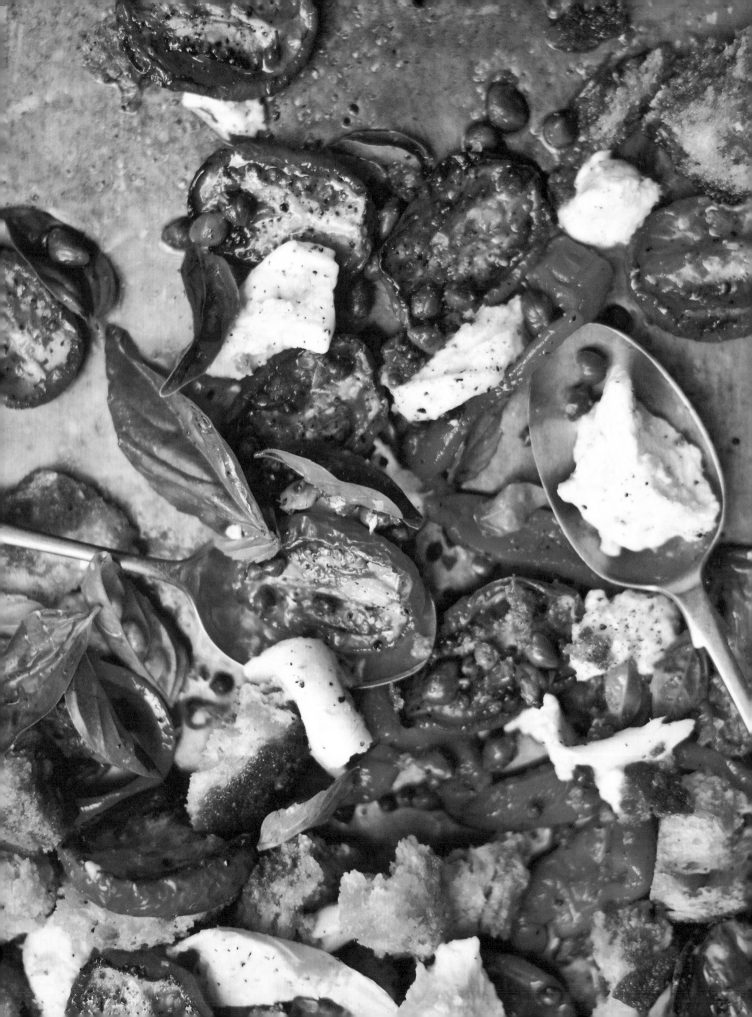

My love of balsamic vinegar is well-known among my friends, and
I was once dared to drink a (reasonable-sized) glass of
the stuff in one go (for the record, I didn't do it, but mainly
because it was a cheap supermarket variety!). Jokes aside,
I really do adore a wonderful aged balsamic, and whenever I am
lucky enough to venture to Italy, I always lug home armfuls of
it. I am the type to pour it with abandon over all the foods
I love, including bread, cheese, tomatoes and capers (so I guess
you could call this salad one of my all-time favourite meals).

If you don't have a gas hob, you can achieve a similar result by
charring the peppers on the barbecue or in a preheated 200°C
(fan), 220°C, gas mark 7 oven for about 1 hour (coating them in
a little olive oil first).

Katie's PANZANELLA

8 ROMA (PLUM) TOMATOES, HALVED LENGTHWAYS
SEA SALT AND FRESHLY GROUND BLACK PEPPER
OLIVE OIL, FOR COOKING
1 SMALL-MEDIUM DAY-OLD SOURDOUGH LOAF,
 TORN INTO BITE-SIZED PIECES
3 RED PEPPERS
1 TABLESPOON EXTRA VIRGIN OLIVE OIL
220 G FRESH BUFFALO MOZZARELLA, ROUGHLY TORN
1 TABLESPOON SALTED CAPERS, RINSED
1 BUNCH BASIL, LEAVES PICKED

Balsamic vinegar dressing
3 TABLESPOONS EXTRA VIRGIN OLIVE OIL
1 TABLESPOON BALSAMIC VINEGAR
SEA SALT AND FRESHLY GROUND BLACK PEPPER

Serves 2 as a light meal or 4 as a side

Preheat the oven to 130°C (fan), 150°C, gas mark 2.

Place the tomato halves on a baking tray, season lightly with salt and pepper and drizzle over a little olive oil. Transfer to the oven and roast for 2 hours or until very soft and slightly caramelised. After 1½ hours, spread the pieces of bread out on a separate baking tray, drizzle lightly with olive oil, and add them to the oven with the tomatoes for the last 30 minutes of cooking time, until they are light golden brown and crispy. Transfer the bread to a large bowl, and leave the tomatoes to cool.

Meanwhile, using tongs, hold the peppers over a naked gas flame on your hob, rotating occasionally, until the skins are charred all over. Place the peppers in a large bowl, cover with cling film and set aside until cool enough to handle, then remove the charred skin. Cut away the core and white inner membrane and discard the seeds, then cut the flesh into thin strips. Place in a small bowl with 1 tablespoon extra virgin olive oil, massaging the oil into the flesh, and set aside.

To make the dressing, whisk all the ingredients together in a small bowl. Pour the dressing over the roasted bread chunks and toss to coat well, then remove the bread with a slotted spoon and transfer to a serving platter, reserving the dressing.

Add the roasted tomato halves, pepper strips (drained of oil), mozzarella, capers and basil to the platter. Drizzle over the dressing, toss to combine well, then season with salt and pepper before serving.

COUSCOUS salad with slow-roasted tomatoes, chickpeas and SOFT-BOILED EGGS

Tomatoes roasted for a long time in a slow oven are packed full of flavour. I like to use vine-ripened tomatoes when I can, as the aroma just from the stems is breathtaking. However, slow-roasting brings out the flavour of any tomato, so you can get away with using bog-standard, less flavoursome ones. Instead of buying semi-dried tomatoes, I slow-roast fresh Roma tomatoes at 100°C (fan), 110°C, gas mark 4 for 3 hours, then place them in a sterilised jar (see page 11), cover with extra virgin olive oil and store in the fridge until required.

For this recipe, I boil the eggs for about 5 minutes so that the whites are set but the yolks are soft and gooey.

8 SMALL VINE-RIPENED TOMATOES, QUARTERED
OLIVE OIL, FOR COOKING
SEA SALT AND FRESHLY GROUND BLACK PEPPER
250 G COUSCOUS
KNOB OF BUTTER
1 x 400 G TIN CHICKPEAS, DRAINED AND RINSED
1 GARLIC CLOVE, FINELY CHOPPED
1 TEASPOON GROUND CUMIN
3 TABLESPOONS PUMPKIN SEEDS
PINCH FENNEL SEEDS
3-4 FREE-RANGE EGGS, SOFT-BOILED AND HALVED LENGTHWAYS
HANDFUL BASIL LEAVES

Spiced yoghurt dressing
280 G NATURAL YOGHURT
1 TEASPOON GROUND CUMIN
1 TABLESPOON LEMON JUICE
1 TEASPOON EXTRA VIRGIN OLIVE OIL
FRESHLY GROUND BLACK PEPPER

Serves 6 as a side

Preheat the oven to 140°C (fan), 160°C, gas mark 2½.

Spread the tomatoes out on a baking tray, drizzle with a little olive oil, season with salt and pepper and roast for 1–1½ hours, or until caramelised and shrivelled.

Place the couscous in a bowl, add the knob of butter and a pinch of salt, then pour over enough boiling water to just cover. Cover with cling film and set aside for 5 minutes or until all the liquid has been absorbed. Using a fork, separate the grains to make the couscous light and fluffy, then season well with salt and pepper.

Meanwhile, warm 1 teaspoon olive oil in a deep frying pan. Add the chickpeas, garlic, ground cumin, pumpkin seeds and fennel seeds, season and toss to coat, then fry over a low–medium heat for 10 minutes, tossing often, until the chickpeas are golden and slightly crispy on the outside. Remove and add to the couscous, along with the roast tomatoes. Gently toss to combine and transfer to a serving dish.

To make the dressing, whisk all the ingredients together in a small bowl.

Scatter the eggs and basil on top of the salad, then drizzle over the dressing and serve.

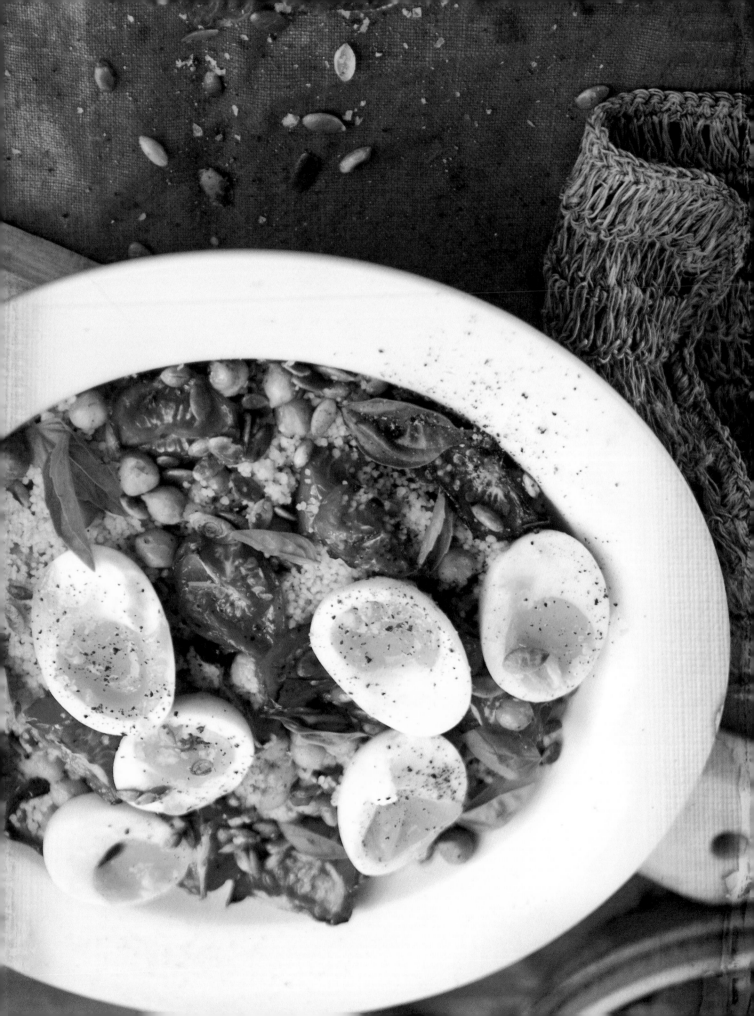

This is a delicious salad that goes especially well with
fish such as poached salmon. I use new baby potatoes, but
a waxy variety would work just as well, as they hold their
shape nicely when cooked. If you can't find watercress,
feel free to substitute rocket.

Fresh green beans, blanched for a minute or two before being
cut into small pieces, make a good alternative to asparagus
when not in season.

Baby potatoes with ASPARAGUS and caper dressing

10 SMALL–MEDIUM-SIZED BABY POTATOES (ABOUT 750 G)
1 TEASPOON FINE SALT
1 LARGE BUNCH THIN ASPARAGUS (ABOUT 10 SPEARS),
 WOODY ENDS REMOVED, SPEARS CUT INTO 2 CM PIECES
HANDFUL WATERCRESS LEAVES, WASHED AND TORN

Caper dressing
100 ML EXTRA VIRGIN OLIVE OIL
2 TABLESPOONS LEMON JUICE
50 G SALTED CAPERS, RINSED AND FINELY CHOPPED
HANDFUL DILL FRONDS, CHOPPED
SEA SALT AND FRESHLY GROUND BLACK PEPPER

Half-fill a large saucepan with cold water and add the
potatoes and salt. Bring to the boil, then reduce the heat
to medium and simmer for 20 minutes or until the potatoes
are just cooked through. Drain and leave to cool completely
before cutting into halves or quarters (depending on their
size — you want bite-sized pieces).

Meanwhile, half-fill a medium-sized saucepan with water,
bring to the boil and add the asparagus. Cook for
2–3 minutes, then drain and plunge immediately into
a bowl of iced water.

To make the dressing, whisk all the ingredients together
in a small bowl and season with salt and pepper.

Place the potatoes and asparagus in a large bowl, then coat
with half the dressing. Turn out onto a large, flat serving
platter. Dress with the torn watercress leaves, drizzle with
the remaining dressing and serve.

Serves 4 as a side

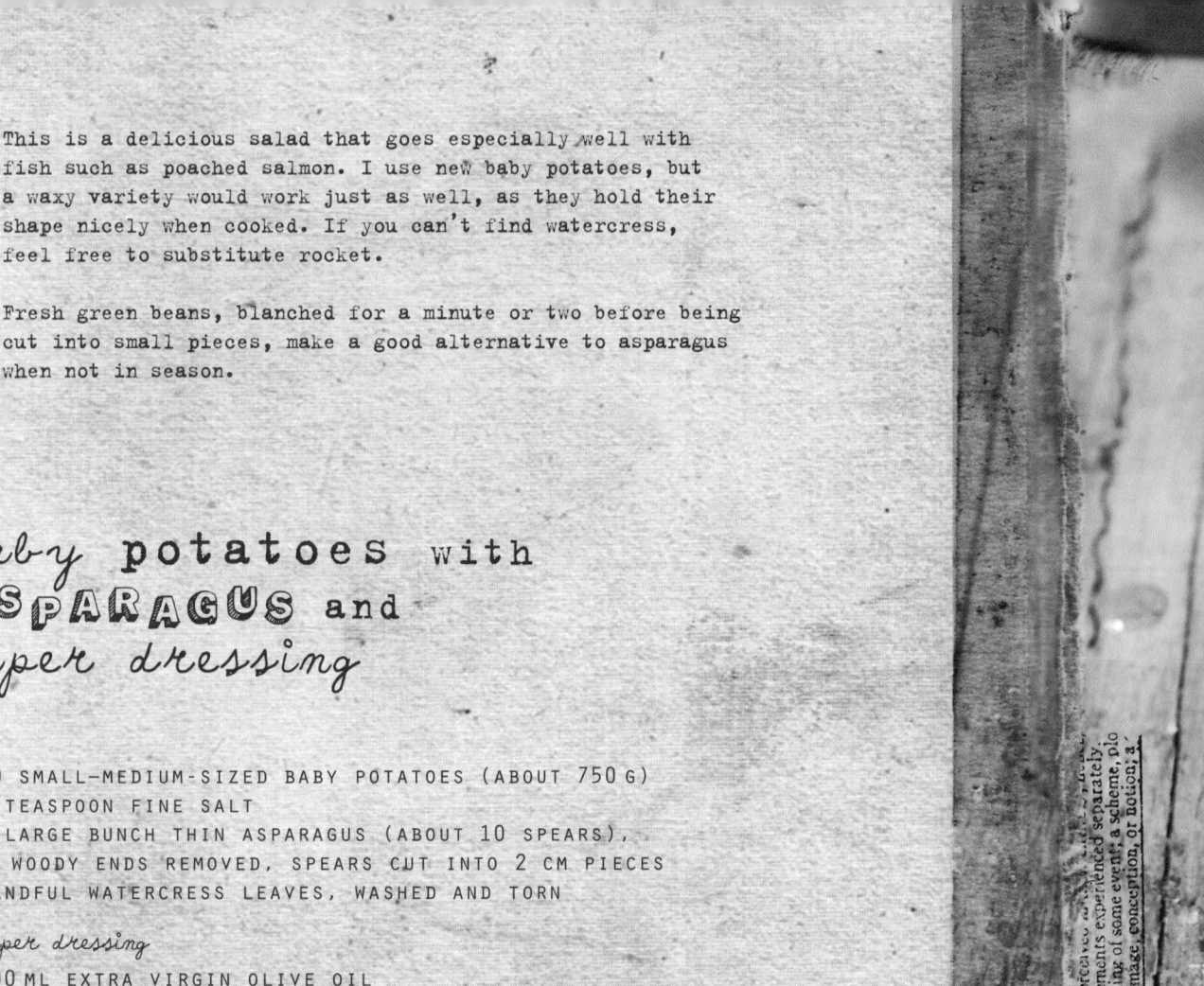

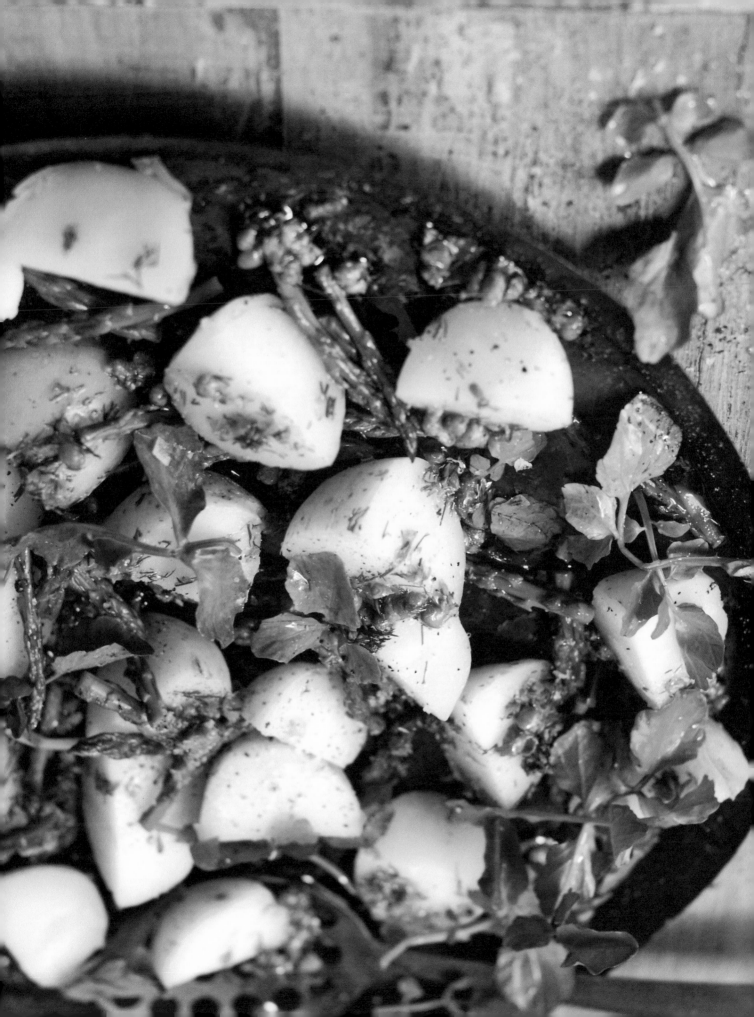

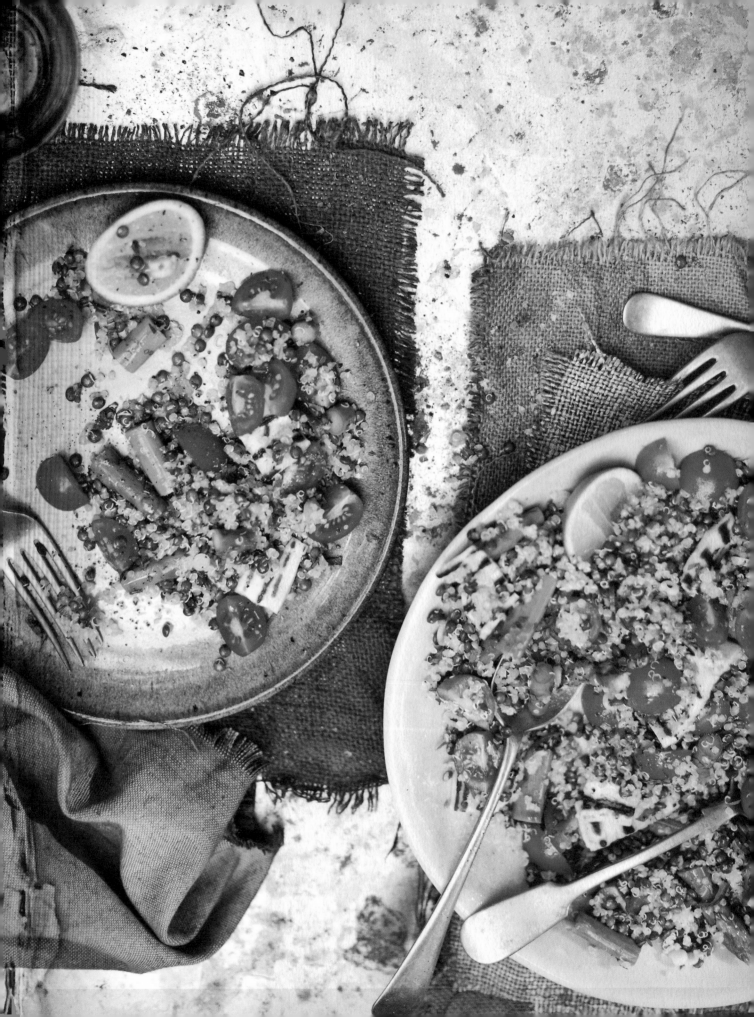

Quinoa and LENTIL SALAD with asparagus, mint and haloumi

Haloumi is a great source of calcium and a good low-fat cheese to include in salads. I love its 'meaty' and substantial, albeit a little squeaky, texture. It's especially wonderful when sliced and pan-fried. For something different, I marinate a whole block of haloumi in lime juice, then pan-fry it whole, before slicing and serving. It turns out seared and crispy on the outside with a smooth and creamy centre.

200 G PUY LENTILS
1 TABLESPOON OLIVE OIL
1 TABLESPOON RED WINE VINEGAR
SEA SALT AND FRESHLY GROUND BLACK PEPPER
100 G QUINOA, RINSED WELL
16 SPEARS ASPARAGUS, WOODY ENDS REMOVED, SPEARS CUT INTO 2.5 CM PIECES
1 x 180 G PIECE HALOUMI, CUT INTO THIN STRIPS
JUICE AND FINELY GRATED ZEST OF 2 LIMES, PLUS EXTRA LIME CHEEKS, TO SERVE
1 PUNNET (250 G) CHERRY TOMATOES, QUARTERED
3 SPRING ONIONS, TRIMMED AND FINELY SLICED
1 LONG GREEN CHILLI, DESEEDED, THINLY SLICED
1 LARGE HANDFUL MINT LEAVES, VERY ROUGHLY CHOPPED
CRUSTY BREAD, TO SERVE

Serves 2 as a main or 4 as a side

Place the lentils and 750 ml cold water in a small saucepan, bring to the boil, then reduce the heat and simmer over a low heat for 25 minutes until cooked (they should be slightly soft yet still al dente and nutty in texture). Drain, then run under cold water to rinse. Transfer to a large bowl and set aside to cool completely before adding the olive oil and red wine vinegar and seasoning well with salt and pepper.

Meanwhile, place the quinoa and 500 ml cold water in another small saucepan, bring to the boil, then reduce the heat to low and cook for 10–15 minutes until all the water has been absorbed and the grains appear translucent. Remove from the heat, fluff up the grains with a fork and transfer to the bowl with the lentils.

Half-fill a small saucepan with water, bring to the boil and add the asparagus. Cook for 2–3 minutes until al dente, then drain and plunge immediately into a bowl of iced water. Drain again and add to the bowl with the lentils and quinoa.

Heat a chargrill pan over a medium heat and add the haloumi to the pan. Drizzle the lime juice over the cheese and sear for 2–3 minutes until golden brown all over. Cut into small squares and add to the lentil mixture, along with the tomatoes, spring onions, chilli, mint and lime zest, then season well with salt and pepper.

Garnish with extra lime cheeks and serve with crusty bread.

Wild rice, mint and chickpea salad with APPLE CIDER DRESSING

This salad tastes even better a day after it's made – just prepare
it in advance and keep it in the fridge overnight. I love the texture
of the nutty rices mixed with the mint. Don't be shy with the nutmeg:
it adds great flavour to this dish and, like cumin, works superbly
with chickpeas. This salad is a good accompaniment to lamb or pork.

200 G WILD RICE
400 G BROWN RICE, RINSED WELL UNDER COLD
 RUNNING WATER, THEN DRAINED
SEA SALT AND FRESHLY GROUND BLACK PEPPER
2 x 400 G TINS CHICKPEAS, DRAINED AND RINSED
1 LARGE HANDFUL MINT LEAVES, ROUGHLY CHOPPED
1 LARGE HANDFUL FLAT-LEAF PARSLEY LEAVES, ROUGHLY CHOPPED
$1/2$ TEASPOON FRESHLY GRATED NUTMEG

Apple cider dressing
60 ML APPLE CIDER VINEGAR
2 TABLESPOONS EXTRA VIRGIN OLIVE OIL

Serves 4 as a side

Bring 1.5 litres cold water to the boil in a medium-sized saucepan, then add
the wild rice and reduce the heat to low. Cook for 40–45 minutes or until the
rice is still a little firm with a nutty texture. Drain and allow to cool.

Meanwhile, bring 2 litres cold water to the boil in a large saucepan, then
add the brown rice and stir. Reduce the heat to medium and cook for 30 minutes,
then drain before returning the rice to the pan. Cover with a tight-fitting
lid and set aside for 10 minutes before fluffing up with a fork. Season to
taste with salt and pepper and allow to cool.

Transfer the cooled rice to a large bowl, then add the chickpeas, herbs
and nutmeg and season well with salt and pepper.

To make the dressing, whisk the ingredients together and pour over the
rice mixture. Toss together well, then chill until ready to serve.

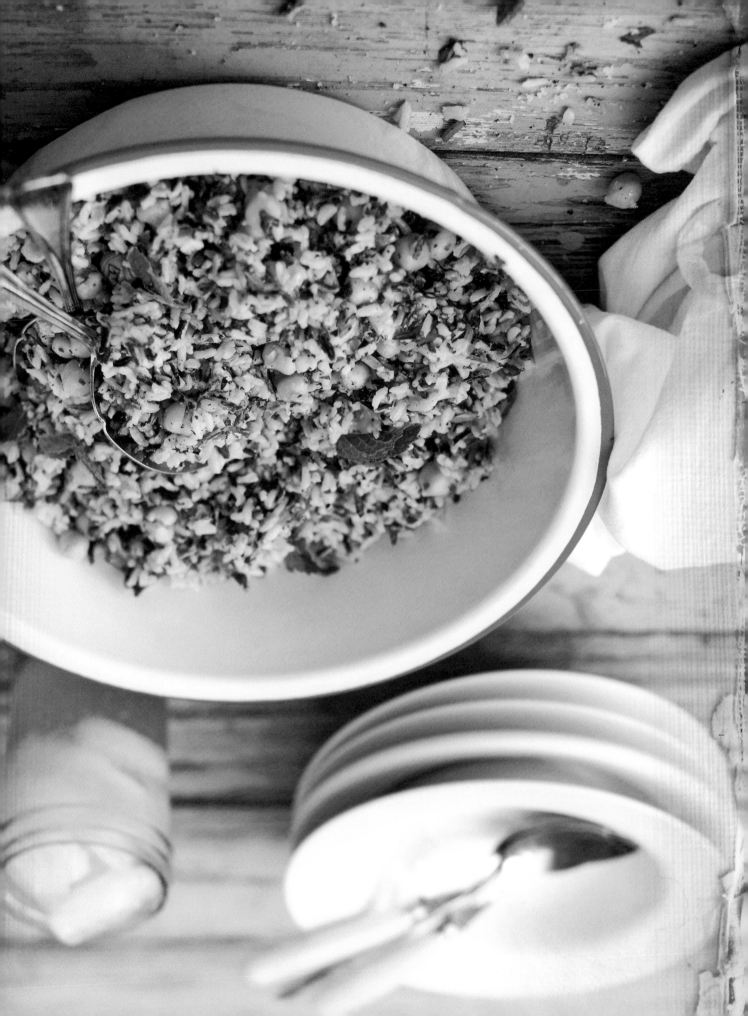

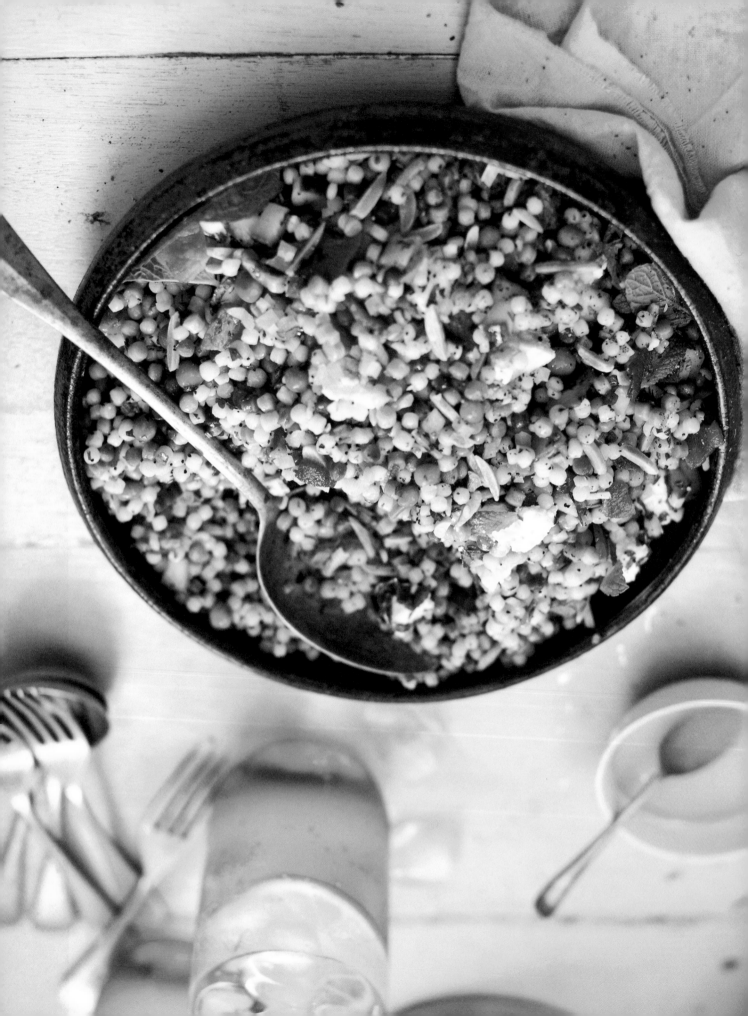

Fregola salad with BACON, baby peas and preserved lemon

Ever since I first tried fregola — or fregula — I have been hooked. It's a small, round, semolina-based pasta that originated in Sardinia; it's very similar to Israeli couscous (so you can use that instead). Fregola pairs terrifically with lemons and tomatoes, in particular. This salad also works well with flaked smoked salmon strips or leftover roast chicken instead of the bacon.

70 G SLIVERED ALMONDS
1 TEASPOON FINE SALT
OLIVE OIL, FOR COOKING
175 G FREGOLA
120 G BABY FROZEN PEAS
6–8 RASHERS FREE-RANGE BACON, FAT AND RIND REMOVED, FINELY DICED
JUICE OF $\frac{1}{2}$ LEMON
1–2 TABLESPOONS EXTRA VIRGIN OLIVE OIL
SEA SALT AND FRESHLY GROUND BLACK PEPPER
1 PIECE PRESERVED LEMON, FLESH DISCARDED, RIND RINSED
 AND FINELY DICED
$\frac{1}{2}$ LARGE CUCUMBER, VERY FINELY DICED
100 G RICOTTA, PERSIAN FETA OR GOOD-QUALITY GREEK FETA
1 TABLESPOON POPPY SEEDS
HANDFUL MINT LEAVES, TORN
HANDFUL FLAT-LEAF PARSLEY LEAVES, FINELY CHOPPED

Serves 2 as a main or 4 as a side

Preheat the oven to 180°C (fan), 200°C, gas mark 6.

Scatter the slivered almonds on a baking tray and roast in the oven for 5–6 minutes until golden brown, then set aside.

Half-fill a medium-sized saucepan with water, add the salt and a drizzle of olive oil and bring to the boil. Add the fregola, reduce the heat and simmer over a medium heat for 9 minutes. Add the frozen peas and cook for 3 minutes. Drain, then rinse well with cold water and transfer the fregola and peas to a sieve or colander to drain while you fry the bacon.

Heat 1 tablespoon olive oil in a frying pan and cook the bacon for 10 minutes until golden and crispy, then remove and set aside to drain on kitchen paper.

Place the fregola and peas in a large serving bowl. In a cup or glass, whisk together the lemon juice and extra virgin olive oil and pour over the fregola. Stir to coat, then season with salt and pepper. Add the bacon, preserved lemon rind, cucumber, slivered almonds, feta, poppy seeds and herbs and season with a little extra pepper to taste.

Gently combine all the ingredients and serve.

BEEF and pork sliders

makes 12

To make the brioche, beat together the butter, sugar and three of the eggs in a large mixing bowl. Add the flour, yeast and salt and stir to combine. Make a well in the centre, then pour in the milk and bring together using your hands; the dough will be quite tacky but don't be tempted to add extra flour. Cover the bowl with a damp tea towel and leave to rise in a warm spot for 2 hours.

Punch your fist into the centre of the risen dough, then knead it gently for a minute or two on a lightly floured work surface. Flour your hands and divide the dough into twelve even portions, then roll them into balls. Place on a floured baking tray, then cover with a damp tea towel and leave to rise in a warm spot for 1 hour.

Preheat the oven to 180°C (fan), 200°C, gas mark 6.

Mix the remaining egg with the extra tablespoon of milk, and brush the buns generously with this mixture, then sprinkle the tops with sesame seeds. Bake for 20–30 minutes or until golden brown and cooked through.

Meanwhile, heat the 2 tablespoons olive oil in a frying pan over medium heat, add the onion and fry for 5 minutes, then add the garlic and cook for a further 5 minutes until the onion is softened. Remove the pan from the heat and allow to cool for 10 minutes.

Place the beef, pork, mustard, Tabasco, balsamic vinegar, capers, chilli flakes, chilli, parsley, 1 teaspoon sea salt and some black pepper in a large mixing bowl and combine thoroughly using your hands. Add the cooled onion and garlic and mix together.

Form the mixture into twelve patties — I use a 4 tablespoon measure for this. Place the patties on a baking tray and chill in the fridge for at least 2 hours, before cooking to your liking on a hot barbecue or chargrill pan or in a frying pan.

Serve the patties in the mini brioche buns with some lettuce, cheese, sliced onion and relish. Secure with cocktail sticks and accompany with extra relish on the side, if you like.

Homemade burgers are one of my favourite foods, but burgers in general get a bad rap for being unhealthy, and I think it's unfair. If they're made with good-quality, organic lean meat and include lots of fresh salad veggies, they're really not that bad for you. These sliders are always a winner at cocktail parties — prepare the patties the night before, then grill them just before you're ready to serve.

2 TABLESPOONS OLIVE OIL

1 BROWN OR WHITE ONION, VERY FINELY DICED

2 LARGE GARLIC CLOVES, FINELY CHOPPED

500 G LEAN MINCED FREE-RANGE BEEF

500 G LEAN MINCED FREE-RANGE PORK

1 TABLESPOON WHOLEGRAIN MUSTARD

1 TABLESPOON TABASCO OR SIMILAR HOT SAUCE

2 TABLESPOONS BALSAMIC VINEGAR

2 TABLESPOONS SALTED CAPERS, RINSED AND FINELY CHOPPED

1/4 TEASPOON DRIED CHILLI FLAKES

1 LONG RED CHILLI, DESEEDED, FINELY CHOPPED

1 TABLESPOON FLAT-LEAF PARSLEY FINELY CHOPPED

SEA SALT AND FRESHLY GROUND BLACK PEPPER

LETTUCE LEAVES, SLICED CHEESE, SLICED ONION AND SPICY VINE TOMATO RELISH (SEE PAGE 228), TO SERVE

Mini brioche

200 G UNSALTED BUTTER, AT ROOM TEMPERATURE

1½ TABLESPOONS CASTER SUGAR

4 FREE-RANGE EGGS

600 G STRONG WHITE BREAD FLOUR

½ TEASPOON INSTANT DRIED YEAST

1 TEASPOON FINE SALT

250 ML WHOLE MILK, WARMED LIGHTLY, PLUS 1 TABLESPOON EXTRA

HANDFUL SESAME SEEDS

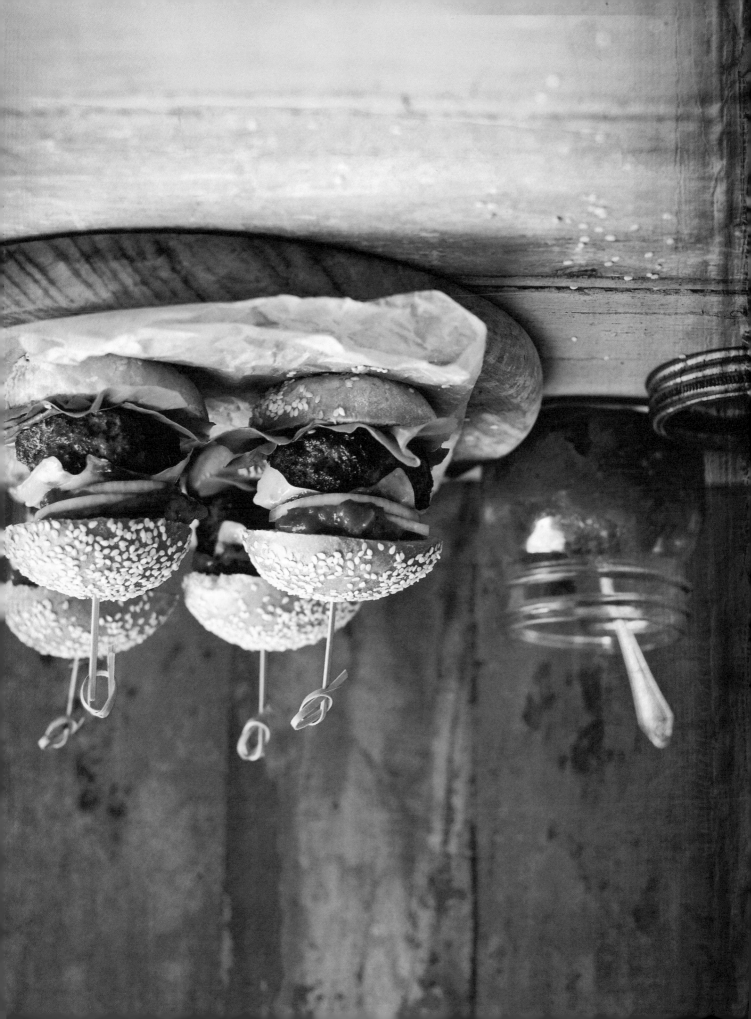

Apple, ginger and cranberry VODKA COCKTAIL

A few years ago, when I was visiting friends in New York,
I bought a bottle of Absolut Brooklyn, an apple- and
ginger-flavoured vodka that came in an incredibly cool
bottle depicting a typical Brooklyn brownstone building.
We enjoyed many a night sipping it while sitting on
the rooftop of my friend's apartment overlooking the
Empire State Building. Great memories, and my inspiration
for this cocktail.

500 ML APPLE JUICE
(USE THE CLOUDY TYPE IF YOU CAN)
500 ML CRANBERRY JUICE
100 ML VODKA
500 ML GINGER ALE
ICE, TO SERVE

Place the apple juice, cranberry juice and
vodka in a blender and whizz until pale
pink and frothy. Pour into a large
serving jug, add the ginger ale
and a good handful of ice.
Serve immediately.

serves 8

The saltiness of the grilled prosciutto works wonderfully here as a contrast to the lemony creaminess of the cannellini bean paste. Feel free to add a pinch of dried chilli flakes to the paste to give it an extra kick. You could also top each canapé with a semi-dried tomato for a real burst of flavour. The paste can be made a day in advance and stored in an airtight container in the fridge until ready to assemble.

№ 112

makes 25–30

ROASTED GARLIC and *cannellini bean* crostini with *prosciutto*

3 LARGE GARLIC CLOVES, UNPEELED
2 x 400 G TINS CANNELLINI BEANS, RINSED AND DRAINED
SMALL HANDFUL SAGE LEAVES, FINELY CHOPPED,
 PLUS 30 WHOLE LEAVES TO GARNISH
FINELY GRATED ZEST AND JUICE OF 1 LEMON
150 G PERSIAN FETA OR GOOD-QUALITY GREEK FETA
SEA SALT AND FRESHLY GROUND BLACK PEPPER
12 SLICES PROSCIUTTO
250 ML RAPESEED OIL
1 BAGUETTE, CUT INTO THIN SLICES
EXTRA VIRGIN OLIVE OIL, FOR DRIZZLING

Preheat the oven to 200°C (fan), 220°C, gas mark 7.

Place the garlic cloves on a small baking tray and roast in the oven for 30–40 minutes or until soft in the middle when pierced with a small, sharp knife. Remove from the oven, cut off the base of the cloves and squeeze the soft pulp into a large bowl.

Add the cannellini beans, chopped sage, lemon zest and juice and feta to the bowl and break up with a potato masher to form a thick paste. Season with salt and a generous amount of pepper and set aside.

Place the prosciutto under a hot grill and cook for 2–3 minutes until crispy. When cool enough to handle, break into shards and set aside.

Heat the rapeseed oil in a small saucepan over a medium heat until very hot. Working in batches of two or three leaves at a time, fry the whole sage leaves for 20–30 seconds until dark green and crispy (keep a close eye on them as they burn super-quickly). Remove with a slotted spoon and set aside to drain on kitchen paper.

Lightly toast the baguette slices under a hot grill. Leave to cool slightly, then smear each slice with 1 teaspoon of the garlic and bean paste. Top each with one or two shards of prosciutto, and garnish with a crispy sage leaf.

Arrange the canapés on platters, then drizzle over a small amount of extra virgin olive oil before serving.

Mini BEEF and *bacon* AUSSIE MEAT PIES

When I first came to Australia on holiday in 2001, I quickly became infatuated with the ubiquitous Aussie meat pie, and I returned to Dublin intent on opening up the first Katie's All-Aussie Meat Pie Company. That plan lasted all of a week, after which I got totally fed up making meat pies 24/7 in my little kitchen. Still, the effort was well worth it, as my mini meat pies are always favourably received at my cocktail parties (here's a tip: it's all in the nutmeg). To make blind baking the little pastry cases that much easier, you'll need four 12-hole mini muffin tins for this recipe. I like to serve these pies with the Spicy Vine Tomato Relish on page 228.

1 TABLESPOON OLIVE OIL
1 ONION, FINELY CHOPPED
5 RASHERS FREE-RANGE BACON, FAT AND
 RIND REMOVED, CUT INTO STRIPS
500 G LEAN MINCED FREE-RANGE BEEF
3 TABLESPOONS WORCESTERSHIRE SAUCE
1 TABLESPOON BARBECUE OR BROWN SAUCE
1 HEAPED TEASPOON CURRY POWDER
1 HEAPED TEASPOON FRESHLY GRATED NUTMEG
SEA SALT AND FRESHLY GROUND BLACK PEPPER
250 ML BEEF STOCK
1 HEAPED TABLESPOON PLAIN FLOUR
2 SHEETS GOOD-QUALITY PUFF PASTRY

1 FREE-RANGE EGG MIXED WITH
 1 TABLESPOON MILK
HANDFUL POPPY SEEDS

Rich shortcrust pastry
600 G PLAIN FLOUR
250 G UNSALTED BUTTER,
 CHILLED AND CUBED
1 FREE-RANGE EGG
1 TABLESPOON ICED WATER

makes 24

Preheat the oven to 200°C (fan), 220°C, gas mark 7. Grease the holes of two of the 12-hole mini muffin tins, and the underside of the holes of the other two tins.

To make the pastry, put the flour and butter into the bowl of an electric mixer fitted with a paddle attachment. Beat at low-medium speed for 5-6 minutes until the mixture resembles fine breadcrumbs, then add the egg and water and beat until the pastry forms a ball. Turn out onto a lightly floured work surface, then knead gently for 5 minutes, forming the dough into a ball as you go. Wrap in cling film and chill in the fridge for 30 minutes.

Roll out the pastry to a thickness of 3 mm, then cut out twenty-four 7 cm rounds and use these to line the holes of the mini muffin tins. Prick each base with a fork once or twice, then place the empty mini muffin tins on top to act as a weight for blind baking. Freeze for 30 minutes, then blind bake in the oven for 20 minutes until golden brown. Remove and allow to cool. Reduce the oven temperature to 180°C (fan), 200°C, gas mark 6.

Meanwhile, heat the olive oil in a frying pan over a medium heat. Add the onion and cook for 5 minutes, then add the bacon and fry until the bacon is lightly browned and crispy. Add the beef and cook for 5 minutes or until browned. Add the Worcestershire sauce, barbecue or brown sauce, curry powder, nutmeg, salt and pepper and stir well to combine. Add the beef stock and cook for 5 minutes, then sprinkle the flour evenly over the top and stir it in. Reduce the heat to low and simmer for 15-20 minutes until the mixture has thickened, then remove from the heat and set aside to cool completely.

Fill the pastry cases with the cooled meat mixture. Cut out twenty-four puff pastry rounds about 4 cm in diameter and place on top of the filled pies. Crimp the edges using a fork if you wish, then brush the tops with the egg and milk mixture and sprinkle over the poppy seeds.

Bake in the oven for 20-30 minutes or until the pastry is cooked through and golden brown.

I've been making these delicious morsels to serve with drinks for years.
I would advise you to make double the amount, as they are always gobbled
down in seconds. You can make the cookies a day or two in advance and
store them in an airtight container until required.

Nº. 116

Parmesan cookies
with ROASTED TOMATO and pesto

30 LARGE CHERRY TOMATOES, HALVED
OLIVE OIL, FOR COOKING
SEA SALT AND FRESHLY GROUND
 BLACK PEPPER
2 GARLIC CLOVES
260 G PLAIN FLOUR, SIFTED
200 G UNSALTED BUTTER, SOFTENED
1 TABLESPOON WHIPPING CREAM
PINCH DRIED THYME

140 G PARMESAN, FINELY GRATED, PLUS
 EXTRA FOR SPRINKLING
180 G PESTO (SEE PAGE 233)
EXTRA VIRGIN OLIVE OIL
60 SMALL THYME SPRIGS

makes **60**

Preheat the oven to 180°C (fan), 200°C, gas mark 6. Generously flour two large
baking sheets and set aside.

Place the tomato halves on a large baking tray, cut-side up, and drizzle with
olive oil. Season generously with salt and pepper and roast for 20—25 minutes
or until just softened. Meanwhile, place the garlic in a small baking dish,
drizzle with olive oil and roast for 40 minutes until soft. Remove and allow
to cool a little before squeezing out the soft flesh and discarding the papery
skin. Set the roasted tomatoes and garlic aside, then turn down the oven
temperature to 160°C (fan), 180°C, gas mark 4.

Using an electric mixer fitted with a paddle beater, beat the flour and butter
until combined; the mixture should resemble coarse breadcrumbs. Add the cream,
roasted garlic, thyme, Parmesan, a pinch of salt and a decent amount of
pepper, then continue to mix until all ingredients are thoroughly combined.

Turn out the dough onto a very well-floured work surface (the dough will be
really soft but don't worry — this is how it's supposed to be). Cover it in a
good amount of flour and gather it all up into a ball, then wrap in cling film
and chill in the fridge for 30 minutes.

Remove the dough from the fridge and cover the work surface generously with
flour (the dough will still appear almost too soft to work with, but don't
panic — this is how we want it). Using a rolling pin, very gently roll out
the dough to a thickness of 5 mm, then cut into rounds using a 3 cm cutter,
transferring each cookie to the prepared baking sheets as you go. Gather up
the remaining scraps of dough and repeat the process until all the dough is
used up.

Sprinkle the cookies with a little extra finely grated Parmesan and season
with extra pepper. Bake for 25—30 minutes or until the tops are lightly golden
brown and the bases are firm. Allow to cool completely.

To assemble the canapés, dot $\frac{1}{2}$ teaspoon of pesto onto the centre of each
cookie and top with a roasted tomato half. Drizzle a tiny amount of extra
virgin olive oil over the top and garnish with a small sprig of thyme
and a sprinkling of extra Parmesan.

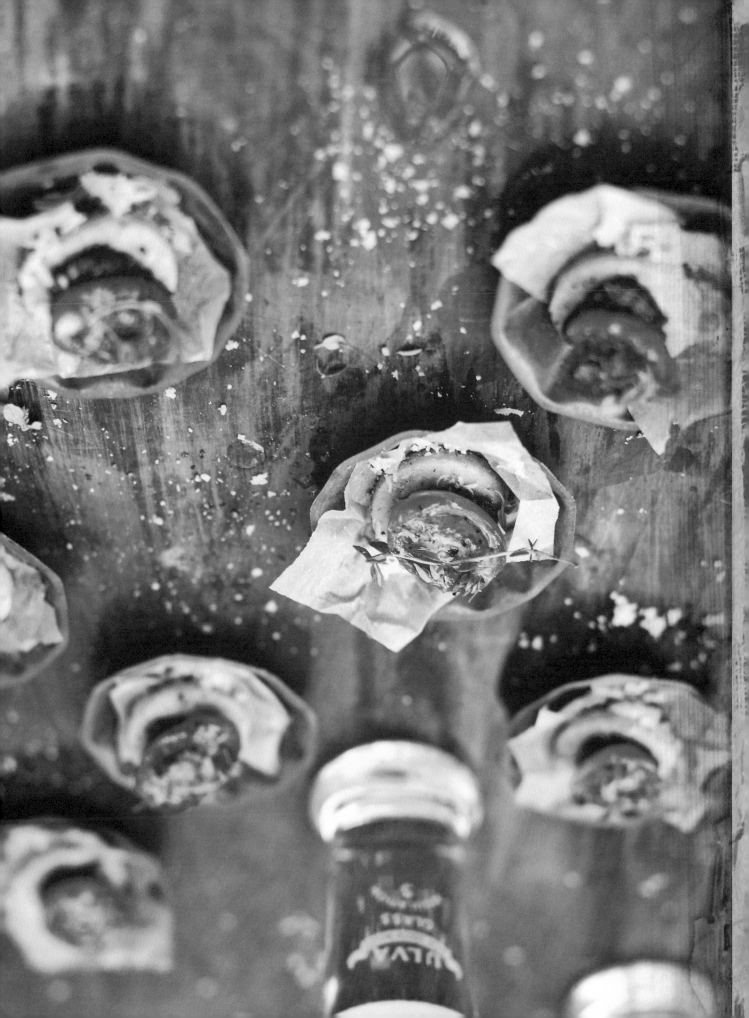

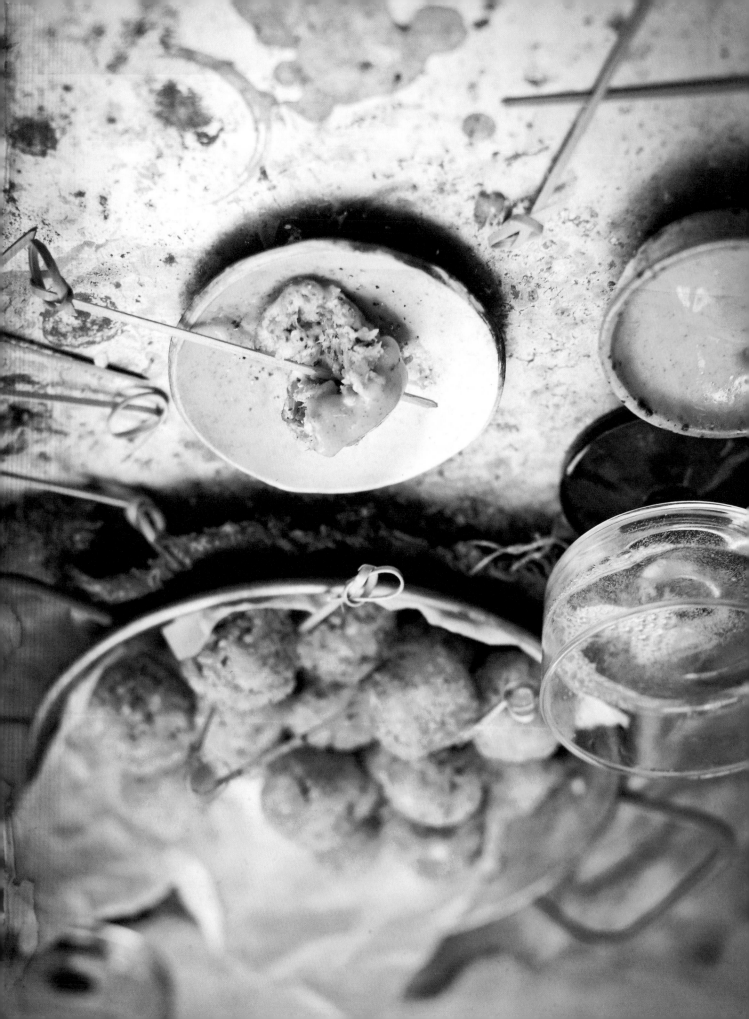

These are very moreish little mouthfuls, inspired by a starter I had years
ago at a steakhouse in Chicago. I will always remember these little crab cakes
coming out covered in an amazing bright pink sauce. I had no clue what was in
the sauce, but after years of experimentation, I've re-created something that
I hope is close to it. You can prepare and cook these crab cakes in advance,
and they keep very well once fried (surprisingly they don't go soggy, as long
as they're kept in an airtight container and aren't stored in the fridge). You
might like to serve the crab cakes skewered onto cocktail sticks or serving
sticks, as I've done here, to make it easier for your guests to eat them.

1 FREE-RANGE EGG
70 G PANKO (JAPANESE) BREADCRUMBS
500–750 ML RAPESEED OR GROUNDNUT OIL

Crab cake filling

250 G BLUE SWIMMER OR OTHER FRESH CRABMEAT
1 LONG RED CHILLI, DESEEDED, FINELY SLICED
2 SPRING ONIONS, TRIMMED AND FINELY SLICED
FINELY GRATED ZEST AND JUICE OF 1 LEMON
2 FREE-RANGE EGGS, HARD-BOILED, THEN VERY
 FINELY CHOPPED
70 G PANKO (JAPANESE) BREADCRUMBS
55 G BABY GHERKINS (CORNICHONS), FINELY CHOPPED
1 TABLESPOON SALTED CAPERS, RINSED AND FINELY CHOPPED
SMALL HANDFUL CORIANDER LEAVES, FINELY CHOPPED
SMALL HANDFUL FLAT-LEAF PARSLEY LEAVES, FINELY CHOPPED
1 FREE-RANGE EGG, BEATEN
SEA SALT AND FRESHLY GROUND BLACK PEPPER

Hot pink mayonnaise

150 G MAYONNAISE
1 TABLESPOON TOMATO KETCHUP
1 TABLESPOON TOMATO PURÉE
1/2 TEASPOON CAYENNE PEPPER
JUICE OF 1/2 LIME

Blue swimmer crab cakes with HOT PINK MAYONNAISE

Makes 24

To make the crab cake filling, place all the ingredients in a large bowl
and mix well to combine.

Take a teaspoonful of the filling and form into a ball about the size of a
small walnut. Transfer to a large baking tray and lightly press to flatten
a little. Continue until all the filling is used up, reserving a small amount
(about 1/4 teaspoon) to drop into the cooking oil later to test it — you should
get twenty-four crab cakes in all.

Beat the egg in a small bowl, and place the breadcrumbs in another small
bowl. Dip each crab cake first into the egg, then the breadcrumbs, rolling
it around a few times to coat thoroughly, then return it to the tray.

Pour the oil into a medium-sized saucepan and heat over a medium heat. Drop
in the reserved piece of crab cake filling — the oil is hot enough when this
floats to the top and turns golden quickly. Working in batches of two or three
crab cakes at a time, fry the crab cakes for around 1 minute or until golden
brown, then remove with a slotted spoon and set aside to drain on kitchen
paper. Once the crab cakes have cooled slightly, insert a cocktail stick or
serving stick into each one (if using).

To make the mayonnaise, combine all the ingredients in a small bowl.

Serve the crab cakes on a large baking-paper-lined platter with the hot
pink mayonnaise alongside.

Kingfish *sashimi* with
SEAWEED VINEGAR DRESSING

I could eat kingfish sashimi until it came out of my ears,
and as luck would have it, I live literally 5 minutes away
from the glorious Sydney Fish Market where, on any day
of the year, I can find THE most amazingly fresh fish.
This is a recipe I made up for a party I threw a couple
of years ago for my birthday. It's very simple, easy to
prepare and packed full of fresh flavours. Just make sure
you get top-quality sashimi-grade fish, and invest in
a very good, sharp knife.

750 G SASHIMI-GRADE KINGFISH OR LEMON SOLE FILLET,
 VERY FINELY SLICED
FINELY SLICED LONG RED CHILLI AND SESAME SEEDS,
 TO GARNISH

Seaweed vinegar dressing
1 TABLESPOON RICE WINE VINEGAR
1 TABLESPOON APPLE CIDER VINEGAR
80 ML LIGHT SOY SAUCE
2 TABLESPOONS SESAME OIL
2 LONG RED CHILLIES, VERY FINELY SLICED
1 LARGE SPRING ONION, TRIMMED AND VERY FINELY SLICED
1 SHEET NORI, CRUMBLED INTO TINY PIECES

To make the dressing, place the vinegars, soy sauce and
sesame oil in a small bowl and whisk together with a fork.
Add the chillies, spring onion and seaweed and leave to
infuse in the fridge for 30 minutes.

Place 2–3 slices kingfish in small individual serving
bowls. Spoon 1 or 2 teaspoons of the dressing over the
fish, and garnish with a sprinkling of red chilli and
sesame seeds.

makes about 40

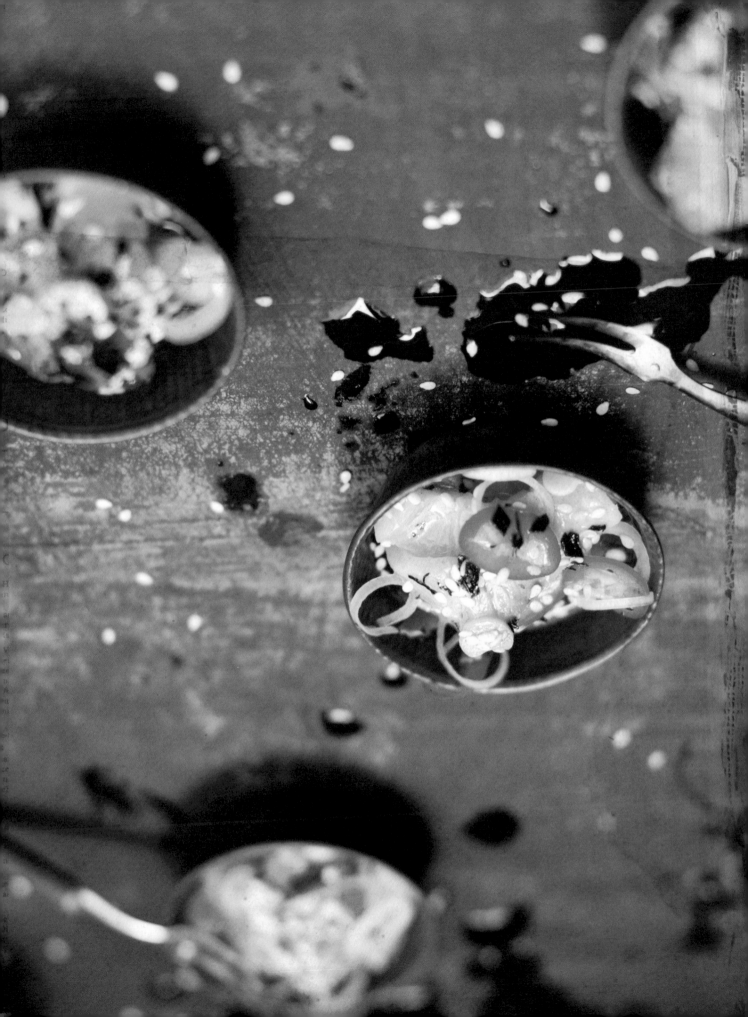

This is my take on my husband Mick's all-time favourite
breakfast dish, Eggs Benedict. It features my mum's scones
(the best on the planet), fried quail eggs and the best
old-school condiment from my childhood, Heinz Salad Cream,
instead of hollandaise. Trust me: the result is delicious.
Fried quail eggs usually elicit lots of 'oooohs' and
'aaaahs' from people, as they look ridiculously cute
and teeny-tiny, yet oh-so-perfectly formed.

mini eggs BENEDICT

500 G PLAIN FLOUR
1 TEASPOON BICARBONATE OF SODA
2 TEASPOONS CREAM OF TARTAR
1 TEASPOON SEA SALT
120 G CHILLED BUTTER, CUBED
20 G CASTER SUGAR
2 FREE-RANGE EGGS, 1 BEATEN, 1 MIXED WITH 1 TABLESPOON MILK
270 ML MILK
OLIVE OIL, FOR FRYING
8 SLICES MILD PANCETTA, VERY FINELY SLICED
24 QUAIL EGGS
80 ML HEINZ SALAD CREAM
TABASCO SAUCE OR SIMILAR HOT SAUCE, TO TASTE
SEA SALT AND FRESHLY GROUND BLACK PEPPER
THYME LEAVES, TO GARNISH

makes 24

Preheat the oven to 180°C (fan), 200°C,
gas mark 6. Sift the flour, bicarbonate of
soda, cream of tartar and salt into a large
mixing bowl. Rub in the butter with your
fingertips until the mixture resembles fine
breadcrumbs. Add the sugar and mix well to
incorporate.

Combine the beaten egg and milk in a jug,
then add to the bowl and mix to just bring
together. Turn out onto a floured work
surface and knead gently to form a light
dough. Using a floured rolling pin, roll out
the dough to a thickness of about 2 cm. Cut
out scones using a 3 cm round cutter, then
roll out the scraps and repeat until all the
dough is used up; you should have twenty-four
scones. Place the scones on a floured baking
tray and brush with the eggwash. Bake for
10-12 minutes or until golden brown, then set
aside on a wire rack to cool.

Meanwhile, heat a little olive oil in
a frying pan and fry the pancetta for
5 minutes or until crisp. Drain on kitchen
paper, patting off any excess oil. Tear

into twenty-four pieces about the same size as
the scones, then set aside.

Place 2 tablespoons olive oil in a non-
stick frying pan and, working in batches
(you should be able to fit eight eggs in a
standard-sized frying pan), fry the quail
eggs over a very low heat for about 5-7
minutes, until the whites are cooked but
the yolks are still bright yellow and runny
(adding more oil to the pan as needed).
Transfer the fried eggs to a plate then,
if you like, you can shape them with the
same round cutter you used for the scones.

Combine the salad cream with a dash or
two of Tabasco sauce and set aside.

Carefully slice off the very top of each
scone and discard, then place the bases
on a serving platter and top with pancetta,
a fried quail egg and a small dollop of
the salad cream mixture.

Serve with a sprinkle of salt and pepper,
and garnish with thyme.

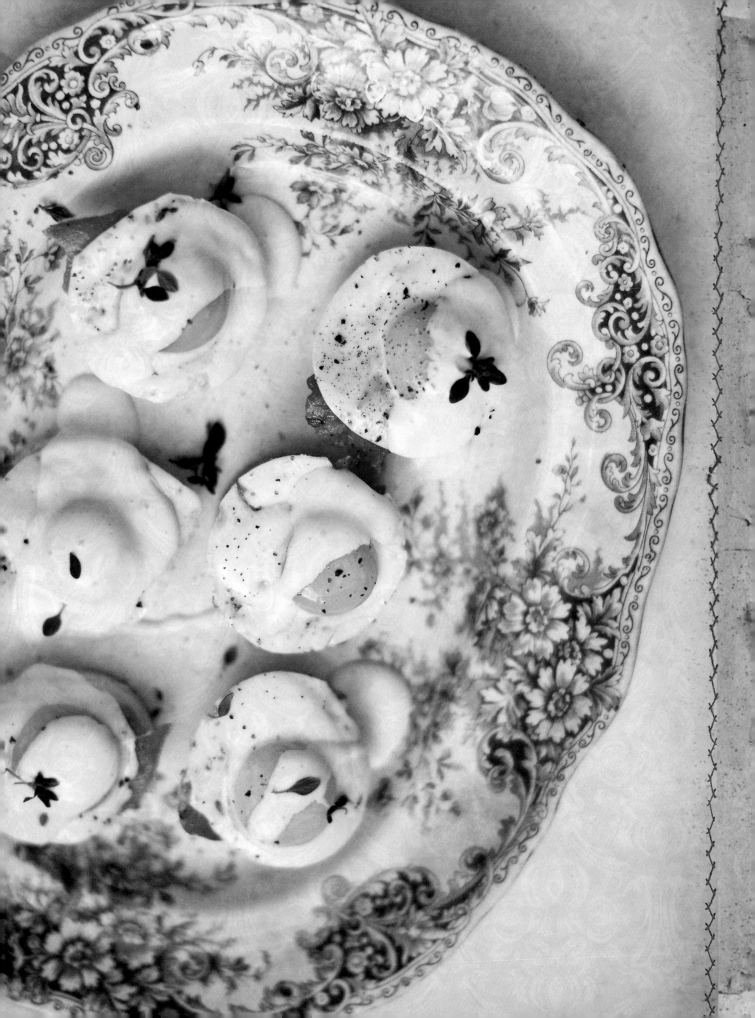

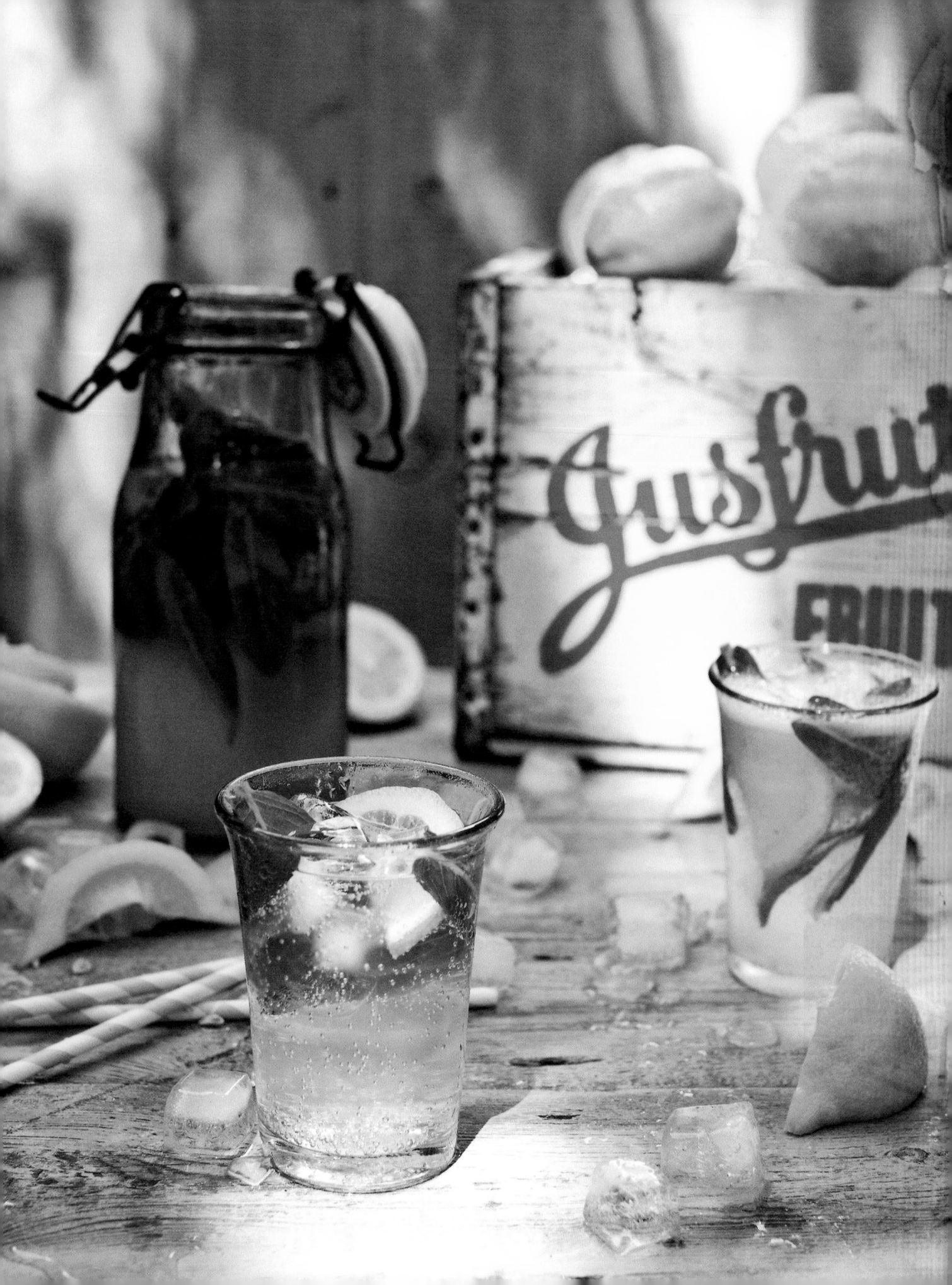

Madeleine's homemade LEMONADE CORDIAL

This is a sweet little recipe given to me by my assistant
Madeleine, whose granny had handed it down to her. It makes
a wonderfully tart yet sweet syrup, which you then mix with
soda water — and perhaps a splash of vodka, if you like.

makes 1 litre cordial

880 G CASTER SUGAR
FINELY GRATED ZEST OF 5 LEMONS
JUICE OF 7 LEMONS (YOU NEED ABOUT 500 ML)
LEMON SLICES AND MINT LEAVES, TO GARNISH
SODA WATER AND ICE CUBES, TO SERVE

Place the sugar and 500 ml water in
a medium-sized saucepan over a medium heat until
the sugar has dissolved. Bring to the boil and cook
over a high heat for 15 minutes or until a thin
syrup forms. Remove the pan from the heat, then
stir through the lemon zest and juice and transfer
to a jug. Cover and leave to stand in the fridge
for a minimum of 5 hours.

Strain the cordial, then pour into
sterilised bottles or jars (see page 11),
placing a few lemon slices and a handful
of mint leaves in each, and store in the
fridge. To serve, mix one part cordial
with five parts soda water and top up
with ice cubes.

Mini pork, apple and pistachio
SAUSAGE ROLLS

Who doesn't love an old-fashioned flaky pastry sausage roll dipped in a big splodge of tomato sauce? These little ones are winners for cocktail parties as you can prepare them in advance, and the apple and pistachio added to the pork mince makes them extra special. They're especially good brought out later in the evening, when you'll find they'll disappear in seconds.

1 TABLESPOON OLIVE OIL
1 RED ONION, FINELY DICED
SEA SALT AND FRESHLY GROUND BLACK PEPPER
2 GARLIC CLOVES, FINELY CHOPPED
500 g LEAN MINCED FREE-RANGE PORK
100 g SHELLED PISTACHIOS, ROUGHLY CHOPPED
2 GREEN APPLES, PEELED, CORED AND GRATED
2 TABLESPOONS WHOLEGRAIN MUSTARD
1 TABLESPOON CIDER VINEGAR
1 TABLESPOON FINELY CHOPPED FLAT-LEAF PARSLEY
6 SHEETS PUFF PASTRY (ABOUT 25 CM X 25 CM)
1 FREE-RANGE EGG MIXED WITH 1 TABLESPOON MILK
SMALL HANDFUL POPPY SEEDS

Makes about 90

Preheat the oven to 200°C (fan), 220°C, gas mark 7.

Heat the olive oil in a large saucepan over a medium heat. Add the onion and a pinch of salt and saute for 5 minutes until soft and translucent. Add the garlic and continue to cook for another 5 minutes, stirring occasionally. Remove the pan from the heat and allow to cool completely.

Place the pork in a large mixing bowl and add the pistachios, apple, mustard, vinegar and parsley and the cooled onion and garlic. Season with salt and a generous amount of black pepper and combine well using your hands.

Cut a pastry sheet into three roughly 8 cm wide strips, then cut each strip into pieces at 5 cm intervals. Lay each piece of pastry on a work surface and place a teaspoon of filling at one end. Roll up to enclose the filling, then seal with some egg mixture. Repeat until all the mixture is used up: you should have about 90 sausage rolls.

Coat each sausage roll generously with the remaining egg mixture and sprinkle the tops with poppy seeds.

Bake for 30 minutes or until golden and crispy, then serve hot.

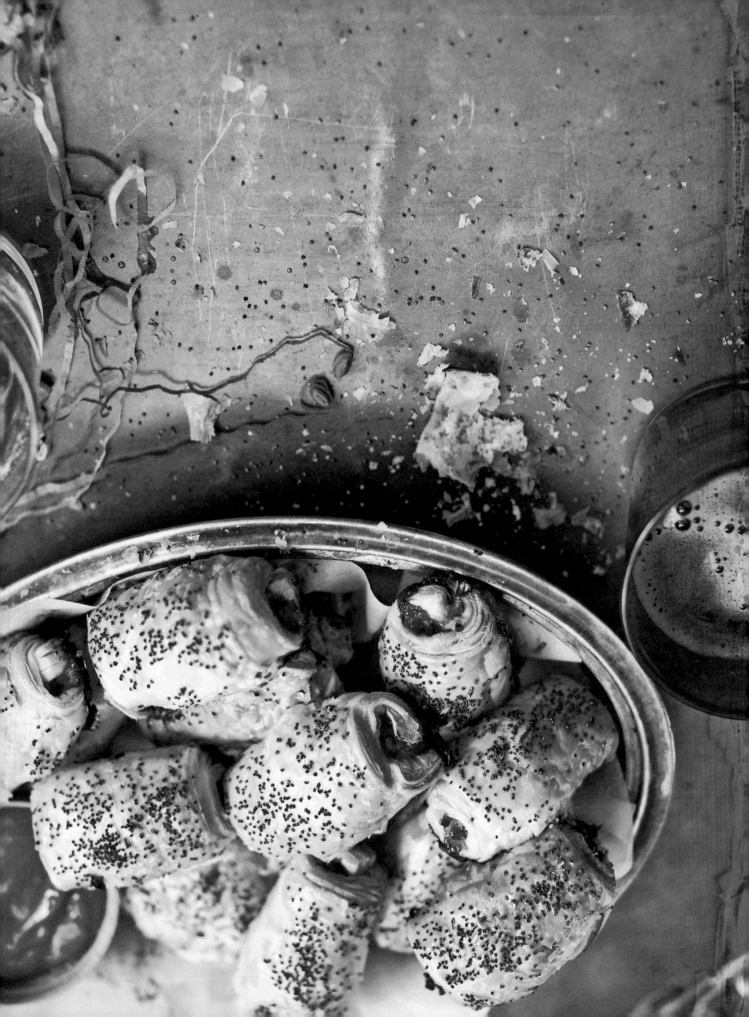

DINNERS

Back in 2000 I was working as a graphic designer in Chicago for one of the nicest bosses I have ever had (Hi Curt!). Working late one night, he offered to order in dinner for us in an attempt to relieve his guilt at making us all stay back, and he asked me what my favourite dinner was. My response – roast chicken with roast potatoes, stuffing and gravy – was really in reference to my mum's version, and I was aghast when I heard him on the phone seconds later, ringing all around Chicago for a takeaway place that would provide such a meal! He didn't have any luck, but I was touched by his efforts. This is my lemony take on my all-time favourite meal.

ROAST chicken with lemon cream gravy

1 x 1.5KG FREE-RANGE CHICKEN (ORGANIC, IF POSSIBLE)
3 LARGE KNOBS OF BUTTER, AT ROOM TEMPERATURE
SEA SALT AND FRESHLY GROUND BLACK PEPPER
4 LEMONS, CUT IN HALVES OR QUARTERS
2 PIECES PRESERVED LEMON
3 GARLIC BULBS, 1 SEPARATED INTO CLOVES,
2 CUT IN HALF LENGTHWAYS
4 ROSEMARY SPRIGS
OLIVE OR VEGETABLE OIL, FOR DRIZZLING
500 ML CHICKEN STOCK
250 ML CREAM
JUICE OF 1/2 LEMON

Serves 4

Preheat the oven to 180°C (fan), 200°C, gas mark 6.

Place the chicken on a clean work surface and, using your hands, gently loosen the skin from the breast, creating a gap between the skin and meat.

Take two large knobs of softened butter and gently push it between the skin and meat, rubbing it into the meat. Take the remaining butter and massage it all over the chicken skin. Season the chicken well with salt and pepper and transfer to a large flameproof roasting tin.

Place four lemon halves or quarters into the cavity, along with the preserved lemon, half the unpeeled garlic cloves and one or two sprigs of rosemary. Scatter the remaining lemon halves or quarters, unpeeled garlic cloves and the halved garlic bulbs around the bird and toss the leaves from the remaining rosemary sprigs all over the bird. Season again with salt and pepper and drizzle with a good glug of olive or vegetable oil.

Transfer the roasting tin to the oven and roast for 30 minutes, then, using a pair of tongs, squeeze the juice from the roasted lemons in the tin all over the chicken. Roast for a further 30 minutes or until the chicken is cooked (to test this, pierce the thigh part with a skewer and press the juices out onto a spoon: if they are clear, the chicken is ready). Remove from the oven, then transfer the chicken to a serving platter, loosely cover with foil and leave it to rest for 10 minutes while you make the gravy.

Place the roasting tin on the hob over a low heat, add the chicken stock and bring to a low simmer. Using a balloon whisk, incorporate the roasting juices into the stock, scraping up all the bits stuck to the bottom of the tin as you go (these will add loads of great flavour to your gravy). Stirring constantly, add the cream and lemon juice, then season to taste with salt and pepper. If you like a smooth, silky gravy, pass it through a fine sieve, then

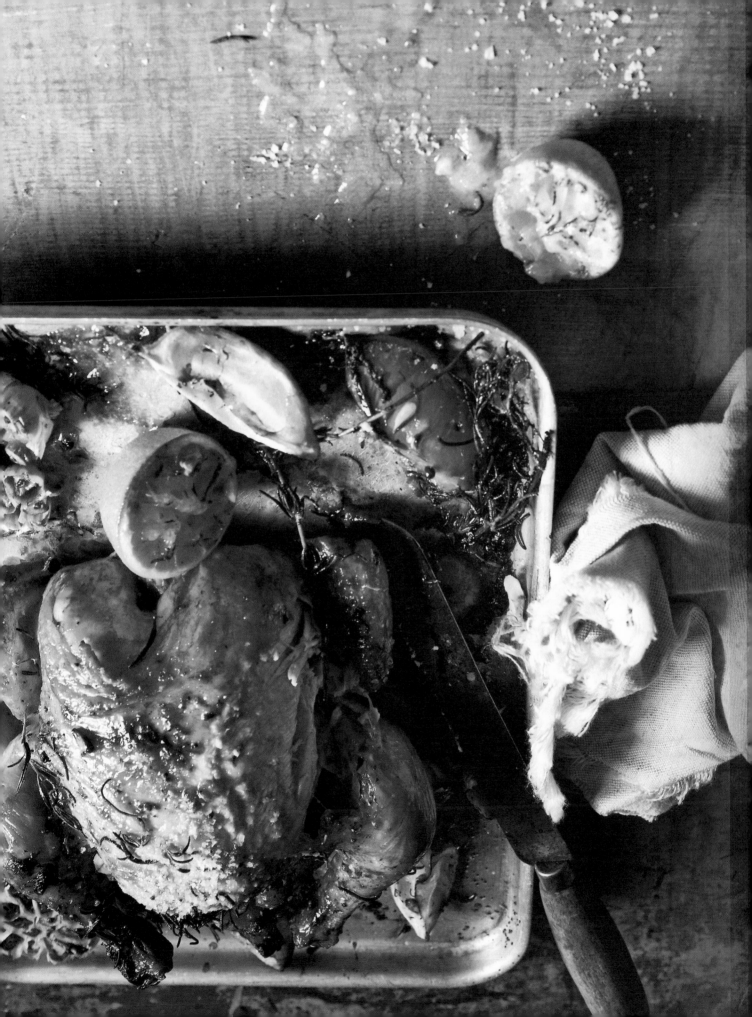

Beef and GUINNESS pie

It would be a sacrilege for any Irish person writing a cookbook not to include a recipe with a dash of 'the black stuff' in it. While I don't like Guinness as a drink myself, I do love it cooked with meat and veggies in a cosy, comforting pie. It's also great cooked in a chocolate cake – but that's a recipe for another book...

Serves 4-6

750G FREE-RANGE BRAISING OR CHUCK STEAK, CUT INTO BITE-SIZED CUBES
2 HEAPED TEASPOONS PLAIN FLOUR
2 TABLESPOONS OLIVE OIL
1 ONION, DICED
4 GARLIC CLOVES, CRUSHED
1 CARROT, DICED
2 CELERY STICKS, DICED
375ML BEEF STOCK
750ML GUINNESS
1 X 400G TIN CHOPPED TOMATOES
3 TABLESPOONS WORCESTERSHIRE SAUCE
3 TABLESPOONS BROWN SAUCE, SUCH AS HP
SMALL HANDFUL EACH ROSEMARY, THYME AND FLAT-LEAF
PARSLEY LEAVES, FINELY CHOPPED
SEA SALT AND FRESHLY GROUND BLACK PEPPER
1 SHEET GOOD-QUALITY PUFF PASTRY
1 FREE-RANGE EGG YOLK MIXED WITH A LITTLE MILK

Toss the cubed meat in the flour to lightly coat.

Heat 1 tablespoon olive oil in a large heavy-based saucepan over a medium heat. Working in batches, fry the meat on all sides until lightly browned, adding more oil to the pan as you need it. Remove and drain on kitchen paper.

Add the remaining oil to the pan, along with the onion and garlic, and cook for a few minutes until soft. Add the carrot and celery, reduce the heat to low-medium and cook for 5-6 minutes. Return the meat to the pan, then add the stock, Guinness, tinned tomato, Worcestershire sauce, brown sauce and the chopped herbs and stir to combine, using a wooden spoon to scrape off any bits stuck to the bottom of the pan. Season to taste, then bring to the boil and simmer, uncovered, over a low heat for 1 hour or until the meat is tender and the sauce has thickened, stirring occasionally and skimming off any fat that rises to the top.

Remove the pan from the heat and spoon the contents into an 18 cm diameter pot or pie dish and leave to cool completely.

Preheat the oven to 180°C (fan), 200°C, gas mark 6. Brush the outside edge of the pot or dish with water, then gently lay the sheet of pastry over the top, pinching the edges to seal (you can twist the pastry to form a decorative edge if you like). Brush the pastry generously with eggwash, transfer to the oven and cook for 30-40 minutes or until the pastry is risen and golden brown.

Serve piping hot.

ROAST PORK with apple, apricot and *pistachio* stuffing

For me, great roast pork is all about the crackling, and achieving really
good crackling comes down to a few factors. Pat the skin dry with kitchen paper
to make sure it is as dry as you can possibly get it. Score the skin
but don't cut all the way down to the flesh; stop when you start to hit the
layer of fat (some people say not to cut this far, but it works for me). Lastly,
really rub the salt into the cuts, and don't drizzle any oil over the
skin before it goes in the oven.

2 KG FREE-RANGE PORK LOIN, SKIN UNSCORED
SEA SALT
6–8 SMALL APPLES

Apple, apricot and pistachio stuffing
1 TABLESPOON OLIVE OIL
1 BROWN ONION, FINELY DICED
3 GARLIC CLOVES, CRUSHED
250 G DRIED APRICOTS, ROUGHLY CHOPPED
3 GREEN APPLES, PEELED, CORED AND GRATED
140 G SHELLED PISTACHIOS, ROUGHLY CHOPPED
HANDFUL EACH FLAT-LEAF PARSLEY, THYME AND SAGE LEAVES, FINELY CHOPPED
280 G FRESH SOURDOUGH BREADCRUMBS
50 G BUTTER, MELTED
SEA SALT AND FRESHLY GROUND BLACK PEPPER

Serves 6–8

Preheat the oven to 240°C (fan), 250°C,
gas mark 10.

To make the stuffing, heat the olive oil in
a large saucepan over a medium heat, add the
onion and garlic and cook for 5–7 minutes
or until slightly softened. Remove from
the heat and allow to cool.

Place the apricots, apple, pistachios, herbs,
breadcrumbs and melted butter in a bowl, add
the cooled onion mixture and combine. Season
well with salt and pepper.

Place the pork loin on a clean work surface,
skin-side up, and pat the skin dry with kitchen
paper. Using a very sharp, small knife, score
the skin widthways at 1 cm intervals. Take a
decent handful of sea salt and crumble it all
over the scored skin, rubbing it really well
into the cuts. Pat the salt all over the skin,
then flip the meat over so the flesh side
faces up.

Place handfuls of the stuffing on the pork
meat, pressing it down as you go and adding
as much as will fit, then gently roll up the
loin to enclose the stuffing. Secure with a
few lengths of kitchen string, then place in
a flameproof roasting tin, seam-side down,
surrounded by the small apples. If you have
one, insert a meat thermometer into the
thickest part of the pork.

Roast for 30 minutes, then reduce the oven
temperature to 180°C (fan), 200°C, gas mark
6. Roast for a further 30 minutes, then
arrange the apples around the pork in the
tin. Cook for another 30 minutes or so
until the pork is cooked through and the
apples have softened. (The pork is cooked
if the juices run clear when the thickest
part of the flesh is pierced with a skewer,
or the internal temperature registers
73°C on a meat thermometer.) Set the pork
aside for 20 minutes to rest before carving
and serving.

Katie's fish pie with CRUNCHY BACON and leek topping

This comforting pie takes a little work but is really good to serve at a dinner party, as you can get all the preparation out of the way in the morning (or even the night before), and keep the assembled pie in the fridge until you're ready to cook it. The bacon, leek and caper topping adds a nice crunch, but you can leave this out if you're pushed for time. For extra richness, serve this with some good-quality freshly grated Parmesan on the side.

500 ML MILK
1/2 TEASPOON BLACK PEPPERCORNS
2 DRIED BAY LEAVES
800 G FIRM WHITE FISH FILLETS, SKIN AND BONES REMOVED
250 G SMOKED HADDOCK FILLETS, SKIN AND BONES REMOVED
SEA SALT AND FRESHLY GROUND BLACK PEPPER
2 TABLESPOONS OLIVE OIL
1 BROWN ONION, DICED
1 LARGE LEEK, WHITE PART ONLY, TRIMMED, WASHED AND THINLY SLICED
2 CELERY STICKS, THINLY SLICED
3 SPRING ONIONS, TRIMMED AND THINLY SLICED
FEW KNOBS OF BUTTER, AT ROOM TEMPERATURE
SNIPPED CHIVES AND LEMON WEDGES, TO SERVE

Mashed potato

6-8 LARGE FLOURY POTATOES, CUT INTO LARGE CHUNKS
1 TEASPOON FINE SALT
LARGE KNOB OF BUTTER
3 TABLESPOONS MILK
3 TABLESPOONS CREAM
SEA SALT AND GROUND WHITE PEPPER

Bacon and leek topping

RAPESEED OR VEGETABLE OIL, FOR PAN-FRYING
1 SMALL LEEK, WHITE PART ONLY, TRIMMED, WASHED
 AND THINLY SLICED
2 SPRING ONIONS, TRIMMED AND THINLY SLICED
1 TABLESPOON SALTED CAPERS, RINSED
6 RASHERS FREE-RANGE BACON, FAT AND RIND REMOVED,
 VERY FINELY DICED

White sauce

300 ML CREAM
1 TEASPOON FINELY CHOPPED FLAT-LEAF PARSLEY
1 TEASPOON FINELY CHOPPED DILL
1 TEASPOON FINELY CHOPPED TARRAGON
FINELY GRATED ZEST OF 1 LEMON
PINCH FRESHLY GRATED NUTMEG
20 G BUTTER
SEA SALT AND FRESHLY GROUND BLACK PEPPER

Serves 6-8

Recipe method over page . . .

Katie's fish pie with CRUNCHY BACON and leek topping continued...

Preheat the oven to 180°C (fan), 200°C, gas mark 6.

To make the mashed potato, half-fill a large saucepan with cold water and add the potatoes and salt. Bring to the boil, then reduce the heat to medium and simmer for 20 minutes or until the potatoes are just cooked through. Drain, then add the butter, milk, cream and salt and pepper to taste. Mash well, then set aside.

Meanwhile, place the milk, peppercorns and bay leaves in a large, wide saucepan, bring to simmering point, then simmer over a low heat for 5 minutes. Add the fish fillets and simmer over a low heat for 10 minutes. Using a spoon, skim off any skin that may have formed on the milk. Remove the fish with a slotted spoon (reserving the milk mixture) and transfer to a chopping board. When the fish is cool enough to handle, flake into a bowl, season with pepper and a small pinch of salt and set aside.

Heat the olive oil in a large heavy-based saucepan, add the onion and a pinch of salt and cook over a low heat for 5 minutes until softened. Add the leek, celery and spring onions and cook for 5-6 minutes over a low heat or until all the vegetables are softened. Transfer the mixture to a 1.5 litre capacity baking dish (I use a 35 cm x 26 cm ceramic pie dish) and spread out evenly. Scatter the flaked fish over the top.

To make the white sauce, strain the reserved milk mixture through a sieve into a small saucepan, then add the cream, herbs, lemon zest, nutmeg and butter and season to taste with salt and pepper. Heat over a low heat, stirring until the butter melts, then pour the sauce evenly over the fish in the baking dish.

Take a piping bag fitted with a 2 cm nozzle and fill with the mashed potato. Pipe this over the pie filling (alternatively, spoon the mashed potato evenly over the pie filling and rough up the surface with a fork). Dot with a few knobs of butter, then transfer to the oven and bake for 45 minutes.

Meanwhile, to make the topping, pour rapeseed or vegetable oil into a small heavy-based saucepan to a depth of 2.5 cm and heat over a medium heat. Add the leek, spring onions and capers and fry for 5 minutes to crisp up. Remove with a slotted spoon and drain on kitchen paper. Reheat the oil, then add the bacon and cook until crisp. Remove and drain on kitchen paper, patting dry to remove any excess oil.

Remove the pie from the oven after 45 minutes and sprinkle over the crispy topping, then return to the oven for another 2-3 minutes. Serve with a scattering of snipped chives and some lemon wedges alongside.

Fettuccine with PRAWNS, cream and sun-dried TOMATOES

I met my husband, Mick, back in late 2000. He was living in Dublin and had become friends with a good mate of mine, Cillian. As I was single at the time, Cillian would often joke 'Ooh Katie, you'd LOVE Aussie Mick!' Long story short, I did indeed 'LOVE Aussie Mick', and after five years together we got married in a small ceremony overlooking Sydney Harbour surrounded by our close friends. One of the things I adore about Mick is his love of cooking. From the minute I met him, he was whipping up amazing meals for me in his rented house in Dublin. This is the very first dish he ever made me, and he still makes it to this day. Instead of prawns, you could use two 200 g chicken breast fillets if you like.

3 TABLESPOONS OLIVE OIL
3 GARLIC CLOVES, CRUSHED
750 G UNCOOKED KING PRAWNS, PEELED AND DEVEINED
2–3 SPRING ONIONS, TRIMMED AND FINELY SLICED
2 TABLESPOONS SHREDDED BASIL, PLUS EXTRA TO GARNISH
75 G DRAINED SUN-DRIED TOMATOES, CUT INTO STRIPS
PINCH GROUND WHITE PEPPER
250 ML CHICKEN STOCK
180 ML DRY VERMOUTH
250 ML CREAM
40 G GRATED PARMESAN, PLUS EXTRA TO GARNISH
320 G FETTUCCINE
SALT AND FRESHLY GROUND BLACK PEPPER
CRUSTY BREAD, TO SERVE

Serves 4

Heat the olive oil in a large frying pan over a low heat and sauté the garlic until softened but not coloured. Add the prawns and cook for a few minutes, stirring frequently, until the prawns are opaque. Remove the prawns from the pan and leave to cool, then chop into thirds.

Add the spring onions, basil, sun-dried tomatoes, white pepper, chicken stock, vermouth and cream to the frying pan, and cook over a medium-high heat for 20 minutes or until the sauce has reduced by about half. Stir in the Parmesan and cook for a further 1–2 minutes until melted and combined.

Return the prawns to the sauce to heat through, and keep warm.

Meanwhile, cook the fettuccine in a large saucepan of salted boiling water for 10–12 minutes or until al dente. Drain well.

To serve, add the pasta to the sauce and toss together with two forks. Garnish with extra Parmesan, basil and a grinding of black pepper, and serve with crusty bread.

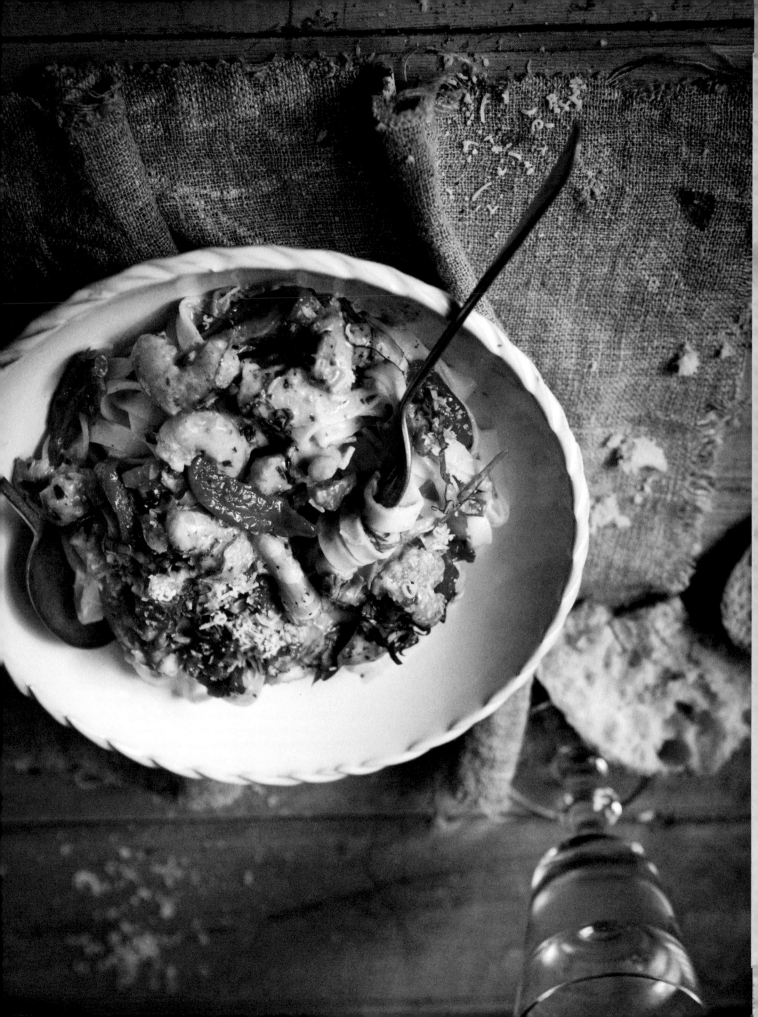

AUSSIE
chilli
burgers

I can confidently attest that these burgers are amazingly good — I've even been told by some appreciative friends that they are the best they've ever eaten (woo hoo!). I like to use a 10 cm round cutter to make uniformly shaped patties — I press the meat firmly into the cutter to mould, then remove the cutter and chill the patty as described below. You can make these the night before and keep them in the fridge until required. The fried egg is optional, but very Aussie!

6 CRUSTY BREAD ROLLS, HALVED AND LIGHTLY TOASTED
1 HEAD LETTUCE, LEAVES RINSED AND DRIED
2–3 LARGE VINE-RIPENED TOMATOES, SLICED
BALSAMIC BEETROOT RELISH (OPTIONAL, SEE PAGE 220), SPICY VINE
TOMATO RELISH (OPTIONAL, SEE PAGE 228), AND ROASTED ONION
RINGS WITH THYME (OPTIONAL, SEE PAGE 223), TO SERVE
6 FREE-RANGE EGGS, FRIED (OPTIONAL)

Beef patties
1 KG LEAN MINCED FREE-RANGE BEEF
1 LARGE ONION, FINELY DICED
1 TEASPOON DRIED CHILLI FLAKES
2 TABLESPOONS WORCESTERSHIRE SAUCE
1 TEASPOON HOT ENGLISH MUSTARD
1 TABLESPOON WHOLEGRAIN MUSTARD
1 TABLESPOON DIJON MUSTARD
SMALL HANDFUL FLAT-LEAF PARSLEY LEAVES, FINELY CHOPPED
SEA SALT AND FRESHLY GROUND BLACK PEPPER

To make the beef patties, place all the ingredients in a large bowl and combine thoroughly using clean hands. Form the mixture into six burger patties, placing them on a plate lined with kitchen paper as you go. Cover with cling film and chill until required.

Preheat a barbecue or chargrill pan and cook the patties until browned on the outside and cooked to your liking — I prefer them medium-rare.

Serve on lightly toasted bread buns with lettuce and tomatoes, and add beetroot relish, tomato relish and onion rings (if using). If you like, finish with a fried egg.

serves 6

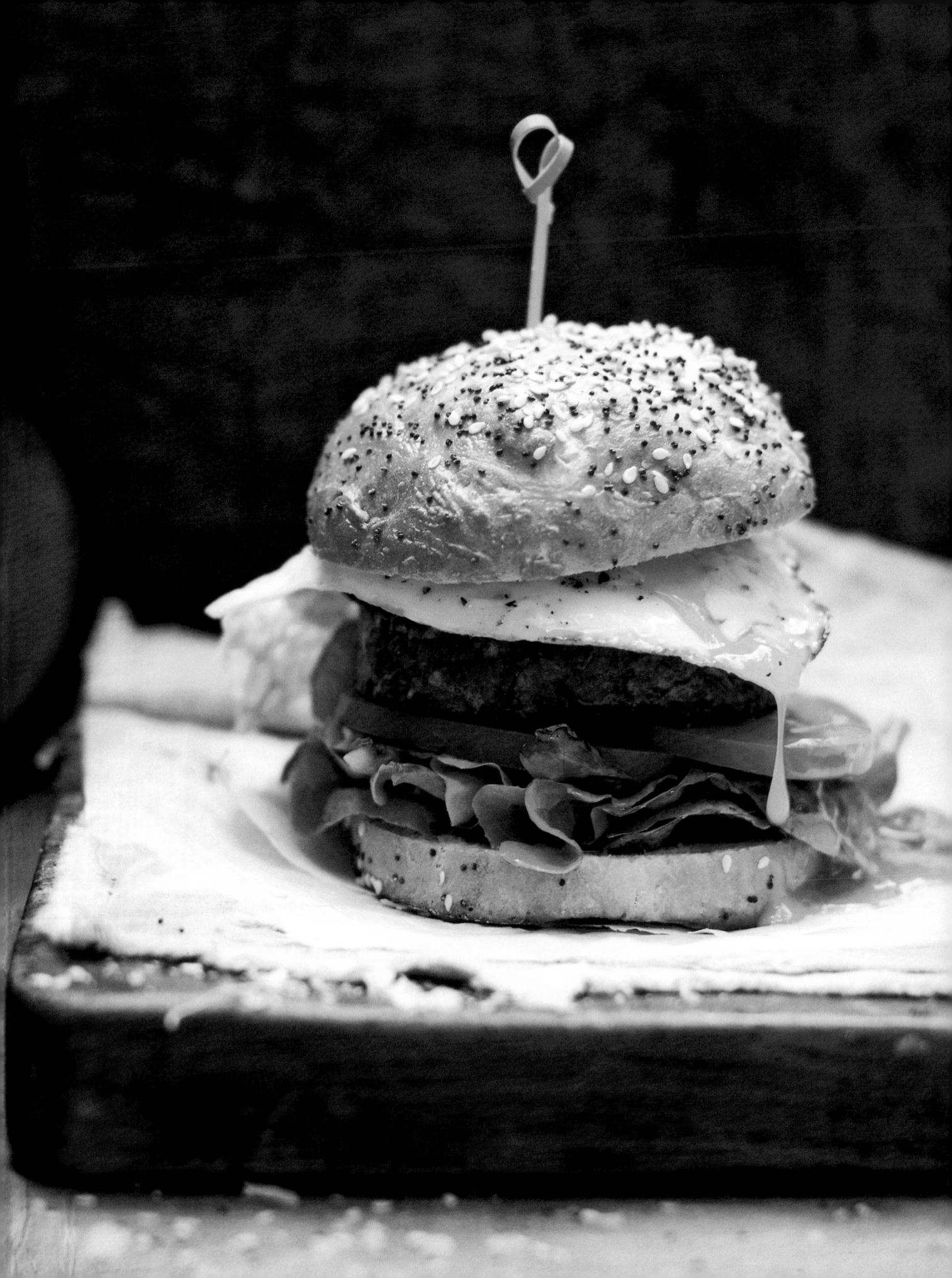

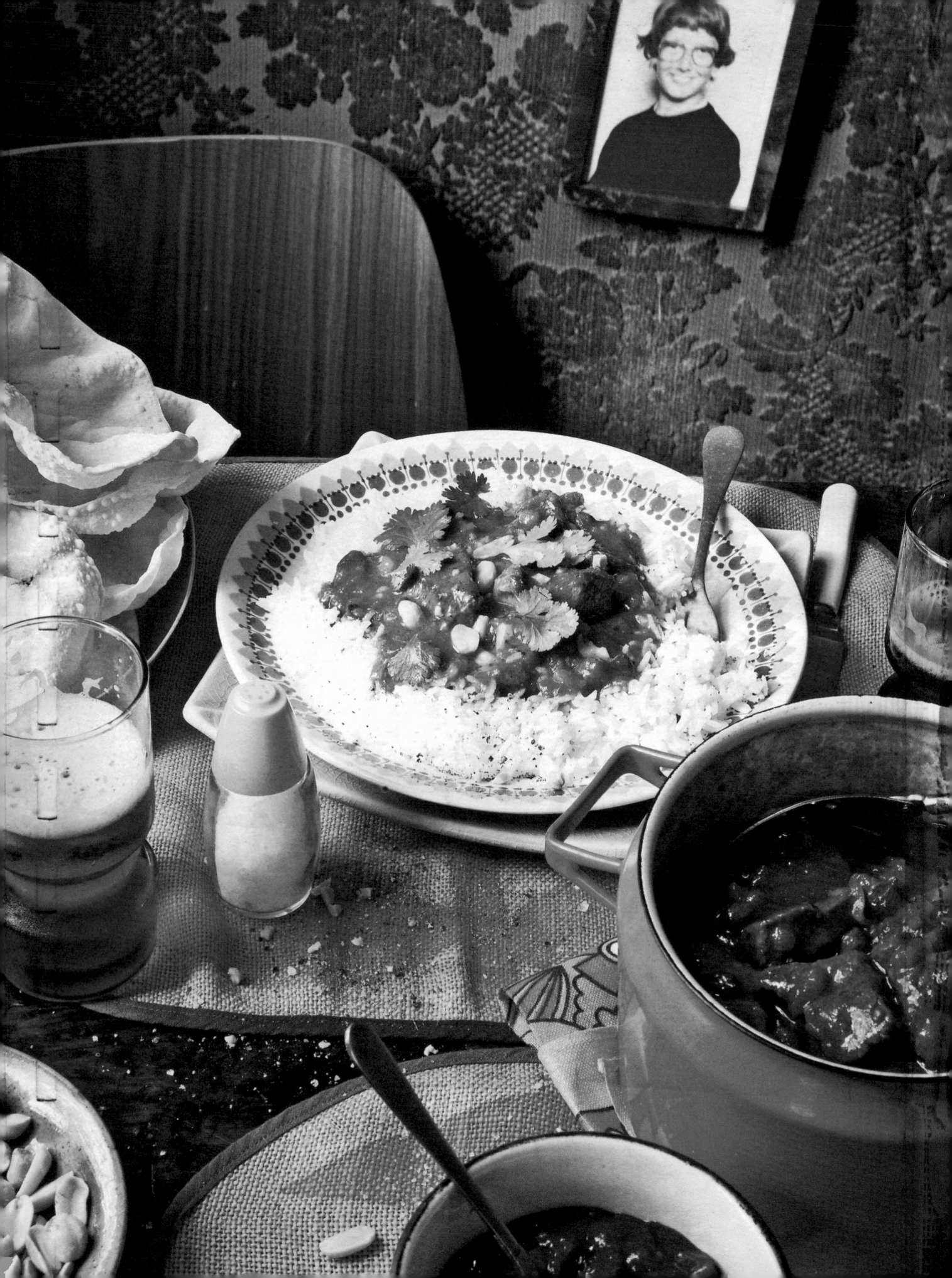

My mother-in-law, Sheila Davies, is a wonderful
woman and I love her to bits. Both she and my
father-in-law, Bob, have welcomed me into their
home and family with open arms. Mick and I often
go to stay with them in Mt Martha, a gorgeous
little seaside spot about 1 hour's drive south of
Melbourne. It's particularly cosy in the winter
months when, on our arrival, they'll have an
amazing home-cooked meal waiting for us, along
with numerous bottles of great Aussie red and
a roaring fire. This curry is one of Sheila's
all-time favourites.

Sheila's retro beef curry {CIRCA 1974}

OLIVE OIL, FOR COOKING
500 G FREE-RANGE CHUCK STEAK, CUT INTO CUBES
3 ONIONS, FINELY DICED
1 COOKING APPLE, PEELED, CORED AND FINELY DICED
1 TABLESPOON CURRY POWDER
$2^{1}/_{2}$ TABLESPOONS PLAIN FLOUR
625 ML BEEF STOCK
SEA SALT AND FRESHLY GROUND BLACK PEPPER
$1^{1}/_{2}$ TABLESPOONS FRUIT CHUTNEY, PLUS EXTRA TO SERVE
55 G SULTANAS
1 x 400 G TIN CHOPPED TOMATOES
$^{1}/_{2}$ LEMON
400 G BASMATI RICE,
RINSED WELL UNDER COLD RUNNING WATER, THEN DRAINED
BOILING WATER, TO COVER
2 BANANAS, SLICED (OPTIONAL)
70 G ROASTED PEANUTS
SMALL HANDFUL CORIANDER LEAVES
PAPPADUMS OR NAAN BREAD AND NATURAL YOGHURT, TO SERVE

Serves 4

Recipe method over page . . .

Sheila's *retro beef curry*
{CIRCA 1974} *continued...*

Preheat the oven to 180°C (fan), 200°C, gas mark 6.

Heat 1½ tablespoons olive oil in a large heavy-based
frying pan over a medium heat, add half the beef and cook
for 6-8 minutes until browned all over. Remove and drain
on kichen paper. Heat another 1½ tablespoons olive oil in
the pan and repeat with the remaining beef. Transfer the
drained meat to a casserole dish.

Heat 1 tablespoon olive oil in the frying pan, add two-
thirds of the onion and all the apple and cook for 5 minutes
or until slightly softened. Add to the meat.

Sprinkle the curry powder into the frying pan and fry
for 4-5 minutes (add a little extra olive oil, if needed).
Sprinkle in the flour and cook for a further 2-3 minutes.
Gradually add the beef stock, stirring constantly to avoid
any lumps, then bring to the boil and cook for 2-3 minutes.
Season with salt and pepper, add the chutney, sultanas,
tinned tomato and a squeeze of lemon juice, then pour over
the meat. Cover and bake for 1½ hours or until the meat is
tender and the gravy has thickened slightly.

Meanwhile, heat 1 tablespoon olive oil in a medium-sized
saucepan over a medium heat, add the remaining onion and
saute for 5 minutes until soft. Add the rice and stir to
coat, then season well with salt and pepper. Fry for 1
minute, stirring often, then pour in enough boiling water
to cover the rice by about 2 cm. Turn the heat down to very
low, cover with a tight-fitting lid and leave to cook for
10 minutes (do not stir the rice at all), then turn off
the heat and leave the pan to stand, covered, for 5 minutes.
Check the rice is cooked to your liking – if it needs more
time, cover the pan again and leave for a further 5 minutes
(you may need to add a splash of boiling water if it is too
dry). Once cooked, fluff the rice up with a fork.

Serve the curry on a bed of rice, topped with sliced banana,
if using, peanuts and coriander. Accompany with extra chutney
and crispy pappadums or naan bread and natural yoghurt.

39633

Pumpkin ravioli with *brown-butter* SAUCE *and roasted pecans*

Making your own pasta takes a little effort and elbow grease, but the results are always well worth it. Pasta machines are readily available and very reasonably priced, and once you start making fresh pasta, you'll be hooked!

This is my favourite flavour combination when it comes to ravioli: sweet roasted pumpkin paired with lots of fresh sage and served with a rich, nutty butter sauce. This is a superb dish to serve at a dinner party. You can make the filling the night before, then store it in the fridge, covered, until required. You can even assemble the ravioli an hour or two before you want to cook them — just keep them on a flour-dusted tray and sprinkle a good amount of flour on top to prevent them becoming sticky.

600 G '00' FLOUR, PLUS EXTRA FOR DUSTING
6 FREE-RANGE EGGS
RAPESEED OR VEGETABLE OIL, FOR DEEP-FRYING
LARGE HANDFUL SAGE LEAVES
SEMOLINA, FOR DUSTING
SALT
250 G BUTTER

Pumpkin filling
60 G PECANS
500 G PUMPKIN, PEELED, DESEEDED AND CUT INTO SMALL WEDGES
4 GARLIC CLOVES, UNPEELED
OLIVE OIL, FOR DRIZZLING
SEA SALT AND FRESHLY GROUND BLACK PEPPER
8–10 SAGE LEAVES
150 G SOFT GOAT'S CHEESE
1 SLICE WHITE BREAD, WHIZZED IN A FOOD PROCESSOR
 TO MAKE BREADCRUMBS
1 FREE-RANGE EGG
1/2 TEASPOON FRESHLY GRATED NUTMEG
50 G PECORINO, GRATED

makes approximately 20 ravioli (serves 4–6)

Recipe method over page . . .

Pumpkin ravioli with *brown-butter* SAUCE and *roasted pecans continued...*

Preheat the oven to 180°C (fan), 200°C, gas mark 6.

To make the filling, scatter the pecans on a baking tray and roast for
10 minutes, tossing halfway through, then set aside.

Meanwhile, place the pumpkin and garlic on a baking tray. Drizzle with olive
oil and sprinkle with salt and pepper, then scatter the sage leaves on top.
Roast for 35-40 minutes until the pumpkin is soft. When cool enough to
handle, peel the pumpkin and place the flesh in the bowl of a food processor.
Squeeze the roasted garlic pulp from the cloves and add to the bowl, along
with the goat's cheese, half the roasted pecans (reserving the rest to
garnish), the breadcrumbs, egg, nutmeg, pecorino and salt and pepper to taste.
Whizz together until smooth, then transfer to a bowl, cover and refrigerate
until needed.

Sift the flour onto a large clean work surface and make a well in the centre.
Crack the eggs into the well, then lightly whisk them with a fork just to break
the yolks. Using your hands, incorporate the eggs into the flour to form a
dough. Knead for 10 minutes or so, then cut the dough into four equal portions
and wrap in cling film. Chill in the fridge for 15-20 minutes.

Quarter-fill a small saucepan with rapeseed or vegetable oil and heat over a
medium heat. Deep-fry the sage leaves in small batches for 1 minute or until
crisp (take care as the leaves will spit when added to the hot oil). Remove
with a slotted spoon and drain on kitchen paper.

Working with one portion of dough at a time and keeping the rest covered,
divide the dough in half. Roll each piece through a pasta machine, starting
at the thickest setting and working your way through to the thinnest until you
have two silky sheets of dough, keeping them dusted in flour to prevent them
sticking. Lay each piece on a semolina-dusted work surface and cover with a
clean tea towel, then repeat with the remaining portions of dough until you
have eight sheets of pasta.

Take one sheet of pasta and cut into 10 cm squares. Place small teaspoonfuls
of the pumpkin filling on half the squares, then brush water around the
edges of the filling. Place another square of pasta on top then, using the rim
of a glass about 7 cm in diameter, press down lightly to seal in the filling
and remove any air pockets. Using a round pastry cutter just slightly larger
than the glass (I use a 7.5 cm fluted cookie cutter), cut out each raviolo
and dust with flour. Repeat with the other pasta sheets until you have twenty
ravioli (you should have used all the pasta and half the filling — freeze
the remaining filling in an airtight container for another time) and place
them on a semolina-dusted tray until ready to cook.

Bring a large saucepan of water to the boil and add 1 teaspoon salt and a good
glug of oil. Cook the ravioli for 5-6 minutes or until tender.

Meanwhile, melt the butter in a small saucepan over a low heat and cook until
a light nutty brown colour.

Divide the ravioli among serving plates, then serve topped with the remaining
roasted pecans, fried sage leaves and a spoonful or two of the butter sauce.

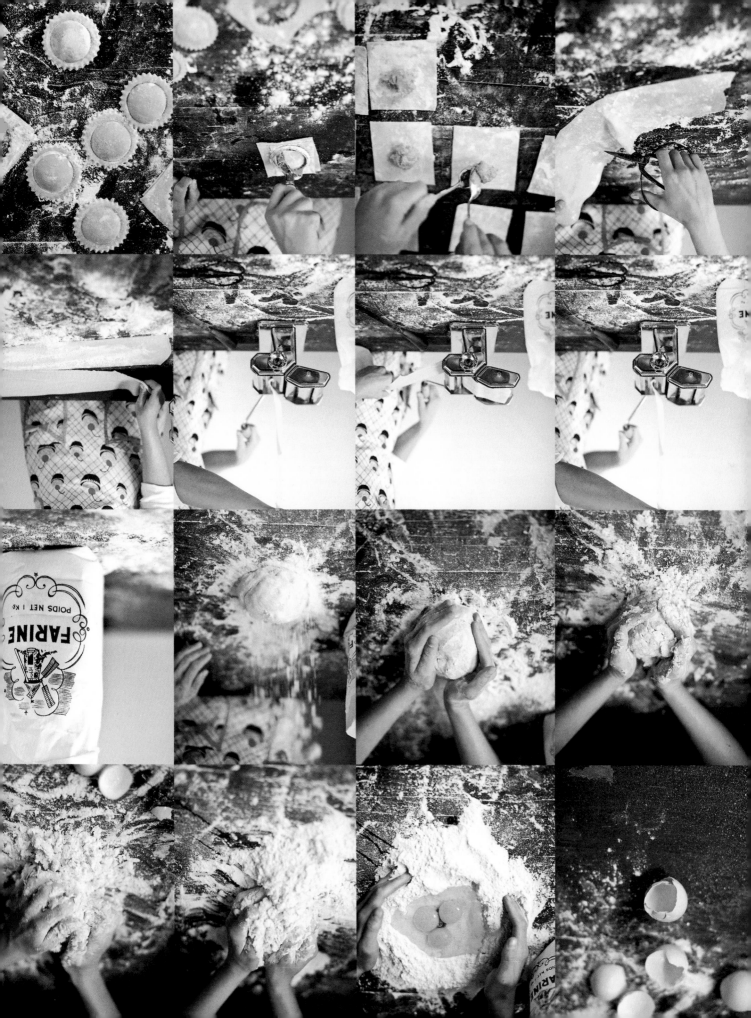

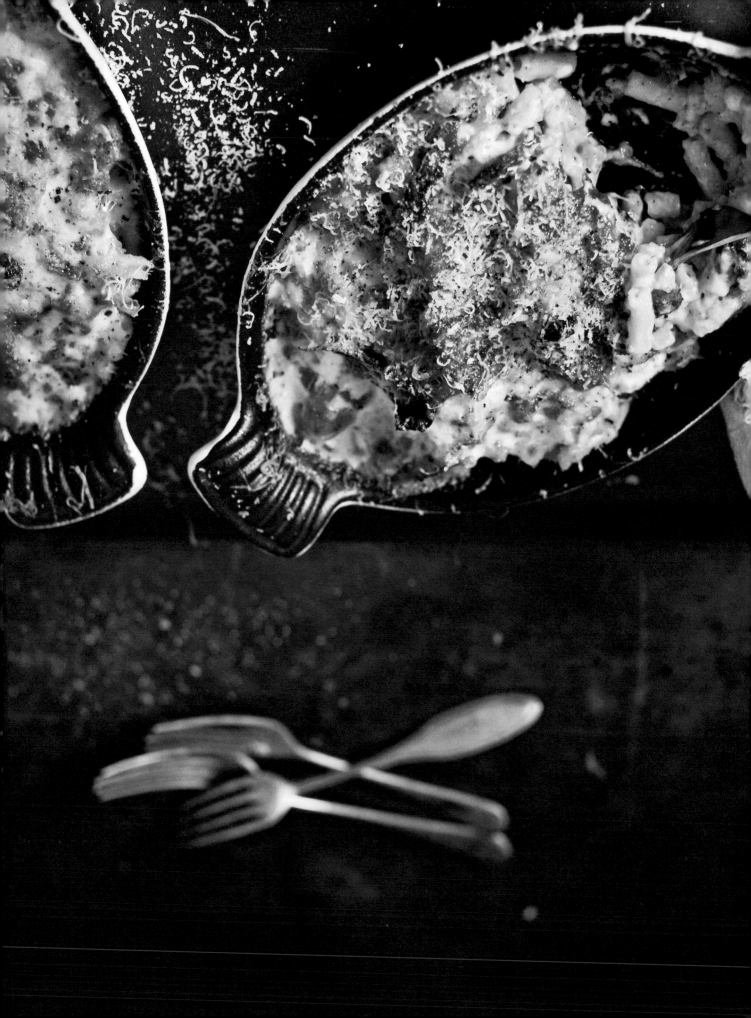

Creamy macaroni bake
with salami and chilli

This is a fantastic weeknight dinner option, especially in the winter months when you're craving some warming comfort food. Don't be shy when scattering the grated cheese on top just before baking — plenty of cheese gives a fantastic, golden, chewy topping. Yum!

1 PUNNET (250 G) CHERRY TOMATOES, CUT IN HALF
OLIVE OIL, FOR COOKING
SEA SALT AND FRESHLY GROUND BLACK PEPPER
500 G MACARONI
250 G SALAMI, CUT INTO BITE-SIZED PIECES
60 G BUTTER
50 G PLAIN FLOUR
1 LITRE MILK
LARGE HANDFUL GRATED PARMESAN, PLUS EXTRA FOR TOPPING AND TO SERVE
LARGE HANDFUL GRATED PECORINO, PLUS EXTRA FOR TOPPING
LARGE PINCH FRESHLY GRATED NUTMEG
$\frac{1}{2}$–1 TEASPOON DRIED CHILLI FLAKES (TO TASTE)
3 TABLESPOONS CREAM
1 TEASPOON WHITE TRUFFLE OIL (OPTIONAL)
80 ML WHITE WINE
HANDFUL BASIL LEAVES, TORN
CRUSTY BREAD ROLLS AND A GREEN SALAD, TO SERVE

Serves 6

Preheat the oven to 160°C (fan), 180°C, gas mark 4.

Place the cherry tomatoes on a baking tray, cut-side up. Drizzle with a little olive oil and season with salt and pepper, then roast for 30–40 minutes. Remove from the oven and set aside, then increase the oven temperature to 180°C (fan), 200°C, gas mark 6.

Half-fill a large saucepan with salted water, add a glug of olive oil and bring to a rolling boil over a high heat. Add the macaroni and cook for 8 minutes until just al dente (the pasta will continue to cook in the oven, so you don't want to overcook it at this stage). Drain and rinse under cold water, then transfer to a large heavy-based casserole dish (or four small ovenproof dishes). Add another glug of olive oil and stir to coat the macaroni evenly, then add the salami and roast tomatoes. Stir again and season with a little salt and lots of pepper, then set aside.

Melt the butter in a medium-sized saucepan over a medium heat. Add the flour and whisk until smooth, then cook for 2 minutes, stirring constantly with a wooden spoon. Reduce the heat a little, then gradually add the milk, stirring constantly until the sauce has thickened and is smooth and creamy. Remove the pan from the heat. Add the Parmesan, pecorino, nutmeg, dried chilli flakes, cream and truffle oil, if using, and season with a little more pepper. Mix together well, then pour over the macaroni mixture in the casserole dish. Toss together well, along with the white wine, and toss to coat well. Stir through the basil leaves, then scatter a generous amount of extra Parmesan and pecorino over the top.

Bake for 30–40 minutes until bubbling, golden brown and crispy (if you like, place the dish/es under a hot grill for a minute or two to get an even crispier topping).

Serve piping hot with extra grated Parmesan, crusty rolls and a green salad on the side.

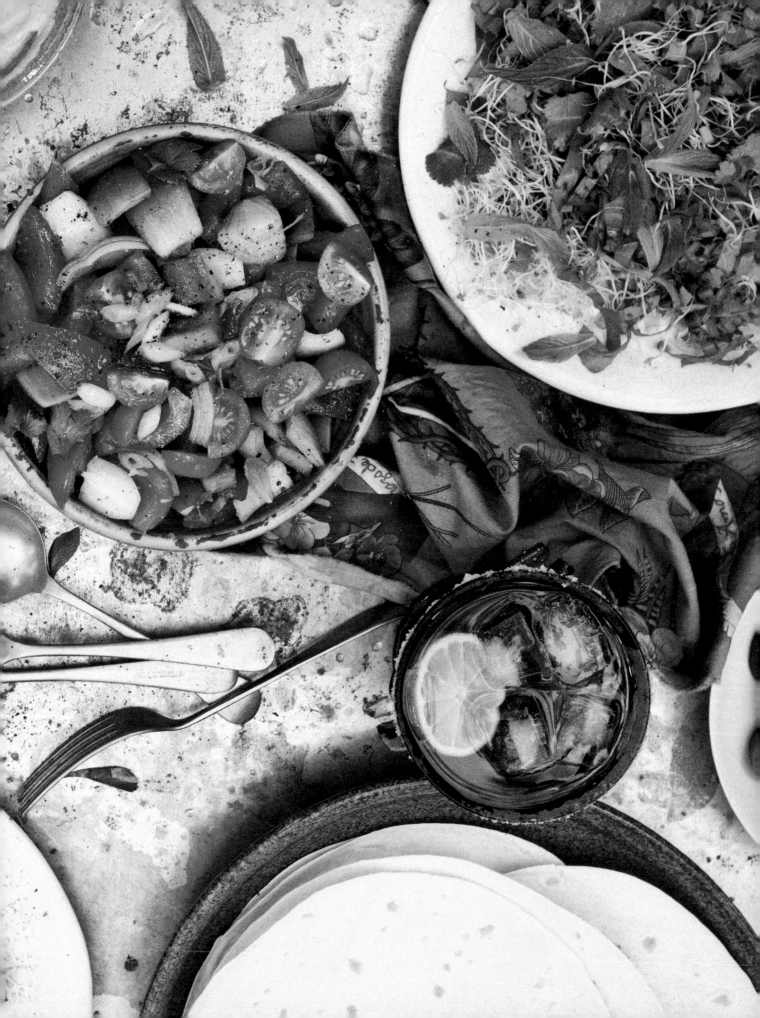

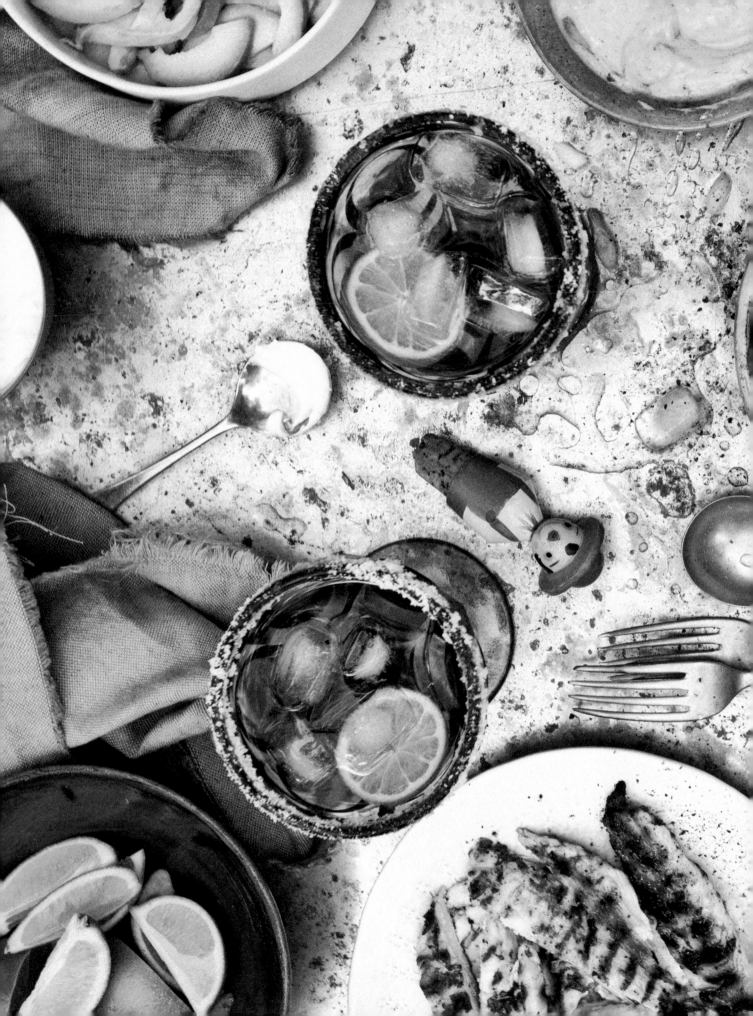

GOURMET Chicken Wraps
with *Chipotle Mayo,*
CHUNKY SALSA
and *Salad*

I adore the desert regions of the US southwest, and this recipe was inspired by the time I spent there in 2011. I particularly love the Mexican-style food of New Mexico, and this recipe (pictured on the previous page) is my take on those exhilarating flavours.

Here in Australia, tinned chipotle peppers can be found in most gourmet food stores. If you can't get the whole peppers, you're sure to find chipotle sauce which you can use instead. Sliced jalapeños in jars are available in most supermarkets.

2 x 200 G FREE-RANGE CHICKEN BREAST FILLETS
FINELY GRATED ZEST AND JUICE OF 2 LIMES,
 PLUS EXTRA LIME WEDGES, TO SERVE
1 LARGE GARLIC CLOVE, CRUSHED
1 TABLESPOON OLIVE OIL
LARGE HANDFUL MINT LEAVES, ROUGHLY CHOPPED
SEA SALT AND FRESHLY GROUND BLACK PEPPER
LARGE HANDFUL ALFALFA SPROUTS
LARGE HANDFUL ROCKET LEAVES, CUT INTO THIN STRIPS
HANDFUL CORIANDER LEAVES
8 TORTILLA WRAPS, SLIGHTLY WARMED
2 AVOCADOS, HALVED, DESEEDED AND SLICED

Chipotle mayo

1 FREE-RANGE EGG YOLK
1 TABLESPOON LEMON JUICE
SEA SALT AND FRESHLY GROUND BLACK PEPPER
250 ML LIGHT OLIVE OIL
2–3 TINNED CHIPOTLE CHILLIES, VERY FINELY CHOPPED
2 TEASPOONS SLICED PICKLED JALAPEÑO CHILLIES,
 VERY FINELY CHOPPED

Chunky salsa

4 VINE-RIPENED TOMATOES, HALVED LENGTHWAYS, SEEDS
 SCOOPED OUT, THEN HALVES CUT INTO FOUR WEDGES
1 RED ONION, HALVED LENGTHWAYS, THEN HALVES CUT
 INTO FOUR WEDGES
1 GREEN PEPPER, TRIMMED, DESEEDED AND CHOPPED
 INTO LARGE CHUNKS
SEA SALT AND FRESHLY GROUND BLACK PEPPER
1$\frac{1}{2}$ TABLESPOONS SHERRY VINEGAR
2 TABLESPOONS EXTRA VIRGIN OLIVE OIL

You can make the chipotle mayo with a hand-held blender or by hand. If using a blender, place all the ingredients in a jug and process until the mixture is thick and silky. Cover and chill in the fridge until required.

If making the mayo by hand, place a mixing bowl on a clean tea towel (this will hold the bowl in place). Add the egg yolk, lemon juice, salt and black pepper and whisk together thoroughly. Drizzle in the olive oil in a very thin, steady stream, whisking constantly until all the oil has been incorporated and the mayo is thick and glossy. Check the seasoning, then stir in the chopped chipotle and jalapeño chillies. Cover and chill in the fridge until required.

Place the chicken breast on a piece of cling film spread over a work surface. Cover the chicken with another piece of cling film then, using a rolling pin or meat mallet, gently pound to a thickness of about 1 cm. Trim off any straggly bits to neaten, and remove any fat. Discard the cling film and place the chicken in a shallow ceramic dish.

Combine the lime zest, lime juice, garlic, olive oil, half of the mint and salt and pepper in a small bowl and whisk together. Pour the marinade over the chicken, then cover with cling film and chill in the fridge for 30 minutes-1 hour.

To make the salsa, place the tomatoes, onion and green pepper in a bowl, season with salt and pepper and drizzle with the sherry vinegar and extra virgin olive oil. Toss gently to coat.

Warm a chargrill pan over a medium heat, add the chicken and marinade and cook for 5-7 minutes. Turn the chicken over, then cook for a further 5-7 minutes until the marinade is bubbling and the chicken is cooked through but still tender. Remove and cut the chicken into strips.

While the chicken is cooking, combine the alfalfa, rocket, remaining mint and the coriander in a bowl.

To assemble, divide the warmed tortillas among plates and arrange a strip of salad three-quarters of the way down the tortilla. Top with a tablespoon or two of salsa, some chicken strips, a slice or two of avocado and finally the chipotle mayo. Fold the bottom of the tortilla over the filling, then fold the left side over and finally the right side to create a tortilla pocket. Serve immediately with lime wedges.

Serves 4

Shepherd's pie was a staple in my mum's kitchen; we must have eaten it once a week. For me, it's comfort food 101. A lot of people like to put diced carrot in their shepherd's pie, but my mum didn't, and I've carried on that tradition. In this version, I've added sweet, flavoursome roasted garlic and Parmesan to the mash; feel free to add a decent handful of good-quality bitey mature Cheddar to the mash as well to make it even more rich and delicious.

Shepherd's pie with roasted garlic and CHEESY mash topping

Serves 4

1 TABLESPOON OLIVE OR RAPESEED OIL
1 BROWN ONION, FINELY DICED
3 LARGE GARLIC CLOVES, CRUSHED
600 G LEAN MINCED FREE-RANGE BEEF
500 ML BEEF OR CHICKEN STOCK
1½ TABLESPOONS TOMATO PURÉE
80 ML WORCESTERSHIRE SAUCE
3 TABLESPOONS BROWN SAUCE, SUCH AS HP
3 TABLESPOONS BARBECUE SAUCE
½ TEASPOON FRESHLY GRATED NUTMEG
4 THYME SPRIGS, LEAVES PICKED, PLUS EXTRA
 SPRIGS TO GARNISH
SEA SALT AND FRESHLY GROUND BLACK PEPPER

Roasted garlic and cheesy mash topping
3 LARGE GARLIC CLOVES, UNPEELED
SEA SALT AND GROUND WHITE PEPPER
5 LARGE FLOURY POTATOES, PEELED AND CUT IN HALF
80 ML MILK
2 TABLESPOONS GREEK-STYLE YOGHURT
50 G PARMESAN, FINELY GRATED, PLUS EXTRA
 FOR SPRINKLING

To make the topping, preheat the oven to 180°C (fan), 200°C, gas mark 6. Place the three whole garlic cloves on a baking tray and roast for 30 minutes or until soft. Remove and allow to cool, then squeeze out the soft flesh and discard the papery skin.

While the garlic is roasting, half-fill a large saucepan with cold water, season with a good pinch of salt, then add the potatoes. Bring to the boil over a high heat, then reduce the heat to medium-high and cook at a rolling simmer until the potatoes are cooked through and soft in the middle when pierced with a knife. This is important if you want a really creamy mash — if they are even slightly firm in the middle you'll never get smooth mash, as there will be tiny lumps dotted throughout.

Drain the potatoes, then tip them back into the pan and break up with a potato masher. Pass the potato through a fine-meshed sieve or the finest setting on a potato ricer until completely smooth. Add the milk, yoghurt, Parmesan and cooled roasted garlic with salt and pepper, then transfer to a large piping bag fitted with a star-shaped nozzle (the one I use measures 1 cm) and set aside until required.

Meanwhile, heat the oil in a large, deep frying pan or saucepan over a medium heat. Add the onion and fry for 5 minutes, then add the garlic and cook for a further 5–7 minutes. Add the minced beef and stir well, breaking up any lumps with the back of a wooden spoon. Cook until the beef is nicely browned, then add the stock, tomato purée, Worcestershire sauce, brown sauce, barbecue sauce, nutmeg and thyme leaves and stir everything together. Season with salt and pepper and cook for 30–40 minutes, stirring occasionally, until the sauce has thickened. Spoon the mixture into one large 1.5 litre capacity ovenproof baking dish.

Pipe the mashed potato over the filling and sprinkle with extra Parmesan and pepper. Bake for 40–50 minutes or until the potato is golden brown. Sprinkle over a little more Parmesan, if liked, scatter over extra thyme

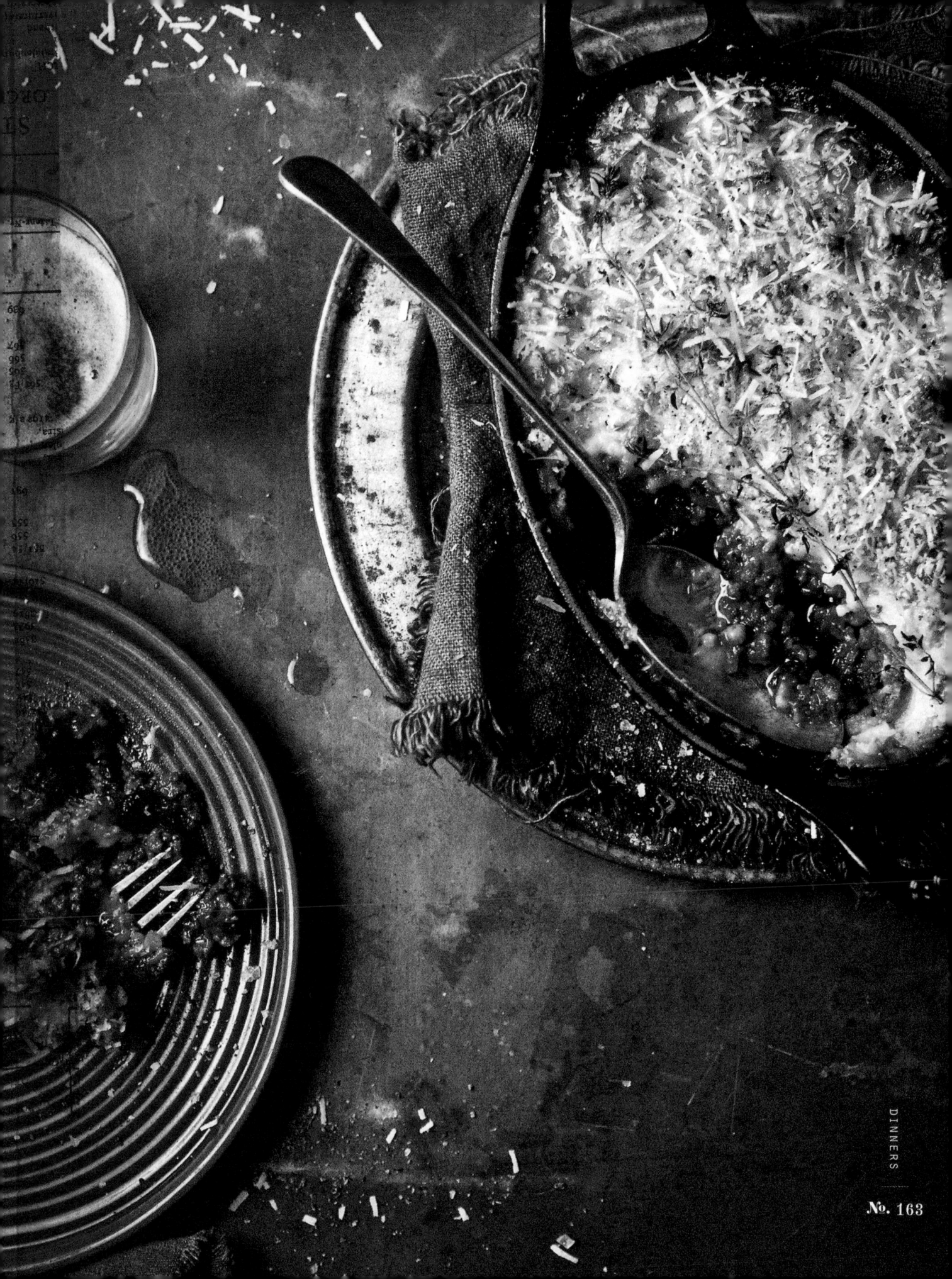

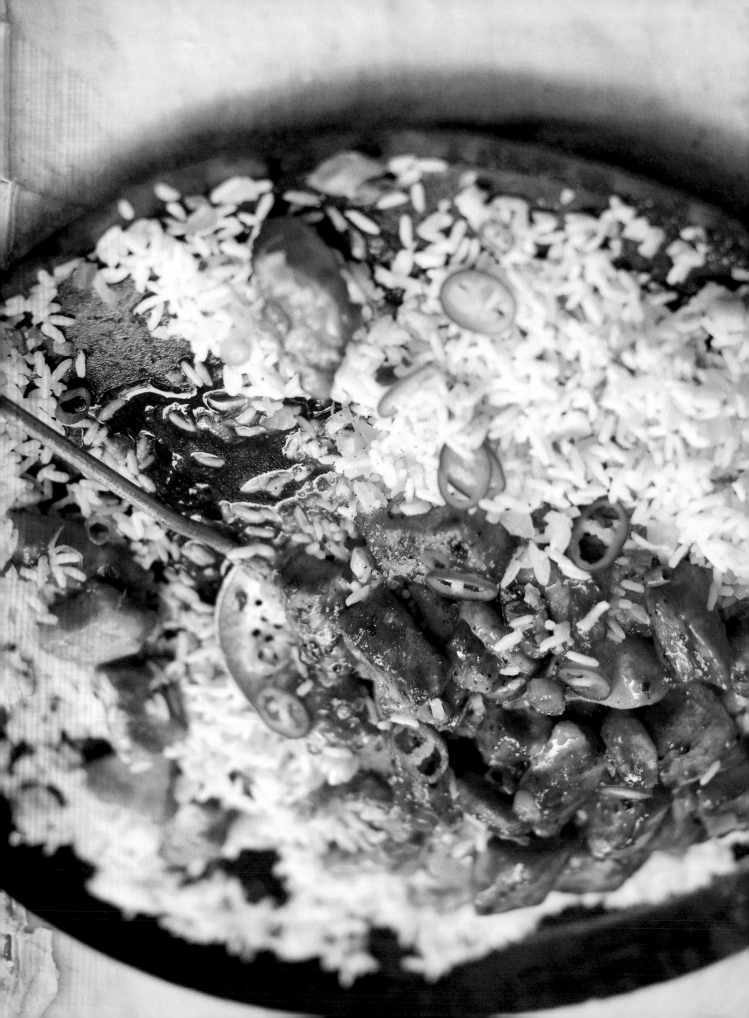

150 G PLAIN FLOUR, SIFTED
3 TABLESPOONS SMOKED PAPRIKA
SEA SALT AND FRESHLY GROUND BLACK PEPPER
2 X 200 G FREE-RANGE CHICKEN BREAST FILLETS, CUT INTO BITE-SIZED PIECES
50 G BUTTER, MELTED
GREEN CHILLI SLICES, TO GARNISH (OPTIONAL)

Lemon sauce

80 ML SOY SAUCE
180 ML LEMON JUICE
125 ML ITALIAN SALAD DRESSING
FINELY GRATED ZEST OF 1 LEMON
2 LARGE GARLIC CLOVES, CRUSHED
SEA SALT AND FRESHLY GROUND BLACK PEPPER

Herbed rice

1 TABLESPOON OLIVE OIL
1 SMALL BROWN ONION, FINELY DICED
400 G BASMATI RICE, RINSED UNDER COLD RUNNING WATER,
 THEN DRAINED
2 SPRING ONIONS, TRIMMED AND VERY THINLY SLICED
SMALL HANDFUL FLAT-LEAF PARSLEY LEAVES, FINELY CHOPPED
SEA SALT AND FRESHLY GROUND BLACK PEPPER

Lemon CHICKEN with Herbed Rice

This is great for a weeknight dinner in winter, as it's pretty simple to make, and you'll find that most of the ingredients will already be in your store cupboard. It also features a shop-bought salad dressing as the base for the sauce, giving a fresh tanginess to the dish, and providing an ingenious shortcut for when you haven't got that much time to get dinner ready.

Serves 2

Preheat the oven to 200°C (fan), 220°C, gas mark 7.

To make the lemon sauce, combine all the ingredients with a pinch of salt and pepper in a jug and chill in the fridge for 30 minutes.

Mix together the flour, paprika, salt and pepper in a bowl. Toss the chicken pieces in the seasoned flour, then place in a shallow casserole dish. Brush each piece generously with melted butter, then bake for 30 minutes. Turn the chicken pieces over and pour the chilled sauce evenly over the top, then reduce the oven temperature to 180°C (fan), 200°C, gas mark 6 and bake for a further 30 minutes or until the chicken is cooked through but still tender.

Meanwhile, to prepare the herbed rice, heat the olive oil in a medium-sized saucepan over a medium heat, add the onion and sauté for 5 minutes until soft. Add the rice and stir to coat. Cook for 1 minute, stirring often, then pour in enough boiling water to cover the rice by about 2 cm. Turn the heat down to very low, cover with a tight-fitting lid and leave to cook for 10-12 minutes (do not stir the rice at all), then turn off the heat and leave the pan to stand, covered, for 10 minutes. Once cooked, fluff the rice up with a fork. Add the spring onions and parsley and season generously with salt and pepper.

Spoon the rice onto serving plates, then top with the chicken and any juices, scatter with chilli, if using, and serve immediately.

The key to making a great risotto is to never let the rice dry out: keep stirring and adding warmed stock as you go. Many people think you can't serve risotto for a dinner party as you'll be stuck at the hob stirring, but you can actually part-cook the risotto in advance, using about two-thirds of the stock (then remove the risotto from the heat, cover and set aside, making sure it's got plenty of liquid in it to prevent it drying out). Just before you're ready to serve, return the pan to the heat, stir in the last few spoonfuls of stock and add the mushrooms and cavolo nero.

MUSHROOM and Bacon risotto
with Poached EGG

1.25 LITRES CHICKEN STOCK
2 TABLESPOONS OLIVE OIL
200 G CHESTNUT MUSHROOMS, CLEANED AND QUARTERED
SEA SALT AND FRESHLY GROUND BLACK PEPPER
55 G BUTTER
250 G FREE-RANGE BACON, FAT AND RIND REMOVED, FINELY DICED
1 ONION, FINELY CHOPPED
300 G ARBORIO RICE
100 ML WHITE WINE
1/2 BUNCH CAVOLO NERO, STALKS REMOVED, LEAVES WASHED AND CUT INTO THIN STRIPS
3-4 THYME SPRIGS, LEAVES PICKED
150 G PARMESAN, 100 G GRATED, 50 G SHAVED
4 LARGE FREE-RANGE EGGS
1 TABLESPOON WHITE VINEGAR

Serves 4

Pour the chicken stock into a large saucepan and bring to a simmer. Reduce the heat to very low, then cover and keep the stock warm until needed.

Heat 1 tablespoon olive oil in a large heavy-based saucepan or flameproof casserole dish, add the mushrooms and season with a little salt. Cook over a medium heat for 5 minutes, stirring frequently. Add about a teaspoon of butter, let it melt, then toss the mushrooms in the butter to coat, before removing them from the pan and setting them aside.

Heat the remaining olive oil in the same pan, add the bacon and fry over a medium heat for 5 minutes until almost cooked through and slightly crispy. Add the onion and remaining butter and cook for 5-10 minutes or until the onion has softened. Add the rice and stir to coat well with the bacon and onion mixture. Pour in the wine and simmer, stirring, until the liquid has reduced a little.

Add a ladleful of warm stock to the rice and cook, stirring, until it has been completely absorbed. Continue adding the stock in this way until there is only one ladleful of stock

Add the mushrooms, cavolo nero, thyme leaves and finally, the remaining stock. Stir to combine and season to taste with salt and pepper. By now, the risotto should have a lovely creamy consistency. When the last of the stock has been absorbed, stir in the grated Parmesan, then cover and keep warm while you poach the eggs.

Crack one egg into a shallow cup. Fill a medium-sized saucepan with cold water, place over a medium heat and bring to the boil, then reduce the heat so the water is just simmering. Add the white vinegar to the water. Using the handle of a wooden spoon, stir the water in the centre quickly to create a mini vortex, then gently tip in the egg. Once the egg starts to take shape, nudge it over to one side with a slotted spoon. Swirl a little vortex in the water to the left or right of the first egg and drop in a second egg. Repeat with the remaining eggs and cook for 2-3 minutes or until the whites are cooked, then remove the eggs with a slotted spoon and drain on kitchen paper.

To serve, spoon the risotto into bowls, top with a poached egg and finish with a scattering

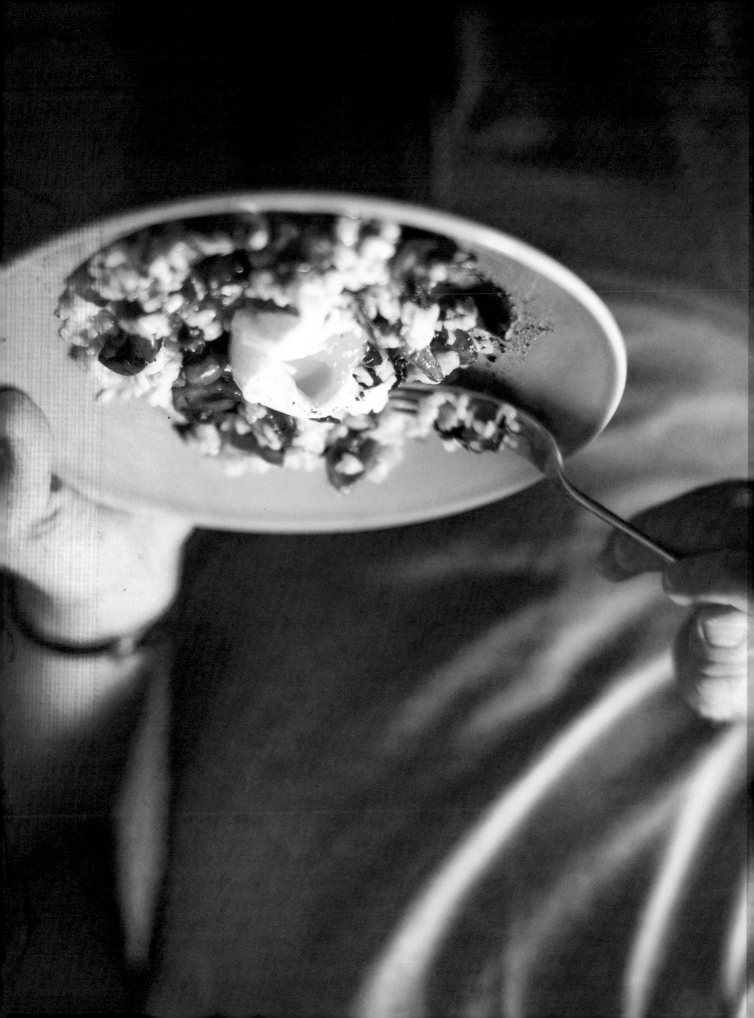

Barbecued *ginger ale* pork RIBS

Serves 4-6

Sticky and sweet and chewy and crumbly and saucy and spicy. Enough said
really, other than be prepared to make quadruple the quantity...

1 KG FREE-RANGE PORK BABY BACK RIBS
SEA SALT AND FRESHLY GROUND BLACK PEPPER
2 TABLESPOONS BALSAMIC VINEGAR
2 TABLESPOONS BROWN SUGAR
2 TABLESPOONS SOY SAUCE
2 TABLESPOONS WORCESTERSHIRE SAUCE
2 TABLESPOONS BARBECUE SAUCE
1 LONG RED CHILLI, DESEEDED, THINLY SLICED,
 PLUS EXTRA TO SERVE
750 ML GOOD-QUALITY GINGER ALE
SESAME SEEDS, TO SERVE (OPTIONAL)

Bring a large saucepan of water to the boil. Add the ribs,
reduce the heat and simmer for 30 minutes, skimming off any
fat from time to time.

Preheat the oven to 140°C (fan), 160°C, gas mark 2½.

Using a sturdy pair of tongs, remove the ribs from the pan
and place in a large roasting tin. Season with salt and pepper.

In a bowl, mix together the balsamic vinegar, sugar, soy sauce,
Worcestershire sauce, barbecue sauce, chilli and ginger ale.
Pour the mixture over the ribs, then cook them in the oven for
2 hours, basting them as frequently as you can. (I baste the ribs
every 15 minutes, as the more you do so, the better they will
taste. After about 1½ hours the sauce will start to thicken,
so it will take a little extra time to baste the meat — but you
will be rewarded with gorgeous, glossy, sticky ribs.)

Serve the ribs sprinkled with a little extra chilli, a scattering
of sea salt and sesame seeds (if using).

When I was a kid, my dad and I would often go the local pizzeria for dinner. We used to stand at the door waiting for a table, and I would watch in awe as the cook flung rounds of thin, elastic dough high up into the air. I would say to Dad over and over, 'When I grow up, I'm going to be a pizza maker!' Even now I can still smell the vivid aromas of this place, where, after demolishing a pizza I'd also scoff down a HUGE knickerbocker glory ice cream (served in a glass that seemed taller than me at the time). My love for pizza has never waned — as long as it's got a thin base, I could live on it. This recipe and the one on the following page are two of my favourites. You can double or triple the quantities for the pizza dough and, once it has risen, divide into equal-sized portions and freeze the excess for another time.

Salsa Verde, Semi-Dried Tomato and Labne Pizza

3 TABLESPOONS LABNE
3 TABLESPOONS DRAINED SEMI-DRIED TOMATOES
PINCH DRIED CHILLI FLAKES
125 ML EXTRA VIRGIN OLIVE OIL
MINT AND BASIL LEAVES, TO GARNISH
FRESHLY GROUND BLACK PEPPER

Pizza Base
250 G '00' FLOUR
SMALL PINCH CASTER SUGAR
SMALL PINCH SALT
30 ML OLIVE OIL
1¼ TEASPOONS EASY-BLEND DRIED YEAST

Salsa Verde
2 GARLIC CLOVES, CHOPPED
3 TABLESPOONS SALTED CAPERS, RINSED
3 TABLESPOONS BABY GHERKINS (CORNICHONS)
1 LONG GREEN CHILLI, DESEEDED, THINLY SLICED
LARGE HANDFUL EACH FLAT-LEAF PARSLEY LEAVES, BASIL LEAVES AND MINT LEAVES
2 WHITE ANCHOVIES (OPTIONAL), DRAINED
40 G PINE NUTS
2 TABLESPOONS RED WINE VINEGAR
1 TABLESPOON DIJON MUSTARD
125 ML OLIVE OIL

Makes 2 x 28 cm pizzas

To make the pizza base, sift the flour into a large mixing bowl. Make a well in the centre and add the remaining ingredients, along with 125 ml water. Whisk them together gently with a spoon or a fork, gradually incorporating the flour. Using clean hands, bring the mixture together to form a dough, then transfer to a well-floured work surface. Knead firmly for 5 minutes, stretching the dough as you go. Place the dough back in the bowl, cover with a clean, damp tea towel and leave in a warm place to rise for 1 hour or until doubled in size.

Turn the dough out onto a floured surface and cut in half, then roll each piece into a round about 28 cm in diameter (this dough is super-elastic and generally very easy to work with, so it makes an incredibly thin pizza base). Transfer the bases to oiled trays or pizza stones.

Preheat the oven to 200°C (fan), 220°C, gas mark 7. To make the salsa verde, place all the ingredients in a food processor and whizz to a thick, creamy paste, then spread a tablespoon or two over each pizza base.

Tear the labne into small pieces and dot over the bases, followed by the semi-dried tomatoes and chilli flakes. Cook in the oven for 15-20 minutes until the pizza base is cooked through and crispy.

While the pizza is cooking, stir the 125 ml extra virgin olive oil into the remaining salsa verde to make it more pourable.

Remove the pizzas from the oven, scatter with the mint and basil leaves and season with black pepper. Drizzle over the remaining salsa verde and serve immediately.

2 TEASPOONS BROWN OR YELLOW
 MUSTARD SEEDS
1 LARGE GARLIC CLOVE, FINELY
 CHOPPED
2 MINT SPRIGS, LEAVES PICKED
 AND FINELY CHOPPED
SEA SALT AND FRESHLY GROUND BLACK
 PEPPER
1 TABLESPOON DIJON MUSTARD
150 G LEAN ORGANIC FREE-RANGE
 LAMB FILLET
OLIVE OIL, FOR COOKING
 AND DRIZZLING
1 QUANTITY PIZZA BASE
 (SEE PAGE 172)
100 G CRUMBLED PERSIAN FETA OR
 GOOD QUALITY GREEK FETA
25 G FLAKED ALMONDS
1-2 LONG GREEN CHILLIES, DESEEDED,
 FINELY SLICED

Tomato sauce
4 VINE-RIPENED TOMATOES,
 HALVED LENGTHWAYS
1 LARGE GARLIC CLOVE,
 VERY THINLY SLICED
1-2 TABLESPOONS BROWN SUGAR
OLIVE OIL
SEA SALT AND FRESHLY GROUND
 BLACK PEPPER
1 X 400 G TIN CHOPPED TOMATOES
SMALL PINCH CASTER SUGAR
SMALL HANDFUL BASIL LEAVES, TORN
SEA SALT AND FRESHLY GROUND
 BLACK PEPPER

Mint yoghurt dressing
95 G GREEK-STYLE YOGHURT
1 MINT SPRIG, LEAVES PICKED
 AND VERY FINELY CHOPPED
SEA SALT AND FRESHLY GROUND
 BLACK PEPPER

makes 2 x 28 cm pizzas

Spiced Lamb Pizza with Mint Yoghurt DRESSING

Preheat the oven to 180°C (fan), 200°C, gas mark 6.

To make the tomato sauce, place the tomatoes, cut-side up, on a baking tray. Top each half with a slice of garlic and a pinch of brown sugar, then drizzle with oil and season with salt and pepper. Roast for 40-50 minutes or until the tomatoes are very soft.

Transfer the roast tomato and juices to a medium-sized saucepan and add the tinned tomato, caster sugar, basil leaves and 250 ml cold water. Simmer over a low heat for 40 minutes, then remove from the heat and whizz in a blender for a few seconds until smooth. Store in the fridge until required.

Place the mustard seeds, garlic, mint and 1 teaspoon black pepper in a small container with a lid. Secure the lid and shake well to combine, then tip out onto a dinner plate. Using a knife, spread Dijon mustard all over the outside of the lamb fillet, then roll the fillet in the seasoning, turning to coat all sides evenly.

Heat 1 tablespoon olive oil in a frying pan and sear the lamb on all sides over a medium heat until golden brown. Remove from the pan and set aside to rest for 10 minutes, before slicing thinly with a super-sharp knife.

Meanwhile, to make the dressing, mix all the ingredients together and set aside.

Preheat the oven to 200°C (fan). 220°C, gas mark 7.

Spoon the tomato sauce all over the pizza bases (you'll need about 2 tablespoons per base), leaving a 2 cm border around the edge. Lay slices of lamb all over the sauce and dot the feta on top. Scatter with flaked almonds and chillies, then season with a little salt and a generous amount of black pepper and finish with a drizzle of olive oil. Bake for 15-20 minutes or until the pizza base is cooked through and crispy.

Cut into slices and serve with the dressing drizzled over.

Mick's PORK
and red wine
LASAGNE

Let's get one thing straight here — this was originally MY lasagne, but
Mick has made it so many times over the years and tinkered about with it
so much that, to be fair, I thought it only fitting he should get naming
rights. Both of us are Italian-food nuts. Actually, I think it is my favourite
kind of food, and most of the time I tend to opt for a good, cosy, family-
style Italian restaurant over any other kind.

Some people insist that you can't have a proper lasagne without carrots,
but I disagree, so this is a carrot-free zone. I also prefer to use dried
pasta when making lasagne or cannelloni, as fresh pasta tends to go a bit
slimy for my liking.

250 G DRIED LASAGNE SHEETS
80 G PARMESAN, GRATED
GREEN SALAD, TO SERVE

Pork ragu
12 LARGE VINE-RIPENED TOMATOES, HALVED
8 LARGE GARLIC CLOVES, 6 LEFT WHOLE AND UNPEELED,
 2 FINELY SLICED
SEA SALT AND FRESHLY GROUND BLACK PEPPER
LARGE HANDFUL EACH OF BASIL, OREGANO AND THYME LEAVES,
 ROUGHLY TORN
1½ TABLESPOONS OLIVE OIL
1 LARGE BROWN ONION, FINELY DICED
300 G LEAN MINCED FREE-RANGE PORK
300 G LEAN MINCED FREE-RANGE BEEF
1 x 400 G TIN CHOPPED TOMATOES
250 ML FULL-BODIED RED WINE (SHIRAZ OR CABERNET SAUVIGNON)
2 TABLESPOONS BALSAMIC VINEGAR

Bechamel sauce
75 G BUTTER
50 G PLAIN FLOUR
SEA SALT AND GROUND WHITE PEPPER
600 ML MILK, WARMED
PINCH FRESHLY GRATED NUTMEG
80 G PARMESAN, GRATED

Serves 6

Recipe method over page . . .

Preheat the oven to 160°C (fan), 180°C, gas mark 4.

To make the pork ragu, place the tomatoes on a baking tray, cut-side up. Top each tomato half with a slice of garlic and season with salt and pepper. Scatter over half the roughly torn herbs, add the remaining (unpeeled) garlic cloves to the tray, then roast for 1½ hours or until the tomato and garlic cloves are very soft. Remove and set aside to cool slightly.

Meanwhile, heat the olive oil in a large heavy-based saucepan or flameproof casserole dish over a low-medium heat. Add the onion, then season with a generous pinch of salt and cook for 6-8 minutes until softened. Increase the heat to medium, then add the minced pork and beef and stir to combine with the onion, breaking up any lumps with a wooden spoon. Season with salt and pepper and cook for a further 4-5 minutes, stirring occasionally, until the meat has browned. Add the tinned tomato, red wine, balsamic vinegar, 375 ml water and the remaining herbs. Stir to combine, then reduce the heat to low and simmer for 1½ hours until the sauce has reduced and thickened, stirring occasionally and scraping down the sides of the pan.

Place the slow-roasted tomatoes in a blender and blend until smooth. Add to the ragu, along with the squeezed flesh from the roasted garlic cloves, and mix well. Simmer for 20 minutes or so to infuse the flavours, then taste and season if required.

Increase the oven temperature to 180°C (fan), 200°C, gas mark 6.

To make the bechamel, melt the butter in a small saucepan over a medium heat, add the flour and a pinch of salt and pepper and stir to form a paste. Cook, stirring, for 2-3 minutes, then gradually add the milk, stirring constantly, until all the milk has been absorbed and you have a smooth, creamy sauce. Bring to a simmer, then add the nutmeg and Parmesan and stir to combine.

Spoon a layer of pork ragu into a baking dish measuring approximately 20 cm x 32 cm x 3 cm and spread evenly over the base. Cover with a layer of bechamel and top with enough lasagne sheets to cover the area without overlapping. Continue layering until the dish is full (you should get three layers), finishing with a layer of pork ragu and any remaining bechamel. Sprinkle the Parmesan evenly over the top and finish with a grinding of black pepper. Bake for 30 minutes or until the top is golden brown and bubbling and the lasagne sheets are cooked through.

Leave to stand for a few minutes before slicing and serving with a green salad.

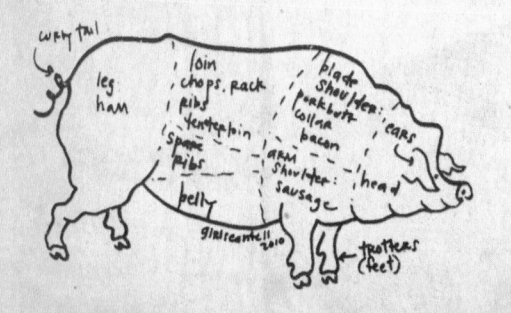

Cannelloni with chicken, MUSHROOMS and WALNUTS

This is my father-in-law Bob's take on cannelloni, and the addition
of mushrooms and walnuts really lifts a classic dish to new heights.
Don't worry if your bechamel looks a bit lumpy to start with, as any
lumps should disappear after a bit of stirring. The secret to getting
a smooth filling is to really break up the chicken mince mixture with
a wooden spoon as it cooks to make it as fine as possible – this will
make filling the pasta tubes much easier. I use a piping bag to fill
the tubes, as it's a lot less stressful than trying to do it with a spoon.

130 G CHICKEN LIVERS
400 G BABY SPINACH LEAVES, RINSED
OLIVE OIL, FOR COOKING
1 WHITE OR BROWN ONION, FINELY DICED
3 GARLIC CLOVES, CRUSHED
500 G LEAN MINCED FREE-RANGE CHICKEN
1 TABLESPOON EACH FINELY CHOPPED SAGE, TARRAGON AND THYME LEAVES
SEA SALT AND FRESHLY GROUND BLACK PEPPER
200 G CHESTNUT MUSHROOMS, CLEANED AND QUARTERED,
 THEN ROUGHLY CHOPPED
KNOB OF BUTTER
50 G WALNUTS, ROUGHLY CHOPPED
280 G RICOTTA
200 G PARMESAN, GRATED
18–20 DRIED CANNELLONI TUBES
GREEN SALAD AND CRUSTY BREAD, TO SERVE

Creamy bechamel sauce
150 G BUTTER
150 G PLAIN FLOUR
750 ML MILK
750 ML CREAM
PINCH FRESHLY GRATED NUTMEG
50 G PARMESAN, GRATED
SEA SALT AND GROUND WHITE PEPPER

Serves 4–6

Recipe method over page . . .

Cannelloni with chicken, MUSHROOMS and WALNUTS continued . . .

Preheat the oven to 180°C (fan), 200°C, gas mark 6.

Blend the chicken livers in a food processor until smooth, then set aside.

Pour 250 ml cold water into a large saucepan and bring to the boil, then add the spinach and cook for 1-2 minutes or until wilted. Drain in a colander and squeeze to remove any excess water, then roughly chop and set aside.

Heat 2 tablespoons olive oil in a deep non-stick frying pan over a medium heat, add the onion and garlic and cook for 10 minutes until soft and opaque. Add the minced chicken and chicken liver purée and cook for 3-4 minutes, breaking up any lumps with a wooden spoon as you go. Add the herbs and season with a decent pinch of salt and pepper, then cook for 10-12 minutes or until the mince and livers are cooked through.

Meanwhile, heat 1 tablespoon olive oil in a separate frying pan over a low heat, then add the chopped mushrooms and cook for 4-5 minutes. Add the knob of butter and allow to melt, then toss to coat the mushrooms. Cook for a further 2 minutes until glossy, then add the mushrooms to the chicken mixture, along with the walnuts and reserved spinach, and stir gently to combine. Remove the pan from the heat and set aside to cool for 15 minutes, then taste the mixture and season if needed.

To make the bechamel sauce, melt the butter in a medium-sized saucepan over a medium heat, then add the flour and cook, stirring, for 1-2 minutes to form a paste. Gradually add the milk, whisking continuously until all the milk has been absorbed and you have a smooth, creamy sauce. Bring to a simmer and add the cream, nutmeg and Parmesan, then season with salt and pepper and stir to combine.

Once the chicken mixture has cooled a little, stir in the ricotta and a quarter of the grated Parmesan. Using a piping bag, fill the cannelloni tubes with the mixture (alternatively, spoon the mixture in).

Spoon a thick layer of the bechamel over the base of a large baking dish, then place the filled cannelloni on top, arranging them close together in a single layer. Cover with the remaining bechamel, sprinkle over the remaining Parmesan and season with black pepper. Cook for 40 minutes, then increase the oven temperature to 200°C (fan), 220°C, gas mark 7 and cook for a further 10 minutes or until the top is golden.

Serve hot with a green salad and crusty bread.

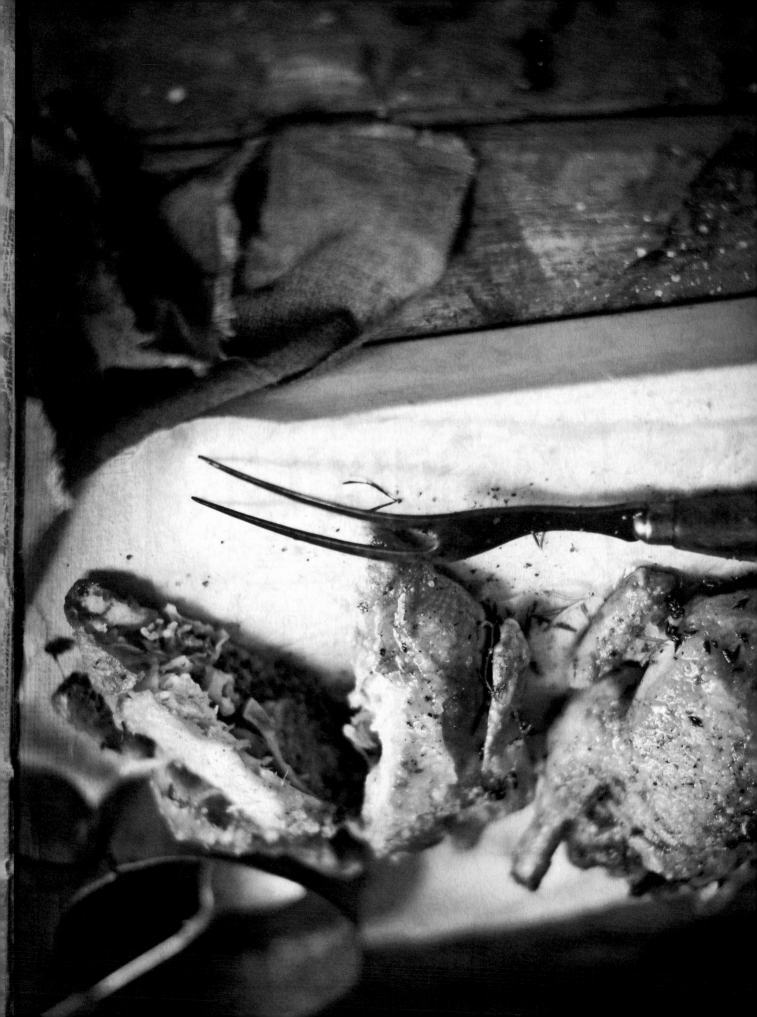

The inspiration for this recipe came from a memorable trip to a restaurant in Woodend, Victoria, back in 2008, where I had a quail dish I'll never forget. I played around with the flavours I remembered, and came up with this winter dish using poussin — it's perfect served with a good creamy mash (see recipe on page 214, but follow the first two steps only and omit the wasabi!).

№. 183

Poussins with CHESTNUT STUFFING and Calvados sauce

4 x 500 G FREE-RANGE POUSSINS (BABY CHICKENS)
SEA SALT AND FRESHLY GROUND BLACK PEPPER
OLIVE OIL, FOR RUBBING
SMALL HANDFUL THYME AND ROSEMARY SPRIGS
250 ML CHICKEN STOCK
3 TABLESPOONS CALVADOS (OR REGULAR BRANDY)

Chestnut stuffing

175 G FRESH SOURDOUGH BREADCRUMBS
4 ROSEMARY SPRIGS, LEAVES PICKED
3 THYME SPRIGS, LEAVES PICKED
3 FREE-RANGE PORK SAUSAGES, MEAT REMOVED FROM CASINGS
70 G HAZELNUTS
2 TEASPOONS OLIVE OIL
115 G MILD PANCETTA, EXCESS FAT AND SKIN REMOVED, CUT INTO 1 CM CUBES
1 ONION, FINELY DICED
1 GARLIC CLOVE, CRUSHED
2 TABLESPOONS CHESTNUT PURÉE
SEA SALT AND FRESHLY GROUND BLACK PEPPER

Serves 4

Preheat the oven to 180°C (fan), 200°C, gas mark 6.

To make the stuffing, place the breadcrumbs, rosemary, thyme and sausagemeat in a bowl, then mix together with clean hands.

Place the hazelnuts on a baking tray and roast for 10 minutes or until golden. If the nuts have their skins on, tip them into a clean tea towel and rub to remove the skins. Using a large sharp knife, roughly chop the nuts, then add to the stuffing mixture.

Warm the olive oil in a frying pan, add the pancetta and cook over a low-medium heat for 10 minutes until it starts to get crispy. Add the onion and cook for 5 minutes, then add the garlic and cook for a further 5 minutes.

Allow the pancetta mixture to cool a little, then add to the stuffing mixture, along with the chestnut purée. Mix everything together (again, using clean hands), then season well with salt and pepper.

Place the poussins on a clean work surface. Season the inside of the birds with salt, then fill the cavities with the stuffing. Secure the opening with a cocktail stick if you like, and tie the legs together with kitchen string. Rub the outside of the birds with olive oil, then scatter a few thyme sprigs on top, along with a few rosemary sprigs. Season with salt and pepper.

Place the birds in a roasting tin and cook in the oven for 1–1½ hours until golden brown all over. To check if cooked, insert a small, sharp knife in the plumpest thigh area of the bird — if the juices run clear, the bird is cooked through. Remove the poussins from the roasting tin and set aside on a plate to rest.

To make the sauce, place the roasting tin on the hob over a low heat. Using a large spoon, skim off as much oil as you can. Add the stock and Calvados and mix together using a balloon whisk — try to scrape up any caramelised bits stuck to the tin. Season to taste with salt and pepper and simmer until the liquid has reduced by half. Strain, if you like, then serve piping hot with the poussins.

Rib-eye STEAKS with anchovy butter and rosemary potatoes

This recipe appeared on the blog in a Valentine's Day feature in 2011. Let's face it, we all know the best way to a man's heart is to cook him a big lump of steak (in my experience at least, this always goes down pretty well with a true red-blooded Aussie bloke). Try to get the best piece of grass-fed, organic meat you can, and similarly with the butter, organic is best. There are a wide range of excellent organic butters on the market now — they do cost a little more, but for meals like this they make all the difference. If you don't like anchovies, you can substitute a tablespoon of chopped capers.

6 WAXY POTATOES, SKINS ON, SCRUBBED
SEA SALT AND FRESHLY GROUND BLACK PEPPER
OLIVE OIL, FOR COOKING AND RUBBING
2 GARLIC CLOVES, THINLY SLICED
HANDFUL FLAT-LEAF PARSLEY LEAVES, FINELY CHOPPED
2 ROSEMARY SPRIGS, LEAVES FINELY CHOPPED
2 RIB-EYE STEAKS (SIZE DEPENDENT ON PERSONAL TASTE)
KNOB OF BUTTER
ROASTED ONION RINGS WITH THYME (SEE PAGE 223)

Anchovy butter

3 TABLESPOONS BUTTER, AT ROOM TEMPERATURE
4 ANCHOVY FILLETS, DRAINED AND VERY FINELY CHOPPED
1 TEASPOON FINELY CHOPPED FLAT-LEAF PARSLEY
FRESHLY GROUND BLACK PEPPER

Serves 2

To make the anchovy butter, combine the butter, anchovies and parsley in a small bowl and season to taste with pepper. Cover with cling film and chill in the fridge until needed.

Bring a large saucepan of water to the boil, add the potatoes and a pinch of salt and boil until just tender (test with a knife — the potatoes should be cooked through but still slightly firm). Drain and set aside to cool slightly.

Meanwhile, warm 1 tablespoon olive oil in a large frying pan over a low-medium heat, add the garlic and cook for 1-2 minutes. Cut the potatoes into 1 cm thick slices and cook in batches in the same pan until both sides are golden brown (take care not to overload the pan or the potatoes will sweat rather than sauté). Remove the potatoes and garlic and drain on kichen paper, then transfer to a bowl. Season with a pinch of salt and pepper, then add the parsley and rosemary and toss to coat.

Meanwhile, pour 1 tablespoon olive oil into the palm of your hand and rub all over the steaks. Season very well on both sides with salt and pepper.

Heat a chargrill pan until almost smoking, then add the steaks and sear for 3-4 minutes each side for medium-rare, or until cooked to your liking. Add the knob of butter and allow to melt, then spoon over the meat. Remove the steaks from the pan and rest for a few minutes, then serve with the anchovy butter, sautéed potatoes and onion rings.

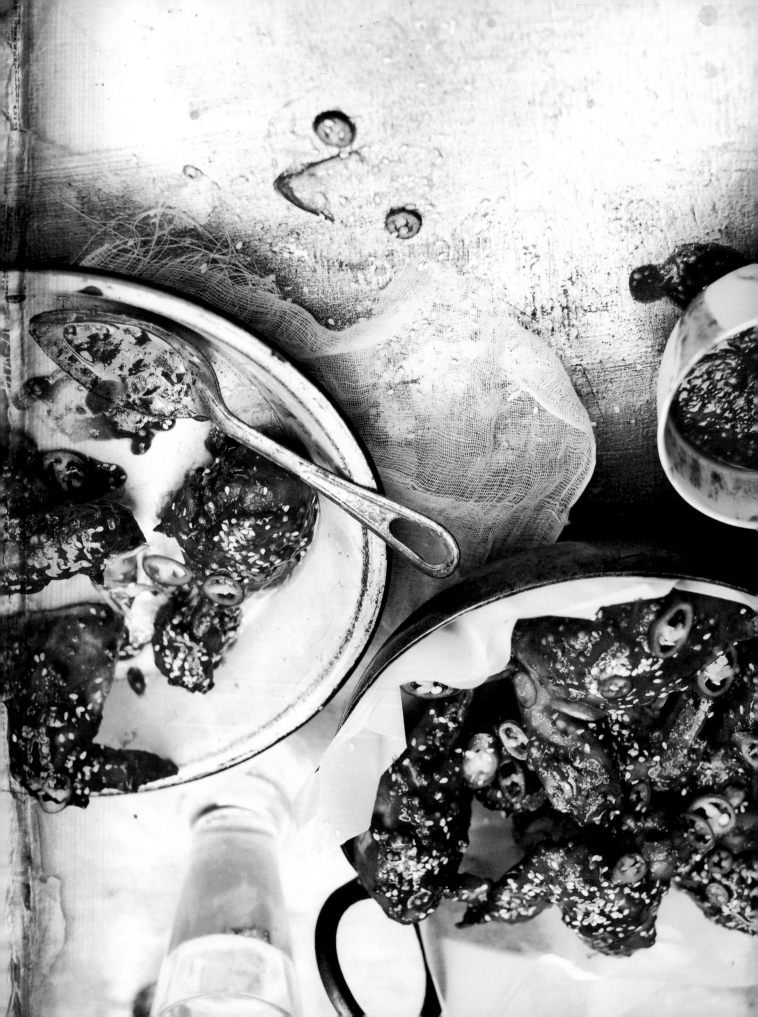

Sticky chicken with SESAME and chilli

This is a great mid-week, easy-peasy, 'throw-it-all-in-the-baking-dish' meal. Even though the list of ingredients looks long, I'm willing to bet you'll find 99% of them in your fridge or store cupboard already, so all you need to do is buy the chicken and you're ready to go. I've suggested removing the skin from the drumsticks as I find this allows the meat to get beautifully caramelised in the sticky sauce. To make it even easier, try to buy the drumsticks already skinned (and don't bother even trying to skin the wings, as life is way too short!).

1 KG FREE-RANGE CHICKEN DRUMSTICKS AND WINGS
SEA SALT AND FRESHLY GROUND BLACK PEPPER
1 TABLESPOON OLIVE OIL
1 SMALL RED ONION, FINELY DICED
3 GARLIC CLOVES, FINELY CHOPPED
250 ML TOMATO KETCHUP
140 G WHOLEGRAIN MUSTARD
120 G RUNNY HONEY
2 TABLESPOONS BROWN SUGAR
1 TABLESPOON SMOKED PAPRIKA
1 TEASPOON CAYENNE PEPPER
3 TABLESPOONS WORCESTERSHIRE SAUCE
3 TABLESPOONS BALSAMIC VINEGAR
HANDFUL EACH SESAME SEEDS AND FINELY SLICED
 LONG GREEN CHILLI, TO GARNISH
STEAMED BASMATI RICE, TO SERVE

Serves 4

Start by removing the skin from the drumsticks. Using a sharp knife, cut the skin all the way around the circumference of the drumstick at the narrowest point of the leg (just above the knuckle bone). Slip your fingers under the skin to loosen it, then pull it up and off the flesh and over the other end of the bone. There will still be skin on the knuckle bone at the end, but don't worry about this – the main aim is to get the skin off the fleshy part of the leg. Place the skinned drumsticks and the wings in a roasting tin and season with salt and pepper.

Preheat the oven to 160° (fan), 180°C, gas mark 6.

Heat the olive oil in a deep frying pan over a medium heat, add the onion and cook for 5 minutes. Add the garlic and cook for a further 5 minutes. Reduce the heat to low and add the ketchup, mustard, honey, sugar, paprika, cayenne pepper, Worcestershire sauce and balsamic vinegar. Stir together thoroughly, then increase the heat to medium and simmer for 5 minutes. Pour the sauce evenly over the chicken in the roasting tin.

Transfer the tin to the oven and cook, basting often, for $1\frac{1}{4}$–$1\frac{1}{2}$ hours or until the chicken is cooked through and sticky on the outside. Garnish with a scattering of sesame seeds and green chilli, and serve with basmati rice.

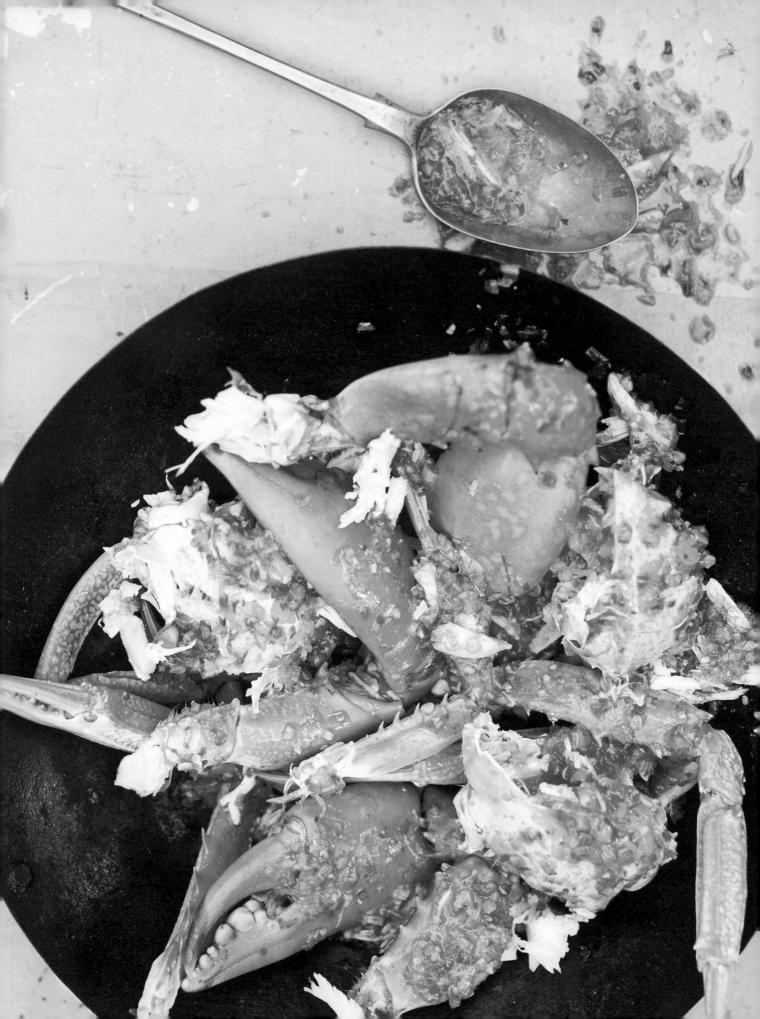

Served with a green salad, lots of crusty bread and some chilled sparkling wine, this dish makes for a great, casual, communal meal with friends.

Some people shy away from cooking crab as they think the preparation is too fiddly and difficult. I would encourage you to give it a go — there are lots of great online tutorials out there that can take you through the process step by step. Please note: mud crab must be cooked live, and the most humane way to go about this is to first place the crabs in the freezer for at least 30 minutes to stun them. The crabs must be completely still before being immersed in the boiling water — if you see any movement at all, return them to the freezer for a short time.

Wok-tossed chilli CRAB

2 LARGE UNCOOKED MUD CRABS OR OTHER CRABS
2 COOKED BLUE SWIMMER CRABS OR OTHER CRABS, CLEANED, BODY
 CUT INTO QUARTERS AND LEGS AND CLAWS CRACKED

Chilli sauce

2 TABLESPOONS OLIVE OIL
3 GARLIC CLOVES, THINLY SLICED
1 TEASPOON FINELY GRATED GALANGAL
1 LONG GREEN CHILLI, THINLY SLICED, PLUS EXTRA TO GARNISH
1 LONG RED CHILLI, THINLY SLICED, PLUS EXTRA TO GARNISH
5-6 SPRING ONIONS, TRIMMED AND THINLY SLICED ON
 THE DIAGONAL, PLUS EXTRA TO GARNISH
100 G CHILLI BEAN PASTE
2 TABLESPOONS RICE WINE VINEGAR
15 G PALM SUGAR, GRATED
250 ML FISH STOCK
SEA SALT AND FRESHLY GROUND BLACK PEPPER
HANDFUL EACH ROUGHLY CHOPPED CORIANDER AND
 FLAT-LEAF PARSLEY

Serves 4

Freeze the mud crabs for 30 minutes or until they are stunned completely, then plunge them into a large saucepan of salted boiling water. Cover and cook for 20 minutes or until cooked through. If your crabs are on the small side, reduce the cooking time to 15 minutes. Drain, then separate the bodies from the claws and legs. Remove the meat from the bodies, and crack the claws and legs, then combine in a bowl with the prepared blue swimmer crabs.

Heat the olive oil in a wok over a medium heat, add the garlic, galangal, chillies and spring onions and stir-fry for 5 minutes. Add the chilli bean paste, vinegar, palm sugar and stock and mix well. Add the crab, along with all the loose meat, and heat through for 5-6 minutes, tossing until heated through and well coated in sauce. Season with a little salt and pepper, then turn out into a large serving bowl.

Scatter the coriander, parsley and extra chillies and spring onions over the top and serve immediately.

Poached chicken risotto with white truffle oil and tarragon

Poaching chicken breasts is a great way to infuse them with flavour and retain moisture – is there anything worse than a dry, flavourless chicken breast? It's also a healthy option, as you're not cooking in any fat. This is quite an indulgent dish – white truffle oil is expensive, but it keeps for ages and a little goes a long way. Tarragon is delicious when added in small amounts, but be careful not to add too much as it can be overpowering.

2 DRIED BAY LEAVES
1/2 TEASPOON BLACK PEPPERCORNS
2 X 200 G FREE-RANGE CHICKEN BREAST FILLETS
1.2 LITRES CHICKEN STOCK
1 TABLESPOON OLIVE OIL
50 G BUTTER
1 BROWN ONION, FINELY CHOPPED
300 G ARBORIO RICE
100 ML WHITE WINE
SMALL HANDFUL FLAT-LEAF PARSLEY LEAVES,
FINELY CHOPPED
SEA SALT AND FRESHLY GROUND BLACK PEPPER
100 G PECORINO, GRATED, PLUS EXTRA TO SERVE
WHITE TRUFFLE OIL, FOR DRIZZLING
A FEW TARRAGON LEAVES, OPTIONAL

serves 4

Place the bay leaves, peppercorns and 750 ml water in a medium-sized saucepan. Bring to the boil, then reduce the heat and simmer for 5 minutes to infuse the flavours. Add the chicken breasts, then cover and simmer over a low heat for 10–12 minutes or until the chicken is cooked through. Remove from the heat and leave to cool slightly, then drain and tear the chicken into strips.

Pour the chicken stock into a large saucepan and bring to a simmer. Reduce the heat to very low, then cover and keep the stock warm until needed.

Heat the olive oil and butter in a large heavy-based saucepan or flameproof casserole dish until the butter has melted. Add the onion and cook for 5–10 minutes or until softened. Add the rice and stir to coat with the onion mixture, then pour in the wine and simmer, stirring, until the liquid has reduced a little.

Add a ladleful of warm stock to the rice and cook, stirring, until it has been completely absorbed. Continue adding the stock in this way until there is only one ladleful of stock left in the pan. Add the chicken and parsley and finally, the remaining stock. Stir to combine, then season to taste with salt and pepper. By now, the risotto should have a lovely creamy consistency. When the last of the stock has been absorbed, stir in the pecorino.

To serve, spoon portions of the risotto onto plates. Drizzle with a little white truffle oil, add a scattering of extra pecorino and one or two tarragon leaves (if using) then finish with a final grind of black pepper.

Eight-hour LAMB with Persian feta

serves 4–6

2 ONIONS, CUT INTO QUARTERS
2 GARLIC BULBS, CUT IN HALF LENGTHWAYS, PLUS 12 GARLIC
 CLOVES, PEELED AND CUT IN HALF LENGTHWAYS
2 BUNCHES ROSEMARY
1 x 1.5 KG LEG ORGANIC LAMB
OLIVE OIL, FOR RUBBING AND DRIZZLING
SEA SALT AND FRESHLY GROUND BLACK PEPPER
200 G CRUMBLED PERSIAN FETA OR SOFT GOAT'S CHEESE
LEMON WEDGES AND STRIPS OF LEMON ZEST, TO SERVE

Herb and lemon dressing
LARGE HANDFUL EACH BASIL, FLAT-LEAF PARSLEY AND MINT LEAVES
1 TEASPOON DIJON MUSTARD
1 TABLESPOON SHERRY VINEGAR
1 TABLESPOON SALTED CAPERS, RINSED
2–3 ANCHOVY FILLETS, DRAINED
FINELY GRATED ZEST AND JUICE OF 1 LEMON
125 ML OLIVE OIL, PLUS EXTRA IF NEEDED

№ 193

This is a fantastic recipe for a dinner party. Simply throw the meat in the oven in the morning and leave it to slow roast all day, before shredding the meat off the bone and serving — the meat will be so tender it will simply fall off the bone. I often prepare this dish when asked to 'bring a plate' for friends' barbecues — it always goes down a treat.

Preheat the oven to 140°C (fan), 160°C, gas mark 2 ½.

Place the onion quarters and the halved garlic bulbs in the middle of a roasting tin and scatter over the sprigs from 1 bunch of rosemary. Place the lamb leg on top.

Pour a glug of olive oil into your hands. Rub them together, then rub it all over the lamb. Using a small, sharp knife make twelve slits (about 2.5 cm deep) in the meat. Push two garlic halves into each of the slits, then cut six rosemary sprigs in half, fold them over and stuff into the slits with the garlic.

Season the lamb generously with salt and pepper and drizzle with a little more olive oil. Cover the meat loosely with foil, lightly tucking it in around the inside of the tray. Roast in the oven for 8 hours, checking the meat occasionally. If it starts to look a little dry, add a splash of water or white wine.

When the lamb is cooked, remove it from the oven and leave to rest for 20 minutes before shredding the meat — it should fall easily from the bone and have a wonderful, silky texture.

To make the dressing, place the herbs, mustard, vinegar, capers, anchovies, lemon zest and juice and olive oil in a food processor or blender and blitz to form a paste. Drizzle in a little more olive oil if it looks too thick — you want the dressing to be a little runnier than a pesto, so you can drizzle it easily over the meat.

Arrange the lamb and crumbled feta on a platter and drizzle over the dressing.

Jill is one of my closest Aussie friends, and she is the most incredible vegetarian cook I have had the good fortune to know. Years ago, when we all lived in Ireland, we would often head down to her husband Frank's cottage in the country for the weekend. It was a gorgeous little cottage set on a few acres of land that had a big lake slap-bang in the middle. After various (hilarious) attempts at kayaking in the f-f-f-freezing winter temperatures, we'd head back to the cottage, light the fire, crack open the red and settle in for a great night filled with lots of good conversation, music and, most importantly, Jill's superb food. This is one of the dishes she used to cook for us. I am continually appreciative to Jill for showing me you can eat wonderfully and feel at no loss if you decide to live a meat-free lifestyle.

Bill's Veggie Roll

serves 4

1 TABLESPOON OLIVE OIL
2 GARLIC CLOVES, CRUSHED
6 SPRING ONIONS, TRIMMED AND SLICED
1 BUNCH SPINACH, WASHED AND ROUGHLY CHOPPED
50 G PINE NUTS
200 G CRUMBLED FETA
200 G FRESH RICOTTA
¼ TEASPOON FRESHLY GRATED NUTMEG
2 FREE-RANGE EGGS, LIGHTLY BEATEN
HANDFUL FLAT-LEAF PARSLEY LEAVES, FINELY CHOPPED
105 G FRESH BREADCRUMBS
375 G FILO PASTRY
150 G BUTTER, MELTED
1 FREE-RANGE EGG YOLK MIXED WITH A LITTLE MILK
HANDFUL POPPY SEEDS
GOOD-QUALITY TZATZIKI, OR SPICY VINE TOMATO RELISH
(SEE PAGE 228), TO SERVE

Preheat the oven to 180°C (fan), 200°C, gas mark 6.

Heat the olive oil in a medium-sized saucepan over a medium heat, add the garlic and spring onions and cook gently for 5 minutes. Add the spinach, then cover and cook for 2–3 minutes until wilted. Drain and set aside to cool, then squeeze out any excess liquid.

Place the pine nuts in a dry frying pan and toast over a low-medium heat for 5 minutes or until lightly golden – don't take your eyes off them as they can burn very quickly.

Combine the cheeses, nutmeg and eggs in a large mixing bowl. Stir in the spinach, parsley, pine nuts and breadcrumbs.

Place one sheet of filo pastry on a clean work surface and brush with a little melted butter. Place another sheet on top and brush with butter, then place a final sheet on top and brush with butter, to give you a stack of three sheets.

Spoon a few tablespoons of the filling evenly along the long edge of pastry closest to you, leaving a 4–5 cm gap at each end. Roll up the pastry and filling to form a sausage shape, tucking the sides in as you go. Brush the sausage liberally with the eggwash. Repeat with the remaining filling and pastry.

Place one filo sausage in the middle of a greased round baking tray and form it gently into a spiral. Take the next filo sausage and join it end-to-end with the first, coiling it around. Continue with the remaining pieces to form a large spiral, brushing with eggwash as you go to seal it all together. Sprinkle with poppy seeds, then bake for 30–35 minutes or until golden brown all over.

Serve with tzatziki or tomato relish.

SIDES & SAUCES

Tenderstem with pancetta, WALNUTS and lemon

Tenderstem is the prettier, slimmer, sexier little sister to broccoli, and I find it much tastier. I tend to use the stems as well as the florets for a more interesting combination of textures. Cook it lightly so it's just tender, then drain and plunge it immediately into a big bowl of iced water so it retains its vibrant colour. Here, the addition of salty crispy pancetta and golden walnuts, along with tangy lemon juice, makes for a side dish that's a world away from the limp, over-cooked broccoli we might be used to.

FINE SALT
2 BUNCHES TENDERSTEM, FLORETS AND STEMS SEPARATED,
 STEMS CUT INTO 2 CM PIECES AND WOODY ENDS DISCARDED
2 TEASPOONS OLIVE OIL
6 SLICES MILD PANCETTA (3 MM THICK), FINELY DICED
35 G WALNUTS, CHOPPED
KNOB OF BUTTER
JUICE OF 1 LEMON
SEA SALT AND FRESHLY GROUND BLACK PEPPER

Bring a saucepan of salted water to the boil.
Add the Tenderstem florets and stems and cook
for 3–4 minutes until tender to the bite.
Drain, then plunge into iced water. Drain
again and pat dry.

Heat the olive oil in a large frying pan
and cook the pancetta over a medium heat for
7–10 minutes until crispy. Add the Tenderstem
and walnuts to the pan. Add the butter and
lemon juice and toss all the ingredients
to coat well. Season with salt and pepper.

Transfer immediately to a serving dish
and serve hot.

Serves 4

Minted baby PEAS

Serves 4-6

3 TABLESPOONS BUTTER, SOFTENED
1 TEASPOON WASABI PASTE
LARGE HANDFUL MINT LEAVES, FINELY CHOPPED, PLUS EXTRA LEAVES TO GARNISH
SMALL HANDFUL FLAT-LEAF PARSLEY LEAVES, FINELY CHOPPED
240G FROZEN BABY PEAS
1/2 TEASPOON CASTER SUGAR
SEA SALT AND FRESHLY GROUND BLACK PEPPER

Place the butter, wasabi, mint and parsley in a small bowl and mix to combine.

Half-fill a saucepan with cold water and add salt. Bring to the boil over a medium-high heat and add the peas. Reduce the heat to medium and simmer for 3 minutes. Drain the peas, then return them to the warm pan. Season with the caster sugar, salt and a generous amount of black pepper.

Add half the seasoned butter to the warm peas and stir through. Transfer to a serving bowl, add the remaining butter and let it melt on top. Garnish with the extra mint leaves and serve immediately.

From a very early age, I decided I detested peas, completely and utterly. Yet any night at dinnertime, when Mum was serving peas, she'd ask me:
'Do you want peas?'
To which I'd religiously answer:
'No, I hate peas! Why do you always ask me when you know I hate peas?'
Then she would say:
'No you don't, you love them.'
It used to drive me mad!

I only overcame my pea phobia about five years ago, when I discovered petits pois, the French baby variety that taste sweet, crisp and fresh, not mushy and horrid. Now I eat baby peas often, mainly with lamb or pasta, or I enjoy them like this, as a side dish, especially with a good wallop of fresh mint, lots of butter and black pepper. I guess my mum knew what she was talking about – I actually did love peas, I just hadn't realised it yet.

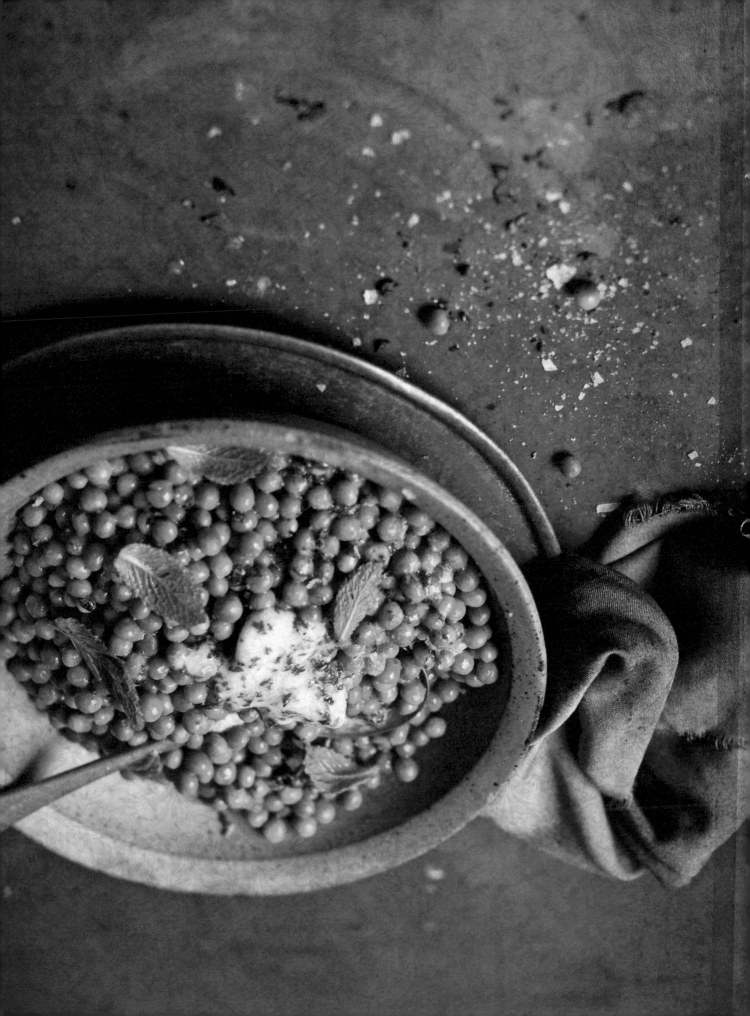

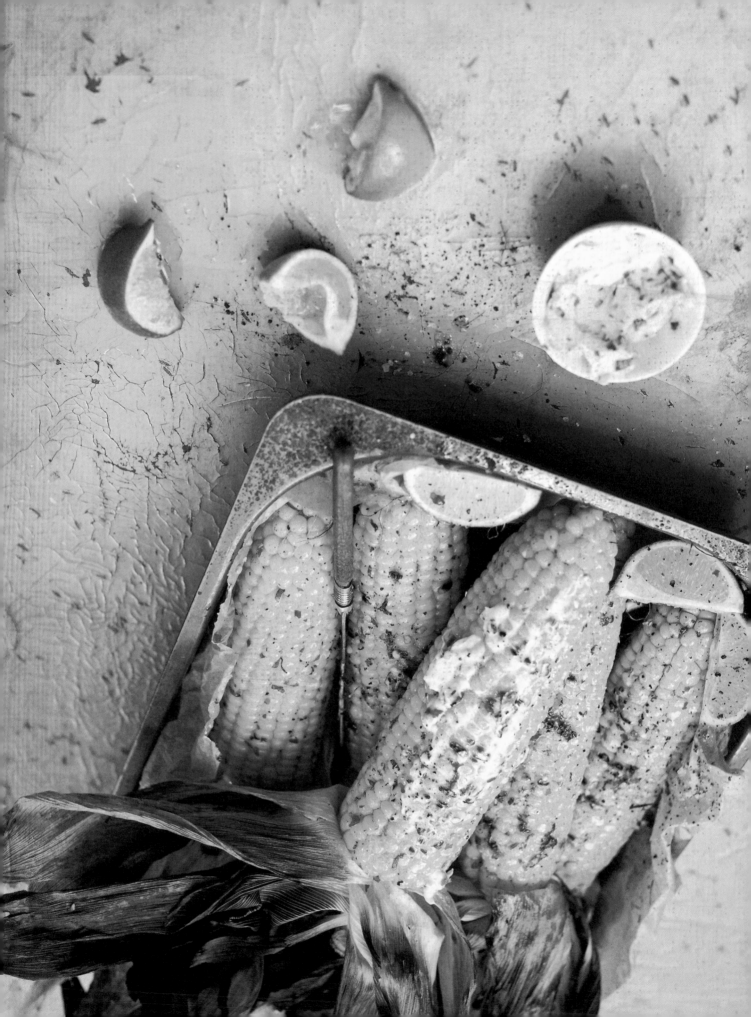

BARBECUED *sweetcorn*
with chilli, mint
and *lime butter*

This is one of my sure-fire hits to serve at a barbecue.
The lime and chilli are a superb combo, and work really well
with the fresh mint. Any leftover butter is especially good
with jacket spuds or tossed over boiled baby potatoes.

4 CORN-ON-THE-COBS, HUSKS ON
LIME WEDGES, TO SERVE

Chilli, mint and lime butter
3 TABLESPOONS UNSALTED BUTTER, SOFTENED
1 TABLESPOON FINELY CHOPPED MINT
1 TEASPOON FINELY CHOPPED CORIANDER
JUICE OF 1 LIME
1 TEASPOON DRIED CHILLI FLAKES
SEA SALT AND FRESHLY GROUND BLACK PEPPER

Serves 4

Soak the corn-on-the-cobs in a bowl of water for 10 minutes
(this will prevent the husks from burning on the barbecue).

While the sweetcorn is soaking, preheat a barbecue or chargrill
pan to medium. Cook the corn for 30 minutes, turning regularly.
Remove from the heat and allow to cool slightly, then peel back
the husks and silks.

Turn down the heat a little, then return the corn-on-the-cobs
to the barbecue for a further 10-15 minutes or until slightly
charred, turning the corn every few minutes (you'll be
surprised just how long it needs to cook on the barbecue so
it takes on that lovely charred appearance).

Meanwhile, to make the chilli butter, combine all the
ingredients in a small bowl. Place in the fridge to chill
for 10 minutes.

Serve the corn-on-the-cobs hot with a large knob of chilli
butter smeared over the top, and lime wedges and a little
extra butter on the side.

Baby carrots roasted with THYME, hazelnuts and white wine

These are a super addition to any roast dinner. The added benefit of cooking
them in a parcel is that it's relatively mess free and reduces the amount
of washing-up required — something I find utterly invaluable when dealing
with the carnage that normally ensues in my kitchen after preparing dinner.

70 G HAZELNUTS
2 BUNCHES BABY CARROTS, TRIMMED
5 THYME SPRIGS
SEA SALT AND FRESHLY GROUND BLACK PEPPER
3 TABLESPOONS DRY WHITE WINE
JUICE OF ½ BLOOD ORANGE (OR A REGULAR ORANGE IF UNAVAILABLE)
1 TABLESPOON EXTRA VIRGIN OLIVE OIL
2 KNOBS OF BUTTER

Serves 4

Preheat the oven to 180°C (fan), 200°C, gas mark 6.

Place the hazelnuts on a baking tray and roast for 10-12 minutes until
lightly golden. Transfer them to a mortar and gently break up the nuts with
a pestle until roughly crushed. Set aside.

Place a large piece of foil or baking paper on a baking tray and lay the
carrots along the middle. Scatter with thyme (use some whole sprigs and a
few loose leaves) and season with salt and pepper. Place another large piece
of foil or baking paper over the top, then fold over the side closest to
you a few times to seal; repeat with the left and right sides. Turn the open
side of the parcel towards you and carefully pour in the wine, orange juice
and olive oil, then add the butter. Fold this side over to seal the parcel,
then place the baking tray in the oven. Cook for about 20 minutes or until
the parcel is puffed up and the carrots are tender but still have a little
bite to them. (To check this, remove the parcel from the oven and carefully
insert a small sharp knife through the parcel into the carrots.)

Remove the baking tray from the oven and slice the package open with a sharp
knife. Use tongs to transfer the carrots to a serving dish, then spoon the
juices left in the parcel all over the top. Sprinkle over the hazelnuts,
then season with salt and pepper and serve.

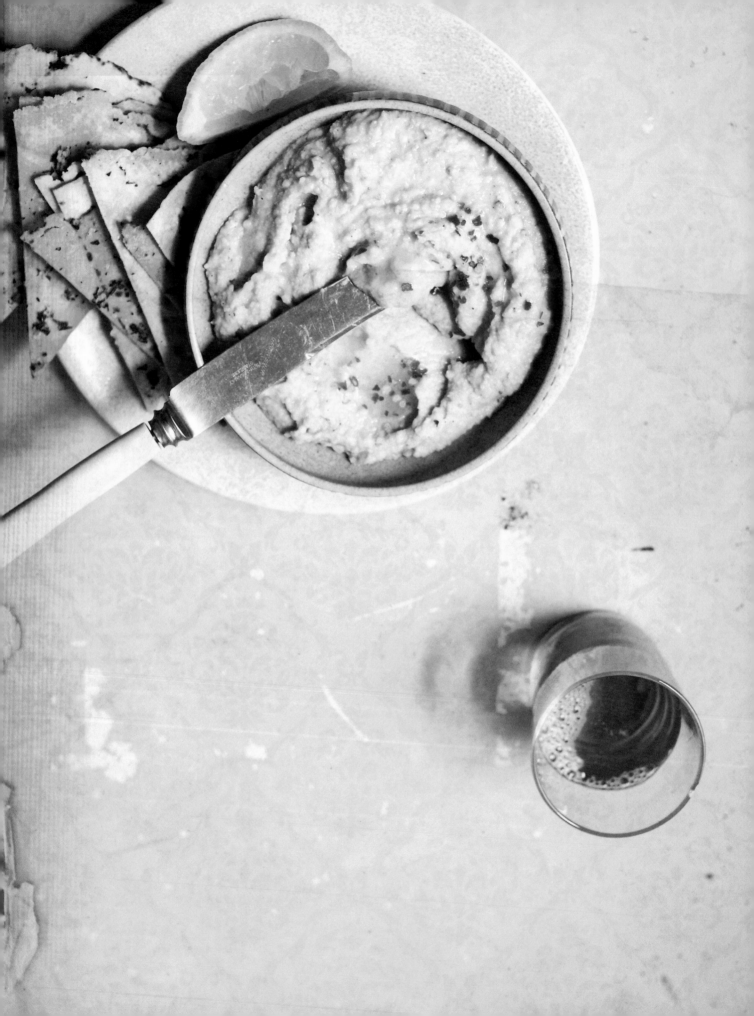

White bean, chickpea and roasted GARLIC dip

Having more of a savoury tooth than a sweet one, most
of the time I opt for a cheese platter over dessert,
or gravitate to the crisps and dips. This dip is my version
of a classic hummus, and it's simple and hassle-free.
Once you've roasted the garlic, you'll have it whipped
up and on the table in no time.

This hummus is especially good served with homemade crackers.
Simply take two or three rounds of Lebanese bread, rub with
a cut garlic clove, then drizzle with olive oil and season
with salt and pepper. Scatter over a handful of finely
chopped basil, then cut the bread into wedges and toast
in a preheated 180°C (fan), 200°C, gas mark 6 oven for
15-20 minutes or until toasted and crisp.

2 LARGE GARLIC CLOVES, UNPEELED
PLUS EXTRA FOR DRIZZLING
1 x 400G TIN CHICKPEAS, RINSED AND DRAINED
1 x 400G TIN CANNELLINI BEANS, RINSED AND DRAINED
JUICE OF $1\frac{1}{2}$ LEMONS
PINCH DRIED CHILLI FLAKES,
PLUS EXTRA TO SERVE (OPTIONAL)
80ML EXTRA VIRGIN OLIVE OIL,
SEA SALT AND FRESHLY GROUND BLACK PEPPER
LEMON WEDGES AND HOMEMADE CRACKERS (SEE ABOVE),
TO SERVE

Preheat the oven to 180°C (fan), 200°C, gas mark 6.

Place the garlic on a baking tray and roast for about
30 minutes until soft. Remove and allow to cool, then squeeze
out the soft flesh and discard the papery skin.

Place the garlic in a blender with the chickpeas, cannellini
beans, lemon juice, chilli flakes (if using) and olive oil.
Whizz together to combine, then season to taste with salt
and pepper. The dip should be thick and slightly grainy in
texture. If you like it a little smoother, just add another
tablespoon or two of olive oil.

Transfer to a serving bowl, drizzle with olive oil
and scatter over some extra chilli flakes (if using).
Accompany with lemon wedges and homemade crackers.

makes 500 ml

potato
GARLIC
gratin

A great all-rounder, this creamy potato
bake goes with just about anything. It pairs
particularly well with roast lamb, such as
the slow-cooked lamb on page 193. It's also
a winner for dinner parties, as you can
assemble it all in the morning, keep it
in the fridge, then throw it into the oven
as your guests arrive, leaving you free
to spend time with them rather than slaving
over a hot hob.

6–8 LARGE WAXY POTATOES, PEELED AND VERY
 FINELY SLICED USING A MANDOLINE
650 ML WHIPPING CREAM
3 LARGE GARLIC CLOVES, VERY THINLY SLICED
50 G BUTTER
SEA SALT AND FRESHLY GROUND BLACK PEPPER

Serves 6

Preheat the oven to 160°C (fan), 180°C, gas
mark 4.

Place a layer of potato slices in the bottom
of a casserole dish measuring about 20 cm x
30 cm x 6 cm and pour a thin layer of cream over
the top. Dot with a few slices of garlic and
a couple of knobs of butter, then season with
a little salt and a good grind of black pepper.
Repeat until all the potatoes are used up.
Top the final layer with the remainder of
the cream, butter and salt and pepper.

Bake for 1–1½ hours or until the potatoes
are cooked through and the top is crispy
and golden brown. Serve piping hot.

I'm Irish, and to 99% of the rest of the world that means I eat potatoes for breakfast, lunch and dinner. To be honest, I only eat potatoes occasionally, but I will admit that nothing beats a super-crunchy roast potato (see page 226), or a good, creamy mash like this one. I was at an Irish wedding a few years ago and overheard a guest complaining to the waiter, 'You've served me roast and boiled potatoes — but where's my mash?'

For this, I put the potatoes through a ricer as I hate lumps of any shape or form, even teeny-tiny ones. And I should add a disclaimer here: this is not a dish for diet days.

Katie's IRISH mash

6 LARGE FLOURY POTATOES,
 PEELED AND CUT IN HALF
FINE SALT
180 ML MILK
80 ML WHIPPING CREAM
3 TABLESPOONS BUTTER, PLUS EXTRA TO SERVE
1 TEASPOON WASABI PASTE
SEA SALT AND FRESHLY GROUND BLACK PEPPER
1/4 WHITE CABBAGE, CORED AND VERY THINLY SLICED
5 SPRING ONIONS, FINELY SLICED

Topping
LARGE KNOB OF BUTTER *OR* 1 TABLESPOON
 EXTRA VIRGIN OLIVE OIL
HANDFUL FINELY SLICED WHITE CABBAGE
3 SPRING ONIONS, TRIMMED AND FINELY SLICED
HANDFUL PINE NUTS
1 TEASPOON SESAME SEEDS

Serves 4

Place the potatoes in a large saucepan of salted boiling water and bring to the boil. Cook for about 30 minutes or until a knife can be inserted easily through the middle. Drain the potatoes well, then return to the pan and mash until smooth (or pass them through a ricer for an extra-smooth texture).

Add the milk to the mashed potato. Return the pan to a very low heat and gently warm while whipping the milk into the potatoes using a wooden spoon. When the milk and potatoes are well mixed, add the cream and butter and whip to combine. Add the wasabi paste and season with a generous amount of salt and pepper. Cover and keep warm over a low heat.

Cook the cabbage in boiling salted water for about 6–8 minutes until tender yet slightly crisp. Drain well, then add to the potato along with the spring onions, and combine everything together well.

To make the topping, place the butter or olive oil in a frying pan over a medium heat. Add the cabbage, spring onions, pine nuts and sesame seeds. Toss in the butter or oil and cook for 5–10 minutes until the pine nuts are roasted and everything is a little crispy and crunchy.

To serve, gently warm the mashed potato until piping hot. You can always add a little extra milk at this stage to make sure the mash is very soft and light.

Transfer the mashed potato to a warm serving bowl, add an extra knob of butter and scatter with the topping. Season with extra freshly ground black pepper and serve.

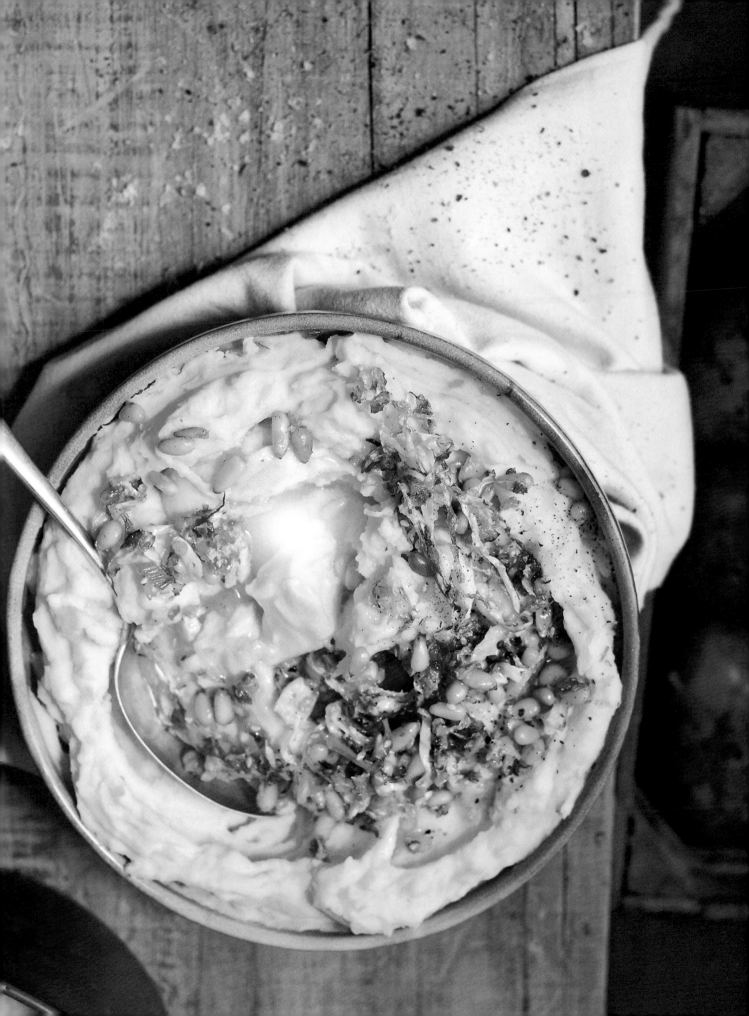

SLOW-COOKED
red cabbage *with*
apples and SULTANAS

This is another 'in-laws staple' that I've enjoyed many times
over the years at family get-togethers. I've always leaned more
towards red cabbage than white, and it's only been in recent
years that I have started to eat cooked cabbage at all,
preferring to have it raw in salads so it retains its crunch
and texture. This cooked version is a lovely flavoursome dish,
with the apple and redcurrant giving it a fruity sweetness.

60 G BUTTER
30 G CASTER SUGAR
100 ML WHITE WINE VINEGAR
1 TEASPOON SEA SALT
1 KG RED CABBAGE, CORED, LEAVES FINELY SHREDDED
$1^1/_2$ TABLESPOONS GREEN APPLE, PEELED AND GRATED
2 TABLESPOONS SULTANAS
3 TABLESPOONS REDCURRANT JELLY
2-3 THYME SPRIGS, LEAVES PICKED
FRESHLY GROUND BLACK PEPPER

Preheat the oven to 160°C (fan), 180°C, gas mark 4.

Place the butter, sugar, vinegar, salt and 125 ml
water in a flameproof casserole dish with a lid. Heat
over a medium heat until the butter is melted and the
ingredients are combined. Add the cabbage and toss
until coated and moistened. Bring to the boil, then
cover the dish and place it in the oven. Cook for
2 hours, checking occasionally and adding a little
water if you think it needs it.

Remove the casserole dish from the oven and stir
in the apple, sultanas and redcurrant jelly. Cover
with the lid and return to the oven for another 10-15
minutes before serving, scattered with thyme
and pepper.

serves 4-6

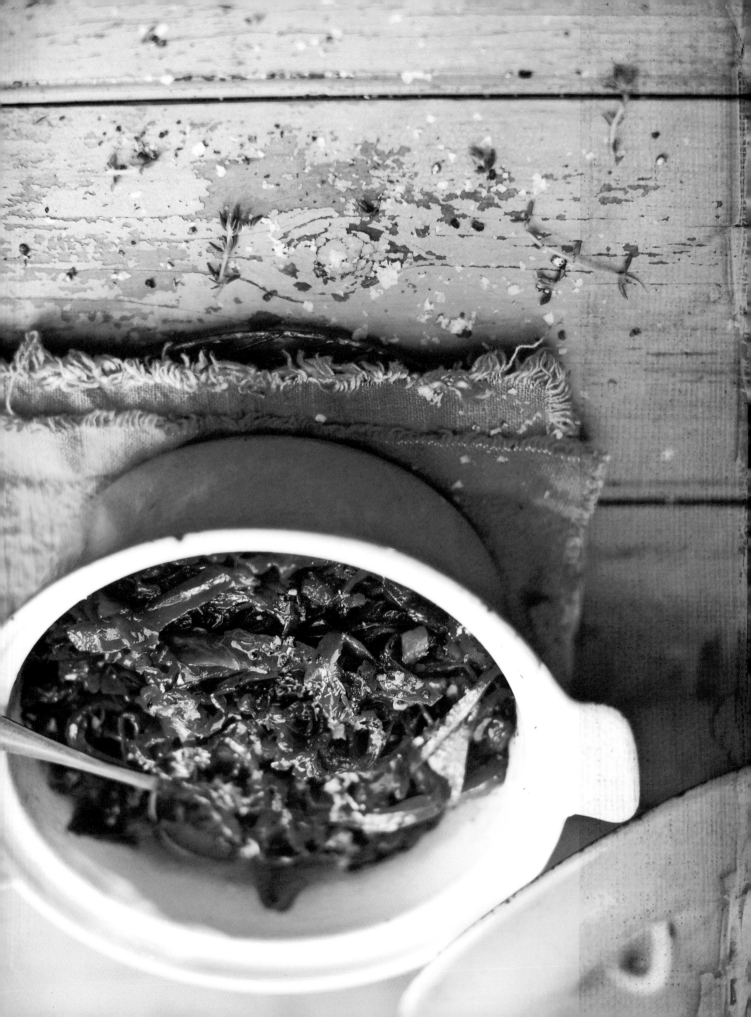

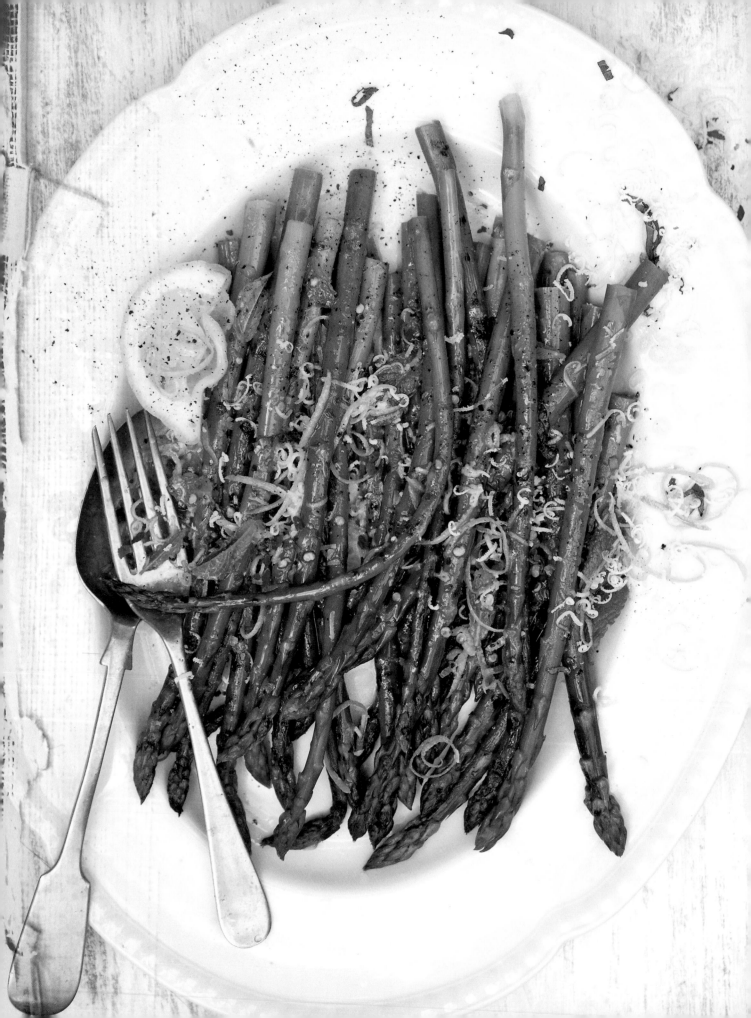

Asparagus with CHILLI, lemon and mint

Like a lot of green vegetables, asparagus can at times be pretty bland, so this recipe works a treat to jazz it up a bit. Chargrilling certainly helps – it tends to bring out the flavour. I always find lemon juice a great accompaniment to broccoli (or at least I can seem to eat a lot more of the latter when there is lots of the former squeezed over it), and it works well here too. The chilli adds a nice little kick. Feel free to use very finely chopped long red chillies instead of dried chilli flakes if you prefer.

FINE SALT
300 G ASPARAGUS SPEARS, WOODY ENDS REMOVED
HANDFUL MINT LEAVES, FINELY CHOPPED
ZEST AND JUICE OF 1 LEMON (ZEST REMOVED IN
 THIN STRIPS USING A CITRUS ZESTER)
PINCH DRIED CHILLI FLAKES
SEA SALT AND FRESHLY GROUND BLACK PEPPER
RAPESEED OR OLIVE OIL SPRAY
GRATED PARMESAN AND LEMON WEDGES, TO SERVE

Serves 4

Half-fill a saucepan with cold water, add a pinch of salt and bring to the boil. Add the asparagus and boil for 2 minutes. Remove and drain, then plunge into a bowl of iced water and leave for 5 minutes. Drain again and pat dry.

Mix the mint, lemon zest and juice, chilli flakes and salt and pepper together and set aside.

Heat a chargrill pan over a high heat until smoking. Spray with a little oil, then add the blanched asparagus. Reduce the heat to medium and add half the mint, lemon and chilli mixture. Cook for 1-2 minutes or until lightly charred, then turn over the asparagus using tongs, add the remaining mixture and cook the other side.

Transfer the asparagus to a serving bowl, along with any mixture remaining in the pan. Season with pepper and scatter with Parmesan. Serve with lemon wedges for squeezing over.

CHERRY Sauce ⇒

A simple, flavour-packed sauce that is very versatile. Serve it as
an accompaniment to pork cold cuts, roast lamb or duck. It also makes
a fantastic pairing with good-quality chocolate or vanilla ice cream.

300 G CHERRIES, STONED
125 ML KIRSCH LIQUEUR
2 TABLESPOONS CASTER SUGAR
1 TABLESPOON FRESH LIME JUICE

makes approximately 250 ml

Place all the ingredients in a heavy-based saucepan, bring to the boil, reduce
the heat and simmer until the sugar has dissolved. Reduce the heat to low and
simmer for 30 minutes until reduced to a thick, glossy syrup.

Strain, discarding any remaining large pieces of cherry, then allow the syrup
to cool. Store in a sterilised jar (see page 11) in the fridge for up to 1 month.

Balsamic BEETROOT relish

This is fantastic served with all kinds of roast meats, and is even better the
next day in a cold-meat sandwich. I find if you halve the beetroot before roasting
them, the skin tends to come away slightly from the flesh and makes for easier
peeling – in fact, you can then usually just pull the skin away.

2 BUNCHES MEDIUM-LARGE BEETROOT (ABOUT 8-10), TRIMMED AND HALVED
100 ML OLIVE OIL
3 TABLESPOONS BALSAMIC VINEGAR
SEA SALT
1 RED ONION, FINELY CHOPPED
55 G BROWN SUGAR
125 ML WHITE WINE VINEGAR
3 TABLESPOONS LEMON JUICE
1 TEASPOON THYME LEAVES

makes 1 litre

Preheat the oven to 180°C (fan), 200°C, gas mark 6.

Place the beetroot on a baking sheet and drizzle with 1 tablespoon olive oil
and the balsamic vinegar. Sprinkle with salt. Roast for 50 minutes-1 hour until
the beets are caramelised and tender. Remove from the oven and leave to cool for
10 minutes, then, wearing thin rubber gloves to prevent the beetroot juices
staining your fingers, peel away the skins.

Place the beetroot in a food processor or blender and pulse until smooth,
drizzling in 3 tablespoons olive oil, and blending until the mixture is a
thickish pulp.

Heat 1 tablespoon olive oil in a small saucepan over a medium heat and sauté the
onion until soft. Add the sugar, white wine vinegar and lemon juice and stir to
combine. Add the beetroot purée and thyme and simmer for 30 minutes until reduced
slightly and relish-like.

Store in a sterilised jar (see page 11) in the fridge for up to 1 week.

Roasted ONION RINGS with thyme

These little gems are super-simple and take hardly any time to prepare.
The roasting results in sweet, beautifully textured little onion rings.
When they are cooked, they should just fall apart into rings. I find it
difficult not to pick at them straight from the oven, especially the extra
crispy, caramelised outer ones. These are great to serve with a burger or with
any grilled or roasted meats.

8-10 BABY BROWN ONIONS (I LIKE TO USE PICKLING ONIONS),
HALVED WIDTHWAYS, SKIN ON
OLIVE OIL, FOR DRIZZLING
SEA SALT AND FRESHLY GROUND BLACK PEPPER
4-5 THYME SPRIGS

Serves 6

Preheat the oven to 180°C (fan), 200°C, gas mark 6.

Place the onions on a baking tray. Drizzle with olive oil, season
with salt and pepper and scatter a few thyme sprigs on top. Roast for
40-50 minutes or until the onions are slightly caramelised and crispy
on top. Peel off the skins (they should come away easily with the
top layer of onion) and serve.

Caramelised ONION jam

This thick, sweet and very yummy onion jam is the base for my Caramelised
Onion and Goat's Cheese Tartlets (see page 62), but you could also serve it
with a good mature Cheddar as part of a cheeseboard, or spread on a grilled
cheese sourdough sandwich.

4 LARGE ONIONS, PEELED AND FINELY SLICED
2 TABLESPOONS OLIVE OIL
SEA SALT FLAKES
3 TABLESPOONS BALSAMIC VINEGAR (PLUS A BIT EXTRA IF REQUIRED)
$1^1/_2$ TABLESPOONS SOFT BROWN SUGAR

makes 375 *ml*

Place the onions in a large, deep heavy-based saucepan and drizzle
with olive oil. Using a wooden spoon, stir the onions to coat
thoroughly with the oil, then season with a pinch of salt.
Cook over a medium-high heat for about 15 minutes or until softened.
Reduce the heat to low and continue cooking for a further
30 minutes, stirring frequently to scrape any sticky bits from
the bottom of the pan.

Add the vinegar and sugar and stir to coat well. Continue to cook over
a low heat for another 30-45 minutes, again scraping all the sticky
bits from the bottom of the pan. Add a splash more vinegar if the
jam becomes too sticky — the consistency should be that of a thick,
luscious marmalade. Set aside to cool.

Store in a sterilised jar (see page 11) in the fridge for up to 1 week.

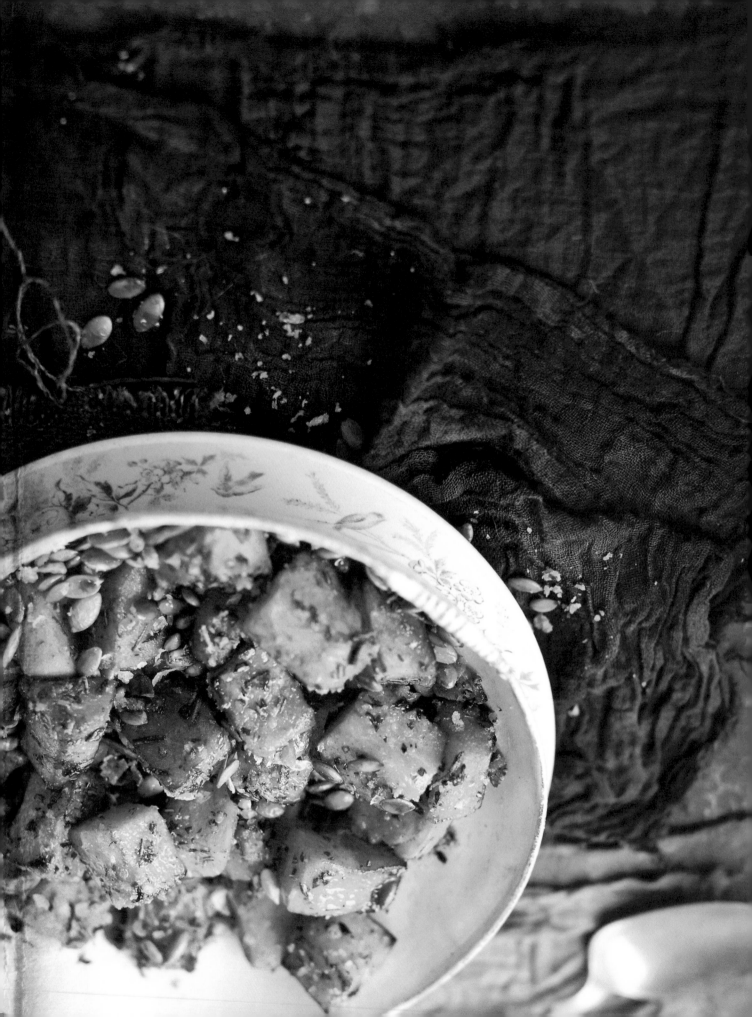

This dish is jam-packed with contrasting textures. The pumpkin is roasted with beautiful aromatic cumin and fresh rosemary, then paired with crunchy toasted pumpkin seeds (a favourite snack of mine), then it's all topped off with a further layer of crunch in the form of pangrattato, which is Italian for breadcrumbs. This is a good accompaniment to roast pork or pork chops.

№. 225

Spicy PUMPKIN with roasted pumpkin seeds and PANGRATTATO

3 TABLESPOONS OLIVE OIL
2 TEASPOONS GROUND CUMIN
2 ROSEMARY SPRIGS, LEAVES PICKED AND FINELY CHOPPED
1 KG PUMPKIN, PEELED AND CUT INTO 2.5 CM CUBES
SEA SALT AND FRESHLY GROUND BLACK PEPPER
65 G PUMPKIN SEEDS
1 TEASPOON OLIVE OIL

Pangrattato

2 TABLESPOONS OLIVE OIL
2 GOLDEN SHALLOTS, FINELY DICED
35 G SOURDOUGH BREADCRUMBS
SMALL HANDFUL SAGE LEAVES, FINELY CHOPPED,
 PLUS EXTRA LEAVES TO GARNISH
SMALL HANDFUL FLAT-LEAF PARSLEY LEAVES, FINELY CHOPPED
SEA SALT AND FRESHLY GROUND BLACK PEPPER

Serves 4

Preheat the oven to 240°C (fan), 250°C, gas mark 10.

Combine the 3 tablespoons olive oil, cumin and rosemary in a bowl, then add the pumpkin and stir to coat evenly. Season with salt and pepper, then transfer to a baking tray. Cook for 35–40 minutes until the pumpkin is soft when pierced with a skewer. Remove from the oven and reduce the oven temperature to 200°C (fan), 220°C, gas mark 7. Cover the pumpkin to keep it warm.

Scatter the pumpkin seeds on a baking tray, season with salt and black pepper and drizzle with the teaspoon olive oil. Cook for 10–15 minutes or until roasted and golden brown.

Meanwhile, to make the pangrattato, warm the olive oil in a frying pan over a medium heat. Add the shallots and cook for 5 minutes, stirring often. Tip in the breadcrumbs and herbs and fry, stirring frequently to coat with the oil. Season with salt and pepper. When the crumbs are starting to turn a light golden brown (5–10 minutes), remove them from the heat.

To serve, place the roasted pumpkin in a large serving bowl and scatter with the roasted pumpkin seeds and pangrattato.

SUPER-CRUNCHY
roast *potatoes*

My mum made the best roast potatoes ever — they were super-crunchy
and crisp. For years, I've tried to replicate them, and this is
what I've learnt along the way. Firstly, once you've par-boiled
the potatoes, drain them well and return them to the pan, then shake
them vigorously to rough them up nicely (you could fluff them up
with a fork as well, for extra crunchiness). Secondly, never try and
roast potatoes in a glass or ceramic dish — it must be metal to make
sure they get really crispy. Finally, if your potatoes are large,
cut them in half or quarters, as the more edges you have on your
potatoes, the crunchier they will be.

8 LARGE FLOURY POTATOES, PEELED
FINE SALT
80 ML RAPESEED OR SUNFLOWER OIL
2 ROSEMARY SPRIGS, LEAVES PICKED
SEA SALT

Serves 4-6

Preheat the oven to 220°C (fan), 240°C gas mark 9.

Cut the potatoes in half lengthways, then again widthways. Half-fill a large
deep saucepan with cold water, add salt and the potato pieces. Bring to the boil
over a high heat, then reduce the heat to medium and simmer for 15-20 minutes
or until a knife can be inserted easily into the potatoes but there's just a
little resistance in the centre. You want to just par-boil the potatoes; if you
overcook them at this stage, they will become too mushy.

Drain the potatoes in a colander, then return them to the saucepan. Cover
with the lid and give the pan a really good shake to fluff up the potatoes;
these soft, loose edges will become really crispy during roasting. If you
want, you can scrape the edges and tops of the potatoes with a fork to
create even more fluffy bits.

Add the oil to a deep roasting tin and place in the oven for 10 minutes until
smoking hot. Remove the roasting tin and reduce the oven temperature to 200°C
(fan), 220°C, gas mark 7. Carefully add the potatoes to the hot oil, then
sprinkle over the rosemary leaves and crumble a bit of sea salt on top.

Return to the hot oven and roast for 50 minutes-1 hour or until the potatoes
are really crispy and a gorgeous golden brown. Feel free to turn the spuds
halfway through to ensure even browning.

Serve piping hot in a serving bowl, with an extra sprinkle of sea salt.

Spicy *vine* tomato RELISH

makes 1 x 500 ml jar

I adore making chutneys — it's easy and I find the process hugely relaxing. It's rustic, simple cooking at its best, utilising the freshest fruit and veggies you can find. This relish pairs exceptionally well with a good mature Cheddar cheese, or the Aussie Chilli Burgers on page 144.

3 LARGE HANDFULS BABY VINE-RIPENED TOMATOES
3 GARLIC CLOVES, PEELED
OLIVE OIL, FOR DRIZZLING
2 THYME SPRIGS, LEAVES PICKED
SEA SALT AND FRESHLY GROUND BLACK PEPPER
1 X 400 G TIN CHOPPED TOMATOES
3 GOLDEN SHALLOTS, FINELY CHOPPED
180 ML WHITE WINE VINEGAR
110 G BROWN SUGAR
1 TEASPOON MUSTARD POWDER
$1/_2$ TEASPOON DRIED CHILLI FLAKES
$1/_2$ TEASPOON ALLSPICE

Preheat the oven to 120°C (fan), 140°C, gas mark 1.

Place the vine-ripened tomatoes and the garlic on a baking tray. Drizzle with olive oil and sprinkle with thyme, salt and pepper. Roast for 1–1$1/_2$ hours until the tomatoes have softened and are slightly blackened around the edges.

Squeeze the roasted garlic pulp from the cloves and place in a saucepan, along with the roasted tomatoes and all the other ingredients. Bring to the boil, then reduce the heat to medium and simmer for 1–2 hours until the relish has reduced to half or a quarter of its original volume. Remove from the heat and leave to cool slightly.

Store in a sterilised jar (see page 11) in the fridge for up to 1 week.

SPICY VINE
TOMATO RELISH

Roasted pepper and
AUBERGINE CHUTNEY

This is another awesome chutney recipe that I make all the time, to team with cheese platters and cold meats. It's pretty much foolproof and a breeze to make.

1 LARGE AUBERGINE
OLIVE OIL, FOR COOKING
SEA SALT AND FRESHLY GROUND BLACK PEPPER
3 RED PEPPERS
3 GOLDEN SHALLOTS, FINELY CHOPPED
2 GARLIC CLOVES, VERY FINELY CHOPPED
250 ML APPLE CIDER VINEGAR
110 G CASTER SUGAR
1 TEASPOON SMOKED PAPRIKA

Makes 1 x 750 ml jar

Preheat a barbecue or chargrill pan to hot. Cut the aubergine lengthways into 1 cm thick slices, then drizzle with olive oil and sprinkle with salt. Grill on each side until the flesh is soft and browned. Set aside to cool, then remove the skin, cut each slice into large pieces and place in a medium-sized saucepan.

Preheat the oven to 160°C (fan), 180°C, gas mark 4. Cut the peppers in half lengthways and remove the stalk, membrane and seeds. Rub the skins with a little olive oil, then place the peppers, cut-side down, on a baking tray and roast for about 1 hour or until the skins are blackened. Remove from the oven, then place in a bowl, cover with cling film and set aside for 10 minutes. Peel off the charred skin (I use thin rubber gloves to do this), then cut the peppers into chunks and add to the saucepan with all the other ingredients.

Bring to the boil, stirring occasionally to prevent the caramelised bits sticking to the base of the pan. Reduce the heat to low and simmer gently for 1½-2 hours, stirring occasionally, until thickened and reduced. Leave to cool.

✎ *mint* and CAPER sauce

makes about 250 ml

I'm a huge fan of Colman's mint sauce. It was part
of my childhood, and I could eat it by the spoonful straight
from the jar (it's a vinegar thing — I adore it). It's hard to
find here in Australia, so I've been determined to make my own
that is just as good — there's nothing like making your own
sauces and relishes to go with your home-cooked food. After much
experimentation, here's the result (by the way, it's dead simple
to make and goes well with just about any roasted meats,
especially lamb).

3 LARGE HANDFULS MINT LEAVES
1 TEASPOON CASTER SUGAR
2 TABLESPOONS APPLE CIDER VINEGAR
1 TABLESPOON VERJUICE
50 G SALTED CAPERS, RINSED
SEA SALT AND FRESHLY GROUND BLACK PEPPER

Place all the ingredients in a food processor or blender
and whizz until the mint is very finely chopped.
Refrigerate until required.

PESTO

makes about 1 x 500 ml jar

This is a great staple to have on hand to add to pasta dishes
or stir into soups. Use the freshest basil you can find to
produce a vivid green sauce, and bring out the best extra
virgin olive oil in the store cupboard for this — it's worth it.

3 LARGE HANDFULS BASIL LEAVES
100 G PARMESAN, GRATED
75 G PINE NUTS
250 ML EXTRA VIRGIN OLIVE OIL
SEA SALT AND FRESHLY GROUND BLACK PEPPER

Place the basil, Parmesan and pine nuts in a food processor or
blender and whizz to combine while slowly drizzling in the olive
oil. Blend until smooth, then season with salt and pepper. Store
in a sterilised jar (see page 11) in the fridge for up to 1 week.

DESSERTS

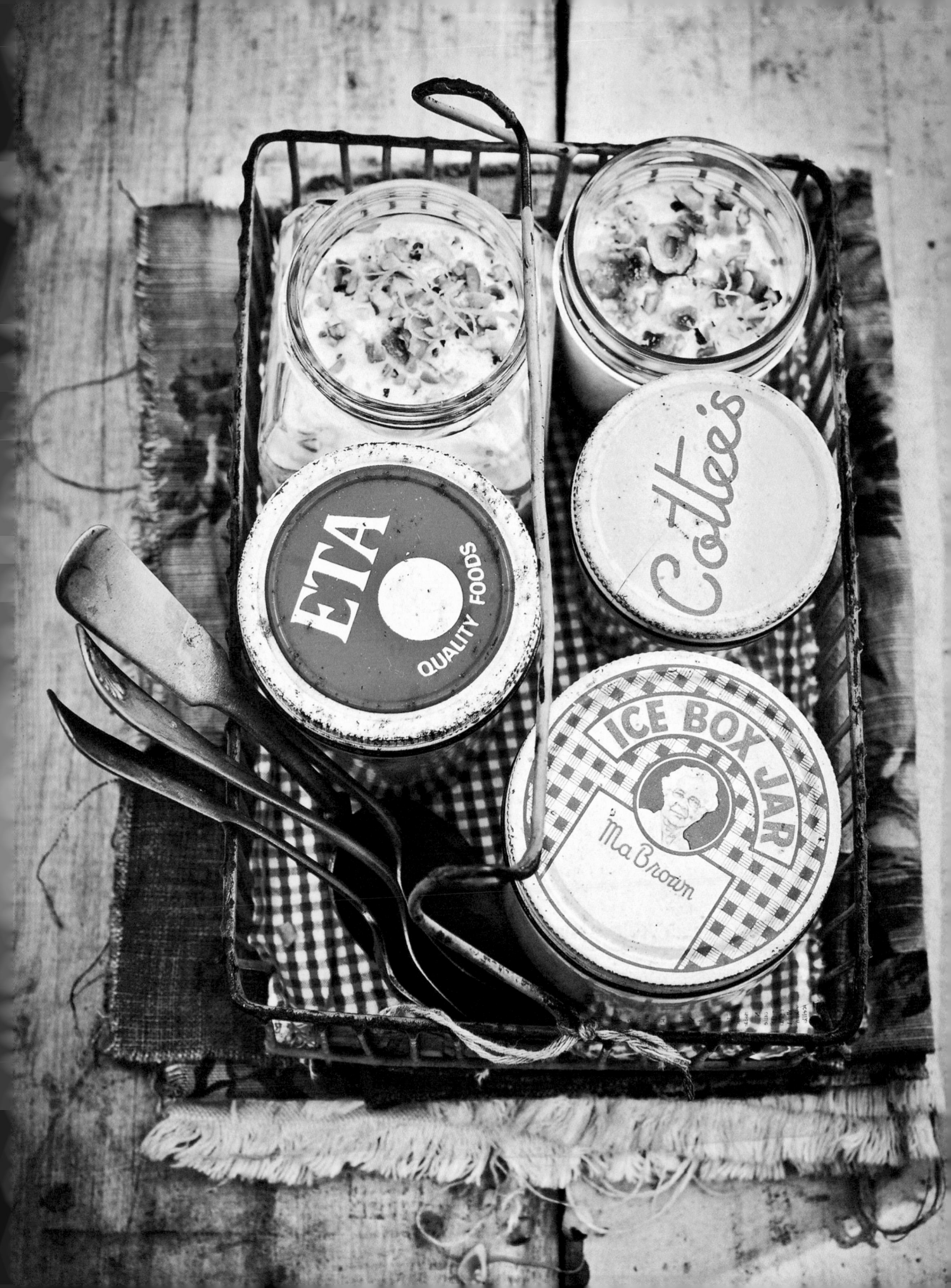

Lemon, *lime* and ginger mousse
with HAZELNUT CRUNCH

These mousses are wonderfully zingy and light — perfect for
a summer's day. I like to serve them in mismatched vintage
glass jars. They're also a great dessert to take on a picnic
as they're nice and portable.

210 G HAZELNUTS
8 SAVOIARDI BISCUITS
300 ML WHIPPING CREAM
50 G CASTER SUGAR
1 X 1 CM PIECE GINGER, PEELED AND FINELY GRATED (ABOUT $\frac{1}{4}$ TEASPOON GRATED GINGER)
FINELY GRATED ZEST AND JUICE OF 1 LEMON AND 1 LIME, PLUS EXTRA ZEST REMOVED
 IN THIN STRIPS USING A CITRUS ZESTER, TO SERVE
2 FREE-RANGE EGG WHITES

Serves 6-8

Preheat the oven to 180°C (fan), 200°C, gas mark 6. Place the
hazelnuts on a baking tray and roast them for 10 minutes until
lightly golden.

Place the savoiardi biscuits into a Zip-lock bag and, using
a rolling pin, crush them into medium crumbs. Place 175 g of
the roasted hazelnuts (reserving the rest for decorating) in a
separate Zip-lock bag and crush them to a fine texture using a
rolling pin; alternatively, you could use a mortar and pestle or
gently whizz them in a food processor if you prefer. Combine the
biscuit crumbs and nuts and mix well, then spoon a generous
tablespoon into each serving jar, glass or bowl, and set aside.

Meanwhile, whisk the cream, sugar, ginger and citrus juices
and zests together in a large mixing bowl until just thickened
(the mixture should have a similar consistency to lightly
whipped cream). Using an electric mixer, beat the egg whites
until soft peaks form then, using a spatula or a large spoon,
gently fold the whisked egg whites into the cream mixture.
Transfer to a large jug and pour into the serving jars, glasses
or bowls, then leave to set in the fridge for 3-4 hours.

Roughly crush the remaining 35 g of hazelnuts and scatter
on top, then sprinkle with thin strips of lemon and lime zest
and serve.

Raspberry
FRIANDS

I featured these little cakes on the blog a year or two ago,
and I've never received so many compliments from my
girlfriends (who claim they can't cook!). They love making
them for all sorts of occasions, including baby showers,
hen nights and engagement parties. Raspberries pair so
well with almonds, but chopped peaches, pears, plums
or cherries would work just as well.

10 FREE-RANGE EGG WHITES
300 G UNSALTED BUTTER, MELTED
175 G GROUND ALMOND
370 G ICING SUGAR, SIFTED, PLUS EXTRA FOR DUSTING
100 G PLAIN FLOUR, SIFTED
2 X 125 G PUNNETS RASPBERRIES, PLUS EXTRA TO SERVE

Preheat the oven to 180°C (fan), 200°C, gas mark 6. Lightly
grease eighteen holes of two silicone friand moulds or non-
stick friand tins.

Whisk the egg whites for a few seconds just to
lightly combine; you don't need to whip them into
peaks or anything like that.

Add the butter, ground almonds, icing sugar and flour and
beat lightly to combine well. Pour into the prepared moulds
or pans, filling each hole two-thirds full.

Place two or three raspberries on top of each friand and bake
for 25-30 minutes or until a skewer inserted into the centre
comes out clean.

Dust the friands with icing sugar and serve warm, with extra
fresh raspberries if you like.

makes 18

This is an adaptation of a pavlova recipe that was given to me by my friend and colleague Ali Irvine to use in my Christmas 2011 blog feature. Ali's Christmas berry pavlova recipe was such a success that I was inspired to adapt it into individual mini meringue 'kisses'. I have always loved chocolate with raspberry and this combination, along with the addition of a little Amaretto liqueur, is a winner. To ensure perfect meringues each time, remember to rub the inside of the mixing bowl with the cut-side of a lemon before adding the egg whites, as the acid in the lemon will remove any oily residue from the bowl and will also help to stabilise the egg whites.

Mini raspberry and CHOCOLATE meringue kisses

$1/2$ LEMON
4 FREE-RANGE EGG WHITES, AT ROOM TEMPERATURE
220 G CASTER SUGAR
1 TEASPOON VANILLA EXTRACT
1 TEASPOON WHITE VINEGAR
$2^{1}/_{2}$ TEASPOONS CORNFLOUR
1 X 125 G PUNNET RASPBERRIES, CRUSHED TO A COARSE PULP WITH A FORK
175 G GOOD-QUALITY DARK CHOCOLATE, BROKEN INTO SMALL PIECES
500 ML WHIPPING CREAM
1 TABLESPOON AMARETTO

makes about 16

Preheat the oven to 140°C (fan), 160°c, gas mark $2^1/_2$. Line two baking trays with baking paper.

Wipe the inside of the bowl of an electric mixer with the cut-side of the lemon to remove any traces of oil. Add the egg whites and whisk until light and frothy. Add the caster sugar gradually, whisking on high speed until it has dissolved and the mixture is thick and glossy. Add the vanilla extract and vinegar, then sift the cornflour over the mixture and whisk lightly until combined. Add half the crushed raspberries and stir gently to combine.

Spoon the meringue mixture into a piping bag and pipe 3-4 cm peaked rounds onto the prepared trays until the mixture is used up. Bake for 1 hour or until the bases of the meringues are firm, swapping the trays over after 30 minutes. Turn the oven off and leave the meringues to cool in the oven for 1 hour, then remove and cool completely.

While the meringues are cooling, place the chocolate in a heatproof bowl. Heat 250 ml cream in a small saucepan over a medium heat until almost boiling. Remove the pan from the heat and pour over the chocolate. Leave to stand for 5 minutes before stirring to combine. Place the chocolate ganache in the fridge for 30-40 minutes, or until thickened. Spoon half the thickened ganache into a piping bag.

Whip the remaining 250 ml cream until stiff peaks form, fold in the Amaretto, then mix with the remaining ganache and crushed raspberries. Transfer to a second piping bag.

To assemble the meringue kisses, pipe a layer of chocolate ganache onto the flat side of one meringue, followed by a layer of raspberry chocolate cream, then sandwich together with a second meringue. Repeat until all the meringues, ganache and raspberry cream have been used.

Place in the fridge to chill for 15-20 minutes, then serve.

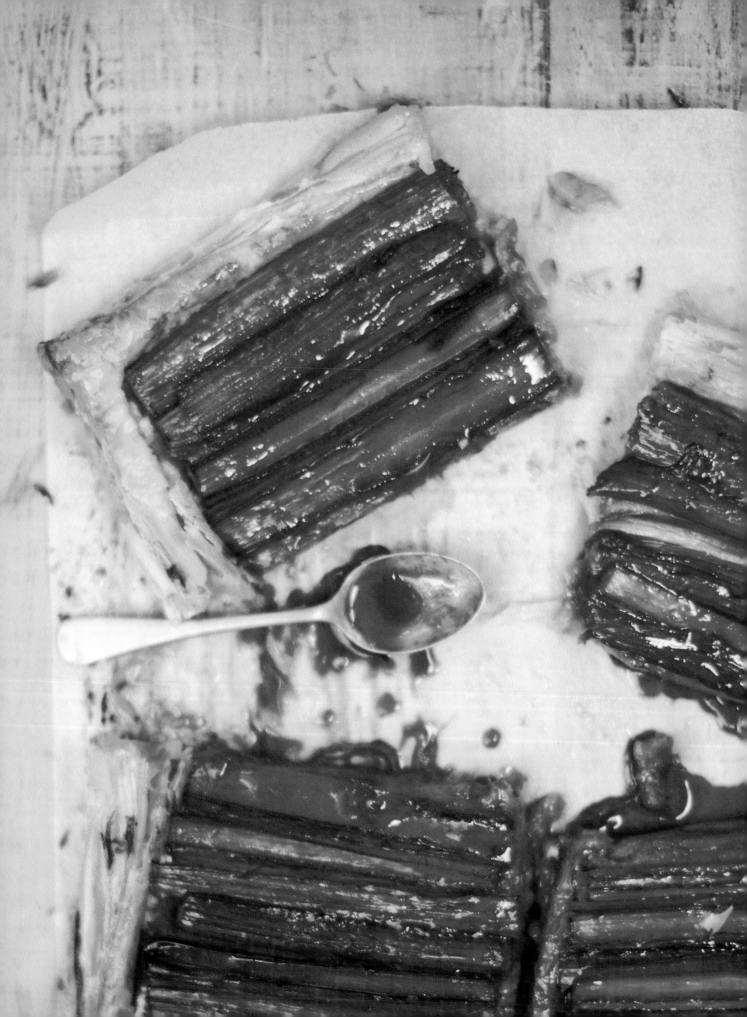

Rhubarb frangipane TART

This tart is a dinner-party staple at our house, as you can pretty much
prepare 90% of it hours in advance of your guests arriving. Make the
frangipane the night before, if you like, chilling it overnight in
a covered bowl in the fridge, then removing it an hour or two before you
wish to use it, to allow it to soften before spreading it on the pastry.
Same with the rhubarb — feel free to prepare this the day before and
set it aside in its juice in a small baking dish until required.

No rhubarb? No problems. Plums or cherries, stoned and cut in half,
work brilliantly in this dish, and they won't need any pre-cooking.
Just arrange them over the frangipane filling before baking.

1 LARGE BUNCH RHUBARB, TRIMMED
AND CUT INTO 10 CM LENGTHS
3 TABLESPOONS CASTER SUGAR
1 SHEET GOOD-QUALITY PUFF PASTRY
1 FREE-RANGE EGG MIXED WITH 2 TEASPOONS MILK

Frangipane filling
75 G UNSALTED BUTTER
60 G CASTER SUGAR
125 G GROUND ALMONDS
2 FREE-RANGE EGG YOLKS
1/2 TEASPOON VANILLA EXTRACT

Vanilla cream
1 VANILLA POD, SPLIT AND SEEDS SCRAPED
300 ML WHIPPING CREAM, WHIPPED
2 TEASPOONS CASTER SUGAR

Serves 4-6

Preheat the oven to 200°C (fan), 220°C, gas
mark 7.

To make the frangipane, place the butter,
sugar, ground almonds, egg yolks and vanilla
extract in a bowl and mix with hand-held
beaters or in a food processor. Chill in the
fridge for 10-15 minutes or until required,
taking care to bring it to room temperature
to soften before use.

Place the rhubarb in a large saucepan and add
the caster sugar and 500 ml water. Stir gently
and bring to a simmer over a medium heat, then
cook for 2 minutes or until the rhubarb is just
tender but not falling apart. Using a slotted
spoon, transfer the rhubarb to a plate and
allow to cool. Simmer the cooking liquid over
a medium heat for 5-7 minutes or until syrupy.

Place the puff pastry sheet on a clean work
surface and score a 1.5 cm border on all sides,
taking care not to cut all the way through.
Prick the pastry with a fork, avoiding the
border. Using a palette knife, spread the
frangipane evenly over the pastry, again
avoiding the border.

Lay the rhubarb lengths over the frangipane
in two rows. Brush the border with the egg
mixture, then transfer to the oven and bake
for 30-35 minutes or until the pastry is
cooked through and the edges are golden.

To make the vanilla cream, mix the vanilla
seeds with the whipped cream. Add the caster
sugar and gently fold into the cream to
combine. Serve the rhubarb tart warm with
the vanilla cream alongside.

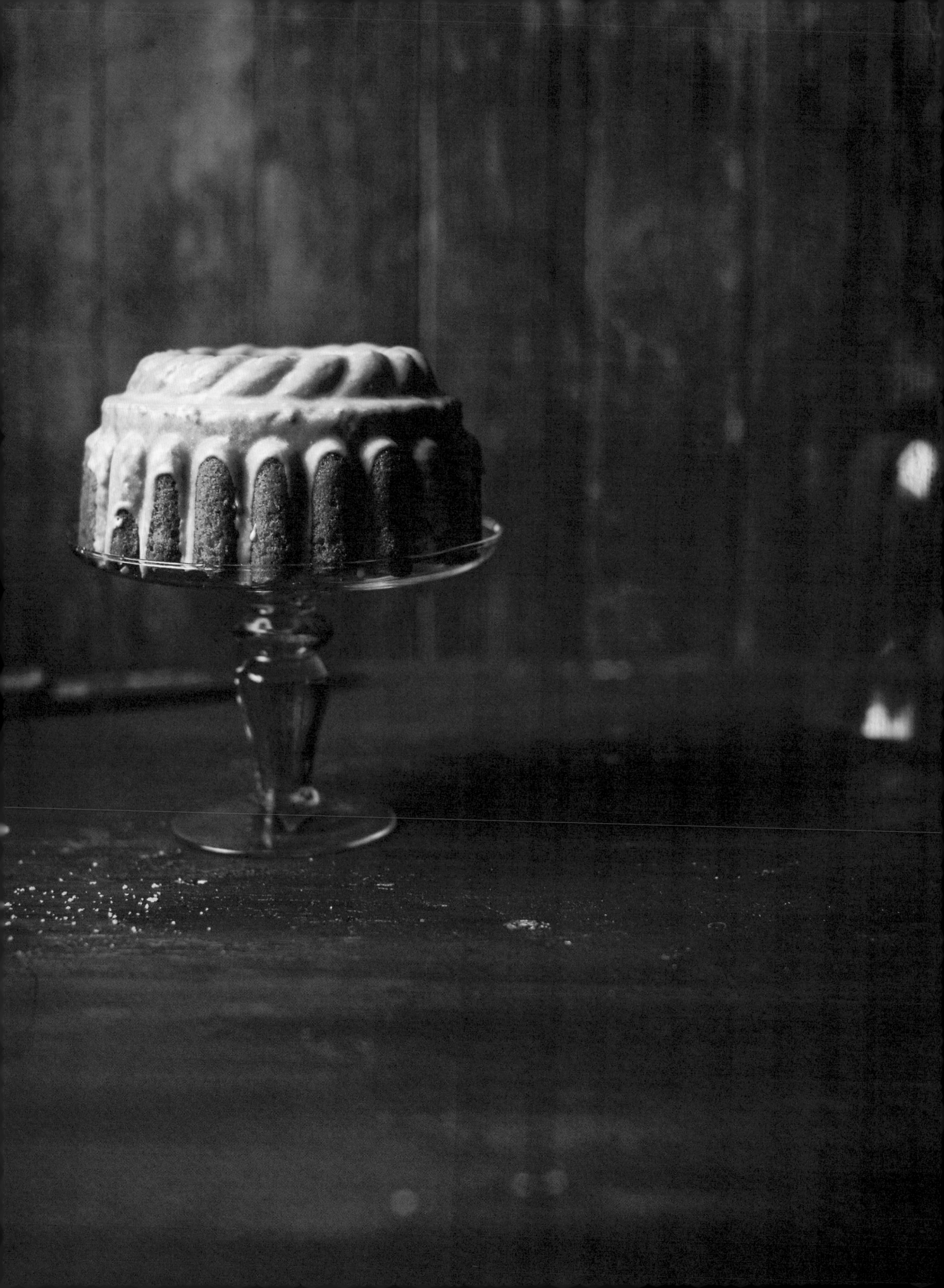

This recipe came to me after a shoot I did that was all about pairing herbs with fruit. Like many people, I hadn't realised just how wonderful some combinations of fruit and herbs can be. For example, blood oranges (one of my favourite fruits) go particularly well with rosemary. The juice from the blood oranges also makes for THE most pretty-coloured icing. A tip: when the blood orange season is coming to an end, buy as many as you can, squeeze out the juice into an airtight container or into small freezer bags and freeze to use later on. The frozen juice may separate a little when you defrost it, but it's still fine to use.

BLOOD ORANGE
and
rosemary
cake

Serves 8–10

225 G UNSALTED BUTTER, SOFTENED
220 G CASTER SUGAR
2 TEASPOONS COINTREAU
3 FREE-RANGE EGGS, BEATEN
1 BLOOD ORANGE, PEELED, PITH REMOVED
 AND CUT INTO SEGMENTS (SEE PAGE 23)
1 ORANGE, PEELED, PITH REMOVED AND CUT
 INTO SEGMENTS (SEE PAGE 23)
3 ROSEMARY SPRIGS, LEAVES PICKED
300 G PLAIN FLOUR, SIFTED
2 TEASPOONS BAKING POWDER, SIFTED

Blood orange syrup
JUICE OF 2 BLOOD ORANGES
JUICE OF 2 ORANGES
1 TABLESPOON CASTER SUGAR

Blood orange icing
JUICE OF 1 BLOOD ORANGE
320 G ICING SUGAR, SIFTED

Preheat the oven to 180°C (fan), 200°C, gas mark 6 and grease a 9 cm, 1.4 litre capacity bundt tin (alternatively, grease and line a 22 cm springform cake tin).

Use an electric mixer to cream the butter and sugar for 10 minutes until light and creamy. Add the Cointreau and the eggs and combine.

Whizz the blood orange, orange and rosemary in a food processor until the rosemary leaves are finely chopped and the oranges are blended to a pulp. Add to the butter and sugar mixture and beat together on low speed until combined.

In a separate bowl, mix together the flour and baking powder. With the mixer on low speed, gradually add the flour mixture to the butter and sugar mixture, beating between additions, until everything is well incorporated.

Pour the cake batter into the prepared tin. Bake for 45–50 minutes or until the top is golden and a skewer inserted into the centre comes out clean.

Meanwhile, to make the blood orange syrup, place the ingredients in a saucepan and bring to the boil, stirring constantly. Reduce the heat to medium and simmer, stirring occasionally, for 10–15 minutes or until the sugar has dissolved and the syrup has reduced by about a third. Keep warm until the cake is ready.

Leave the cake to cool a little before transferring it to a wire rack. Place a plate underneath the rack to catch any drips, then prick the top of the cake with a skewer and spoon the warm syrup over the cake and leave it to be absorbed.

Make the icing by combining the blood orange juice and icing sugar until smooth. Drizzle the icing all over the cooled cake, then chill the iced cake in the fridge for 20 minutes before serving.

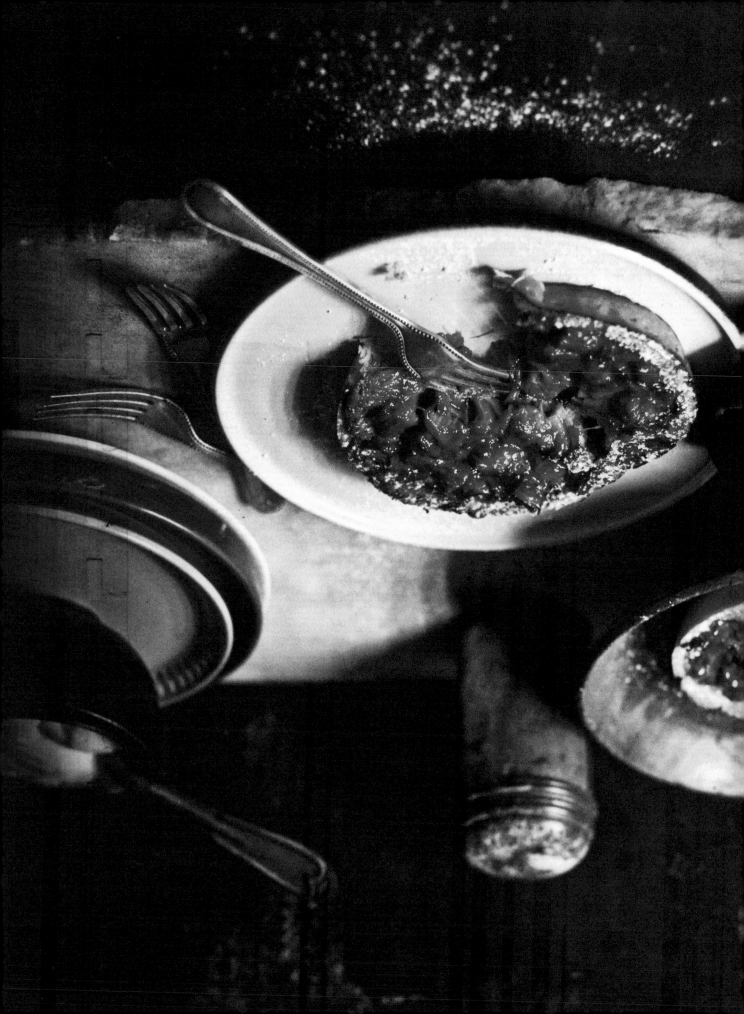

Rhubarb, MASCARPONE and *hazelnut tartlets*

These are marvellously tasty little tartlets, thanks to the piquancy of
the rhubarb, which is offset perfectly by the sweet pastry and crunchy
toasted hazelnuts. Make them in advance and reheat for 10 minutes in
the oven before serving. If you prefer, you can use cherries, apples
or even figs in place of the rhubarb.

1 SHEET SHORTCRUST PASTRY
 (BUY SWEET PASTRY IF YOU CAN)
50 G HAZELNUTS
35 G PLAIN FLOUR
2 TABLESPOONS BROWN SUGAR
3 HEAPED TABLESPOONS MASCARPONE
1 TEASPOON VANILLA BEAN PASTE
2 TEASPOONS FRANGELICO
8 RHUBARB STALKS, CUT INTO 2.5 CM LENGTHS
3 TABLESPOONS CASTER SUGAR
ICING SUGAR, FOR DUSTING

Serves 4

Preheat the oven to 200°C (fan), 220°C, gas mark 7 and grease four
individual non-stick tartlet tins (the ones I use measure 13 cm in
diameter).

Cut out four pastry rounds large enough to line the tins, then press them
into the tins. Line each pastry case with baking paper and fill with baking
beads or rice. Arrange the tins on a large baking tray, then place in
the oven and blind bake for 10-15 minutes or until just golden. Carefully
lift out the paper and beads or rice and bake for a further 5 minutes,
then remove the pastry cases from the oven and allow to cool slightly.

Scatter the hazelnuts over a baking tray and roast for 6-8 minutes until
lightly roasted, then rub off the skins in a clean, dry tea towel. Blitz
the nuts to a medium-fine sandy texture in a food processor, or chop very
finely by hand.

Combine the flour, brown sugar, mascarpone, vanilla bean paste, Frangelico
and hazelnuts in a bowl and stir thoroughly to make a thick paste.

Place the rhubarb, caster sugar and 125 ml water in a medium-sized saucepan
and bring to a simmer over a medium heat for 2-3 minutes. Remove the
rhubarb with a slotted spoon and place in a bowl, then simmer the liquid
over a medium-high heat for about 10-15 minutes or until it is reduced by
three-quarters and is a very thick, glossy syrup.

Spoon 1½ heaped tablespoons of hazelnut paste into each tartlet case and
smooth over the base. Top with the stewed rhubarb. Bake for 30 minutes
or until the pastry is golden and the rhubarb is fully cooked.

Brush the tops of the tartlets with the rhubarb syrup, dust with icing
sugar and serve.

BLOOD ORANGE, mango
and peach granita

Perfect for a cool treat on a warm summer's day lunch
or dessert at a barbecue, this granita, like the one
on page 286, is incredibly easy and quick to prepare
and can be made and frozen hours before serving.

1 MANGO, PEELED AND STONE REMOVED,
 FLESH CUT INTO SMALL PIECES
3 RIPE YELLOW PEACHES, PEELED AND STONED,
 FLESH CUT INTO CHUNKS
500 ML BLOOD ORANGE JUICE
JUICE OF 1 LEMON

Place all ingredients into a food processor and
whizz until smooth.

Have ready a baking tray that is at least 4 cm deep
and will comfortably sit flat on a shelf in your
freezer. Pour the mixture through a sieve onto the
tray, pressing firmly on the contents of the sieve
with the back of a spoon to get as much of the mixture
through as possible. Whatever you can't push through
the sieve, discard.

Carefully transfer the filled tray to the freezer
and freeze for at least 4 hours. When ready to serve,
scrape the frozen mixture into fluffy granita snow
using a fork, and serve in tall glasses or bowls.

Serves 4

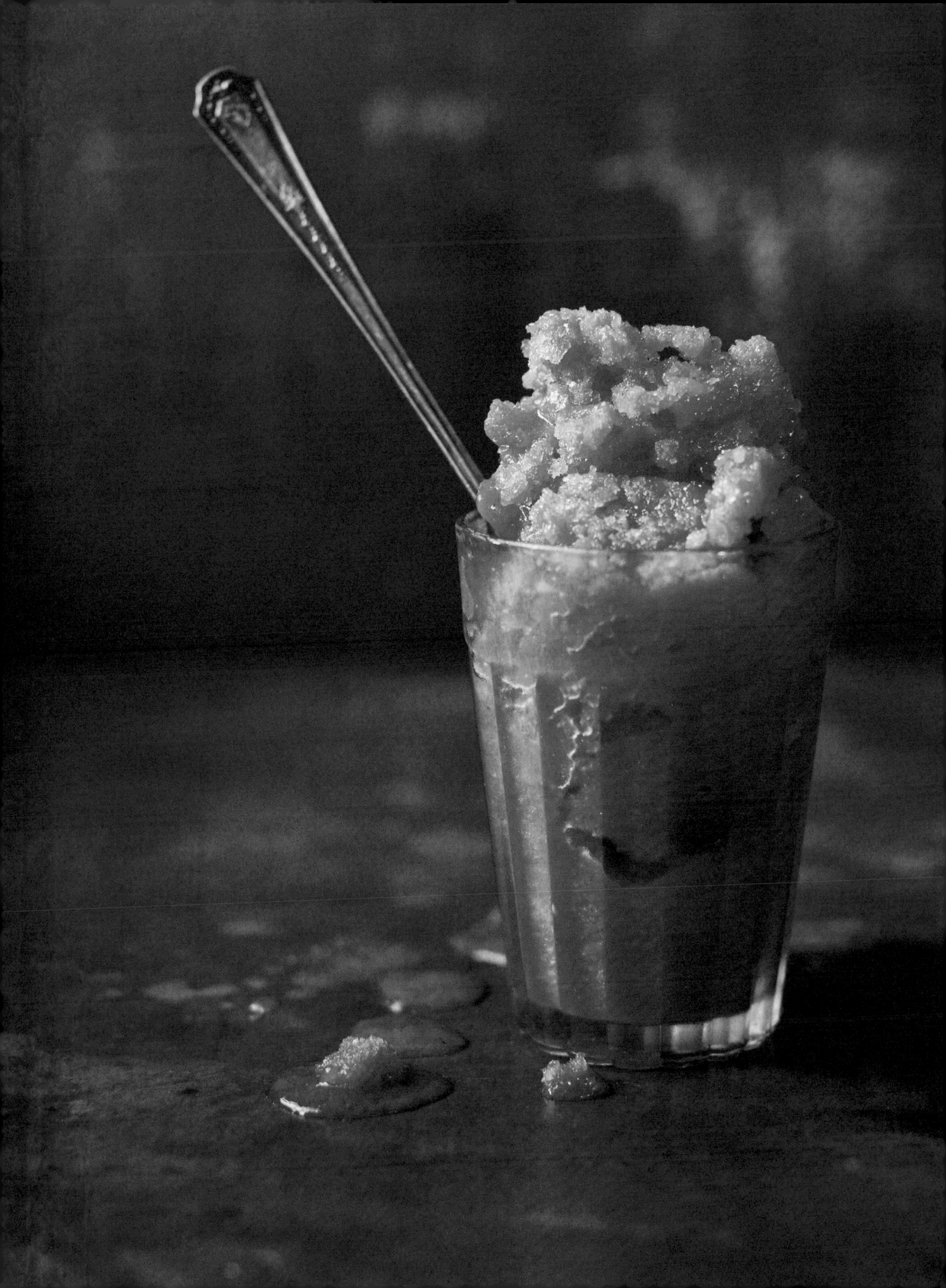

Personally, I've come to the conclusion that, if you're going to make
ice cream at all, you've got to go the whole hog — full-fat milk, full-fat
cream, etc etc. If not, honestly, what's the point?! This is decadent,
sweet, rich, creamy, nutty and caramely all rolled into one — I dare you
to stop munching it by the spoonful straight from the container. For best
results, make the ice-cream mixture the day before churning it.

Vanilla ICE CREAM with salted butterscotch sauce and honey-roasted almonds

140 G SLIVERED ALMONDS
1/2 TEASPOON CASTER SUGAR
2 TEASPOONS RUNNY HONEY
HANDFUL WHOLE ROASTED ALMONDS,
 OPTIONAL, TO SERVE

Vanilla ice cream

375 ML WHOLE MILK
220 G CASTER SUGAR
500 ML DOUBLE CREAM
250 ML WHIPPING CREAM
2 VANILLA PODS, SPLIT AND SEEDS SCRAPED

Salted butterscotch sauce

180 ML WHIPPING CREAM
165 G BROWN SUGAR
50 G UNSALTED BUTTER, CUBED
PINCH SEA SALT FLAKES

makes 1.5 litres

Preheat the oven to 180°C (fan), 200°C,
gas mark 6.

Line a baking tray with baking paper and
scatter over the slivered almonds. Sprinkle
with caster sugar and drizzle over the honey.
Roast for 10 minutes or until golden. Remove
the almonds from the oven, stir to coat
evenly, then set aside and allow to cool.

To make the ice cream, whisk the milk and
caster sugar together for 2 minutes until
the sugar has dissolved. Add the double and
whipping creams and vanilla seeds and stir
gently to break up the seeds as much as you
can (but don't worry too much if they still
clump together a little, as the ice-cream
machine will break them up as it churns).
Place in the fridge overnight.

To make the salted butterscotch sauce, place
all the ingredients in a small- to medium-
sized saucepan and bring to the boil over a
medium heat, stirring constantly. Reduce the
heat and simmer for 10 minutes, stirring
occasionally to prevent it from catching,
then remove from the heat and leave to stand
at room temperature to cool — the mixture
will thicken as it cools.

Remove the ice-cream mixture from the
fridge and pour into the bowl of an ice-
cream machine. Churn for 25-30 minutes or
as per the manufacturer's instructions,
until the consistency is that of a thick,
soft-serve ice cream.

Place 5 or 6 tablespoons of ice cream in
the bottom of a 1.5 litre capacity plastic
freezer container (I use one measuring
14 cm x 20 cm x 9 cm), then add a tablespoon
or two of the butterscotch sauce and gently
fold it through the ice cream: you are
looking for a ripple effect, rather than
an even layer of butterscotch. Scatter with
a handful of honey-roasted almonds. Repeat
two or three times, until all the ice cream
and sauce are used up, then scatter a
final handful of almonds on top. Serve
immediately, spooned into cups or bowls. (If
you prefer a harder ice cream, freeze for
1-2 hours before serving.) Serve scattered
with roasted almonds (if using).

STRAWBERRY, *basil* and BLACK PEPPER ice cream

№. 254

Here's another example (see page 247 for a great
blood orange and rosemary cake) of how amazingly good
pairing fruit with herbs can be. This ice cream features
basil and strawberry — a magical combo. I wondered if
introducing black pepper would work, and it did,
brilliantly. The colour is oh-so-pretty too!

350 G STRAWBERRIES, HULLED AND CUT
 INTO QUARTERS
330 G CASTER SUGAR
2 TABLESPOONS LEMON JUICE
2 TABLESPOONS LIME JUICE
HANDFUL BASIL LEAVES
1/2 TEASPOON FRESHLY GROUND BLACK PEPPER
375 ML WHOLE MILK
500 ML DOUBLE CREAM
250 ML WHIPPING CREAM
1 VANILLA POD, SPLIT AND SEEDS SCRAPED

makes 3 litres

Place the strawberries in a bowl with 110 g of
the caster sugar and the lemon and lime juices.
Mix well, then cover with cling film and place
in the fridge for 2 hours.

Add half the macerated strawberries to a food
processor, along with the basil leaves and black
pepper. Whizz for a few minutes to form a juicy
pulp, then set aside. Crush the remaining
macerated strawberries with a potato masher
and set aside until needed.

Using an electric mixer, whisk the milk and
remaining 220 g of the sugar together for
2 minutes until the sugar has dissolved. Add
the creams, the strawberry pulp from the
processor and the vanilla seeds, then gently
stir together. Place in the fridge overnight
if possible, or for at least 6-8 hours.

Churn in an ice-cream machine for 25-30 minutes
or as per the manufacturer's instructions,
adding the crushed strawberries 10 minutes
before the end of churning.

Spoon into small plastic containers or cups
to serve. (If you prefer a harder ice cream,
freeze for 1-2 hours before serving.)

Ice Cream

ONE HALF PINT
Mass. Standard Liquid Measure
Approved by the Director of Standards
for Massachusetts M-13

I first came across this dessert via my sister-in-law, who made it with oranges and toffee. I was intrigued by the flavours, plus it's a great recipe for a dinner party as you can make it in advance. I was inspired to make this version one Sunday morning, when my husband bought about 300 mandarins from a farmer who had knocked at our front door selling his wares (and who, by the way, talked WAY too loudly for 7.14 on a Sunday morning). Watch the toffee as it's cooking — it can spoil really quickly if you take your eyes off it. I generally put toffee in the freezer to harden, but you can just set it aside on the work surface — it will take a bit longer but will be just as good.

Orange blossom water and Persian fairy floss are available from some gourmet food stores or online at pariya.com.

CARAMELISED mandarins
with orange blossom TOFFEE
and fairy floss

70 G SHELLED PISTACHIOS
12 MANDARINS, PEELED AND PITH REMOVED
500 G CASTER SUGAR
1 TABLESPOON ORANGE BLOSSOM WATER
1 TEASPOON VANILLA EXTRACT
HANDFUL ORANGE-BLOSSOM-FLAVOURED PERSIAN FAIRY FLOSS, TORN
WHIPPED CREAM, TO SERVE (OPTIONAL)

Serves 4–6

Preheat the oven to 180°C (fan), 200°C, gas mark 6. Scatter the pistachios over a baking tray and roast for 10 minutes or until lightly roasted. Roughly chop.

To segment the mandarins, take the fruit in your hand and, holding it over a bowl to catch the juices, carefully cut each segment away from the membrane with a sharp knife, letting the segments fall into the bowl. Toss the segments in the juice, then arrange them on a heatproof tray. Scatter half the roasted pistachios on top, saving the rest to use as a decoration.

Bring the caster sugar, orange blossom water, vanilla extract and 200 ml water to the boil in a heavy-based saucepan. Do not stir, but rather swirl the saucepan occasionally. Boil for about 20 minutes or until the sugar syrup has thickened and is starting to turn a very light brown. Meanwhile, line a baking tray small enough to sit flat on a shelf in your freezer with baking paper.

Once the sugar syrup is a light golden brown, quickly spoon three-quarters of it all over the mandarin pieces (be careful, as they will sizzle as the syrup is super-hot), then place in the fridge to chill. Pour the remaining syrup onto the prepared baking tray and distribute evenly by gently tilting the tray (be mindful — the tray will be very hot from the syrup). Transfer to the freezer and leave until hardened (10–15 minutes).

Once the toffee is hard, remove it from the freezer. Place a piece of baking paper over the top and, using a hammer or rolling pin, smash the toffee into small pieces.

To serve, bring the mandarins to room temperature, then scatter them with the toffee pieces and remaining roasted pistachios. Top with fairy floss and serve with whipped cream, if you like.

These are great little sweets to serve with coffee at a dinner party. I use a 5 cm diameter cookie cutter to make bite-sized florentines, but you can make them as big or small as you like. Here are a couple of tips to make cooking these that bit easier. You need to get the timing just right when cutting the biscuit slab into rounds — it shouldn't be too hard or too soft. I have found, through trial and error, that the optimum time to do this is 4 or 5 minutes after the slab has come out of the oven. Another tip is to dot the corners of the baking tray with a small fingertip of the wet mixture to hold the baking paper in place.

Almond
and cherry
FLORENTINES

450 G CHERRIES, STONED
1 TEASPOON CASTER SUGAR
220 G ALMONDS
100 G UNSALTED BUTTER, CUBED
150 G BROWN SUGAR
175 G GOLDEN SYRUP
1 TEASPOON AMARETTO (OPTIONAL)
100 G PLAIN FLOUR, SIFTED
2 TEASPOONS GROUND GINGER
300 G GOOD-QUALITY DARK CHOCOLATE, BROKEN INTO SMALL PIECES

makes about 30

Preheat the oven to 180°C (fan), 200°C, gas mark 6. Place the cherries on a baking tray lined with baking paper and sprinkle with caster sugar. Bake in the oven for 50 minutes–1 hour until the cherries are shrivelled up and caramelised. Remove from the oven and set aside to cool.

Meanwhile, scatter the almonds on a baking tray and roast in the oven for 7–10 minutes. Leave half the almonds whole and coarsely chop the remainder, then set both aside.

Place the butter, brown sugar, golden syrup and Amaretto (if using) in a saucepan over a medium heat until melted, then remove the pan from the heat and stir in the flour and ground ginger.

Line two large baking trays with baking paper. Carefully pour half the mixture onto the middle of one of the trays and, using an angled palette knife or a spatula, very gently and gradually spread the mixture out to form a rough rectangle about 2–3 mm thick, leaving a 5 cm border all around as the mixture will spread as it cooks. Repeat with the remaining mixture on the second baking tray, then transfer both trays to the oven and cook for 5 minutes.

Remove the trays from the oven (at this stage, the mixture will be a bit lighter and thicker in the centre than the outside). Scatter the cherries, whole roasted almonds and crushed almonds over the top, then return to the oven and cook for 12–15 minutes or until the mixture is bubbling and golden brown. Remove from the oven and set aside to cool for 4–5 minutes.

Starting from the outside and working inwards, use a cookie cutter to carefully cut out rounds. Place the florentines on a lined baking tray or plates and chill in the fridge while you melt the chocolate.

Line your work surface with foil (this makes for an easier clean-up afterwards) and place two or three wire racks on top.

Half-fill a small saucepan with water and bring to a simmer. Place the chocolate in a small heatproof bowl that fits snugly over the pan without touching the water, and heat over a low heat, stirring occasionally, until the chocolate has melted. Carefully remove the bowl from the heat and set aside.

Remove the florentines from the fridge and dip each one halfway into the melted chocolate, then place on a rack and leave for 15 minutes. Transfer to the baking trays or plates and chill in the fridge for 1 hour or until the chocolate has set.

I grew up on pavlovas and meringues — Mum was brilliant at making them. In fact, even though I live in Australia, home of the pav (apologies to all those Kiwis out there, but I have to say that as I'm married to an Aussie), I still think my mum's were the best.

You have to be mindful of the weather conditions when you make meringues: don't attempt to make them if it's really humid and hot, as they'll probably flop. Also, once whipped, try not to let the egg whites sit around for too long — the key with meringues is to work fast and get them into the oven straight away.

No. 262

Mum's CHOCOLATE meringues

1 TEASPOON CREAM OF TARTAR
1 TEASPOON CORNFLOUR
1 TABLESPOON ESPRESSO COFFEE POWDER
1 TABLESPOON DUTCH-PROCESS COCOA POWDER,
 PLUS EXTRA FOR DUSTING
100 G GOOD-QUALITY DARK CHOCOLATE, FINELY CHOPPED
$1/2$ LEMON
6 FREE-RANGE EGG WHITES, AT ROOM TEMPERATURE
300 G CASTER SUGAR
1 TEASPOON WHITE VINEGAR
WHIPPED CREAM, TO SERVE

makes 12

Preheat the oven to 140°C (fan), 160°C, gas mark 2½ and line two baking trays with baking paper.

Place the cream of tartar, cornflour, coffee powder, cocoa powder and chocolate into a small bowl, stir to combine and set aside.

Wipe the inside of the bowl of an electric mixer with the cut-side of the lemon to remove any traces of oil. Add the egg whites and beat on medium speed until soft and frothy and just starting to hold soft peaks. Turn up the speed to medium-high and gradually add the caster sugar, beating just until the mixture turns thick and super-glossy and holds stiff peaks. Add the dry ingredients and the vinegar, then gently fold together using a large metal spoon (don't overwork the mixture — five or six folds should do it). Take dessertspoonfuls of the mixture and drop onto the prepared trays.

Bake in the oven for 1 hour or until the bases of the meringues are firm, then turn off the oven and leave the meringues in the oven to cool (use a wooden spoon handle to keep the oven door ajar, if you wish). Serve dusted with cocoa, with freshly whipped cream alongside.

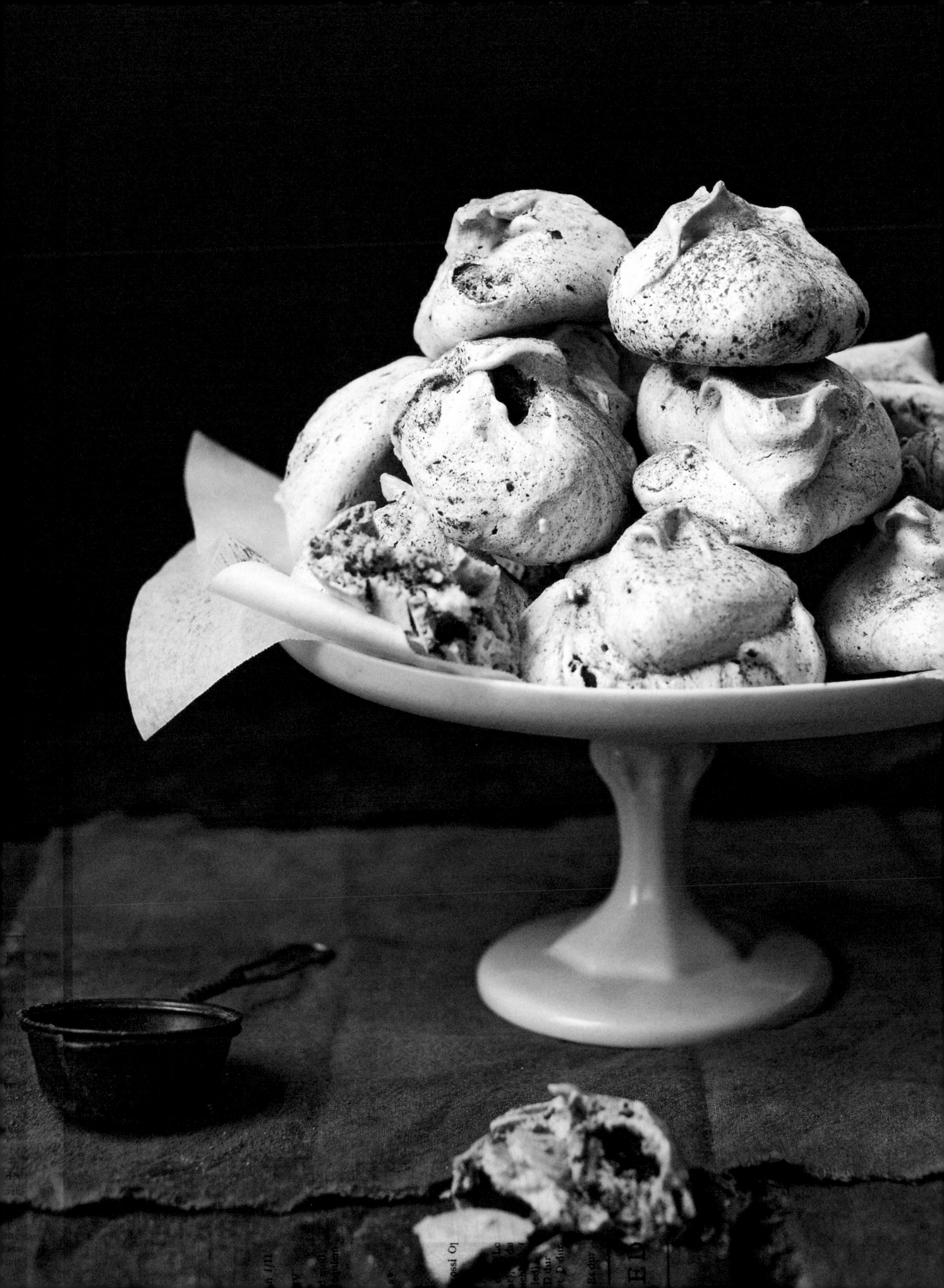

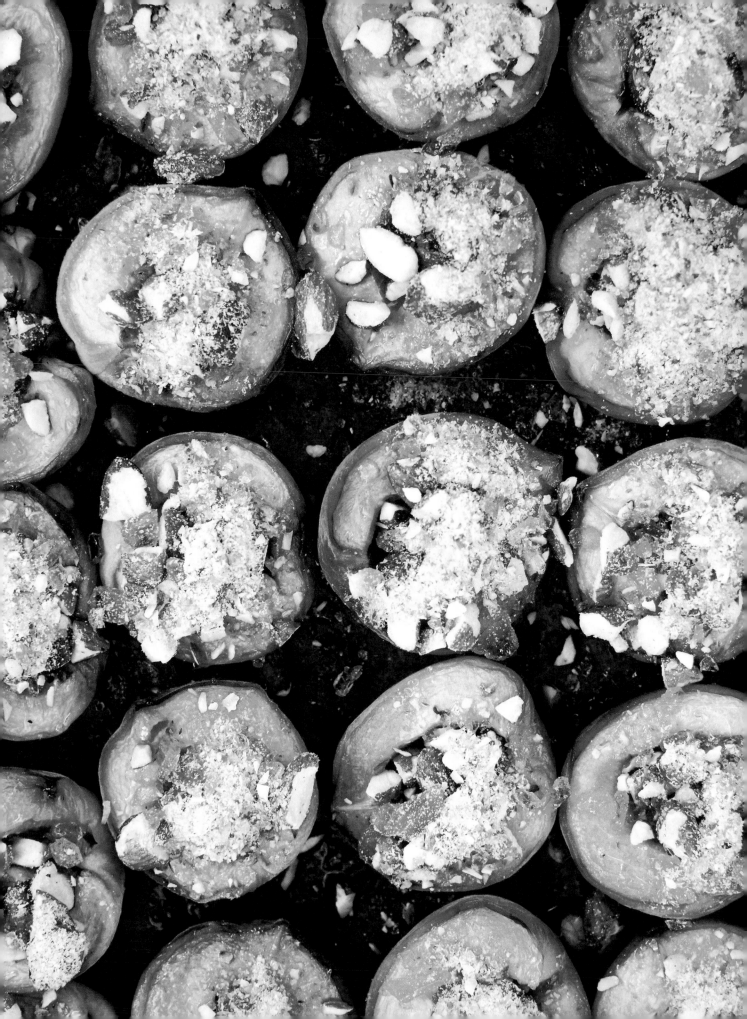

Honey-baked peaches

A 'What Katie Ate' staple, and one of the first recipes I put
on the blog, these are super-easy and a good crowd-pleaser —
especially for Sunday brunch. Swap fresh peaches for plums
or pears, and pecans for almonds if you like.

10 RIPE PEACHES, HALVED AND STONED
1 TABLESPOON RUNNY HONEY
80 G ALMONDS
150 G CASTER SUGAR

Vanilla crème fraîche (optional)
240 G CRÈME FRAÎCHE
1 VANILLA POD, SPLIT AND SEEDS SCRAPED

Serves 6-8

Preheat the oven to 180°C (fan), 200°C, gas mark 6.

Place the peaches, cut-side up, on a baking tray and drizzle with honey.
Bake for 20-30 minutes until softened.

While the peaches are baking, place the almonds on a separate baking tray lined
with baking paper and roast for 7-10 minutes until golden brown, then remove and
set aside.

If you're making the vanilla crème fraîche, combine the crème fraîche and vanilla
seeds in a small bowl. Leave in the fridge until required.

Place 3 tablespoons water and the sugar in a deep, heavy-based saucepan and bring
to the boil — do not stir, but rather swirl the contents of the saucepan every
now and again. Reduce the heat to medium, then simmer for about 15 minutes until
the sugar has dissolved and the syrup starts to turn a light- to mid-golden
colour. Quickly remove from the heat and pour over the roasted almonds, coating
evenly (take care not to splash the syrup on yourself as it will be super-hot).
Leave the praline to cool, then grind to a coarse texture in a food processor.

Remove the peaches from the oven and spoon some praline into the centre of each
one. Top with the vanilla crème fraîche (if using) and sprinkle a little extra
almond praline on top to serve.

JERSEY MAID

VANILLA ICE CREAM

JERSEY MAID ICE CREAM COMPANY SYDNEY & MELBOURNE

Coffee HAZELNUT Frangelico Cake

No. 270

This is definitely a cake for a special occasion. Although it does take time to make, I can promise you the results are worth the effort — it's quite a show-stopper. The chocolate sand adds an extra textural element to the buttercream filling, but you can omit this if you like.

If your chocolate ganache 'splits' (which has happened to me many times, normally when I've really splurged on expensive chocolate), it's really easy to remedy — just whisk the ganache with a hand-held blender, and in no time it will be restored to its former shiny, glossy self.

250 G HAZELNUTS
1 TABLESPOON GOOD-QUALITY INSTANT COFFEE GRANULES
80 ML BOILING WATER
300 G UNSALTED BUTTER, SOFTENED
300 G CASTER SUGAR
6 FREE-RANGE EGGS, LIGHTLY BEATEN
60 ML FRANGELICO
2 TABLESPOONS MILK
450 G PLAIN FLOUR
2$\frac{1}{2}$ TABLESPOONS BAKING POWDER
1$\frac{1}{2}$ TABLESPOONS COCOA POWDER
CHOCOLATE LIQUEUR (OPTIONAL), TO SERVE

Chocolate buttercream

375 G UNSALTED BUTTER, SOFTENED
60 G ICING SUGAR, SIFTED
105 G GOOD-QUALITY DARK CHOCOLATE
3 TABLESPOONS MILK
2 TABLESPOONS FRANGELICO

Chocolate sand (optional)

45 G HAZELNUTS
50 G MERINGUE (I USE SHOP-BOUGHT MERINGUE SHELLS)
50 G GOOD-QUALITY DARK CHOCOLATE (60–70% COCOA SOLIDS)

Chocolate ganache

135 G GOOD-QUALITY DARK CHOCOLATE (60–70% COCOA SOLIDS),
 BROKEN INTO SMALL PIECES
180 ML WHIPPING CREAM
1 TABLESPOON FRANGELICO

Serves 8–10

Recipe method over page . . .

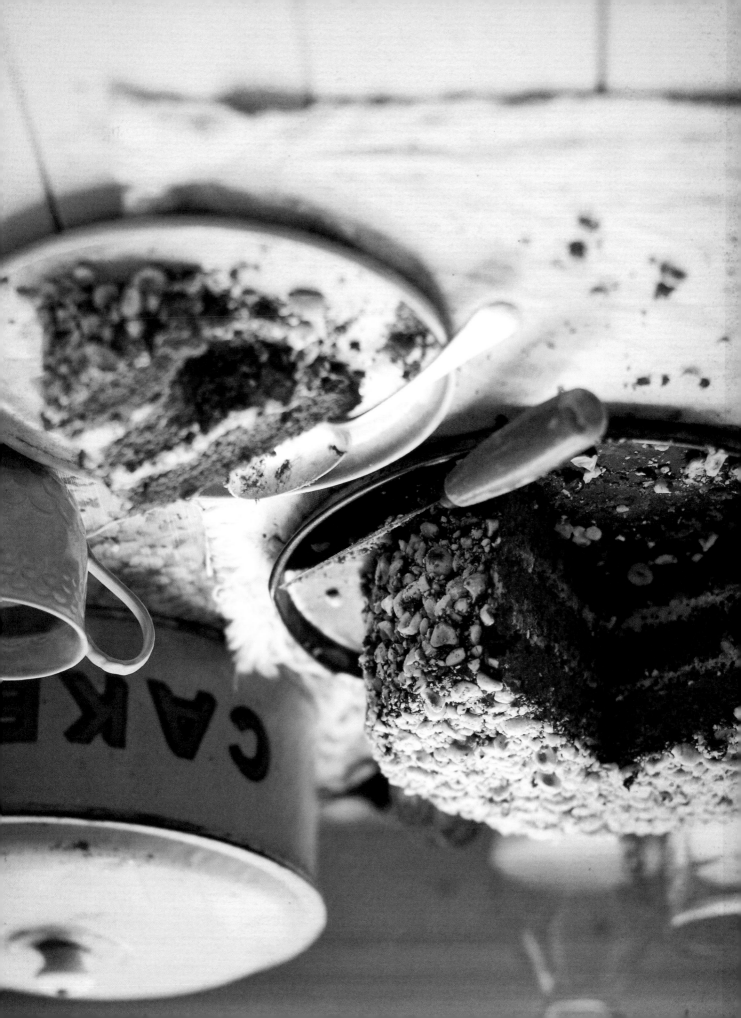

Coffee HAZELNUT
Frangelico Cake continued . . .

Preheat the oven to 180°C (fan), 200°C, gas mark 6. Scatter the 250 g
of hazelnuts on a baking tray and roast in the oven for 10 minutes until
lightly golden brown, being careful not to burn them. Rub off the skins
in a clean, dry tea towel and coarsely crush the nuts. Set aside. (If you
are making the chocolate sand, roast the extra 45 g hazelnuts for this at
the same time, then rub off the skins and set the nuts aside in a separate
bowl.)

Grease and line three 20 cm springform cake tins.

Dissolve the instant coffee granules in the boiling water, stirring well
to combine, then allow to cool. Using an electric mixer, beat the butter
and sugar on a medium-high setting for 8-10 minutes until very light,
fluffy and pale. Turn the speed down to medium and gradually add the
beaten eggs in four or five additions. Continue to beat until incorporated.
Add the Frangelico and milk and beat for a further minute or so, then add
the cooled coffee mixture and beat on low speed just to combine all the
ingredients together.

Sift the flour, baking powder and cocoa into a bowl and combine, then add to the
cake mixture and beat until everything is incorporated. Spoon the cake batter
into the prepared tins and smooth the tops. Bake for 40-50 minutes, swapping
the tins halfway through the cooking time to ensure even cooking. When cooked,
the cakes should be golden, and a skewer inserted into the centre should come
out clean. Allow to cool a little before removing the cakes from the tins and
transferring them to wire racks to cool completely.

To make the chocolate buttercream, use an electric mixer to beat the
butter and icing sugar until light, fluffy and pale (about 8-10 minutes).
Meanwhile, bring a small saucepan of water to a gentle simmer and melt the
chocolate in a small heatproof bowl that fits snugly over the pan without
touching the water, stirring occasionally. Carefully remove the bowl from
the heat and allow to cool slightly, then pour into the butter and sugar
mixture. Stir to combine, then stir in the milk and Frangelico.

If making the chocolate sand, place the 45 g of roasted hazelnuts
and meringue shells in a food processor and blitz until finely ground,
then transfer to a medium-sized heatproof bowl. Bring a small saucepan of
water to a gentle simmer and melt the chocolate in a small heatproof bowl that
fits snugly over the pan without touching the water, stirring occasionally.
Pour the melted chocolate over the hazelnut and meringue mixture and mix
together using the edge of a spatula until evenly coated. The whole lot
should look like, well, chocolate sand!

To make the chocolate ganache, place the chocolate in a heatproof bowl.
Bring the cream to a slow boil in a small saucepan over a low heat. Once
boiling, remove from the heat and pour the cream over the chocolate.
Leave to stand for 5 minutes, then stir to combine. Stir in the
Frangelico and set aside until required.

To assemble the cake, use a sharp bread knife to carefully trim off
the rounded tops of the three cakes to provide flat surfaces for the
buttercream. Place the first (bottom) cake on a clean work surface and
spread a layer of buttercream on top, then sprinkle with a good layer of
chocolate sand (if using). Add the second cake and repeat with buttercream
and chocolate sand. Top with the third cake. Using a palette knife, cover
the entire cake with a thin layer of buttercream and place in the fridge to
chill. After about 15 minutes, remove the cake from the fridge and cover
with chocolate ganache.

Return to the fridge to chill for a further 5 minutes, then remove and
sprinkle the top and sides of the cake with the crushed hazelnuts. Serve
with a small drizzle of chocolate liqueur, if you like.

Mocha chocolate mousse
with IRISH WHISKEY

One of my mum's best desserts was her chocolate mousse — it was out of
this world, and I'll never forget it. It was rich, luscious, thick, smooth
and almost chewy in parts, and I can taste it as I am writing. I've tried
many times to re-create Mum's mousse, and this recipe comes closest. Here
I've added a good glug of Irish whiskey — use the best quality you can
get. I also find that instant coffee works better than stronger espresso.
Serve this chilled and topped with freshly whipped cream, and I guarantee
everyone will come back for more.

170 G GOOD-QUALITY DARK CHOCOLATE, BROKEN INTO SMALL PIECES
170 G UNSALTED BUTTER
3 TABLESPOONS GOOD-QUALITY INSTANT COFFEE GRANULES,
MIXED WITH 2 TABLESPOONS HOT WATER
4 FREE-RANGE EGGS, SEPARATED
150 G CASTER SUGAR, PLUS 1 TABLESPOON EXTRA
2 TABLESPOONS IRISH WHISKEY (OR DARK RUM)
PINCH FINE SALT
WHIPPED CREAM, TO SERVE

Serves 6–8

Bring a medium-sized saucepan of water to
a gentle simmer and melt the chocolate,
butter and coffee in a heatproof bowl that
fits snugly over the pan without touching
the water, stirring occasionally. Carefully
remove the bowl from the heat and set aside.
Keep the saucepan of water simmering away.

Place a few handfuls of ice in a large bowl
and half-fill with water. Set aside nearby.

Sit a heatproof bowl that will fit into the bowl
of ice over the saucepan of simmering water and
add the four egg yolks, caster sugar, whiskey
(or rum) and 1 tablespoon cold water. Using
a balloon whisk or hand-held electric beaters,
whisk for about 3 minutes until the mixture
thickens, becomes paler and has a similar
consistency to that of runny mayonnaise. Remove
the bowl from the heat and place it in the bowl
of iced water. Continue to whisk for a further
few minutes until the mixture thickens and cools
slightly, being careful that no water gets into

the mixture. Add the chocolate mixture to the
beaten eggs and stir to combine.

Whisk the egg whites with a pinch of salt until
just stiff and frothy. Add the extra tablespoon
of caster sugar and beat again until just glossy.

Using a large mixing spoon, add one spoonful
of egg whites to the chocolate mix and fold it
in gently. Gradually fold in the remaining egg
whites, taking care not to overmix.

Transfer the mousse to a jug, then pour into
individual serving jars or glasses. Place
in the fridge and chill for 3–4 hours before
serving. Serve topped with a thick layer of
whipped cream.

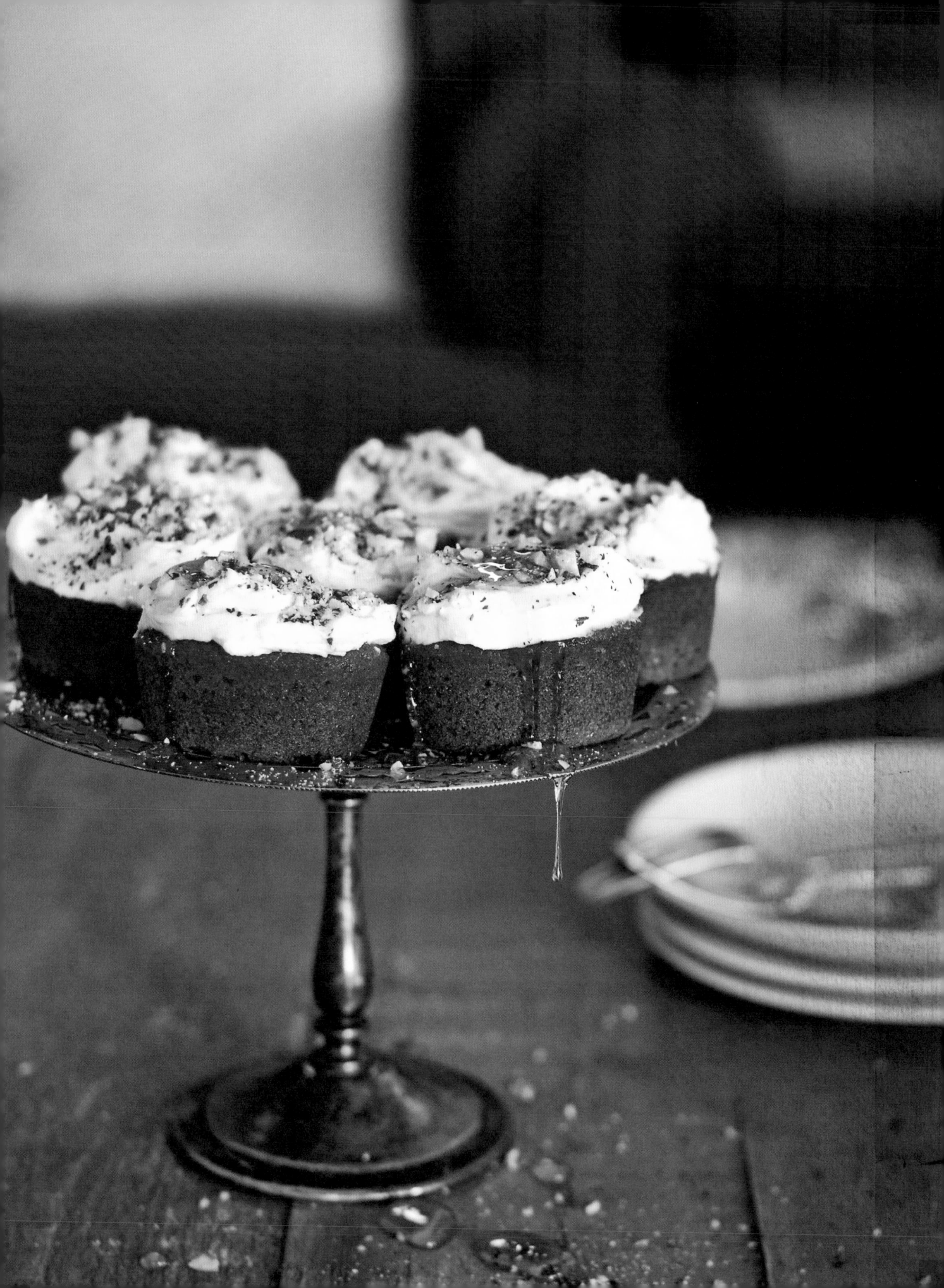

Carrot cakes with COINTREAU-SOAKED *sultanas*

My publisher, Julie Gibbs, always presents amazing little baked treats for us
to enjoy at our meetings. One day she came laden with tiny carrot cakes,
and from the moment I took my first bite, I was on a mission to work out how
to make something similar. These little cakes are the result — they are moist
and spicy and really rather wonderful with a big mug of hot tea.

80 G SULTANAS
JUICE OF 1 BLOOD ORANGE
1 TABLESPOON COINTREAU (OPTIONAL)
75 G BROWN SUGAR
125 ML RAPESEED OIL
125 ML RUNNY HONEY, PLUS EXTRA FOR DRIZZLING (OPTIONAL)
3 FREE-RANGE EGGS
1 VANILLA POD, SPLIT AND SEEDS SCRAPED
$1/2$ TEASPOON GROUND GINGER
225 G PLAIN FLOUR
2 TEASPOONS BAKING POWDER
1 TEASPOON BICARBONATE OF SODA
PINCH SALT
3 CARROTS, GRATED
SMALL HANDFUL WALNUTS, ROUGHLY CHOPPED

Cream cheese icing
135 G ICING SUGAR
85 G UNSALTED BUTTER, SOFTENED
80 G CREAM CHEESE
1 TABLESPOON WHIPPING CREAM
1 TEASPOON VANILLA EXTRACT

makes 12

Place the sultanas, blood orange juice and Cointreau (if using), in a small
bowl and leave in the fridge overnight to macerate.

Preheat the oven to 180°C (fan), 200°C, gas mark 6. Grease a 12-hole silicone
friand mould or non-stick friand tin.

Place the brown sugar, oil, honey, eggs and vanilla seeds in a large bowl. Sift
the ginger, flour, baking powder, bicarbonate of soda and salt into another
large bowl. Add the wet ingredients to the dry ingredients and mix well to
combine. Stir in the grated carrot and soaked sultanas.

Pour the mixture into the prepared mould or tin, filling each hole
three-quarters full. Bake for 45-55 minutes or until a skewer inserted into
the centre of a cake comes out clean. Remove the cakes from the mould or pan
and allow to cool on wire racks.

To make the icing, mix all the ingredients in an electric mixer for
about 10 minutes until really light and fluffy.

Ice the cooled cakes and serve them topped with a scattering of chopped walnuts
and a drizzle of honey, if you like.

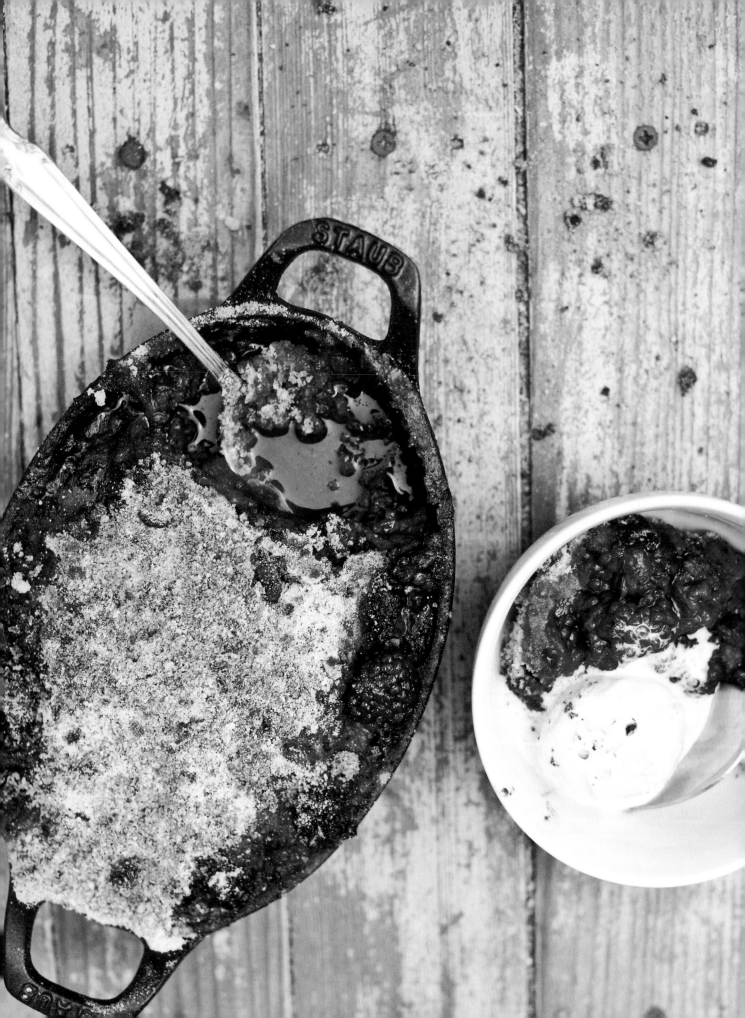

Use extra blackberries or blackcurrants if you can't get boysenberries.
If you can't find fresh berries at all, use frozen (skip the simmering step
and just place the frozen berries in the dish with the sugar and vanilla).
Try to get vanilla extract rather than imitation essence, as it really makes
a difference to the flavour. I generally put praline in the freezer to
harden, but you can just set it aside on the work surface — it will take
a bit longer but will be just as good.

Boysenberry, blackberry and ALMOND PRALINE CRUMBLE

2 x 225 G PUNNETS BLACKBERRIES
1 x 170 G PUNNET BOYSENBERRIES
55 G CASTER SUGAR
1 TEASPOON VANILLA EXTRACT
ICE CREAM, TO SERVE

№. 279

Crumble topping
50 G BLANCHED ALMONDS
165 G CASTER SUGAR
125 G WHOLEMEAL PLAIN FLOUR
115 G CHILLED UNSALTED BUTTER, CUBED
2 TEASPOONS BROWN SUGAR

Serves 4

Preheat the oven to 200°C (fan), 220°C, gas mark 7.

Place all the berries in a medium-sized saucepan along with 125 ml water and the caster sugar. Simmer gently for about 10 minutes until the berries start to soften. Add the vanilla extract and stir gently to combine. Pour the berries into a 1 litre capacity baking dish (mine is 17.5 cm x 12.5 cm x 5.5 cm) and set aside.

For the crumble topping, roast the almonds in the oven for 7–10 minutes until lightly golden, being careful not to overcook them (keep an eye on them as they can burn in seconds). Meanwhile, choose a baking tray or plate that is small enough to sit flat on a shelf in your freezer, line it with baking paper and set aside.

Place 110 g caster sugar and 2 tablespoons water in a small, heavy-based saucepan and cook over a low-medium heat for 5–10 minutes until the sugar starts to dissolve. Turn up the heat and bring to the boil, then cook for 10–12 minutes — do not stir, but rather swirl the contents of the pan every now and then until the mixture

starts to turn a light golden brown. When the syrup is golden brown and bubbling, add the roasted almonds and swirl the pan to coat evenly, then quickly and carefully tip the contents of the pan out onto the prepared baking tray or plate. Spread out evenly using an angled palette knife or a spatula. Place in the freezer and chill for 10 minutes or until rock-hard, then blitz to a medium-fine texture in a food processor or blender.

Place the flour in a mixing bowl and add the butter, then rub together with your fingertips until the mixture resembles fine breadcrumbs. Add the remaining 55 g caster sugar and half the almond praline and combine.

Scatter the crumble topping over the berries, add another tablespoon or two of praline and sprinkle over the brown sugar. Bake for 30–40 minutes until bubbling and golden brown, then remove from the oven and scatter with the remaining praline. Serve warm with ice cream.

This pie recipe appeared on the blog back in March 2011, and I received such a great response that I just knew I had to include it in the book. If you can't get fresh blueberries, feel free to use frozen (just simmer them for a bit less time — about 6 or 7 minutes as opposed to 10). A tip for lining pastry for blind baking: crumple up the baking paper first and then flatten out — it's much easier to handle this way.

Apple, ginger and BLUEBERRY SHORTCRUST PIE

5 COOKING APPLES
100 G CASTER SUGAR
PINCH GROUND GINGER
FINELY GRATED ZEST AND JUICE OF 1 LEMON
2 X 150 G PUNNETS BLUEBERRIES
8-10 GINGER NUT COOKIES, CRUSHED INTO FINE CRUMBS
1 FREE-RANGE EGG MIXED WITH 1 TABLESPOON MILK
CREAM, TO SERVE

Shortcrust pastry
100 G SELF-RAISING FLOUR
160 G PLAIN FLOUR
PINCH FINE SALT
125 G CHILLED UNSALTED BUTTER,
 CHOPPED INTO SMALL CUBES

Serves 8

Preheat the oven to 180°C (fan), 200°C, gas mark 6.

To make the pastry, sift the flours and salt into a chilled bowl. Drop the butter into the flour and rub in with the tips of your fingers, lifting the mixture high over the bowl so it remains cool and does not become sticky; keep going until the mixture resembles fine breadcrumbs. Make a well in the centre and gradually add 1 tablespoon cold water, mixing with a cold dinner knife and then your fingertips, until the dough binds together and starts to come away from the sides of the bowl. Turn out onto a floured work surface and knead lightly until smooth. Flatten the dough into a disc, wrap in cling film and refrigerate for 30 minutes.

Meanwhile, peel, core and cut the apples into 1 cm slices. Place them in a medium-sized saucepan and add 250 ml water and the caster sugar, ground ginger and lemon zest. Bring to the boil, then reduce the heat to medium and simmer for 15 minutes. Add half of the blueberries to the pan and simmer for a further 10 minutes. Turn off the heat and allow to cool in the pan. Strain the syrup into a small clean saucepan, and set the fruit aside.

Butter the base and sides of a 22 cm round springform tin. Remove the pastry from the fridge and roll it out to 5 mm thick. Use three-quarters of the pastry to line the tin, leaving some pastry overhanging the edges to allow for shrinkage. Line the pastry with baking paper and fill with baking beans or rice. Blind bake the pastry for 10-15 minutes or until just lightly golden, then carefully take out of the oven and remove the paper and beans or rice. Allow to cool slightly, then sprinkle a layer of ginger-nut crumbs over the base, then add the apple and blueberry mixture. Sprinkle the remaining blueberries on top.

Cut four or five 21 cm x 2.5 cm strips from the remaining pastry and lay them across the top of the pie, leaving a 1 cm gap between each strip. Cut another four or five strips and lay them across the top of the pie in the other direction to make a criss-cross pattern. Pinch the strips to the edge of the pie crust, then brush with the egg mixture.

Bake the pie for about 50 minutes or until the pastry is golden. While the pie is cooking, add the lemon juice to the small pan of apple and blueberry syrup, and boil for about 15-20 minutes until the liquid has reduced by half. Set aside to cool.

Serve the pie warm with the apple and blueberry syrup and cream.

Since this cake was featured on the blog back in 2011, I've made a few
tweaks to the recipe, which I think make it even nicer. To make the
chocolate shards, put the chocolate in the fridge to chill completely,
then scrape a large sharp knife along the side of the bar to create shards.
The gorgeous little flags that adorn the cake were a present to me from
the beautiful Nikole Herriot, one of the nicest women in the food-blogging
world (check out her stuff at herriottgrace.com).

Katie's CHOCOLATE FUDGE cake

6 FREE-RANGE EGGS
220 G CASTER SUGAR
350 G GOOD-QUALITY DARK CHOCOLATE,
 200 G BROKEN INTO SMALL PIECES,
 THE REST SET ASIDE IN THE FRIDGE
75 G PLAIN FLOUR, SIFTED
4 TABLESPOONS COCOA POWDER, SIFTED

Chocolate coffee buttercream
300 G UNSALTED BUTTER, SOFTENED
155 G ICING SUGAR, SIFTED
170 G GOOD-QUALITY DARK CHOCOLATE
1 TEASPOON VANILLA EXTRACT
1 TABLESPOON PRE-MIXED STRONG INSTANT COFFEE

Serves 8–10

Preheat the oven to 180°C (fan), 200°C,
gas mark 6 and grease and line the base
and sides of two 20 cm round springform
tins.

Using an electric mixer, whisk the
eggs for 5 minutes on medium speed
until pale and frothy. Add the caster
sugar and continue to whisk until thick
and pale. Meanwhile, bring a small
saucepan of water to a gentle simmer
and melt the 200 g chocolate in a small
heatproof bowl that fits snugly over
the pan without touching the water,
stirring occasionally.

Using a large metal spoon, gently fold
the flour and cocoa into the whisked
egg and sugar mixture, followed by the
melted chocolate, and combine well.
Pour into the prepared cake tins and
bake for about 20 minutes or until
a skewer inserted into the centre comes
out clean. Remove the cakes from the
oven and allow to cool a little before
removing from the tins and transferring
to wire racks to cool completely.

To make the buttercream, beat the
butter and icing sugar in a bowl until
smooth and creamy. Meanwhile, bring
a small saucepan of water to a gentle
simmer and melt the chocolate in a
small heatproof bowl that fits snugly
over the pan without touching the
water, stirring occasionally. Remove
from the heat and add the vanilla and
coffee to the melted chocolate and
combine; it will start to become lumpy
but don't worry. Add this to the butter
and sugar mixture, beating gently until
glossy and smooth.

Trim off the rounded tops of the cakes to
form flat surfaces for the buttercream.
Use a spatula to spread a dollop of
buttercream on top of the first cake
and spread it out towards the edges.
Place the second cake on top, then ice
the top and sides of the cake. Using
a sharp knife, carefully scrape shavings
from the chilled chocolate and scatter
all over the cake.

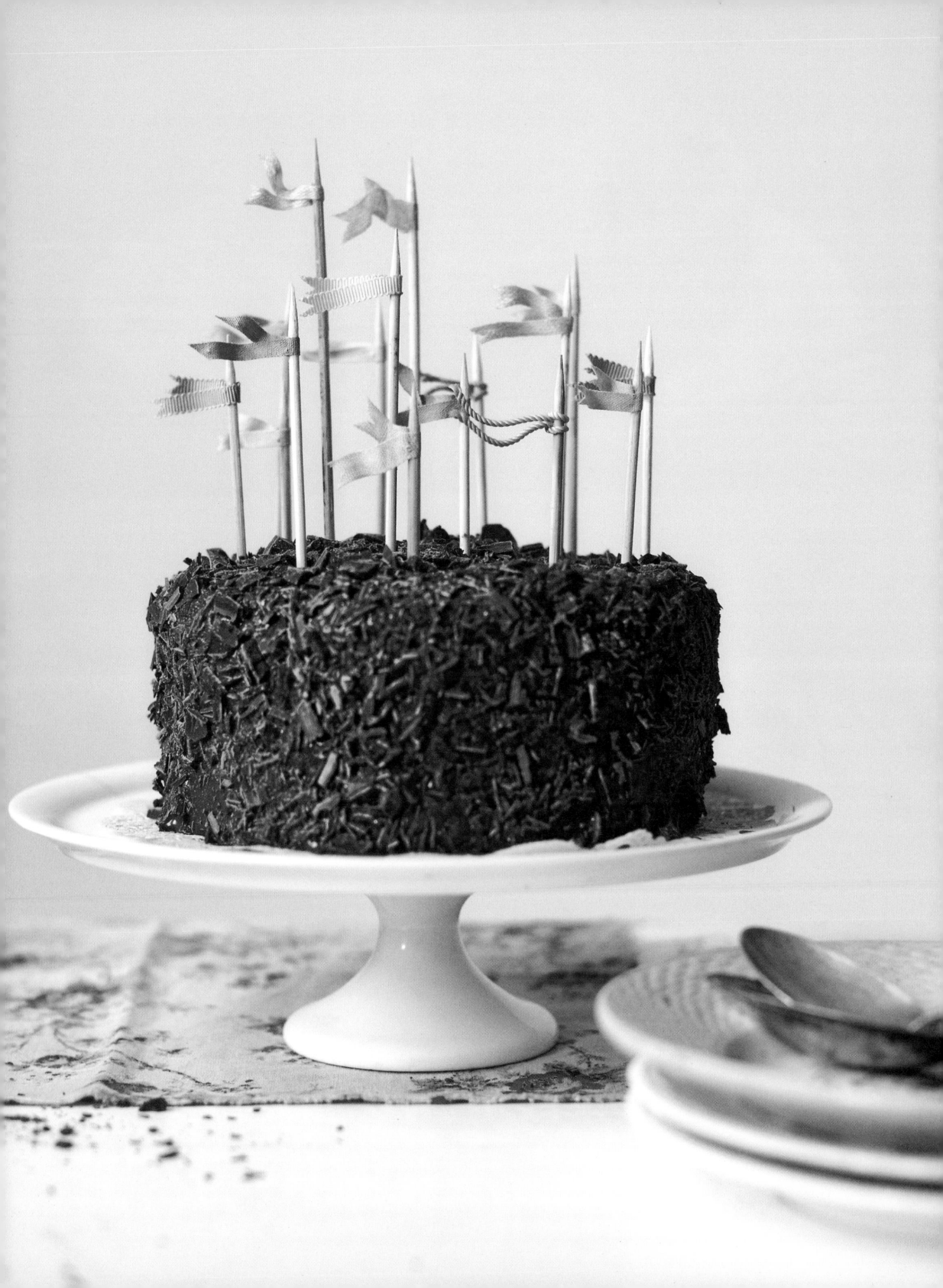

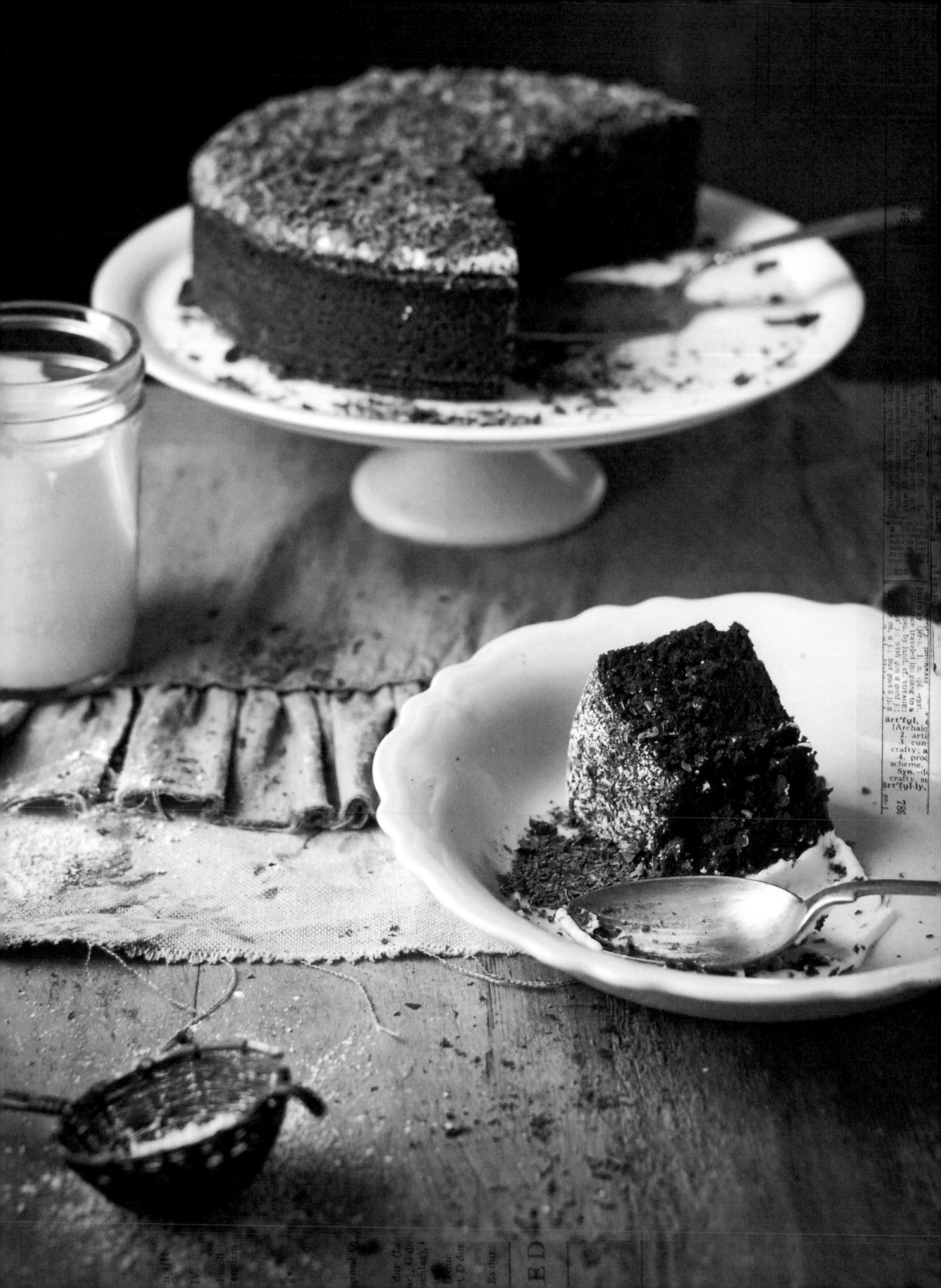

EASY
chocolate cake

This is a recipe my husband Mick gave to me around the time we started
dating. It came from his little black book of recipes, a collection he
had amassed over the years via his travels or that had been passed
down to him from his family. This is a recipe from his mum, and it's
pretty much impossible to get wrong. The cake is really moist and
luscious, and can be served on its own with cream or with some fresh
raspberries. If you want to make it kid-friendly, omit the Frangelico
and add 2 tablespoons of milk instead.

6 SMALL SAVOIARDI BISCUITS, CRUSHED
300 G GOOD-QUALITY DARK CHOCOLATE, BROKEN INTO SMALL PIECES
150 G UNSALTED BUTTER, SOFTENED
165 G CASTER SUGAR
4 FREE-RANGE EGGS
155 G GROUND ALMONDS
150 G MASCARPONE
3 TABLESPOONS FRANGELICO
ICING SUGAR, SHAVED CHOCOLATE AND DOUBLE CREAM, TO SERVE

Serves 8-10

Preheat the oven to 180°C (fan), 200°C, gas mark 6. Grease
and line a 22 cm round springform tin. Sprinkle with
1 tablespoon of crushed savoiardi biscuits, just to coat
the base of the tin.

Bring a small saucepan of water to a gentle simmer and melt
the chocolate in a small heatproof bowl that fits snugly over
the pan without touching the water, stirring occasionally.
Carefully remove from the heat and set aside.

Using an electric mixer, cream the butter and sugar until light
and creamy, then add the eggs one at a time, beating between
each addition — don't panic if the mixture resembles scrambled
eggs at this stage. Stir in the remaining crushed savoiardi
biscuits, the ground almonds, melted chocolate, mascarpone and
Frangelico. Mix until combined.

Pour the mixture into the prepared tin and bake for
55-65 minutes until the cake has a crust on top and is firm
around the edges — a skewer inserted into the centre should
come out clean. Be careful not to overcook, as the centre of
the cake should remain a little moist.

Dust the cooled cake with icing sugar and sprinkle
with chocolate shavings before slicing and serving with
a generous dollop of cream.

The inspiration for this granita came to me after a trip to New York in 2011. While I was there, I met up with my friend Melina Hammer for dinner. Melina was one of the first contacts I made in the blogging world when I set up 'What Katie Ate'. She was very supportive to me, and I am thrilled we have kept in touch. We always meet up for drinks and dinner whenever I am in her neck of the woods. Last year, Melina kindly gave me some candy she had picked up during a tour of a local boutique sweet factory — it was flavoured with watermelon, chilli and salt, and I thought the combination would make for a fab dessert idea. Once made, this granita will keep in the freezer for 3 days.

Watermelon, SALT and chilli granita

750 G SEEDLESS WATERMELON, SKIN REMOVED AND ROUGHLY CHOPPED
1 TABLESPOON LIME JUICE
1/4 TEASPOON FINE SALT
1/4 TEASPOON DRIED CHILLI FLAKES, PLUS A PINCH EXTRA

Serves 4

Place all the ingredients into a food processor and blend until the mixture has a pulpy consistency.

Have ready a baking tray that is at least 4 cm deep and will comfortably sit flat on a shelf in your freezer. Pour the mixture through a sieve into the tray, pressing firmly on the contents of the sieve with the back of a spoon to get as much of the mixture through as possible. Whatever you can't push through the sieve, discard.

Carefully transfer the tray to the freezer and freeze for 4 hours. When ready to serve, scrape into fluffy granita snow using a fork, and serve.

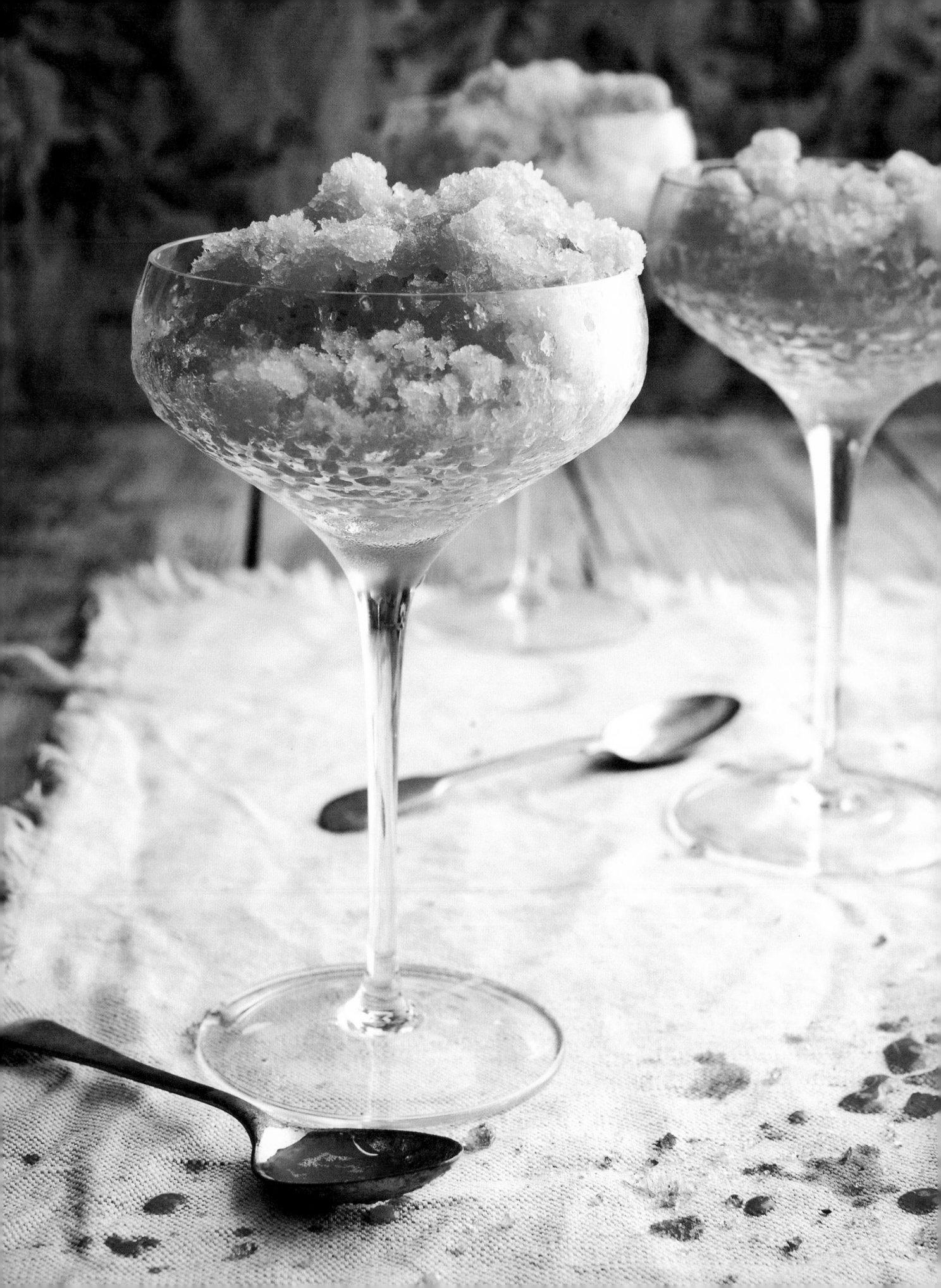

COLD DRINKS
ICE CREAMS

Thank You!

Creating this book has been an amazing journey for me from start to finish: every inch of the way, I have grown and learnt so many valuable lessons. My number one thank you must go to my husband and best friend, Mick. Without him, I could not run the blog the way I do, nor could I have written and shot this book in the time that I did. I feel utterly blessed by his patience, enormous generosity with his free time, and unending and sometimes mind-boggling support. Mick is a tremendous part of this book, and should there ever be an Olympic sport for 'washing up at the weekends and running back and forth to the shop countless times when your wife has forgotten to buy flour (again)', then Mick, you are the champion of the world (as well as being the best hand and arm model in Australia!). I love you eternally, and I thank you so, SO much. x

Without the wonderful Julie Gibbs, there would be no *What Katie Ate* book. Thank you, Julie, for seeing the potential in the blog and for offering me this opportunity. You are truly inspirational at what you do, and your support has been amazing. Being the stubborn, proud Irish perfectionist I am (as you now know all too well!), I thank you for always fighting my corner and, lest I forget, for always bringing THE most incredibly naughty sweetie delights to our meetings!

Virginia Birch, my diligent and considerate editor, you have held my hand throughout this journey without ever making me feel pressured, at times when I was fit to explode from outside work and day-to-day pressures. Thanks for spotting all the teeny-tiny incredible details only the best editors can spot. You have been a joy to collaborate with. Katrina O'Brien, thanks for being the superb organisational star that you are; it was great to know you were always there for any questions I might have along the way. To designer Emily O'Neill, thanks for all your hard work and perseverance in dealing with a very pedantic, 'I've done this for 12 years!!!' ex-designer: the drinks are on me! Thanks also to the Penguin design team for your fantastic assistance in the latter days of the design process.

To all of the gang at Penguin in Australia and the US, I couldn't have dreamt of a better publisher to pair with for my first cookbook. I am honoured to work with such an established and respected company. Thanks also to HarperCollins UK and Hachette Livre in France for taking *What Katie Ate* on board.

Colm Halloran is a very dear friend of mine. Colm, you have always believed in me, supported me and, most importantly, been an amazing friend over the years. I will always be eternally grateful for your continuing words of advice and your unconditional support and love. Here's to the next pint in Rosie's! To my great friend, the beautiful Siobhán, I will always be grateful for your creative guidance. To Madeleine Mouton, for being my number one (amazing) assistant and for providing me with your granny's lemonade recipe. To the one and only Georgie, for your support with the props and your endless patience when I kept forgetting to return your napkins(!). You are a joyful person to work with, your laidback and easy-going attitude is so appreciated, and it makes manic recipe writing/prepping/styling/shooting a tad less hectic working with someone as great as yourself. I also want to say thank you to Alan Benson, one of the most incredibly talented and humble photographers I have ever met. Alan, you were a blessing and a huge support to me when I moved to Sydney, and your unending help will always be much appreciated.

Thanks to all my good friends who have helped and supported me over the past two years. You may not have realised it, but you shared this journey with me whenever you asked: 'How are things going with the book?'. Such a simple question, yet hugely appreciated. Thanks to all the people who have become part of this book by sharing their recipes with me: Bob and Sheila Davies, Michael and Michelle from love.fish restaurant in Sydney, and Jill in Brisbane for her fantastic vegetarian recipe. A special thank you to Mark Boyle for encouraging me to start a blog in the first place: without your persistence, none of this would have been possible. I also want to thank Peta Dent for her help with testing the recipes: your input and ideas were invaluable.

Most importantly, thank you to all the incredible and continually supportive followers of my blog 'What Katie Ate'. Without you, this book would not exist. I thank you from the bottom of my heart for following my journey and always reminding me you are out there, somewhere in the world, waiting with bated breath for my next post (and being very patient when said post took me a little longer than I thought!). I hope you, most importantly, enjoy this book.

Katie x